Treasures of

THE
FITZWILLIAM
MUSEUM

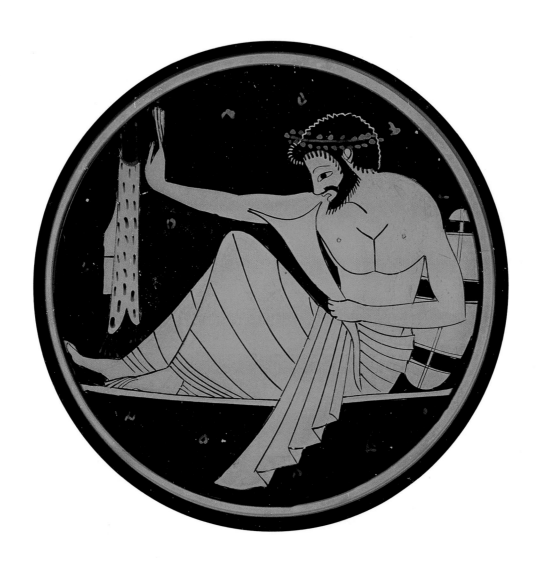

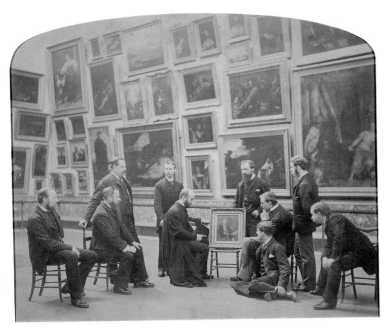

The staff of the Fitzwilliam Museum, *c.*1890

© 2005 Scala Publishers
Text and photography © 2005 The Fitzwilliam Museum, Cambridge

First published in 2005 by
Scala Publishers
Northburgh House
10 Northburgh Street
London EC1V 0AT

ISBN 1 85759 334 8

Text: David Scrase, Jane Munro and Craig Hartley (Paintings, Drawings & Prints);
Julia E. Poole and Carol Humphrey (Applied Arts); Lucilla Burn, Sally-Ann Ashton
and Helen Strudwick (Antiquities); Stella Panayotova (Manuscripts & Printed Books);
Mark Blackburn, Adrian Popescu and Martin Allen (Coins & Medals)

Photography: Andrew Morris, Andrew Norman, Bridget Taylor and Evangeline Markou
(Fitzwilliam Museum); Christopher Titmus and Christopher Hurst (Hamilton Kerr Institute);
Stanley Eost

Museum Coordinator: Andrew Morris
Project Editor: Esme West
Copy Editor: Robert Williams
Designer: Yvonne Dedman
Produced by Scala Publishers
Printed by Ingoprint, Barcelona, Spain

SCALA

Front cover:
**Venus Crowned by Cupid, with
a Lute Player** (detail)
Titian, *c.*1555–65

Back cover:
Panel from a book cover
Lotharingian, late 10th century

Front flap:
Mica fan
European, late 17th century

Back flap:
The Medici Psalter (detail)
Florence, *c.*1480–90
Portrait medal of Lucy Harington
London, 1625

Title page:
Interior of a red-figured cup
Athenian, *c.*500BC

Right:
The Reichenau Epistolary (detail)
European, late 10th century

Contents

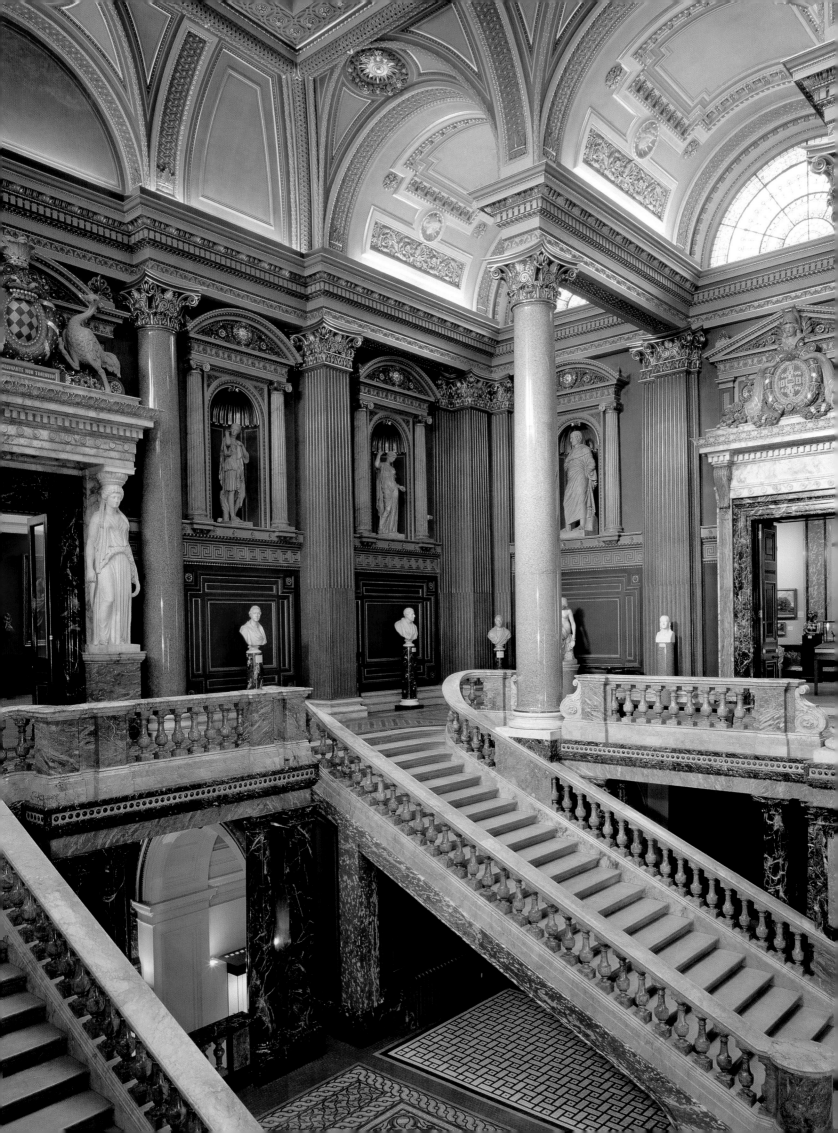

Introduction

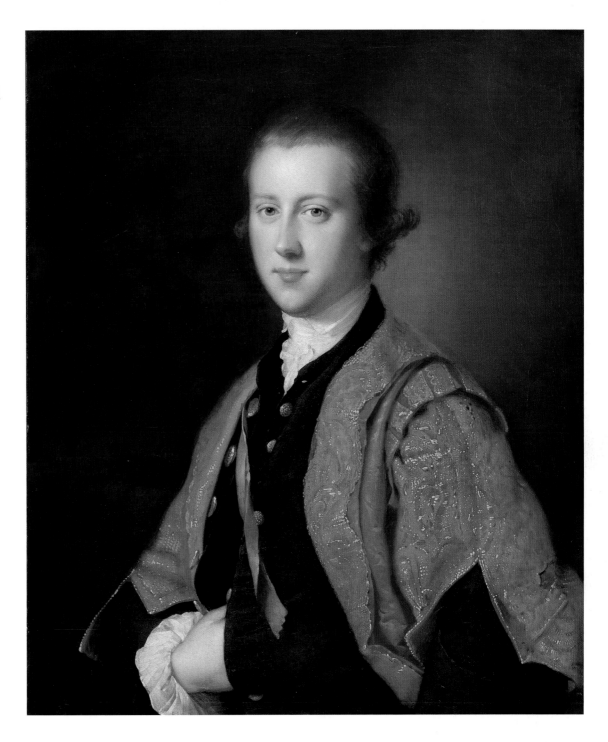

The Fitzwilliam Museum is named after its founder, Richard, 7th Viscount Fitzwilliam of Merrion (1745–1816), who bequeathed his art collection and library to the University of Cambridge 'for the increase of learning and other objects of that noble foundation'.

A former student who was admitted to Trinity Hall as a nobleman fellow commoner in 1761, and took the MA degree in 1764, Fitzwilliam divided his life between his house in Richmond, Surrey, estates in Ireland and, before the French Revolution, lodgings in Paris. From his maternal grandfather, Sir Matthew Decker, an Anglo-Dutch merchant with a house and admired garden near Richmond, he inherited a collection of seventeenth-century Dutch cabinet pictures to which he added other choice examples, including the view of Haarlem by Berckheyde, in addition to collecting old master prints. From his undergraduate days, he maintained a love of music that took him to Spain and Italy as well as to France in search of manuscripts and early printed scores, although it was an Edinburgh bookseller, Robert Bremner, who supplied him with what is today one of the most famous of his acquisitions of music, the Fitzwilliam Virginal Book.

But perhaps the most important opportunity Fitzwilliam enjoyed as a collector was at the sale of paintings from the Orléans collection, which took place in London in 1798–9. He was frustrated in his attempt to buy them all privately, but he did succeed in purchasing several masterpieces, including Titian's *Venus, Cupid and the Lute-player* and Veronese's *Hermes, Herse and Aglauros*.

Introduction

To this wide-ranging collection of books and manuscripts, paintings and prints, the founder added the sum of £100,000 to provide 'a good substantial Museum repository'. Thirty-two years later it opened on Trumpington Street, built to designs by George Basevi (1794–1845) and, after his accidental death, by C. R. Cockerell (1788–1863). Throughout the nineteenth century, the collections grew by gift and bequest. In 1823 the scholar adventurer G. B. Belzoni presented the lid from the granite sarcophagus of Ramesses III (1184–1153 BC). John Disney's gift of Roman sculpture in 1850, and the purchase of the Leake collection of Greek vases, terracottas, coins and gems in 1864, evidence the importance attached at mid-century to the study of classical civilization. This was further emphasized by Sidney Colvin, the University's Slade Professor of Fine Art, who became the first Director of

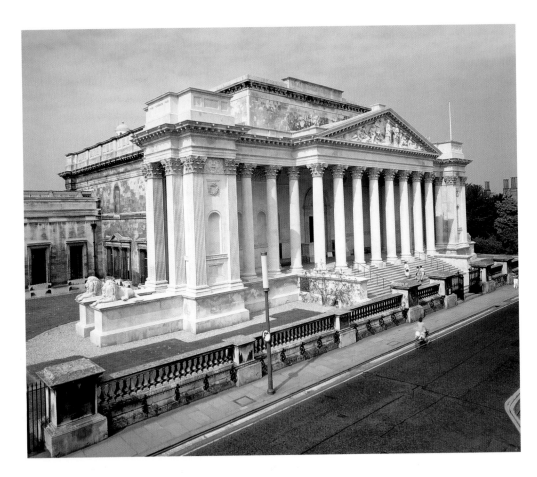

Exterior of the Fitzwilliam Museum

the Museum in 1876. In the following year, the Syndicate allocated £200 for the purchase of plaster casts to assist him and others in their teaching; by the time he resigned in 1883, the cast collection had grown to such an extent that plans were under way to build a separate Museum of Classical Archaeology.

By the end of the nineteenth century, space had become a problem throughout the Museum. The photograph of the staff taken at the time (see page 2) leaves little doubt about the density of the hanging in the upper galleries, while a Guide published in 1868 describes a similar state of affairs downstairs: next to the cast of 'the Diana of Versailles', an idol from the sacred grove near Ava in Burma; a Roman hand-mill found in Coveney Fen; a Japanese umbrella; an Egyptian tombstone; a marble inscription in Armenian; and two plaster casts of medallions by Thorwaldsen.

It fell to Sydney Cockerell, who became Director in 1908, to tackle the Museum's problems, which he did with relish to judge from his boast that 'I found it a pigstye; I turned it into a palace'. He was helped, immeasurably, by the bequest received in 1912 from Charles Brinsley Marlay, which, like that of the Founder a century before, combined an important art collection with a generous endowment. In 1915 Cockerell unveiled his master plan, drawn up by the architects A. Dunbar Smith and Cecil C. Brewer, to attach a vast courtyard to the Founder's building. The first phase, the Marlay wing, opened in 1924, allowing Cockerell to demonstrate his flair for display. With its combination of fine and decorative arts, including furniture and oriental rugs, the Upper Marlay Gallery has changed little since he set it out and introduced what became the Museum's characteristic house-style. The Courtauld Galleries followed in 1931 and the Henderson Galleries and the Charrington Print Room in 1936, before the Smith and Brewer plan was abandoned as unrealistic.

Meanwhile the collections continued to grow, and as they did so, to reflect changes of taste. Fitzwilliam's generation was the last to be dominated by the Grand Tour, with its profound respect for those classical principles that underlay the Renaissance of art and architecture in Italy during the fifteenth and sixteenth centuries. On the other hand Marlay witnessed the renewed interest in the Middle Ages that stimulated the Gothic Revival in Victorian art and architecture. His own collection included numerous works from the fourteenth and fifteenth centuries, including hundreds of 'cuttings', or leaves removed from medieval manuscripts. Marlay was the first in a succession of twentieth-century benefactors whose eclecticism as collectors was reflected in their gifts to the Museum; he was followed by Charles Fairfax Murray, whose first gift of medieval manuscripts was made in 1904 and who marked the Museum's centenary by giving Titian's great, late masterpiece of *Tarquin and Lucretia*; by F. Leverton Harris, whose bequest in 1925 included Italian maiolica together with Italian and French medieval and Renaissance works of art; by T. H. Riches who supported the Museum from 1913 onwards when he gave Japanese prints and illustrated books until 1935,

when he bequeathed medieval manuscripts, Turkish pottery, English silver and works by William Blake; and by Charles Ricketts and Charles Shannon, aesthetes *par excellence*, whose lives were described by their contemporary Jacques-Emile Blanche as 'all for art', their apartments 'filled with exquisite things, Persian miniatures, Tanagra figures, Egyptian antiques, jewels and medals, which millionaires overlooked.'

The Museum received the Ricketts and Shannon Bequest in 1937. Two years later that of Frank Hindley Smith added the first Impressionist paintings to the collection, including Renoir's *Gust of Wind* and Degas' *At the Café*, as well as a Cézanne landscape of *c*.1900. Even so, when the catalogue of French paintings was published in 1960, it contained no more than a handful of works by the Impressionists; Jane Munro's *French Impressionists* handbook of 2004 details 64 works, in a wide variety of media. Of particular note are the drawings by Degas included in A.S.F. Gow's bequest of 1978, the three studies of dancers in wax by the same artist given by Paul Mellon in 1990, and the long-term loan of works by Cézanne and Seurat, in addition to those by Matisse, Braque and Picasso, from the bequest of John Maynard Keynes to King's College. Two of the most recent acquisitions in this area are both late landscapes by Monet from the Parker collection, which were accepted in lieu of estate tax by H.M. Treasury and allocated to the Museum in accordance with the testator's wishes.

Acceptance in lieu accounts for a number of important recent acquisitions. So does assisted purchase, towards which we look for help on a regular basis to the Friends of the Fitzwilliam Museum, the National Art Collections Fund and the Purchase Grant Fund administered for the Museums Libraries and Archives Council by the Victoria and Albert Museum. And like all museums that acquire works of art in the national interest, we turn on occasion with equal gratitude to the Heritage Lottery and Memorial Funds.

Like the collections it preserves, the Museum itself has grown in response to both cultural and social changes. The extensions designed by David Roberts that opened in 1966 and 1975 respectively, reflected both a renewed commitment to 'the increase of learning' within the context of a university museum and, with the addition of a temporary exhibition gallery, a growing interest in wider participation. The Hamilton Kerr Institute was set up as a department of the Museum in 1976 in direct response to a need perceived nationally for training and research in the area of paintings conservation. At the same time the Museum began a partnership with the local education authority that led, eventually, to the establishment of the Museum's own Education Department with a commitment to all forms of lifelong learning. In common with all museums, the Fitzwilliam experienced a surge in attendance figures towards the end of the last century, from 100,000 for the first time in 1970 to over 300,000 in 1996. By then, plans were under way for a further extension. The Courtyard Building, completed in 2004 to plans of John Miller + Partners, adds nearly 3,000 square metres of new and renovated space to the existing buildings. It also encapsulates another significant shift in attitudes towards museums; towards greater access to the collections, intellectually as well as physically. This latest extension, together with the improvements that have been made to existing galleries and study areas, has been achieved by a combination of public and private funding. Individuals and corporate supporters have matched the capital grant of £6 million made to the Courtyard project by the Heritage Lottery Fund. It is thanks to this widespread support that the Museum can look towards the future with confidence, as a university museum with outstanding, designated collections eager to play an ever widening role regionally, nationally and internationally.

Duncan Robinson
Director

**The Fitzwilliam Museum
Courtyard Development, 2004**

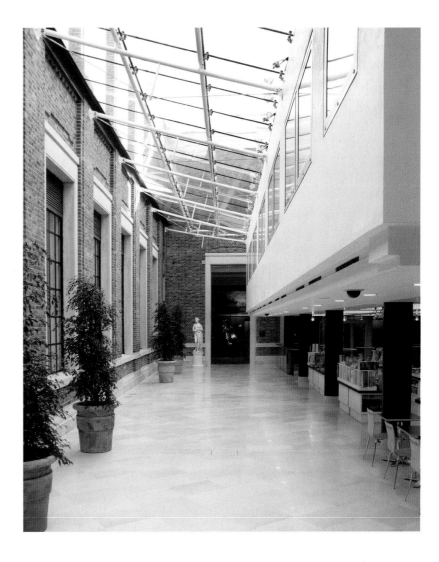

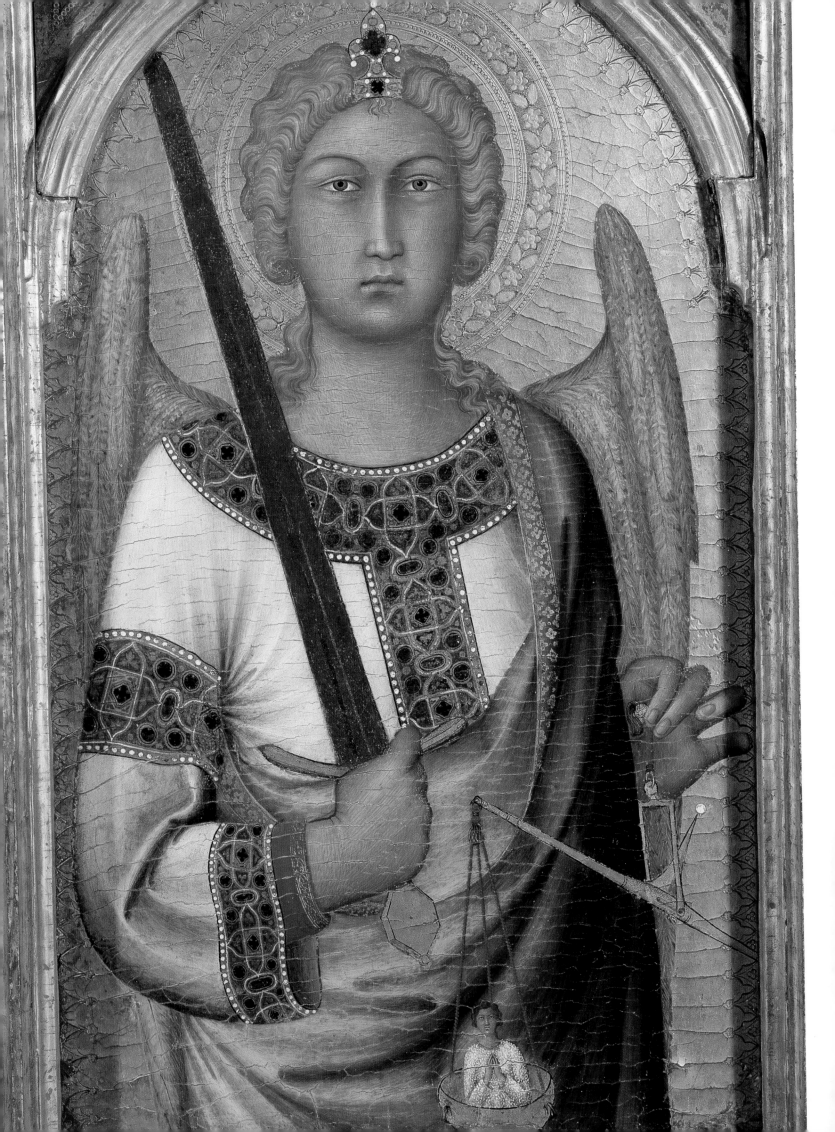

SS Geminianus, Michael and Augustine, with Angels, *c.*1319
Simone Martini, (*c.*1284–1344)

The figures of the Saints float against a background of shimmering gold. On the left, Geminianus, Bishop of Modena, patron of San Gimignano, resplendent in pink, holds a crozier of ivory with a golden head. St Michael, the Archangel, his wings of gold tinted with green, holds a sword of Judgement in his right hand, the blade of which is of silver, now tarnished black. In his left is a balance, with a kneeling, saved Christian soul praying in the pan, which rises towards Heaven. St Augustine in episcopal vestments over a black habit is distinguished by his leather belt and holds an ivory crozier in his gloved hand. Both Bishop Saints also hold clasped books, which are probably Gospels. Above each Saint is an Angel, holding an ivory staff and gesturing towards what was the centre of the altarpiece, the image of the Virgin and Child. These panels are from a polyptych. Two other panels have been associated with them: a *Virgin and Child* in the Wallraf-Richartz-Museum, Cologne, and a *St Catherine* in a private collection. The altarpiece was made for the church of S. Agostino in San Gimignano, a hill town in Tuscany on the pilgrims' route from Canterbury to Rome.

Tempera on poplar wood, 59.7 x 35.8 cm; 59.7 x 35.8 cm; 60 x 35.8 cm; angels, each: 33 x 31.1 cm
Acquired from Charles Butler, 1893
552

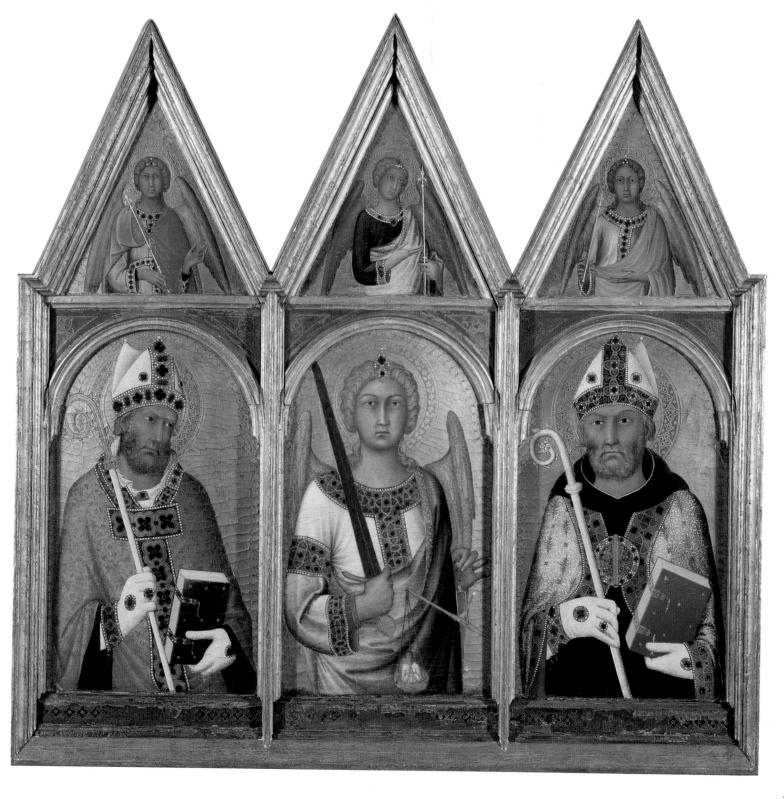

Virgin and Child Enthroned with Angels, *c.*1400
Lorenzo Monaco, (?1370/75–?1425/30)

The composition derives from Giotto's famous *Ognissanti Madonna* of *c.*1310. This panel would have been intended for private devotion and may have formed part of a diptych. The sense of volume and space are characteristic of Florentine painting, but the detailing of the crocketing on the top of the throne and the delicacy of handling of the sculpted angels bowing towards the Virgin and Child are more redolent of Sienese painting and the International Gothic style. Mary's robe is emblazoned with a gold star, a reference to the medieval poem 'Hail Mary, Star of the Sea'. She holds the Christ Child tenderly, both presenting Him and yet holding Him safe. She engages the spectator whilst He raises His right hand in a general benediction, but looks directly at His mother. This shows a new humanity, beyond the monumentality of Giotto's prototype. The attendant angels support themselves on the arms of the throne, hovering on clouds and gazing with rapt concentration at the sacred image of the Virgin and Child. The small scale of the painting suggests intimacy, but the scale is belied by the inherent majesty of the composition.

Tempera on wood panel, 32.4 x 21.2 cm
Acquired from Charles Butler, 1893
555

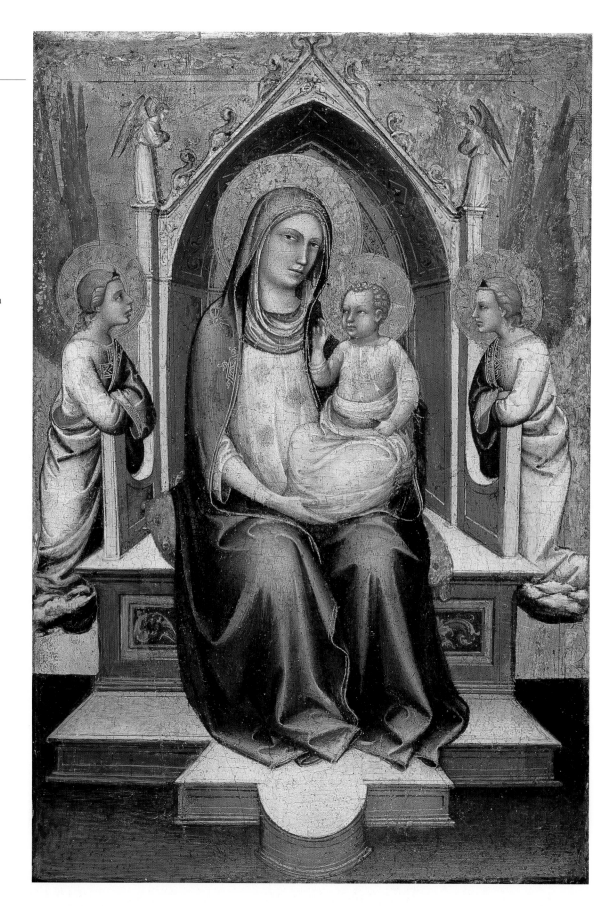

Virgin and Child Enthroned with Angels and a Donor, with St John the Baptist and (?)St Ansanus, *c.*1430–33
Fra Filippo Lippi (*c.*1406–1469)

This little portable altar was made for private devotion. The donor, kneeling on the ground, is granted a vision of the Virgin and Child enthroned in Heaven with attendant angels. Clouds separate him from his vision. The slightly awkward proportions are characteristic of Lippi's early style, and he has crowded the angels so close around the cushion behind the Virgin that one of them has no halo, but this is compensated for by a fillet of gold around his temples. The monumentality of the Virgin is counterbalanced by the tender way the Christ Child touches the top of the donor's hat while offering him a benediction. Heaven is seen as a classically inspired chamber, and the composition owes much to sculpted prototypes by both Donatello and Luca della Robbia. The figure of St John with his hair shirt and

his label proclaiming the Lamb of God shows Masaccio's influence in the fall of drapery, while the figure of the other Saint, sometimes identified as St George, but more probably St Ansanus, holding a burning heart in his right hand, protected by his cloak, has a sense of refinement and a delicacy of colouring that is reminiscent of Fra Angelico. The coat of arms can be connected with eight different Florentine families, but the donor's motto has not been associated with any of them. Although Lippi has painted a proper likeness of him he remains unidentified.

Tempera on wood panel, 61 x 29.8 cm; 41.9 x 11.8 cm; 42.3 x 11.4 cm
Acquired from Charles Butler, 1893
559

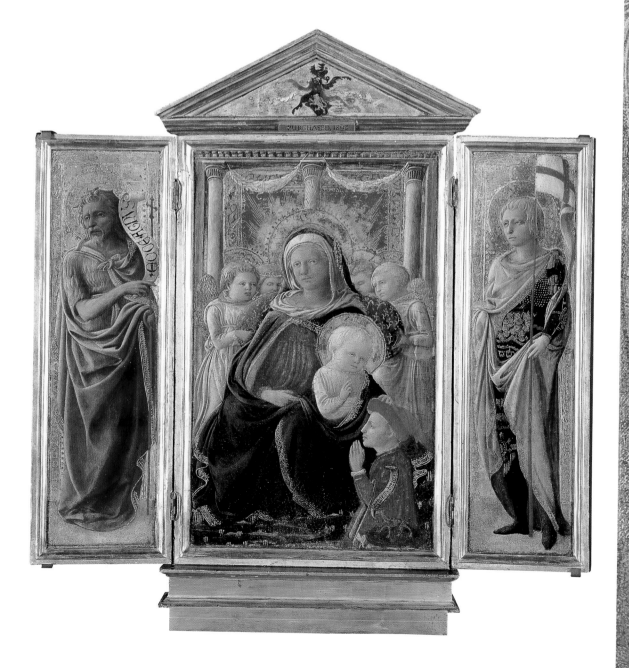

Above: ***The Annunciation***, mid-1440s
Below: ***A Miracle of St Zenobius***, mid-1440s
Domenico Veneziano (active 1438–61)

Domenico Veneziano, with whom Piero della Francesca worked, was one of the great innovators of Florentine painting in the second quarter of the fourteenth century. These panels were part of the predella, or narrative strip that forms the lower edge of a large altarpiece of Veneziano's *St Lucy Altarpiece*. Originally in the church of S. Lucia de' Magnoli in Florence, the altarpiece appears to have been dismantled by 1816. The main panel of the *Virgin and Child with Saints* is in the Uffizi, Florence; the predella is divided between Berlin, Washington, DC, and the Fitzwilliam. The *Annunciation* (part of the predella's central panel) is marked by the clarity of its colour and the novelty of its composition. The arch leading to the barred door gives an excuse for the artist to display his brilliance at perspective. The barred door serves as a metaphor for the Virgin; it refers to Her inviolate status, as does the enclosed garden.

In *A Miracle of St Zenobius*, a widow mourns her dead son in the Borgo Albizzi in Florence. He has been run over by an ox-cart. St Zenobius, patron bishop of Florence, raises his hands in supplication to Christ, and we are assured of a happy outcome. The faces of the onlookers are surely intended as portraits of individuals. At the back can be seen the now destroyed Church of S. Pier Maggiore. The scene preserves its fictive frame, painted pink, which is no longer visible on the *Annunciation*.

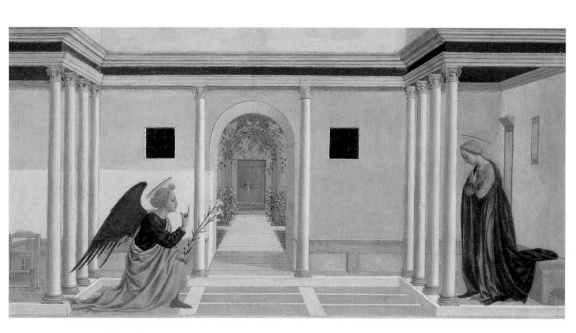

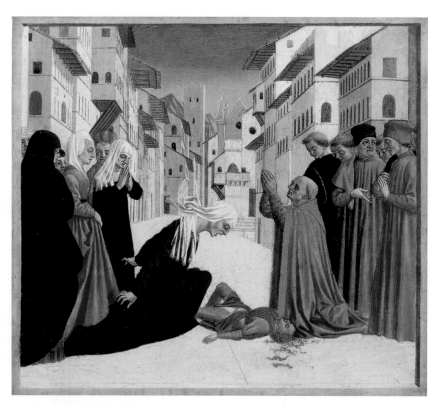

Tempera on wood panel,
27.1 x 54.1 cm (*Annunciation*),
23.5 x 32.5 cm (*Miracle*)
Both bequeathed by
Professor Frederick Fuller,
1909; received 1923
1106, 1107

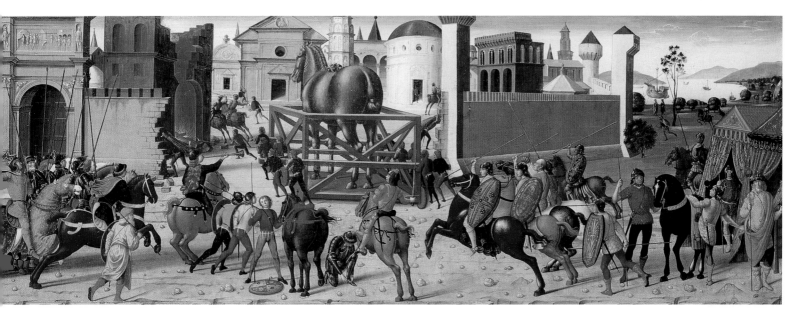

Above: ***The Death of Hector***, *c.*1490–95
Below: ***The Wooden Horse of Troy***, *c.*1490–95
Biagio di Antonio (1446–1516)

These two panels originally were part of the decorations in
a Florentine palazzo. They would have been set into the
wainscotting of a room at shoulder height, from which they
derive their name of *spalliere* (*spalla* is the Italian for
shoulder). One shows a scene from Homer's *Iliad*, the other
from Virgil's *Aeneid*, both relating to the Siege of Troy. They
are painted to be read rather like a strip cartoon, and they
contain several events in sequence: *The Death of Hector*
shows the Greek camp on the left; in the middle are Hector
and Achilles in personal combat; on the right Achilles rides
round the walls of Troy, dragging the body of Hector
behind him. In *The Wooden Horse* the Trojans in the middle
are pushing the horse into Troy. Greeks set the city on fire
and follow the horse through the breach in the walls. The
city is represented as a Renaissance town. The overall effect
is richly decorative.

Tempera on wood panel, 47 x 161 cm (*Death of Hector*),
47 x 161.6 cm (*Wooden Horse*)
Both bequeathed by Charles Brinsley Marlay, 1912
M.44, M.45

The Road to Calvary, *c.*1495
Juan and Diego Sanchez (active late 15th century)

This is signed by two painters of the same surname, who almost certainly worked in Seville towards the end of the fifteenth century, Juan and Diego Sanchez. The scene is a particularly brutal rendering of Christ falling beneath the Cross on the road to Calvary. On the left, the apostle, St John, helps to prevent the Cross from crushing Christ; the heaviness of the wood is emphasised by the strain apparent in his left foot and the compressed muscles evident in his torso. To the right, Christ, who remains remarkably serene as he falls, is attacked and half choked with his halter by two bully-boys, who are clearly intending to nail him to the Cross. Further to the right is a group of Roman soldiers. All these figures are given exaggeratedly coarse features in line with the tradition of Netherlandish painting, exemplified by Hieronymus Bosch. In the background the two thieves are seen in procession, also carrying their own crosses, and on the far left the swooning Mary is supported by three women. Raised gesso decoration is characteristic of Spanish painting of this period, but the inscriptions around the shields are garbled. The armour of the soldiers on the right would have been originally bright silver, contrasting with the damascened effect of St John's robe. The painting was probably part of a larger retable.

Oil on sweet chestnut panel, 100 x 128.5 cm
Bought from the Marlay Fund, 1925
M.Add.16

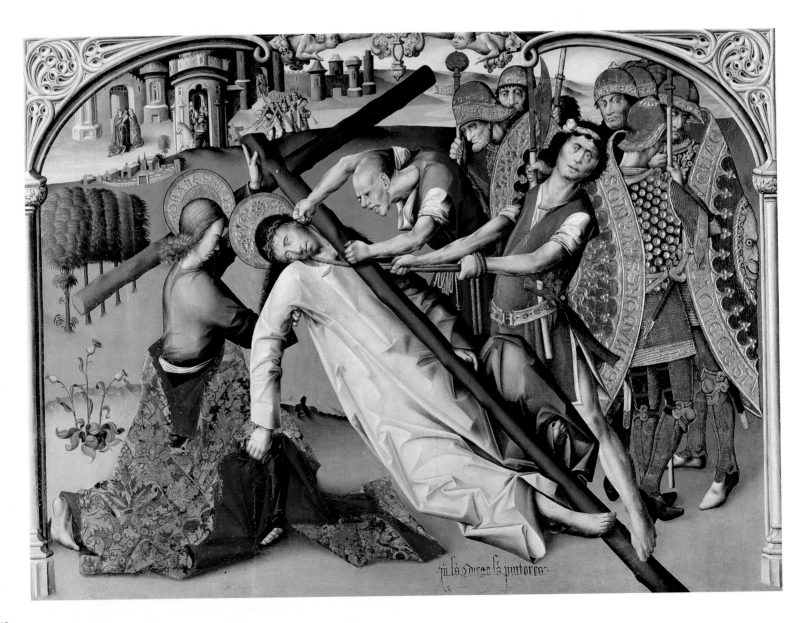

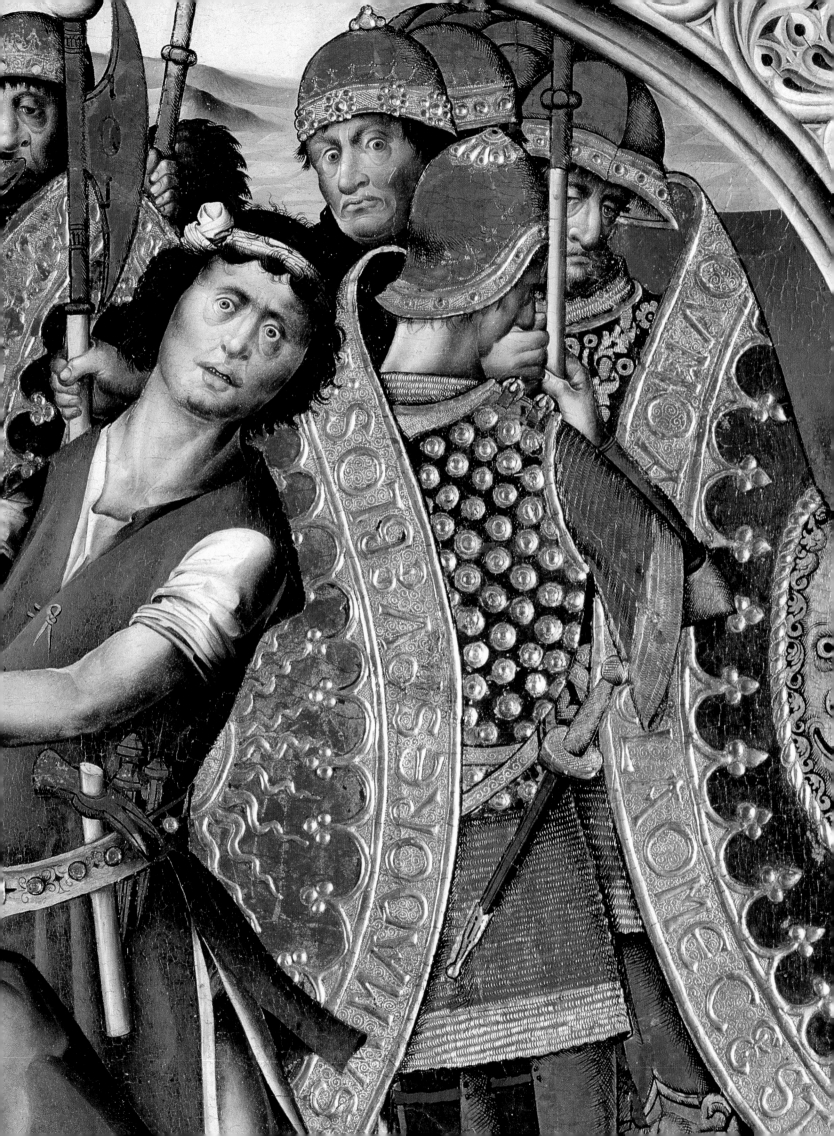

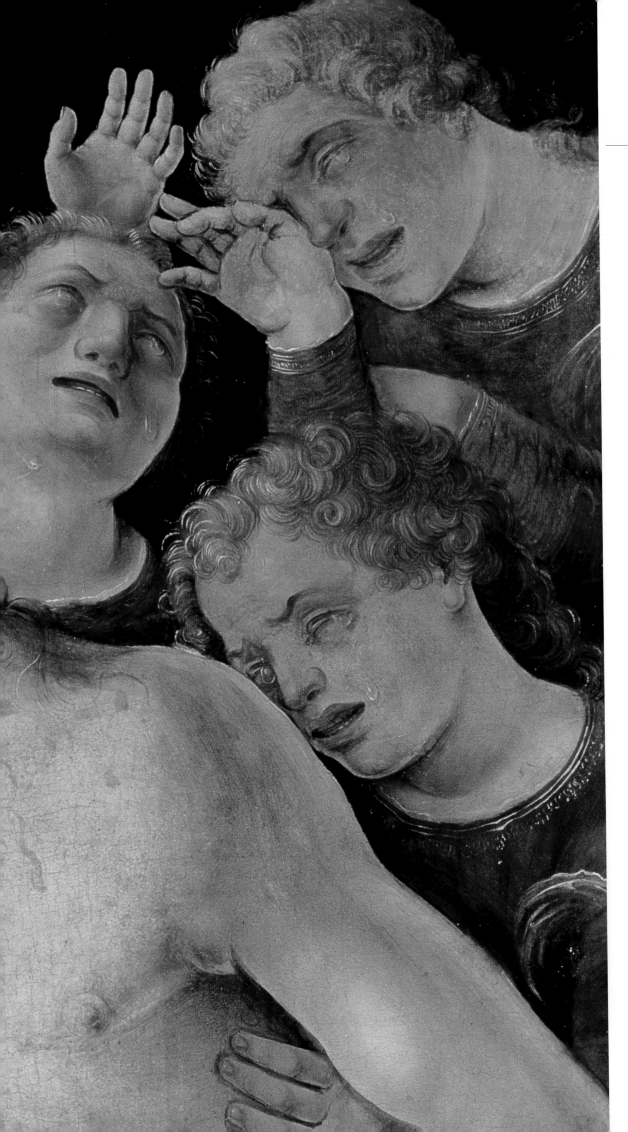

The Dead Christ Supported by Mourning Angels, c.1489
Liberale da Verona (c.1445–1527/9)

Artists who worked outside the main centres of Florence, Venice and Rome are often not well known; their freshness of response to a well-worn theme can frequently surprise. The heightened emotion displayed by the mourning angels in Liberale's painting is emphasized by the dark background of the work. It thrusts their keening figures into the foreground of the composition, crowding the picture plane. This adds to the dramatic sense of loss presupposed by the limp figure of the Dead Christ. The foreshortening of the tomb suggests that this was once at the top of a large complex altarpiece, intended to be seen high up, far from the viewer. Liberale, whose early career was spent as an illuminator of manuscripts in Siena, returned to Verona c.1476. He then visited Venice, where he was clearly influenced by the work of Giovanni Bellini. It may also have been in Venice that he learned to use oil paint as well as tempera. The subtle glazes of the angels' drapery show how well he understood the potential of this new technique that Antonello da Messina brought to Venice. There is a strong sense of sculptural form and a very real, almost Northern, sense of pathos.

Tempera with oil glazes on (?)pine wood, 116.5 x 76 cm
Accepted by H.M. Government in lieu of Inheritance Tax and allocated to the Fitzwilliam Museum, 2003
PD.21-2003

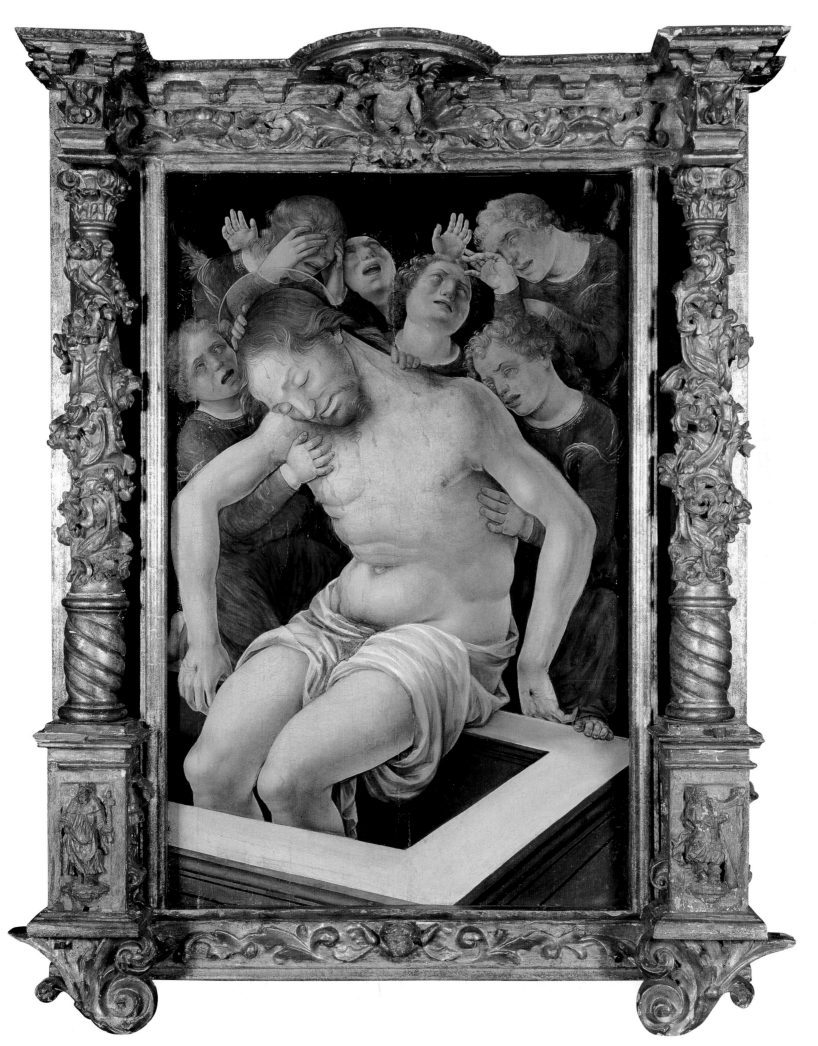

The Virgin and Child Enthroned with SS Cosmas and Damian, with SS Eustace and George in the Background, c.1500
Gian Francesco Maineri (active 1489–1506)

Maineri appears to have been born in Parma between 1460 and 1470. He was a pupil of his father, who came from Ferrara. He studied with Ercole de' Roberti and is first documented in Ferrara in 1489. He is also recorded in Mantua, where he worked on several commissions for Isabella d'Este. He is particularly renowned for the jewel-like finish of his paintings and was noted as a painter of miniatures. Although the painting is tiny, its composition has a grandeur of scale not inappropriate to a large altarpiece. This exquisitely painted panel, intended for private devotion, may have been intended as a present for one of the Medici, as the physicians, Cosmas and Damian, were their patron saints. In the background to the left can be seen St Eustace, checked in the hunt by seeing a vision of a stag with Christ crucified between its antlers. To the right is a vignette of St George killing the dragon. The landscape details show knowledge of Flemish painting, while the throne in which the Virgin sits has a complexity characteristic of the highly elaborate decoration favoured at the court of Ferrara. Attention to detail and extensive gilding add to the precious surface effect of the painting.

Oil on wood panel, 28 x 21 cm
Bequeathed by the Hon. Sir Steven Runciman, CH, 2000
PD.30-2000

Madonna and Child, c.1513
Sebastiano Luciani, known as Sebastiano del Piombo (1485–1547)

The Christ Child holds a goldfinch, symbol of His future Passion. The twisting pose suggests that He wishes to escape from His mother, who enfolds Him towards Her, wrapping Him in her yellow cloak. Behind Her is a cloth of honour and to the left a radiant landscape, reminiscent of Venice, which Sebastiano had recently left to come to Rome. The figures of both Madonna and Child derive from Michelangelo's Sistine Chapel ceiling, the first part of which was unveiled in 1512. Sebastiano was a pupil of Giovanni Bellini and a friend of Giorgione, but already in this, one of his first paintings made in Rome, he has turned away from their example towards a greater monumentality and seriousness. The use of a tondo (circular) form is un-Venetian; the shape was developed in Florence. Sebastiano has understood brilliantly its possibilities, above all how its constraint can be used to psychological advantage. In the contrast between the wriggling Christ Child and the calm poise of the Virgin, whose hands express control and security, Sebastiano creates a sense of profound human contact.

Oil on poplar, tondo shape, average diam. 68.5 cm
Bought with grants from the National Lottery through the Heritage Lottery Fund and the National Art Collections Fund with contributions from the Friends of the Fitzwilliam Museum, 1997
PD.55-1997

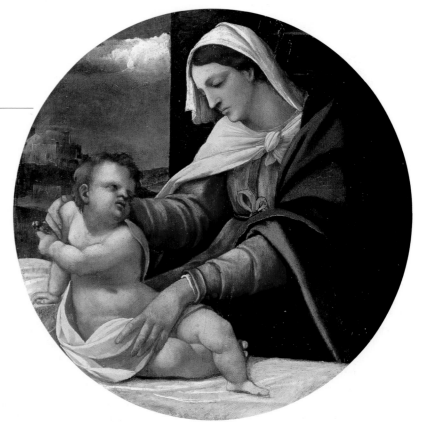

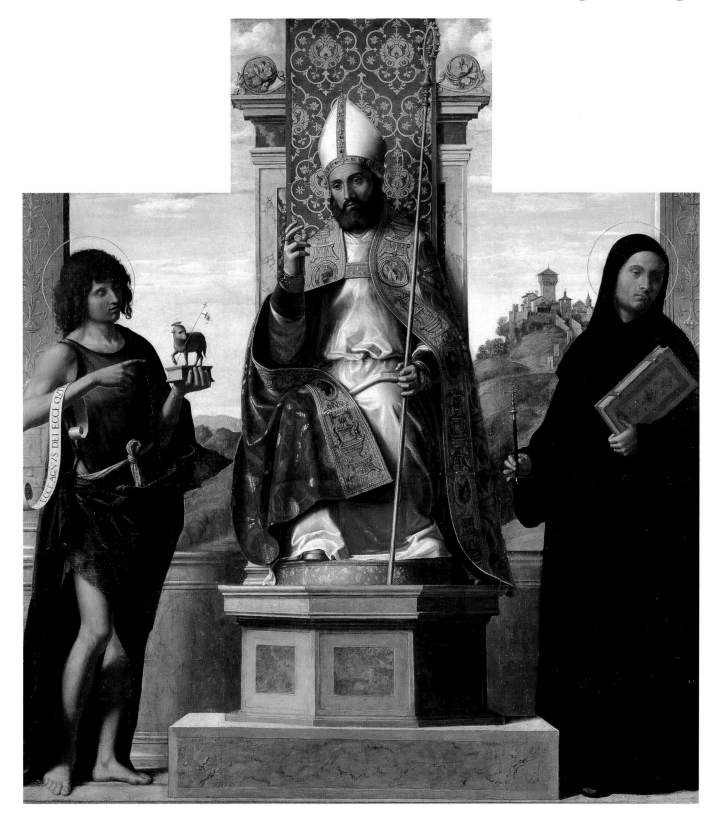

St Lanfranc Enthroned between St John the Baptist and (?)St Liberius, *c.*1515–16
Giovanni Battista Cima da Conegliano (*c.*1459/60–1517/18)

This altarpiece probably was commissioned by the Arte dei Pellicari or Guild of Furriers. They owned premises adjoining the Church of S. Maria dei Crociferi (afterwards Gesuiti) in Venice. The altar of the Guild was situated immediately to the right of the main entrance. The prominence of St Lanfranc of Pavia, Archbishop of Canterbury from 1070 to 1089, suggests that Lanfranc's head, one of several precious relics owned by the Crosier friars, was actually preserved on or within this altar. The saint to the right wears the blue habit (now darkened by time almost to black) and carries the silver cross granted to the Crosier order in 1459 by Pius II. He has been identified as St Liberius, a secondary patron saint of Ancona, who took the habit of the Crociferi. On the left is St John the Baptist holding a model of the Lamb of God. In the background can be seen the small hill town of Conegliano, where Cima was born. He was much influenced by both Antonello da Messina and Giovanni Bellini. In this painting light models the three figures in a particularly Venetian way. Cima's use of oil paint brilliantly evokes the sensuous qualities of surface textures. The painting makes use of rather an old-fashioned composition, placing a cloth of honour behind the principal figure and making use of a fictive window to display the landscape, rather than setting the figures firmly in it.

Oil on wood panel, 144 x 128.5 cm
Bequeathed by Charles Brinsley Marlay, 1912
M.16

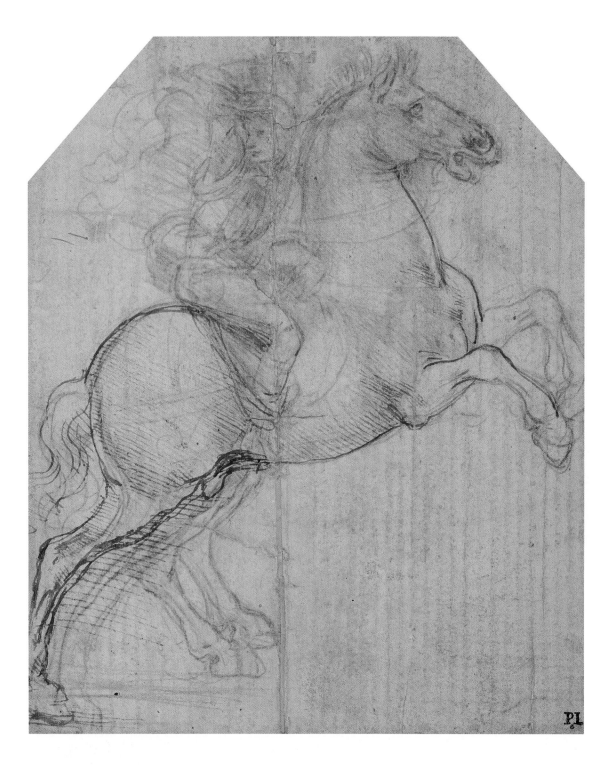

A Rider on a Rearing Horse, c.1481–2
Leonardo da Vinci (1452–1519)

In 1481 Leonardo was commissioned to paint an Adoration of the Magi by the convent of S. Donato a Scopeto near Florence. This remained unfinished when he went to Milan in 1482 to work for Lodovico Sforza, and it is now in the Uffizi, Florence. Leonardo made many drawings in preparation for the Adoration, and this is considered a study for the fighting horseman in the distance on the right of the painting. The drawing has tremendous vitality. It is made with a metal-point instrument on a prepared ground. This is a technique that requires extreme skill, for the slightest error requires the ground to be prepared again and the drawing to be started afresh. At this stage of Leonardo's career his use of this medium has a delicate luminous quality, unmatched at any other period of his life. Horses remained central to Leonardo's interest as a draughtsman, but he rarely depicted them with such vigour.

Metal-point, reinforced with pen and brown ink on a pinkish prepared laid paper, 14.1 x 11.9 cm
Bought from the Gow, Cunliffe, Leverton Harris, Perrins and Reitlinger Funds with contributions from the National Art Collections Fund, the National Lottery through the Heritage Lottery Fund, the Pilgrim Trust, Mrs Monica Beck and two anonymous donors, 1999
PD. 44-1999

Right:
The Adoration of the Shepherds,
c.1522
Antonio Allegri, known as Il Correggio
(?1489–1534)

An early study, with many differences, particularly in the architecture, for Correggio's *Adoration of the Shepherds*, known as *La Notte*, now in Dresden. The altarpiece was commissioned in 1522 for the Pratoneri chapel in the church of S. Prospero in Reggio Emilia, and was completed before the chapel was opened in 1530. It is likely to be the study immediately prior to the completed design or *modello* supplied to Alberto Pratoneri on 14 October 1522, although it may be the *modello* itself, as Correggio often made radical changes to his compositions between the *modello* and the finished painting. In its complex use of different media it shows Correggio's draughtmanship at its most elaborate. The tenderness of the relationship between the Virgin and the infant Christ is beautifully depicted and reminds one that Sir Joshua Reynolds, at a loss to describe the singular effect of Correggio's work, coined the phrase the 'correggiosity of Correggio' in his attempt to define it.

Pen and brown ink, brown wash over red chalk, heightened with white on prepared paper, 24.3 x 20.9 cm
Bequeathed by Louis C. G. Clarke, LL.D, 1960; received 1961
PD.119-1961

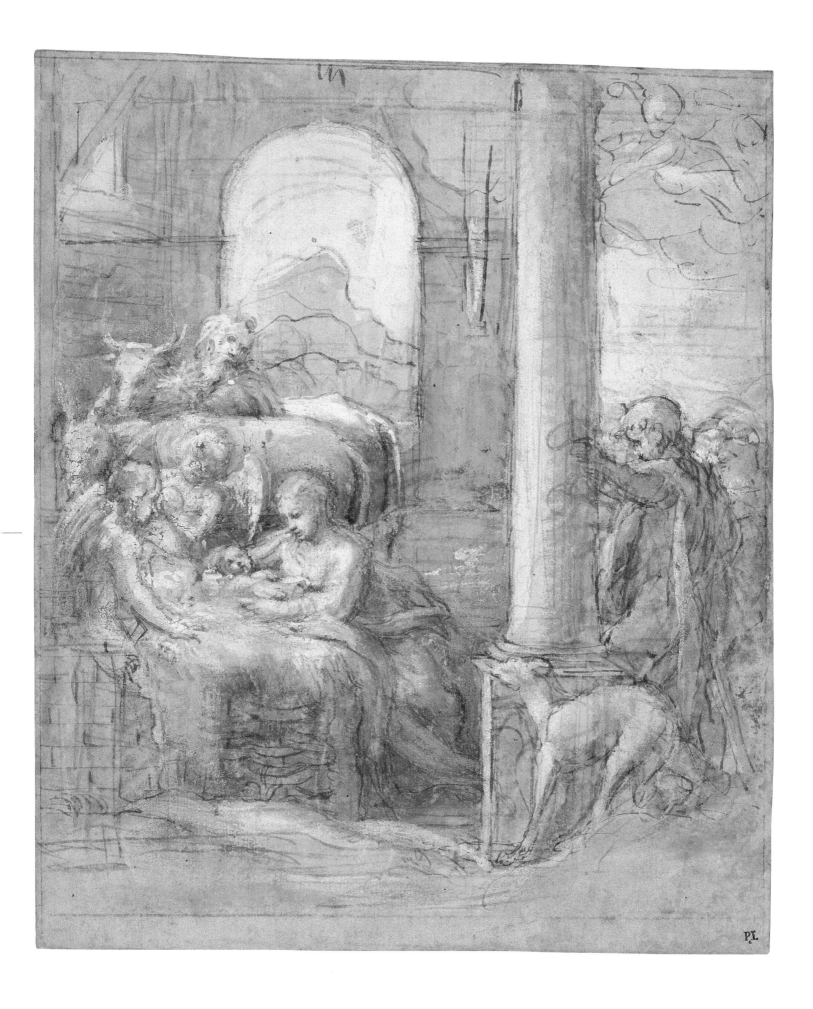

Two Nudes in a Landscape, c.1537–40
Domenico Beccafumi (1484–1551)

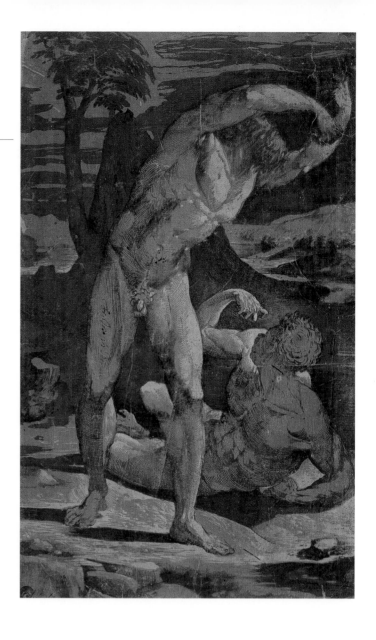

Beccafumi worked largely in Siena. He developed a highly personal figure style, incorporating elements of the latest trends from Florence and Rome, and he also made a number of technical innovations. This is probably the earliest of his extraordinary experiments in printing an engraved metal plate with tone-blocks cut in wood. It is one of only three known impressions to survive that were printed as Beccafumi intended. The print is relatively common in later (almost certainly posthumous) impressions, which miss out the woodblocks. It is clear from the combination of engraved hatching with flat pools of tone that woodblocks were an integral part of the design: without them, the shading does not make proper sense. The process has striking technical and expressive affinities with Beccafumi's pavement for the Duomo in Siena (1519–47), in which chiselled and filled black lines were combined with areas of coloured marble. In terms of imagery, the print is more closely related to figures in Beccafumi's painting of 1537, *Moses Breaking the Tablets*, which was also made for the Duomo in Siena. The red chalk drawing (now at Chatsworth, Derbyshire) made in preparation for the print, shows the reclining figure's raised arm in the same position as in the painting; so the print, with the position of the arm changed, was presumably made later than the painting. Various attempts have been made to pin a narrative to the print, but it is probably best seen as two figures abstracted from a dramatic context yet retaining much of their expressive strength: they are far from being merely academic nudes, and the landscape is beautifully atmospheric.

Engraving on copper printed in combination with
two woodblocks on laid paper, 26.6 x 16.4 cm
Founder's Bequest, 1816
31.K.9-29

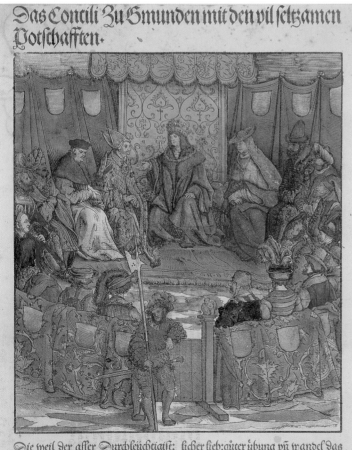

The Council at Gmunden with Important Foreign Visitors, c.1514–15
Hans Burgkmair (1473–1531)

This is an illustration to *Der Weisskunig* (the white, or wise, king), an idealized biography of the Holy Roman Emperor Maximilian I (reigned 1508–19) written by the Emperor and his secretary Marx Treitzsaurwein, and illustrated with 236 woodcuts. This particular scene is a depiction of a meeting held between 16 July and 22 August 1514 at Gmunden, purportedly to advance Maximilian's plans for the marriage of his grandchildren to the children of Ladislas Jagellon, King of Bohemia and Hungary. The 'important visitors' of the title included Russian and Hungarian diplomats, who are depicted in their national costume on the right, with the German negotiators on the left. The Emperor sits on a raised dais in the centre, talking to a bishop on his right. As with many of Maximilian's ambitious projects to promote his reign using the medium of woodcut prints, *Der Weisskunig* was never completed; it appeared in book form only in 1775. As the Emperor's chief woodcut designer, Burgkmair was responsible for around 120 of the prints. The blocks were cut in Augsburg in 1514–16 by cutters under the supervision of Jost de Necker, with whom Burgkmair had worked to develop multi-block colour printing in the preceding years at the behest of Maximilian's artistic advisor, Conrad Peutinger. For this project, however, only a single black block was used. This hand-coloured trial proof was printed on a waste copy of a proclamation dated to 1514. The colouring is contemporary with the printing, so this proof may have been used to demonstrate the intended look of a luxury coloured version.

Woodcut coloured by hand with watercolour, printed on a sheet of letterpress,
21.7 x 19.5 cm (image), 29.7 x 21.8 cm (sheet)
Founder's Bequest, 1816
23.K.1-154*

The Large Spruce, *c*.1520
Albrecht Altdorfer (*c*.1482/5–1538)

Altdorfer spent most of his life in Regensberg, where he was employed as an architect and played a part in the political life of the city. He is principally known as a painter and printmaker, and his patrons included Duke Wilhelm IV of Bavaria and Emperor Maximilian. His prints comprise finely wrought woodcuts and engravings, mostly on a very small scale, and a number of prints in the relatively new medium of etching. Around 1520 he used etching to make the first pure landscape prints in the history of European art. Altdorfer would have known Dürer's etched *Landscape with a Cannon* of 1518, but whereas Dürer's etching had a prominent figure subject, Altdorfer's prints are entirely dominated by the landscape. It is likely that the landscapes were seen as experimental and printed for a handful of collectors in a small edition. Each of the nine prints survives in only a few impressions, and these are exceedingly rare (the group of six landscapes in the Fitzwilliam, which came from an album originally in Cambridge University Library, is the third largest in the world). This example is by far the largest of the group. The delicate line and free handling recalls contemporary pen drawings by artists associated with the so-called Danube School (working in the towns of Regensburg, Passau and Vienna around the river Danube). In particular, Altdorfer's landscapes have an affinity with a group of drawings made by Wolf Huber (*c*.1485–1553); Altdorfer's innovation was to realize the possibility of etching to convey the spirit of this new style of drawing. The influence of these prints helped to establish landscape as an independent genre.

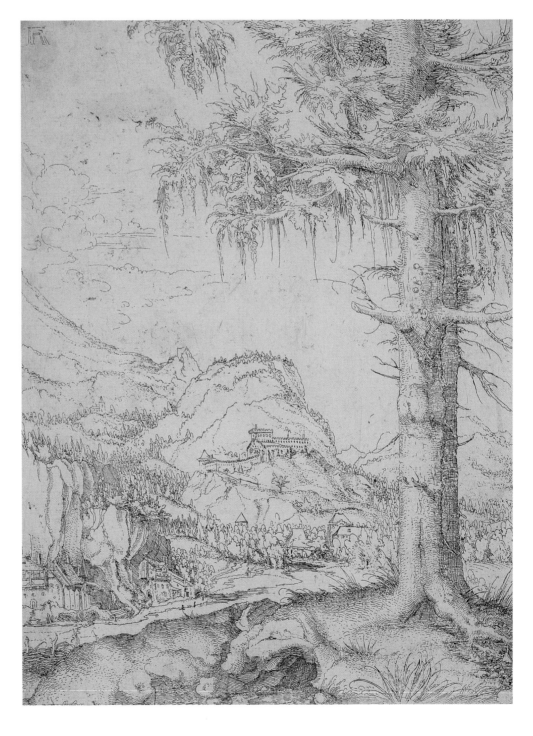

Etching printed on laid paper, 23.6 x 17.8 cm
Transferred from Cambridge University Library, 1876
AD.5.22-122

The Annunciation, *c.*1520
Antwerp School

The refined elegance of this painting
reflects the courtly splendour of the
Habsburg Regents of the Netherlands.
The flamboyant architectural setting
shows the influence in Northern
Europe of 'Romanism' combined with
a native Gothic sense of ornament.
Amid architectural splendour the
Virgin is seated surrounded by objects
of a more domestic nature: scissors,
a ball of wool and a sewing basket
with a cloth thrown over it, a *prie-dieu*
and a Book of Hours. To Her right is
glimpsed the interior of a bedroom
with a canopied bed and a convex
mirror. To Her left is a Netherlands
majolica vase with white lilies, allud-
ing to Her purity, a blue iris, referring
to the Virgin as Queen of Heaven and
what appear to be pinks, suggesting
the Incarnation; beyond that the
Angel of the Annunciation gestures to
Heaven, while the Holy Ghost, in the
form of a dove, hovers between them.
The white cat may symbolize the fact
that the Devil is trapped by Christ's
Incarnation like a mouse by a cat.
Above the Angel is a sculpture of
Mercury, perhaps an allusion to the
Messenger of God. High on the right
a sculpture of a seated Bishop and an
attendant seems to come alive at the
miracle of the Annunciation. On the
second archway Moses is represented
between two circular reliefs represent-
ing Samson with the lion and Cain
killing Abel. Joseph is shown outside,
chopping wood, apparently unaware
of the miraculous event.

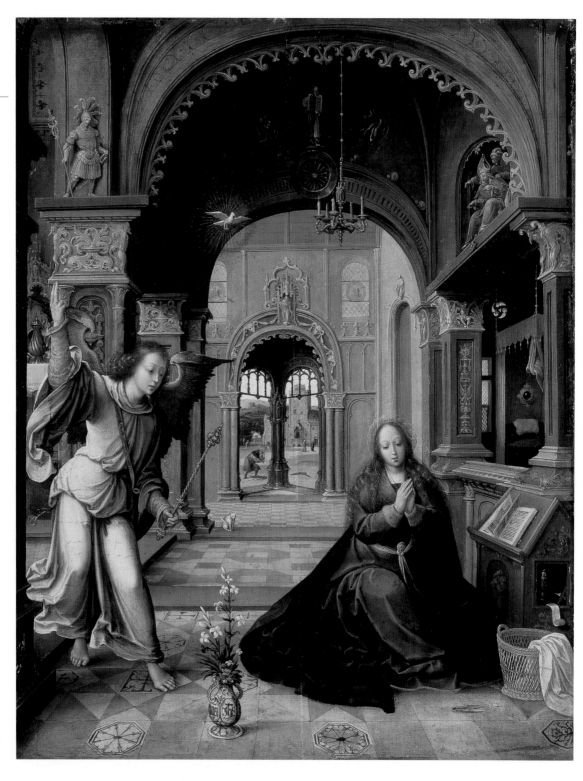

Oil on wood panel, 68 x 54 cm
Founder's Bequest, 1816
98

The Virgin and Child, *c.*1528–30
Joos van der Beke, known as Joos van Cleve (died 1540/41)

Van Cleve has stressed Christ's humanity in this gentle painting. He is asleep after feeding at His mother's breast, His right hand resting on it. The Virgin enfolds Him within Her fur-lined cloak and looks down tenderly at Her son. Her face is painted in a subtle *sfumato*, or gradual and soft transition from light to shadow, which suggests that van Cleve was aware of the work of Leonardo da Vinci. He could have seen Leonardo's paintings when he was working in France at the court of Francis I, between 1528 and 1535. Leonardo's influence would explain the enigmatic sweetness of the Virgin's smile. To the left is a tin-glazed earthenware pitcher of the type referred to as Netherlands majolica, with lilies and daisies in it, both symbolizing Mary's purity. Van Cleve has cleverly used the cloth of honour to suggest that there are two windows behind the Virgin; on the left is a landscape with a shepherd with his flock, to the right a country house. The background is painted with a clarity that recalls the work of Joachim Patinir, commonly referred to as the founder of Netherlandish landscape painting.

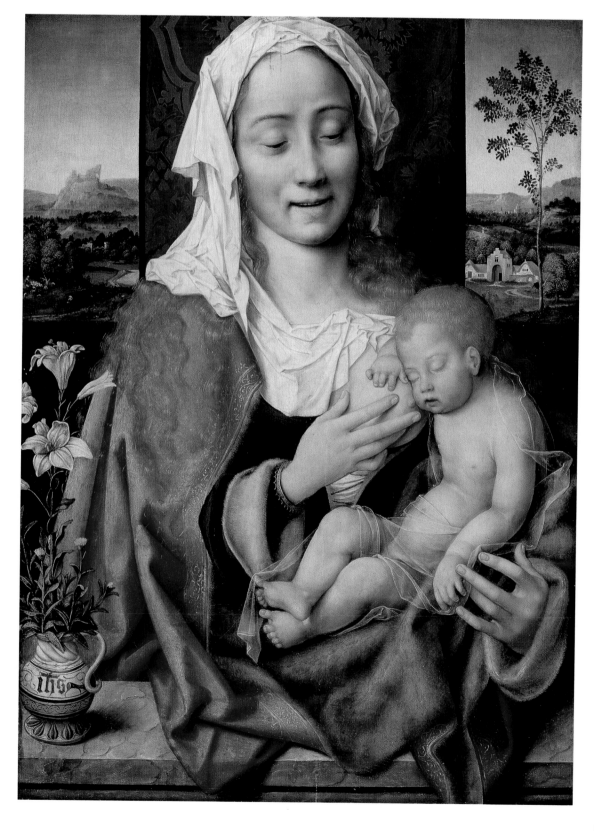

Oil on wood panel, 61 x 45.1 cm
Bequeathed by Revd R. E. Kerrich, 1873

Venus and Cupid, *c.*1522–24
Jacopo Palma, known as Palma il Vecchio
(?1479/80–1528)

The radiant sky and brilliant colouring of the
Arcadian landscape are characteristic of Venetian
painters in the first quarter of the sixteenth century,
in particular the ageing Giovanni Bellini and the
young Titian. The reclining Venus has an antecedent
in the *Sleeping Venus* in Dresden, begun by Giorgione
and completed by Titian *c.*1512. Although it has been
suggested that Cupid may be summoning Venus to a
wedding to act as the bride's patroness, it is more
likely that the action illustrates a passage from Ovid.
In Book X of his *Metamorphoses* Venus is accidentally
wounded by an arrow that her son, Cupid, gives to
her. This leads ultimately to her falling in love with
Adonis. The pose of Venus and her monumental
form suggests that Palma has based her figure on a
classical image or carving of a river nymph or river
god. Nudes of this type were collected by the
grandest of patrons for their private delectation and
would not have been seen by many people; this
painting was formerly in the collection of Queen
Christina of Sweden.

Oil on canvas, 118.1 x 208.9 cm
Founder's Bequest, 1816
109

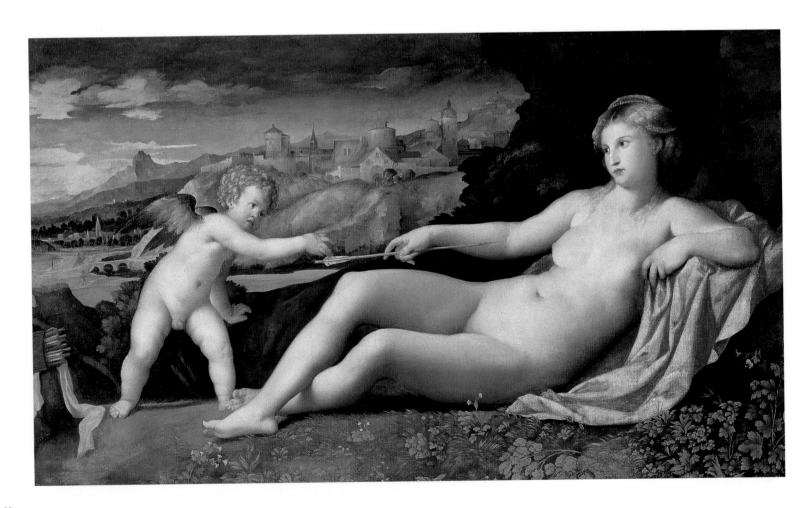

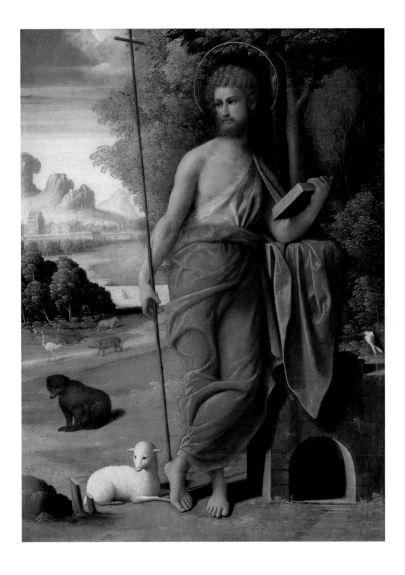

St John the Baptist in the Wilderness, *c.*1525
Giovanni Battista Benvenuto, known as L'Ortolano
(active *c.*1500–after 1527)

L'Ortolano's nickname derives from his father's profession, that of a gardener. He shows St John wearing a hair shirt reading a book in an idyllic landscape. The lamb at his feet signifies the Lamb of God, and he holds a cross for further identification. The animals in the background – lion, stag, ostrich, monkey, wild boar, rabbits and bear – suggest a new Paradise rather than a wilderness. L'Ortolano, although influenced by Ferrarese artists, such as his contemporary, Dosso Dossi, also knew what was happening in Florence in the work of Fra Bartolommeo and Raphael. His animals suggest that he was also aware of Piero di Cosimo. The figure of St John is based on a classical sculpture of Apollo with the duck (known as the *Medici Pothos*) and the conduit with water flowing through it on which St John leans taking the place of the hanging draperies that supported the sculpted figure. The colouring of the painting with its high tones is characteristic of Ferrarese art at the beginning of the sixteenth century.

Oil on wood panel, 73.7 x 53.3 cm
Given by Mrs J. C. Hare, 1855

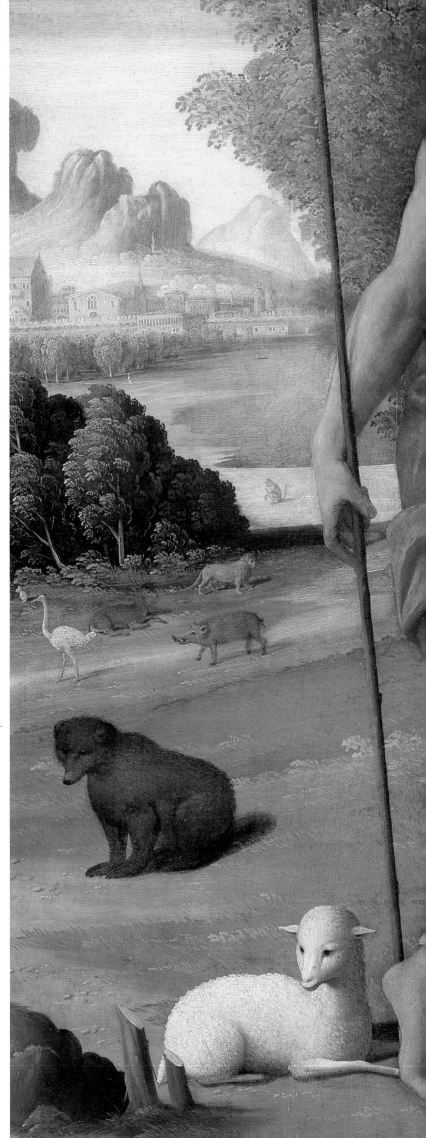

Venus Crowned by Cupid, with a Lute Player, *c.*1555–65
Tiziano Vecelli, known as Titian (*c.*1488/90–1576)

Bought by Lord Fitzwilliam from the Orléans Collection, this once belonged to Queen Christina of Sweden and probably to Emperor Rudolf II in Prague. It is one of five paintings of a female nude with a musician, which are the culmination of Titian's exploration of the female nude. Originally Venus was painted looking at the lutanist, but Titian changed the composition so that Venus, identified by her son, Cupid and the roses in the garland with which he crowns her, looks out of the picture towards the spectator. In all these mature paintings of the female nude Titian has used some sort of cartoon to replicate her basic form and subsequently has added individual touches to distinguish them one from another. He knew that there would be a market for this type of painting among the very richest of his personal clients. Three of these paintings (two in the Prado, one in Berlin) show her with an organist, the other (now in the Metropolitan Museum of Art, New York) shows her also with a lutanist. In each painting she is seen reclining within a room by a window that looks out to a landscape. These paintings are often considered to have allegorical meanings, concerned with the senses of sight, hearing and touch in a context of love. Here the lutanist introduces the element of song in the form of madrigal music with its connotation of love music. However, we cannot be certain that Titian regarded them as such, as in his letters the paintings are referred to simply as of a female nude. The richness of colour is characteristic of Titian's mature style, and the landscape with deer running in front of trees with a mountain, reminiscent of the Adige, is handled with extraordinary freedom.

Oil on canvas, 150.5 x 196.8cm
Founder's Bequest, 1816
129

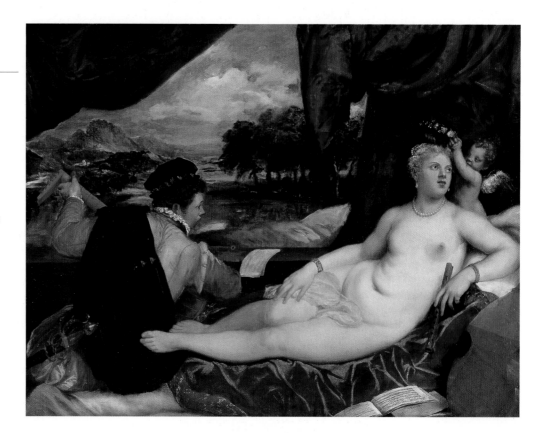

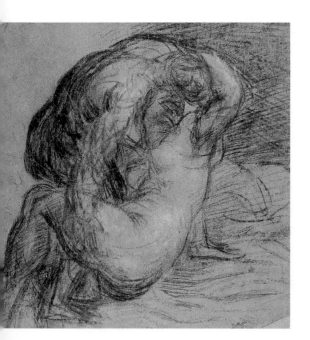

Below left:
A Couple in an Embrace, *c.*1570
Tiziano Vecelli, known as Titian (*c.*1488/90–1576)

There is a tangible excitement to the strokes in this drawing: Titian is exploring the contours of his figures with great rapidity, constantly changing the outline. At the same time the body of the woman has a palpable sense of weight, achieved with considerable economy of line. The drawing probably dates from late in Titian's career and it can be compared with the under-drawing, revealed by x-ray examination, of his *Tarquin and Lucretia*, sent to Philip II of Spain in 1571, now in the Fitzwilliam. A copy of the drawing by Jacob Jordaens is in the Louvre, suggesting that Titian's original may once have belonged to Jordaens's master, Rubens. The composition recurs in reverse in a painting of *Mars and Venus* from Titian's workshop now in Vienna. Rubens was to pay his own homage to the drawing in his free adaptation of elements of the composition in his painting now in Munich of the so-called *Rape of the Daughters of Leucippus*.

Charcoal heightened with white chalk
on faded blue paper, 25.2 x 25.8 cm
Bequeathed by Charles Haslewood Shannon, RA, 1937
2256

Right:
Tarquin and Lucretia, 1571
Tiziano Vecelli, known as Titian (*c.*1488/90–1576)

In a letter to Philip II of Spain written in August 1571 Titian described this painting as 'an invention involving greater labour and artifice than anything, perhaps that I have produced for many years'. The subject, taken from Livy, shows Tarquinius Sextus, son of the last King of Rome, forcing Lucretia, wife of Tarquinius Collatinus, to submit to his desires. He threatens to kill her and then to cut the throat of her attendant slave to make it appear that they had been caught in adultery. Lucretia subsequently tells her husband and her father what has happened and kills herself. By confining the main action to the front of the picture plane Titian emphasises the drama of the scene. This is passion at a moment of crisis. The explosion of Tarquin's attack is emphasized by the violence of the thrust of his knee, the bulging vehemence of his eye and the shocking juxtaposition of the crimson of his trousers and the vermilion of his hose. Lucretia's tears are to no avail. Her hand trying to push him back is as poignantly powerless as her empty slipper on the floor, where Titian has signed his name in red. The painting was part of Joseph Bonaparte's booty from Spain in 1813, and was given to the Museum as a centennial present by Charles Fairfax Murray, William Morris's former secretary.

Oil on canvas, 188.9 x 145 cm
Given by Charles Fairfax Murray, 1918
914

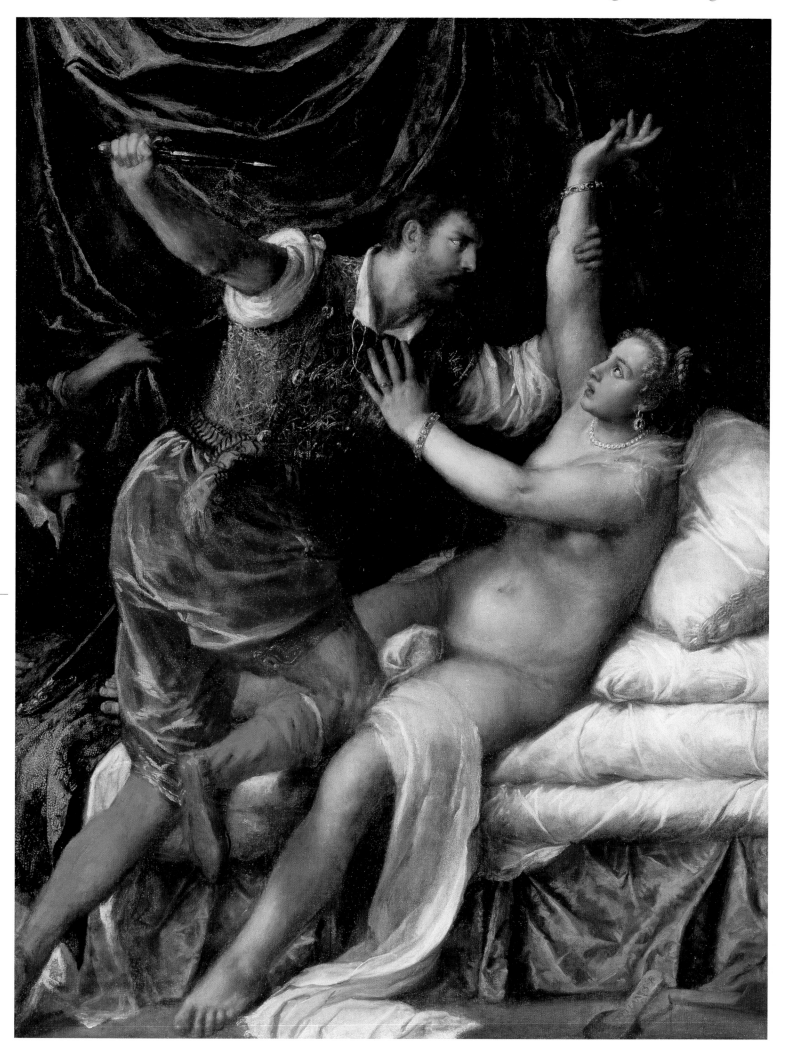

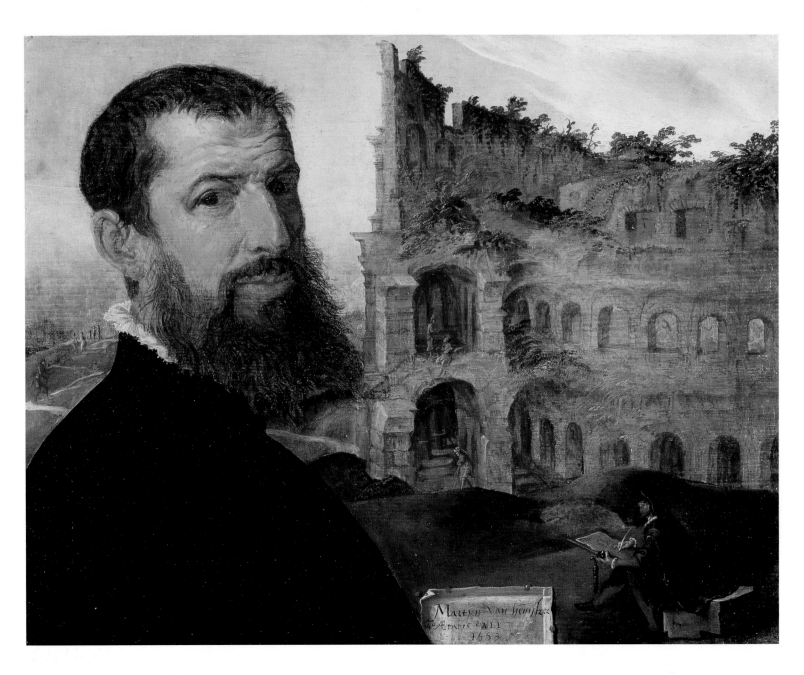

Self-portrait, with the Colosseum, Rome, 1553
Maarten van Heemskerck (1498–1574)

Executed in 1553 when Heemskerck was the Dean of the artists' Guild of St Luke in Haarlem, this painting may have been made to celebrate his appointment. At the age of 55 Heemskerck presents himself as a gentleman, wearing an expensive black damask jacket. To the right he has painted an artist seated on a broken piece of marble masonry, drawing the ruined Colosseum from the life with a quill pen, supporting his paper on a wooden board and holding an ink-well in his left hand. With a hat to shade him from the sun Heemskerck may have intended this figure, possibly a self-portrait, to remind people that he had spent over four years in Italy, between 1532 and 1536/7. The image of the Colosseum can be interpreted allegorically as a *memento mori* or reminder of death, suggesting that all splendours ultimately decay. This too may be the purpose of the draughtsman, signifying perhaps the futility of the artist's craft.

Above:
Oil on wooden panel, 42.2 x 54.2 cm
Given by Revd R. E. Kerrich, 1846
103

Right:
Oil on canvas, 232.4 x 173 cm
Founder's Bequest, 1816
143

Right:
Hermes, Herse and Aglauros, c.1576
Paolo Caliari, known as Il Veronese (1528–1588)

The subject is taken from Ovid's *Metamorphoses*. Herse and Aglauros were daughters of Cecrops, King of Athens. Hermes became infatuated with Herse and, for a large bribe, arranged with Aglauros to have access to her. This annoyed Athena, who afflicted Aglauros with jealousy, so that she tried to prevent Hermes from entering Herse's room, whereupon Hermes changed her into a black stone. Veronese depicts the very moment when Hermes touches Aglauros with his winged wand, the caduceus, to transform her into stone. Herse seems unmoved by her sister's fate, although the spaniel at her feet is spellbound by the event. The room is luxurious in the extreme, and Veronese has indulged his pleasure in materials of rich damasks and ornate architectural features to the full. He has also set himself a formidable task of foreshortening in his depiction of the viol on the carpeted table. The roses in the vase suggest Herse's beauty, and to the left is a sensually painted female satyr, clearly a bedpost, backing the pillow and sheet glimpsed behind Hermes' cloak. The opulence of textures, clarity of colour and grandeur of the composition display Veronese's gifts as a painter. His is the eye through which the glory of Venice in the sixteenth century is exemplified, and his influence on later artists such as Tiepolo is manifest in this painting.

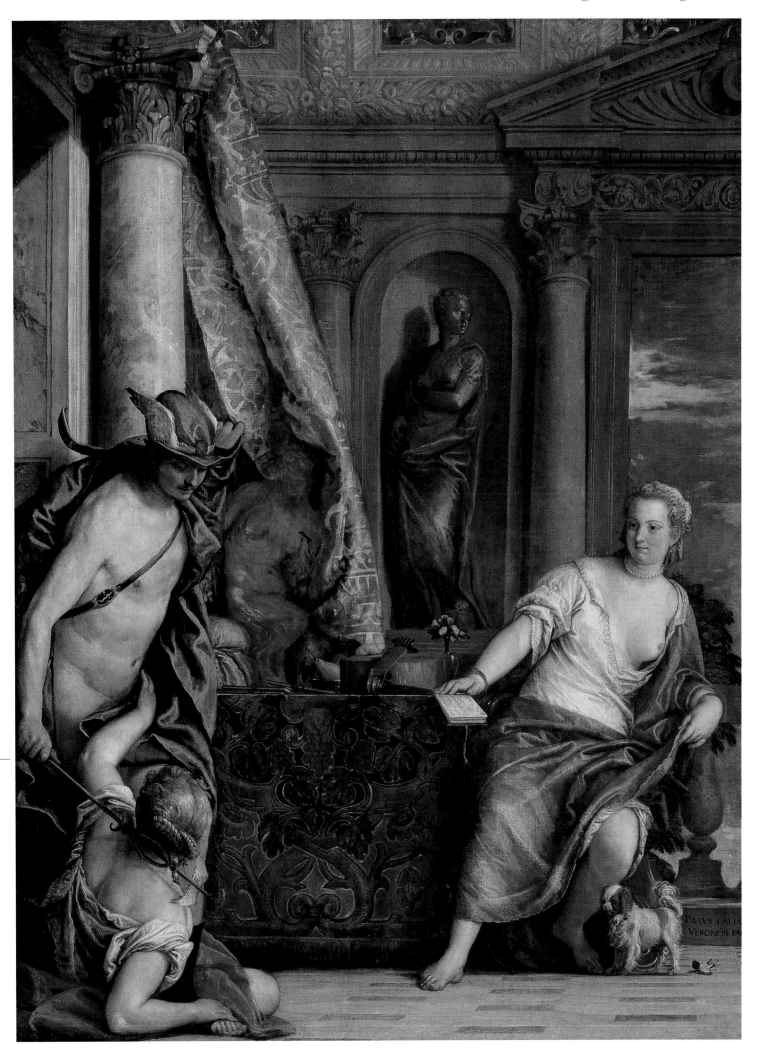

Henry VIII, *c.*1526
Lucas Horenbout (died 1544)

This is the first independent portrait miniature produced in England. Horenbout, who came from a family of painters and illuminators, left Flanders for England in the early 1520s and was working for Henry VIII by 1524. This portrait shows the King, who was born in 1491, at the age of 35, before he grew a beard. Another miniature by Horenbout in the Royal Collection shows him at the same age, but bearded. The King wears a doublet of silver-grey brocade decorated with an oak-leaf pattern, and his outer gown has a deep fur collar and sleeves of blue decorated with gold dots, attached by gold cords. On his black hat, which appears to be made of velvet, he wears a badge with a gold motif and two sets of three diamond and gold pins. Around his neck is a doubled gold chain. In the corners of the miniature are angels bearing cords that knot together the initials H and K, representing the King and his Queen, Katherine of Aragon. This rather ironically signifies their love, as the miniature was being painted at the very moment when the King was starting the proceedings which were to lead to his divorce from his first Queen.

Watercolour and gold on vellum on card, 5.3 x 4.8 cm
Bought from the Spencer George Perceval Fund, 1949
PD.19-1949

Henry Wriothesley, 3rd Earl of Southampton, 1594
Nicholas Hilliard (?1547–1619)

This is the first dated example by Hilliard of a miniature painted with a folded crimson curtain as a background to his sitter. This is executed in the wet-in-wet technique, in which the crimson pigment is worked over a paler layer before it dries. Henry Wriothesley, Earl of Southampton, (1573–1624), was twenty when this was painted. He is sporting the excessively long hair for which he was notorious at the Elizabethan Court. His black doublet is intricately decorated with a raised floral pattern and his lace collar is embroidered with a black design of flowers. Wriothesley was a lavish patron of the arts, and this miniature was painted in the same year that Shakespeare dedicated *The Rape of Lucrece* to him in terms of warmest friendship: 'What I have done is yours; what I have to do is yours.' Southampton was imprisoned in the Tower of London for his part in the rebellion of the Earl of Essex, but was released and restored to favour by James I. He died of fever while campaigning in the Netherlands. The Fitzwilliam has a full-length portrait of his wife, Elizabeth Vernon, and another portrait miniature of him by Peter Oliver, painted about 25 years after this one by Hilliard.

Watercolour and gold on vellum on card, 4.1 x 3.2 cm
Bequeathed by L. D. Cunliffe, 1937
3856

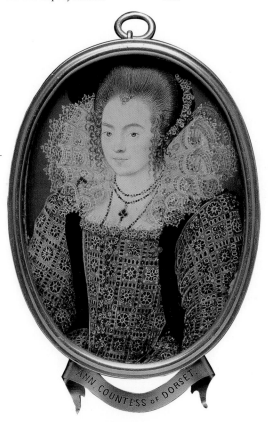

Portrait of an Unknown Lady, *c.*1595
Nicholas Hilliard (?1547–1619)

This is an extremely fine example of Hilliard's ability to render the minute details of Elizabethan costume. The sitter, formerly identified as the Countess of Dorset, must have been a Court lady. She is wearing an intricate Italian lace over a black bodice, which is ornamented with gold and pearls. Her long necklace appears to be made of black and white pearls, and the cross which is attached to it is probably of diamonds, but the pigment has oxidized, giving it the appearance of jet. Her black hat is also adorned with gold and pearls. The form of her ruff, made of elaborate lace, rising in enlarging folds to the back, indicates what was in fashion *c.*1595. The cherry sprig pinned to her dress symbolizes her virginity.

Watercolour on vellum on card, 7.3 x 5.3 cm
Bought with money bequeathed by Mrs Coppinger Prichard in memory of her father, Thomas Waraker, LL.D, and with a grant from the National Art Collections Fund, 1942
3898

Still-life with Flowers in a Silver Gilt Vase, *c.*1604 or later
Georg Flegel (1566–1638)

Flowers were often used as symbols that life is fragile and death comes to us all.
This meaning is given extra emphasis here, because the silver gilt vase in which the
flowers are arranged is decorated with a skull and crossbones and the motto
memento mori, a reminder of death. Because Flegel has chosen to paint nothing
but spring flowers, the contrast between youth and death is even more marked.
On the shelf below, the coins are a reminder of the futility of worldly wealth;
among them is a decadrachm of Arsinoë from Egypt, medieval German and
sixteenth-century European coins and a gold coin inscribed 'Romanorum', which
appears to be a copy after the Antique. Beans refer to the Resurrection; the frog is
linked to ideas of death and decay. Not all flower paintings are intended to be read
as allegories, but when artists first began to paint flowers as a subject in their own
right rather than as incidental details in a painting, they were assumed to have a
secondary meaning.

Oil on wooden panel, 22.5 x 15 cm
Bought from the Gow and Perceval Funds, 1996
PD.12-1996

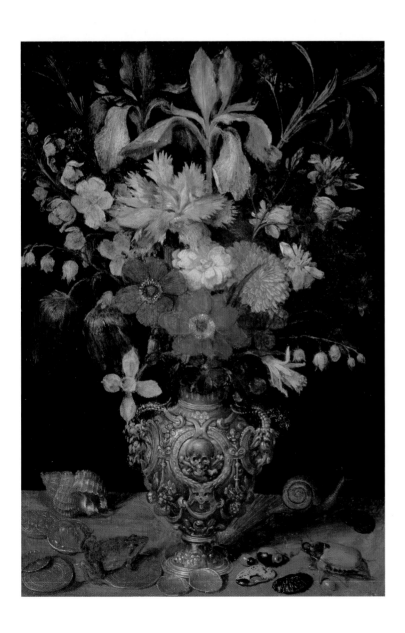

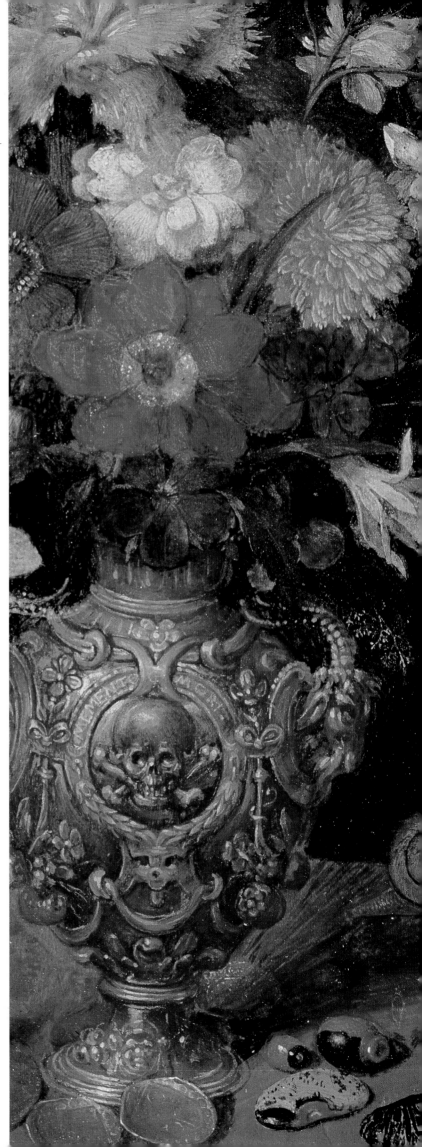

A Stoneware Vase of Flowers, c.1607–8
Jan Brueghel, the Elder, known as 'Velvet' Brueghel (1568–1625)

Brueghel's patron in Milan, Cardinal Federico Borromeo, considered that the great variety in nature reflected God's goodness. In a letter to the Cardinal of 25 August 1606, Brueghel, writing of a painting now in the Ambrosiana, gave an intimation of how he viewed his flower paintings: 'I believe that so rare and varied flowers never have been finished with similar diligence; in winter this painting will make a beautiful sight. A few of the colours are very close to nature …'. Borromeo explained that 'when winter encumbers and restricts everything with ice, I have enjoyed from sight – and even imagined odour, if not real – fake flowers … expressed in painting'. This attitude is similar to that of Erasmus of Rotterdam, who when writing of the pleasure to be derived from comparing real with painted flowers, stated that the painting holds fresh and green all winter when the flowers are dead and withered. Brueghel was one of the founding fathers of flower painting as an independent genre. The brilliance of his technique is well displayed in this virtuoso performance. The unusual addition of uncut diamonds on the ledge to the right of the stoneware vase suggests that the patron of this painting may have been an Antwerp diamond merchant.

Oil on oak panel, 60.3 x 42.2 cm
Bequeathed by Major the Hon. Henry Rogers Broughton,
2nd Lord Fairhaven, 1973; received 1975
PD.20-1975

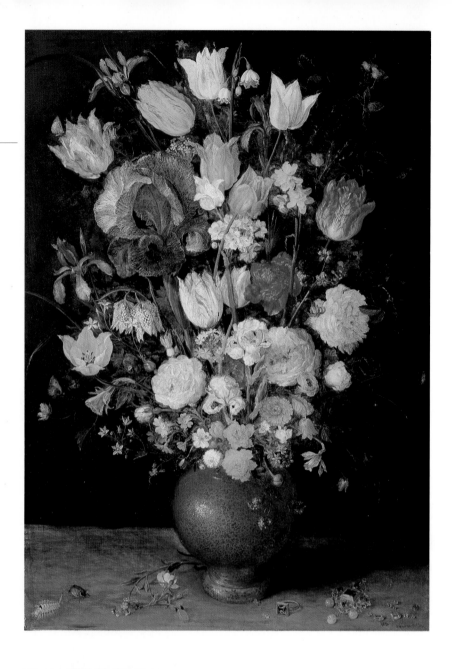

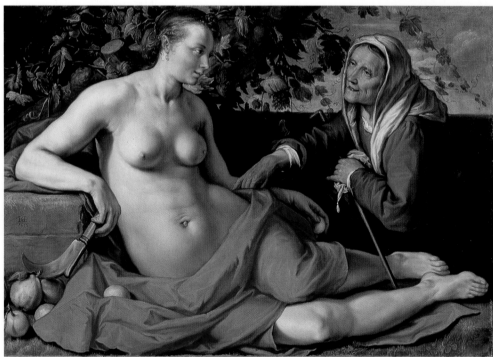

Oil on canvas, 70.8 x 101.2 cm
Bequeathed by Henry Scipio Reitlinger, 1950; received 1991
PD.33-1991

Vertumnus and Pomona, 1615
Hendrick Goltzius (1558–1617)

When Goltzius began to paint in 1600, late in his career, he was already famous as a master engraver and draughtsman. The greater prestige associated with painting was probably the stimulus that made him take up the brush. The subject for this work is taken from Ovid's *Metamorphoses*, XIV, 623–700. Pomona, the goddess of fruit, has locked herself away in her orchard, to protect her virginity. Vertumnus, the god of the seasons, has appeared to her in many manly disguises, all to no avail. Finally he has disguised himself as an old woman and here is begging Pomona to choose Vertumnus as her lover, commenting that even in her garden sanctuary the elm tree and the vine are mated. Pomona is about to give in. The sickle with which she might protect herself is turned away from Vertumnus, while his cane is provocatively placed between her legs. For his composition Goltzius must have remembered Titian's *Danaë* as he painted this, and he must have been thinking of Rubens's way of painting flesh. The coupling of an old hag with a beautiful young woman, the contrast of youthful flesh with wrinkled age, has rarely been more eloquently painted.

The Visitation, 1560
Tommaso d'Antonio Manzuoli, known
as Maso da San Friano (1536–1571)

This is the most important Florentine
Mannerist altarpiece in Britain. The
grandeur of the composition and the
easy way in which its message can be
read was probably a response to the
demand for pictorial clarity advo-
cated by the Council of Trent and
Counter Reformation writers.

Mary, standing to the right of
centre, greets Her cousin Elizabeth,
who kneels before her. Elizabeth has
realized that Mary is pregnant of
Christ, just as she, who had been
thought to be barren, is pregnant of
John the Baptist. Behind Elizabeth
stands her husband, Zaccharias, his
arms raised in astonishment. Above,
between two *putti* carrying garlands,
an angel scatters roses, a symbol of
Mary. There is a clearly visible
pentiment in the angel's face, for
Maso changed the direction in which
the angel looks down. A beggar sitting
in the foreground observes the scene.
Originally, the colour of Mary's cloak
was blue, not grey, but the smalt used
by Maso as his pigment has changed
in the course of time. This altarpiece,
generally considered to be Maso's
masterpiece, was painted for the
chapel of the de' Pesci family in the
Church of S. Pier Maggiore, Florence.
Here Maso pays homage to Andrea
del Sarto and also to Pontormo. Since
1955 the work has been on loan to the
chapel of Trinity Hall, the Founder's
college.

Oil on poplar, 408.8 x 248.6 cm
Given by Henry Thomas Hope, 1859
496

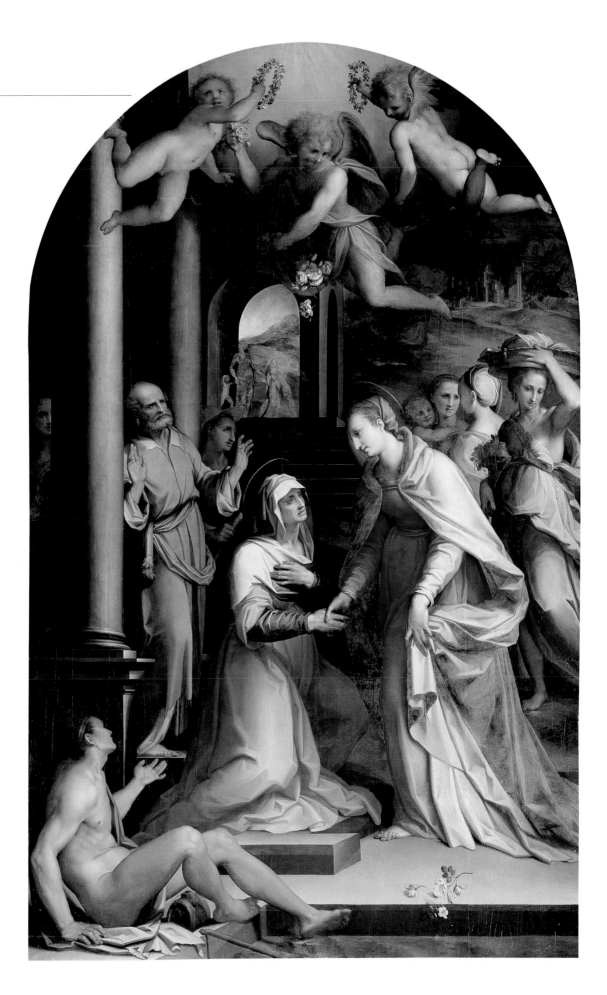

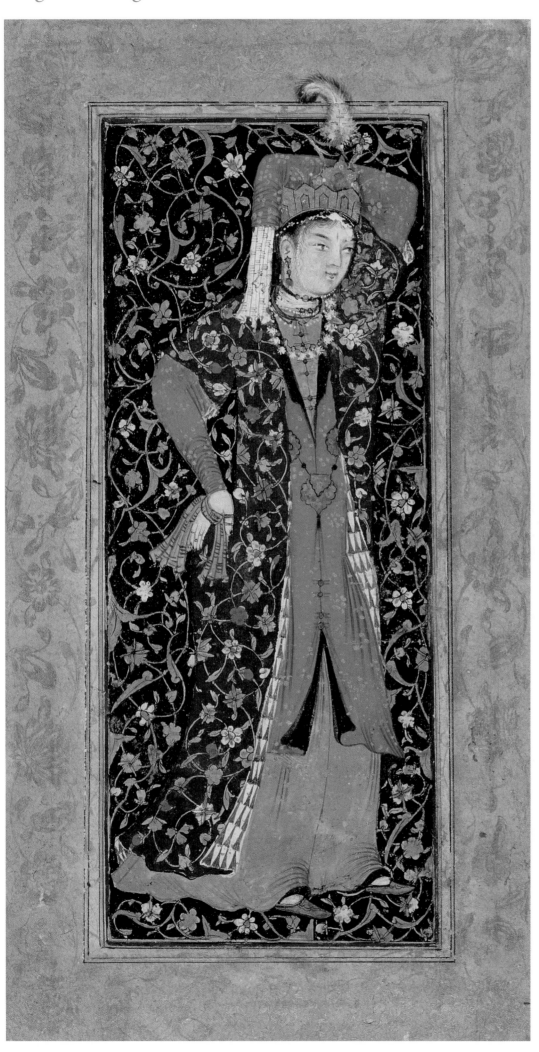

Dancing Figure, *c.*1555–60
Early Mughal

The dancer is set against a riot of ornamental decoration as though she were transfixed in sculpture. Only the tip of her feathered headdress breaks out from this confinement. She holds handkerchiefs in each hand, which presumably fluttered as she danced. She is one of two figures of female dancers, elaborately dressed and bejewelled, both of which form part of a group of ten early Mughal miniatures thought originally to come from a single album now referred to as the Fitzwilliam Album. Six of these miniatures are in Cambridge. It was the custom in these albums for miniatures to alternate with examples of calligraphy. On the back of the other female dancer is a specimen of writing by Mahmud, son of Maulana Khwaja, made at Kabul in 1546–7. This suggests that the album was put together at the court of Humayun. Humayun was the son of Babur, ruler of Ferghana in eastern Iran and a descendant of the great Turko-Mongol conqueror, Timur, whose family had ruled in Iran from 1369 to 1507. The Mughal court remained at Kabul until 1555 when it moved to Delhi. Humayun's son, Akbar, succeeded him in 1556, the approximate date of the miniatures.

Bodycolour on paper, 16.8 x 9 cm
Bequeathed by P. C. Manuk and Miss G. M. Coles, through the National Art Collections Fund, 1946; received 1948
PD.163-1948

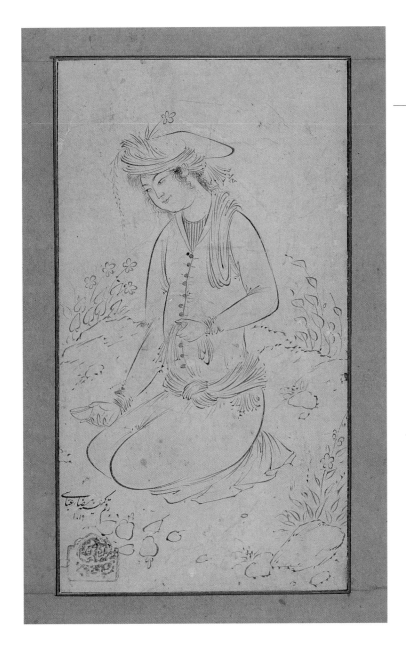

Seated Youth with a Wine Cup and a Handkerchief, 1610
Rizā 'Abāssi (died 1635)

The calligraphic line of this drawing has an elegance and sophistication characteristic of the very best of early seventeenth-century Persian miniatures. The youth is kneeling on the ground, holding a handkerchief in his left hand and a wine cup in his right, which he holds out to someone outside the drawing to fill, at whom he is clearly looking, in a knowing way. Rizā 'Abāssi is at his best at capturing personality in a quick sketch. Here the young man's complacency and elegance are splendidly characterized, but one has also a sense that the artist is gently mocking him, with his turban wittily decorated with a flower and a piece of long grass. The drawing may be cut down, but it is signed and dated towards the bottom left of the page in a position characteristic for signatures. Drawn in 1610, this is the second earliest dated miniature by Rizā 'Abāssi. He was the best-known miniaturist at Isfahan, working for Shah 'Abbās (1571–1629). During his reign single paintings and drawings became fashionable, and albums of portraits, sketches and specimens of calligraphy were put together and, to some extent, superseded illustrated manuscripts.

Point of the brush and black and red ink on paper, 13.9 x 7.9 cm
Bequeathed by Charles Brinsley Marlay, 1912
Marlay 40, pl. 40

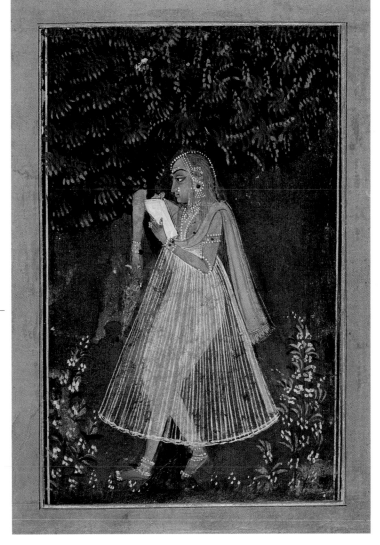

Hindu Lady Reading a Love Letter under a Tree, c.1630–50
Rajputana School

A Hindu lady swings her right arm between two branches of a tree to support herself off the ground, elevated perhaps by the contents of the love letter she reads. She wears a diaphanous skirt, but to all apparent purposes is naked apart from her jewels, mostly pearls and rubies, and a yellow scarf slung over her shoulders. Her hands and feet are lavishly painted with henna. Rajasthan is a desert region that for many centuries was divided into states under the control of Rajput rulers, each with his separate court and administration. Late in the sixteenth century the Rajput states had become targets for Mughal subjugation, and in consequence their art became influenced by the sophisticated painting of the Mughal empire. This seventeenth-century example shows the continuing individuality of the native school of Rajput painting, with its strong imagery and firm palette.

Bodycolour heightened with white on paper, 15.5 x 9.8 cm
Bequeathed by Charles Brinsley Marlay, 1912
Marlay 40, pl. 16

St Teresa of Ávila's Vision of the Dove, c.1614
Sir Peter Paul Rubens (1577–1640)

Teresa of Jesus (1515–1582) was a Carmelite nun and founder of the Barefooted Carmelites. In her *Life*, which she wrote in 1563–5, she recounts a vision of a dove she had on the eve of Pentecost: 'It hovered above me during the space of an *Ave Maria*. But such was the state of my soul, that in losing itself, it lost also the sight of the dove.' Teresa's beatification and canonization were rushed through because of Philip II of Spain's influence. Although she died only in 1582 she was beatified by Pope Paul V in 1614 and canonized by Gregory XV in 1622. Four paintings by Rubens survive of Teresa of Ávila. The particular interest in Spain for her canonization may explain why Rubens, living in the Spanish-ruled Netherlands, should have painted her so often. Three of these paintings can be dated on stylistic grounds to *c.*1614, the year of her beatification. They were probably all part of the larger campaign towards her canonization. Rubens, by concentrating the composition into a tight vertical format, forces the viewer to think of the religious significance of his subject; there is nothing else to distract the eye.

Oil on wood panel, 97 x 63 cm
Accepted in lieu of Inheritance Tax by
H.M. Government and allocated to the
Fitzwilliam Museum, 1999
PD. 43-1999

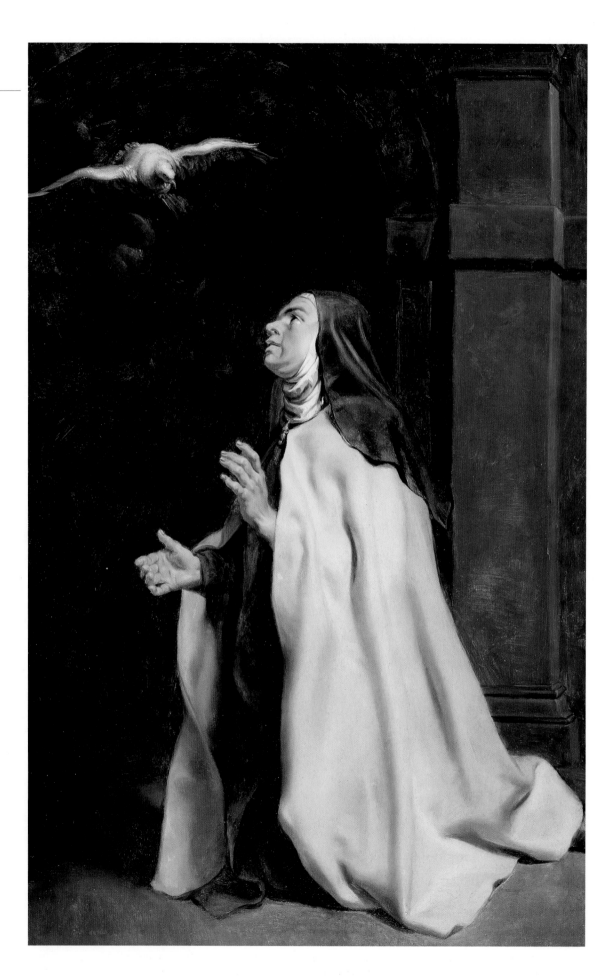

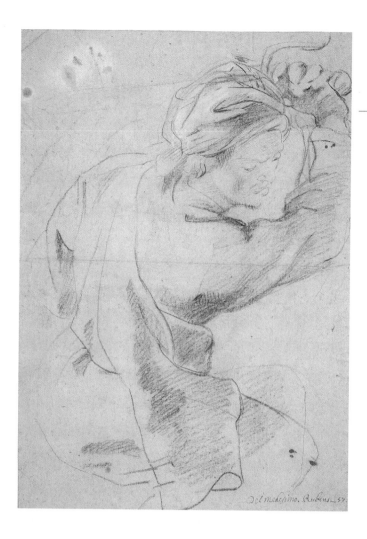

A Tartar Huntsman, c.1615–16
Sir Peter Paul Rubens (1577–1640)

Rubens is renowned for his energy. In this drawing most of the tension is concentrated in the hand with which the huntsman grips his sword as he raises his arm to kill. His face expresses savagery and concentration and the Tartar features are indicated but not exaggerated. The sense of volume in his arm is created by subtle shading, with emphasis given to his shoulder and armpit. Much of the rest of the drawing is summary. Folds in his cloak are indicated by swiftly drawn lines, and the shading on them gives the direction of the light falling on the figure. The drawing is a study for the mounted Tartar at the left, about to deliver the final blow to the beast at bay in the *Lion Hunt*, one of the four famous hunting scenes commissioned from Rubens by Maximilian of Bavaria in 1615. In the painting the huntsman is riding a horse, which explains the curving line of the buttocks below his back and the change of line showing two possibilities for the placing of his knee. The original painting is lost, but its composition is known from a studio version.

Black chalk, heightened with white on cream paper, 38.3 x 26.9 cm
Accepted in lieu of capital taxes by H.M. Treasury
and allocated to the Fitzwilliam Museum, 1989
PD.14-1989

Triumph of the Eucharist over Ignorance and Blindness, 1625–27
Sir Peter Paul Rubens (1577–1640)

Rubens designed four cycles of tapestries. The third of these, *The Triumph of the Eucharist*, was commissioned by his patron the Infanta Isabella, Governess of the Spanish Netherlands, to hang in the Convent of the Descalzas Reales, Madrid. The Infanta had spent eight months with the order of the Poor Clares in her youth, and after her husband's death in 1621 she wore their habit for the rest of her life. Seven *bozzetti*, or preliminary designs, for these tapestries are in the Fitzwilliam. This is the largest. The Church (Ecclesia) rides in a chariot, holding before her a monstrance in which is displayed the Host, or Communion wafer. Behind her an angel holds the Papal tiara above her head. In front of her a winged angel on horseback holds up the Papal umbrella above the crossed keys of St Peter. Her chariot crushes Hate and Envy beneath its wheels, while Ignorance and Blindness follow behind as prisoners. In a brilliant piece of illusionism Rubens has painted the whole scene as if it were a tapestry hung from a Composite capital strung up between Solomonic columns. This design was further elaborated in the *modello* now in the Prado, which was in turn made into a full-scale cartoon by Rubens's studio, from which the tapestry was woven.

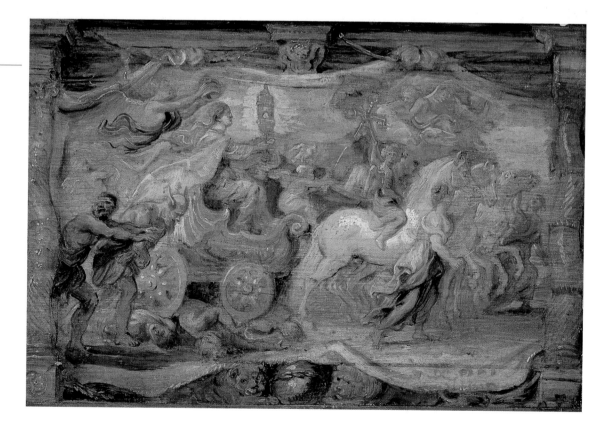

Oil on wood panel, 16.2 x 24.4 cm
Bequeathed by Revd R. E. Kerrich, 1873
228

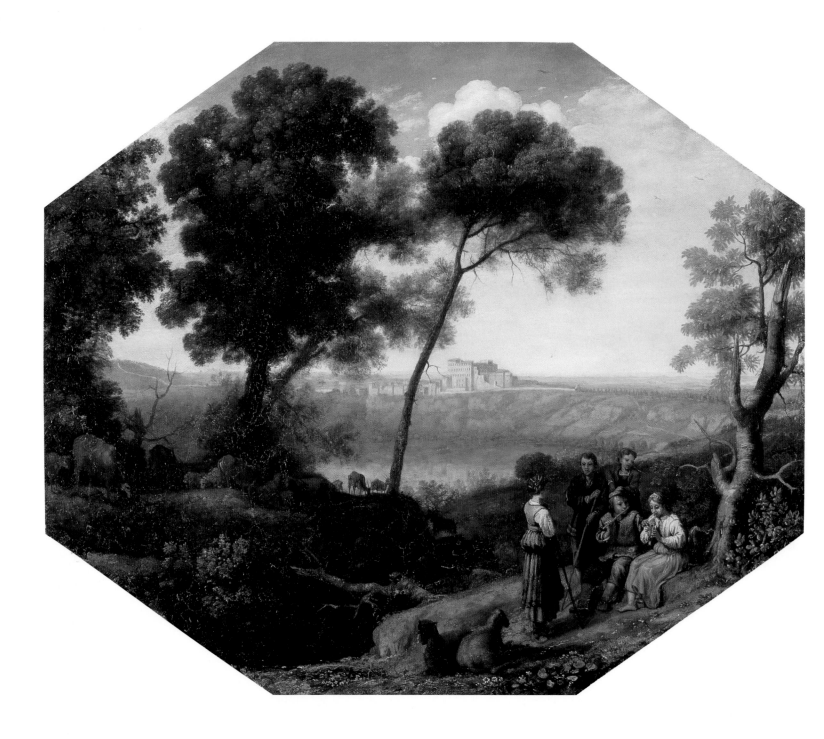

***Pastoral Landscape with Lake Albano
and Castel Gandolfo***, 1638–9
Claude Gellée, called Le Lorrain (1604/1605–1682)

Claude took the surname by which he is familiarly known from his place of birth, the Duchy of Lorraine, but spent virtually all of his working life in Italy. Highly popular in his own day, his luminous landscapes exercised a profound influence over generations of European painters. This beautiful landscape was painted for Pope Urban VIII, Maffeo Barberini (1568–1644), who was renowned for his interest in art and literature; it remained in the Barberini family until 1962. A pendant, *A View of the Port of Santa Marinella near Civita Vecchia* is now in the Petit Palais, Paris. The Pope, who almost certainly chose the subjects, celebrated the charm of Lake Albano in a sonnet written in Italian. The imposing palace of Castel Gandolfo that rises above

the Lake was built for Urban VIII by the architect Carlo Maderna, who was also responsible for the façade of St Peter's; since 1624 it has been the papal summer residence. Claude's viewpoint is fairly accurate, if slightly higher than in reality; the foreground incorporates elements which are frequently found in his paintings – the group of rural figures, animals at pasture and *repoussoir* tree, carefully placed so as to lead the eye to the palace on the distant horizon. The music-making figures in the foreground may be intended to evoke the Pope's own keen interest in music.

A gem-like quality of finish owes much to the level of detail that Claude was able to achieve by using copper as the support.

Oil on copper, 30.5 x 37.5 cm
Bought from funds bequeathed by Miss I.M.E. Hitchcock and L. D. Cunliffe, with grants from the National Art Collections Fund and the Victoria & Albert Museum, 1963
PD.950-1963

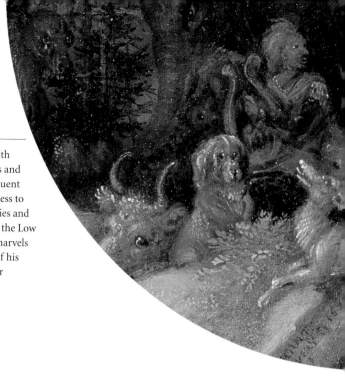

Orpheus Charming the Beasts and Birds, 1622
Roelandt Savery (1576–1639)

At first sight this could be mistaken for a picture of the Garden of Eden. But high on the right is the clue to the subject. There, just below the elephant, can be seen a figure with red hair, seated, playing the lyre; he is Orpheus, the quintessential mythical singer. The story goes that after Orpheus lost his wife, Eurydice, for the second time, when he turned back to check she was following him out of Hades but she had disappeared, he withdrew into the wilds of nature. There his song of lamentation moved animals, trees and rocks to tears. Savery had worked for the Emperor Rudolf II and his brother Matthias at their court in Prague from 1604 until 1613. While working for Rudolf, Savery had been sent south to

the Tyrol to 'draw wonders'. He returned with spectacular views of mountains, forest trees and waterfalls, which were to enliven his subsequent paintings. At Rudolf's court he also had access to the wild animals in the Emperor's menageries and hunting grounds. When Savery returned to the Low Countries he incorporated many of those marvels into paintings like this one. The brilliance of his colouring is enhanced by his use of a copper support, which adds luminosity to the oils.

Oil on copper, 22.6 x 26.4 cm
Bequeathed by Daniel Mesman, 1834
342

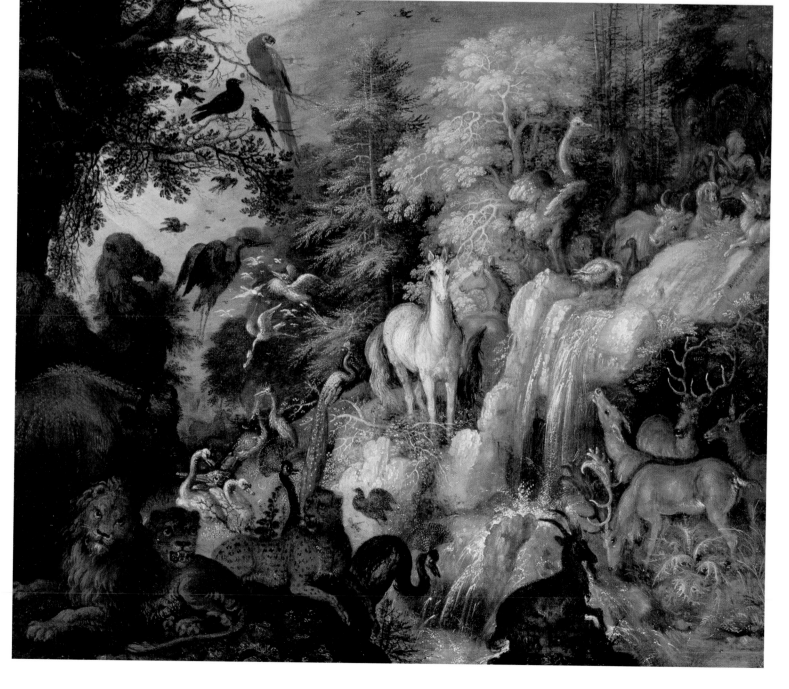

Oil on copper, circular, diam. 21.3 cm
Founder's Bequest, 1816
432

Above: ***Classical Landscape with Ruins***, *c.*1628–30
Right: ***Classical Landscape with Rocks***, *c.*1628–30
Bartholomeus Breenbergh (1598–1657)

Breenbergh was one of the first generation of Dutch Italianates, Northern artists who travelled to Italy in the 1620s and were inspired by the light and poetry of the southern landscape. He arrived in Rome in 1619 and stayed in Italy until *c.*1629, when he returned to the Netherlands, settling in Amsterdam in 1633. Paired paintings like these are very rare in his output, but they conform to the principles applied in the pairs of most other artists of the time. Each painting is balanced in itself, but viewed together their motifs and compositions are contrasting. Here the tonal range of colours is comparable, with a dark foreground extending into a lyrical expanse of light and space. The massive ruin, not an actual building but a composite fantasy inspired by the church of S. Maria della Febbre, Rome, and the Tomb of Scipio on the Via Appia, is balanced in the landscape in the painting on the right by the high rock with a citadel on it. The landscapes are enlivened by the careful grouping of figures and animals, suggestive of a Golden Age. The way in which the eye is drawn across many planes by the subtle shifting of light into the open distance was to be emulated by Claude Lorrain.

Oil on copper, circular, diam. 21.3 cm
Founder's Bequest, 1816
431

Paintings, Drawings & Prints

Head of an Old Woman, *c.*1590
Annibale Carracci (1560–1609)

The practice of making oil sketches on paper, while rare in Bologna in the late 16th century, was a technique used occasionally in the Carracci studio. All three of the Carracci visited Venice in the 1580s, where such sketches were common, and they may have learned the technique there. The paper on which this one was painted had already been marked with written accounts for food. Annibale has turned it upside down and used it again as the support for this quickly sketched head from the life. It is likely that this and other studies were intended to build up a body of psychological heads that could be used by the Carracci studio as a resource when composing a painting on a larger scale. They are generally considered to have been painted between 1585 and 1595, before Annibale left Bologna for Rome.

Oil on paper, 42 x 29 cm
Bequeathed by Warren Pollock, 1986; received 1992
PD.17-1992

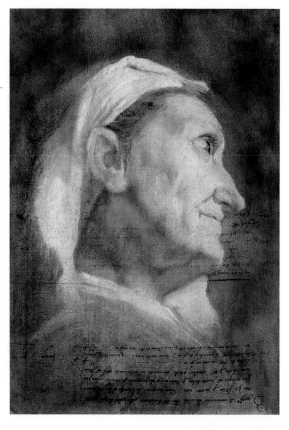

A Village Festival, With a Theatrical Performance and a Procession in Honour of St Hubert and St Anthony, 1632
Pieter Brueghel the Younger (1564–1638)

Although it has been suggested that this is a copy after a lost painting by Brueghel's father, Pieter Bruegel the elder, it is more likely to be an independent invention. It is generally considered the best of twenty versions known of this composition, two of which are also signed and dated, 1604 and 1624. In the middle a play is taking place. This is the well-known Flemish comedy entitled 'The Trick-Water Farce'. A seated woman is flirting with the Devil, disguised as a monk, while her husband is hidden in a coalman's hod waiting to catch them in the act of adultery. To the right is a procession in honour of St Hubert and St Anthony, whose images are carried behind a banner emblazoned with an image of the Virgin and Child.

Oil on wood panel, 118.1 x 158.4 cm
Given by Viscount Rothermere, 1927
1192

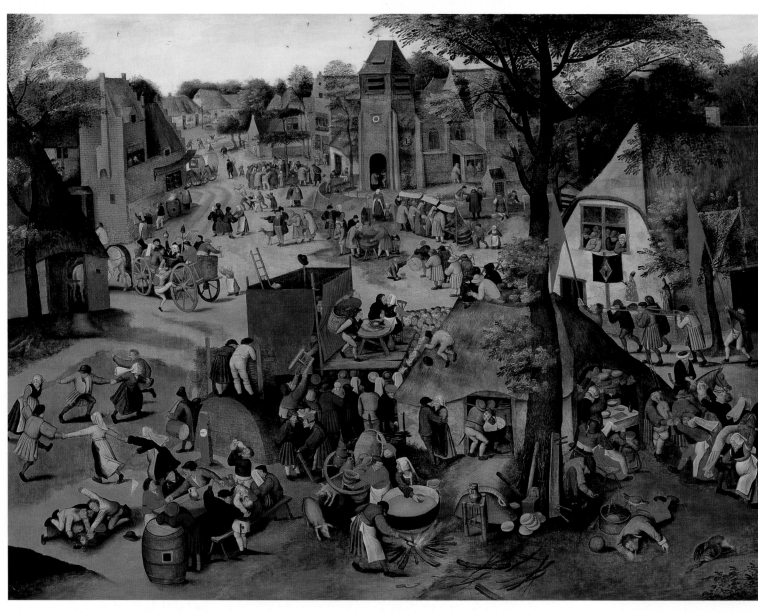

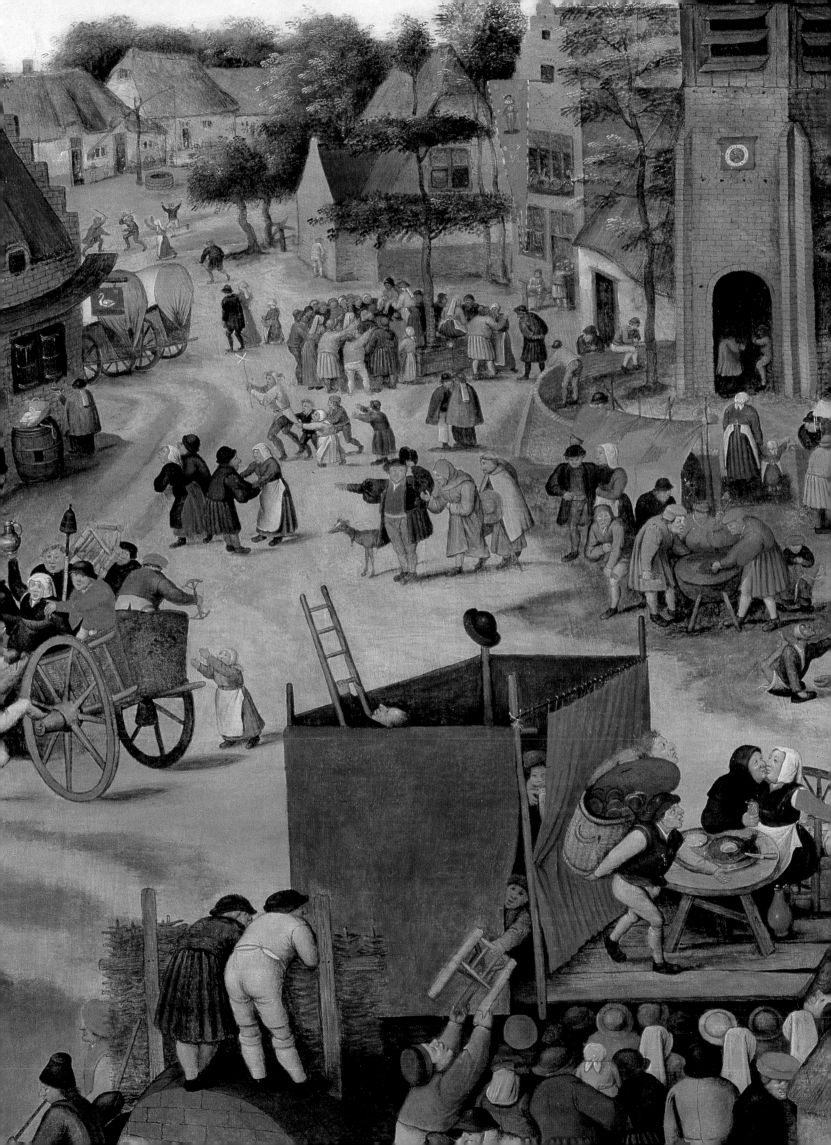

The Calling of St Peter and St Andrew, 1626–30
Pietro da Cortona (1596–1669)

A preliminary study for one of a series of frescoes of landscapes with small figures depicting scenes from the life of Christ in the chapel of the Villa Sacchetti (now the Villa Chigi) at Castel Fusano near Ostia. The frescoes form part of a larger series decorating the villa, which were commissioned from Pietro da Cortona in 1626 by the Marchese Marcello Sacchetti, Cortona's first patron, and were completed in 1630. Cortona has depicted the scene described in the gospel of St Matthew, iv, 18–20, when Christ summoned Peter and Andrew from fishing at sea to make them 'fishers of men'. It is one of the rare views towards the sea by a seventeenth-century Italian painter. The shower of rain in the background is typical of the fresh and immediate rendering of atmospheric effects characteristic of Cortona's few landscape paintings. He may have been inspired to paint landscape by Sacchetti's interest in the subject (Sacchetti was an amateur landscape painter), but, after Sacchetti's death in 1629 he concentrated instead on history painting and grand decoration. This is the only *bozzetto* (preliminary sketch) that is known for any of the frescoes in the villa. It would have been painted to show to Marchese Sacchetti for his approval.

Oil on canvas, 28.7 x 57.4 cm
Given by the Friends of the Fitzwilliam, with contributions from
the Victoria & Albert Museum, Grant-in-Aid and from the funds of
Miss I.M.E. Hitchcock's bequest, 1965
PD.3-1965

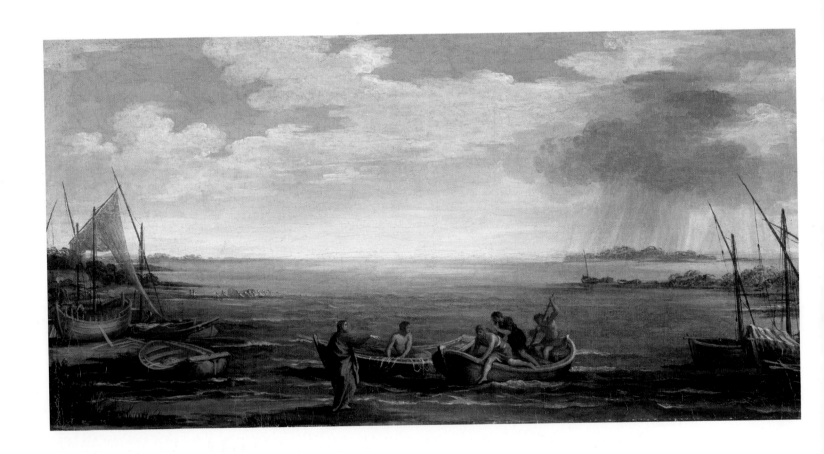

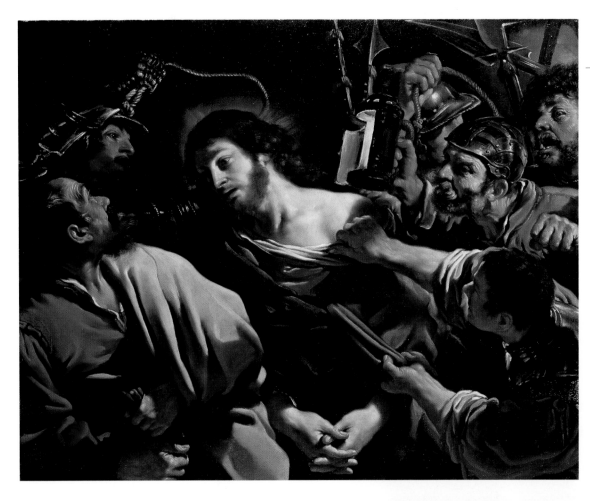

Oil on canvas, 115.3 x 142.2 cm
Given by Captain R. Langton Douglas, 1924
1131

The Betrayal of Christ, *c.*1621
Giovanni Francesco Barbieri, known
as Il Guercino (1591–1666)

Painted for Bartolommeo Fabri in
his native Cento, this is a pair to *The
Incredulity of St Thomas* in the
National Gallery, London. It shows all
the features of Guercino's early style:
rich handling of paint, a gorgeous
sense of colour, bold naturalism,
powerful contrast of light and dark
and daring compositional inventive-
ness. Here the crowding of the picture
plane creates a sense of claustro-
phobia, increased by the contrast with
Christ's dignified acceptance of His
fate. He looks at Judas, who clutches
the bag containing the thirty pieces of
silver, with compassion and foregive-
ness. The features of the soldiers have
a menacing brutality. The noose
about to be placed around Christ's
neck acts as a double nimbus. Christ's
ivory flesh is in direct contrast to the
ruddier coloured flesh tones of his
captors. Noteworthy too is the
difference in the treatment of the
hands: the captors' tense, aggressive,
clenched; Christ's, clasped in prayer,
resigned.

Ecce Homo (The Man of Sorrows), *c.*1639
Guido Reni (1575–1642)

Reni's contemporary, the sculptor Gianlorenzo Bernini, said that he painted
'Pictures of Paradise'. This gives a good idea of how his audience responded
to the dual nature of his religious paintings. They balance the calculated
artifice of a great artistic image with a humanity that is both immediate and
personal. It is not surprising that they have remained religious icons for the
Catholic faithful ever since they were painted. This work was painted late in
Reni's career and exemplifies both the supreme subtlety of his colouring
and his ability to convey intense emotion with great economy of means.
Christ's passion is conveyed without any movement at all. The subtle
inclination of His head suggesting the pressure of the Crown of Thorns, the
glistening highlights of His flesh, expressed through loaded brushwork, the
gentle way His arms enfold His body to protect it, all create the impression
of His suffering. His weariness is suggested by the delicacy with which His
hands are painted, scarce able to hold His robe and reed. The image is one
of divine pathos.

Oil on canvas, 113 x 95.2 cm
Given by Mrs Sigismund Goetze, 1943
2546

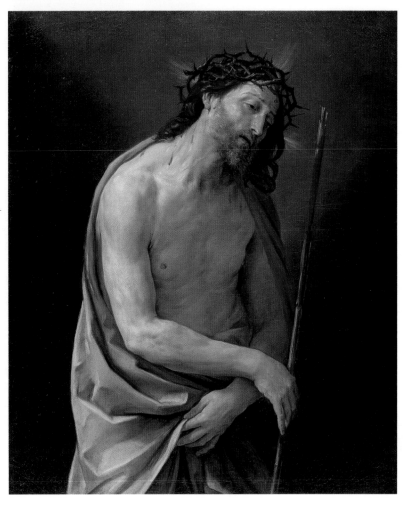

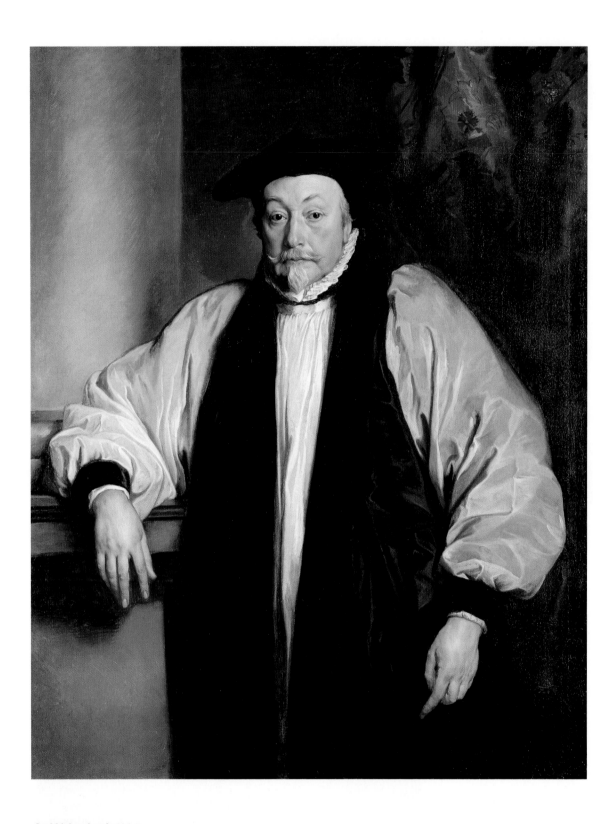

Archbishop Laud, 1635–7
Sir Anthony van Dyck (1599–1641)

Over 40 versions of this portrait were painted in the seventeenth century, which indicates its contemporary fame. William Laud (1573–1645) was appointed Archbishop of Canterbury by Charles I in 1633. He was self-made, an ecclesiastical reformer and a very successful Chancellor of Oxford University. Impeached by Parliament in 1640, he was beheaded in 1645. Van Dyck's vivid portrait conveys a strong sense of character. Laud, like King Charles, was short in stature, and by presenting him at three-quarters-length van Dyck has managed to give the impression of his authority without compromising his dignity. The pose derives from prototypes by Titian. Van Dyck's ability to paint textures is shown to exceptional advantage in the contrasting and subtle tones of black, grey and white of the prelate's clothes. Van Dyck was particularly renowned for his skill in painting hands, an especially noteworthy feature in this portrait, one of the finest of his British period.

Oil on canvas, 120.5 x 96 cm
Bequeathed by Charles Haslewood Shannon, RA, 1937
2043

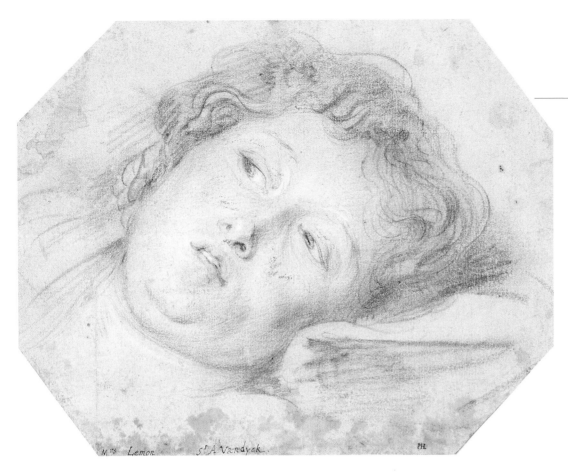

***Portrait of Margaret Lemon**, c.*1637
Sir Anthony van Dyck (1599–1641)

Rubens's influence on van Dyck is particularly evident both in his choice of three chalks with which to draw and in the unusual intimacy of this relaxed and sensual composition. Mrs Margaret Lemon, known as 'Peg', was probably born in 1613/14. She was van Dyck's model from 1629 and his mistress from 1632; and she is seen here very much 'in the flesh'. Her character was not an easy one, and she was described by the Bohemian artist Wenceslaus Hollar as a 'dangerous woman', a 'demon of jealousy, who caused the most horrible scenes when ladies belonging to London society had been sitting without chaperone to her lover for their portraits and who on one occasion in a fit of hysterics had tried to bite off Van Dyck's thumb so as to prevent him ever painting again'. Van Dyck broke off relations with Mrs Lemon in 1639 under pressure from Charles I to marry Mary Ruthven, a lady-in-waiting to Queen Henrietta Maria.

Black and red chalk, heightened with white on paper, octagonal, 19.2 x 24.5 cm
Bought from the Gow and Perceval Funds with contributions from the National Art Collections Fund (with a contribution from the Wolfson Foundation) and Resource / V&A Purchase Grant, 2001
PD.41-2001

***Vase of Flowers on a Ledge**, c.*1640–50
Giovanna Garzoni (1600–1670)

The flowers include anemones, carnations, roses and tulips, placed in an elaborate gilt urn decorated with a frieze showing a scene of pagan worship, above a bearded head confronted by griffins. The handles of the urn are made of birds' heads. Characteristic of Garzoni is the stippled background. She was born in Ascoli Piceno in the Marche and worked in Rome for Cassiano dal Pozzo in the late 1620s. She went to Naples in 1630 to work for the Duque de Alcalá and in 1632 travelled to Turin to the court of Charles Emmanuel II, Duke of Savoy. She was in Paris in 1640 when Ferdinando de' Bardis, the ambassador in France for the Medici, wrote to the secretary of Grand-Duke Ferdinand II stating that Garzoni would like to return to Italy as she could not adapt to French customs. She worked for the Medici in Florence from 1642 to 1651 and then settled in Rome, where she died. She was widely admired and was patronized by collectors in Italy and Spain, who particularly appreciated her botanical knowledge and artistic sophistication.

Watercolour and bodycolour, heightened with gold on vellum, 31.8 x 26 cm
Bequeathed by Major the Hon. Henry Rogers Broughton, 2nd Lord Fairhaven, 1973
PD.903-1973

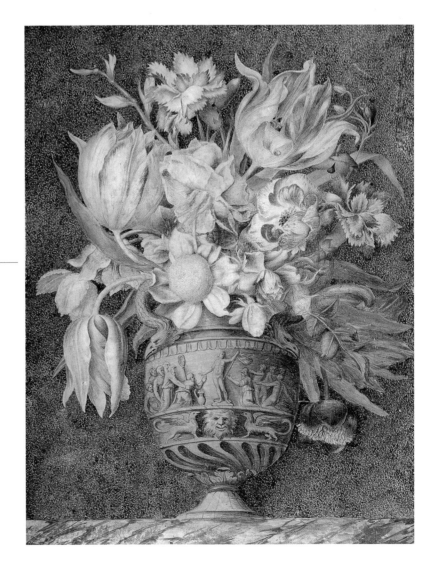

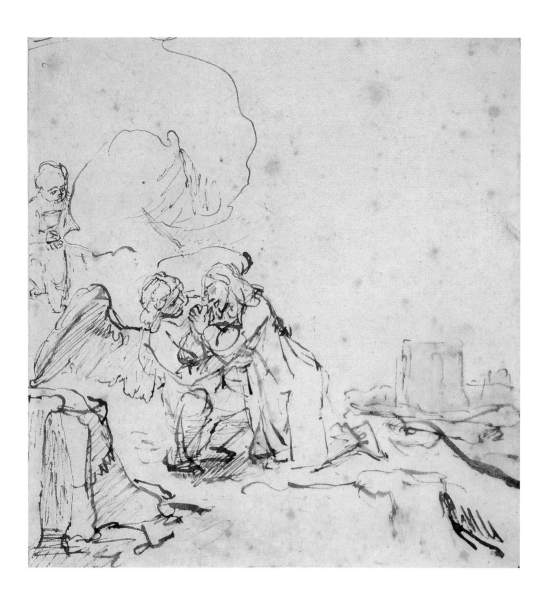

The Agony in the Garden, c.1648–54
Rembrandt van Rijn (1606–1669)

The intensity of feeling expressed in this drawing is characteristic of Rembrandt's biblical scenes. Christ's anguish is shown by the way He grips His hands in prayer and by His precarious balance. He looks as though He might fall were it not for the support given Him by the angel at His side. The shading on the angel's face somehow denotes compassion, and the stress of the situation is expressed by the many pentimenti in the drawing as Rembrandt reworked the salient details of the limbs of his figures. In the background the light wash on the distant buildings dissipates the tension of the main composition by giving it a key-note of calm. To the left, above the angel's wing, appears another angel holding rather hesitantly the cup of Christ's passion. Rembrandt made several drawings of this subject, each of which correspond in various details to an etching (Bartsch 75) of *The Agony in the Garden* that he was printing in 1654.

Pen and brown ink, brown wash on paper, 19.6 x 19 cm
Bequeathed by Charles Haslewood Shannon, RA, 1937
2140

Christ Presented to the People, 1655
Rembrandt van Rijn (1606–1669)

In the 1650s Rembrandt tackled the subject of Christ's Passion in two of his most ambitious and profound prints. In each case the plate was subsequently reworked to create another version of the biblical narrative. Illustrated here are two impressions printed at successive stages ('states') in the development of work on one of these plates. The earlier state (*above*) owes a debt to a version of *Christ Presented to the People* by Lucas van Leyden (1494–1533), in which the crowd that refused Pilate's offer of Christ's freedom plays a similarly prominent part. Rembrandt drew directly on the plate with a sharp needle, throwing up a metal burr that trapped ink and gave the line a velvet quality. The immediacy of Rembrandt's drawing is particularly impressive in the crowd, with many of the figures characterized from the rear without showing their faces. Although this impression was printed on vellum – an expensive option aimed at a few specialist collectors – a large number of impressions were also printed at this stage on the standard European paper that Rembrandt used for large print runs for general sale. After these were printed, and the plate had become worn, Rembrandt reworked it (*below*), burnishing away the figures of the crowd and replacing them with a bearded sculptural figure between two arches. He also added his signature and the date. By far the most striking effect of the reworking is to place the viewer in the role of the crowd, at once making the print more intimate, yet more powerful in its universal impact: we are all guilty of condemning Christ. Only a few impressions were printed before Rembrandt decided to make a further adjustment, reducing the impact of the mysterious bearded figure, before printing a large number of impressions on European paper.

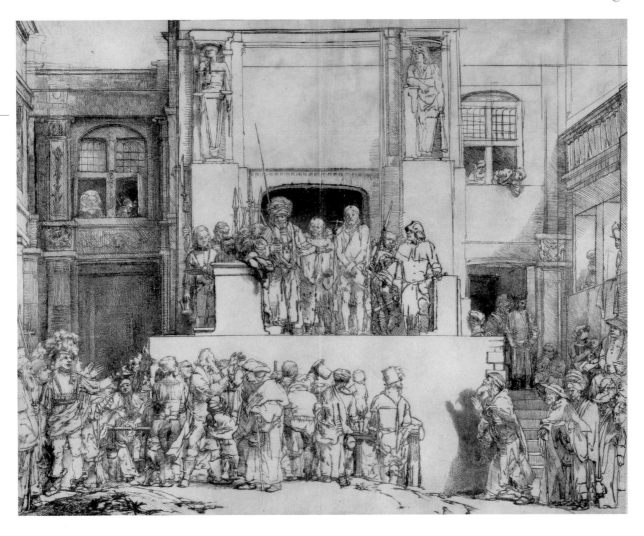

Drypoint printed on vellum,
state 5 of 8, 35.8 x 45.5 cm
Transferred from Cambridge
University Library 1876
AD.20.15-2

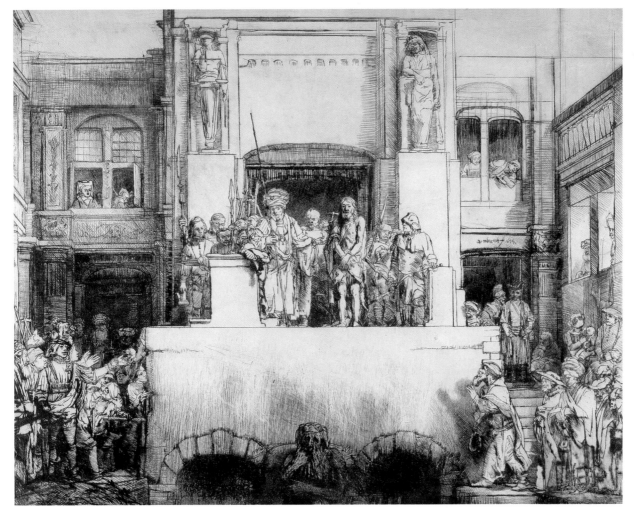

Drypoint printed on oriental
paper, state 7 of 8,
36.2 x 45.4 cm
Founder's Bequest, 1816
23.K.5-130

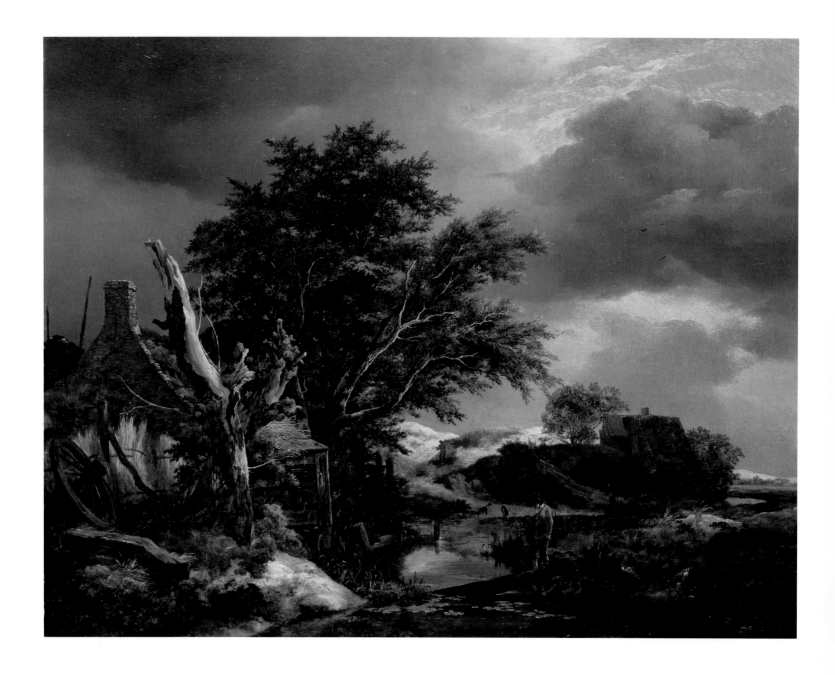

Landscape with a Blasted Tree near a House, *c*.1645
Jacob van Ruisdael (1628/9–1682)

In Holland by the mid-1640s landscape painting was a flourishing genre in its own right. Ruisdael, who came from a family of painters, was continuing a tradition established by the generation of his uncle, Salomon, who may have taught him. Ruisdael painted landscapes with a penetrating realism. The colour and textures of the blasted tree (seen by some as a symbol of the transience of life) contrast brilliantly with the softer handling and different shades of green in the two trees behind. The moody darkness of the sky, reflected in the stagnant grey water of the stream, suggests a storm, as do the highlights of sharp light on the dunes in the background and on the corn to the left of the house. Vitality is added to the scene by the dogs and the two figures, although the pensive nature of the peasant in the foreground contributes to a sense of brooding, which emanates from the painting as a whole. The picturesque features of the painting, while incidental to it, are of the type that had considerable influence on subsequent landscape painters in both France and Britain.

Oil on wood panel, 52.7 x 67.6 cm
Given by A. A. VanSittart, 1864

Sunset after Rain, *c.*1648–52
Aelbert Cuyp (1620–1691)

The painting gained its suggestive title in the nineteenth century. Its shape is unique and suggests that it might have been intended to be fitted into the panelling of a room to act as a fictive window. The composition is ideally suited to the shape; the strong left to right direction of the light is checked by the solid group of animals and figures with the Dutch farmstead in the right background. Cuyp never visited Italy, but he was inspired by the golden light in the paintings of his compatriots who had. From

*c.*1645 the light in his paintings became less northern, more honeyed, although otherwise he continued to paint with great fidelity to life and nature. His 'golden glow' shimmers across the flanks of the reclining cows, almost as though they had been bathed in syrup. Thomas Gainsborough was inspired by Cuyp's composition in Gainsborough's painting now in Dublin, *Open Landscape with a Herdsman, his Sweetheart and a Herd of Cows*, so the Cuyp must have reached England by *c.*1767.

Oil on wood panel, 83.9 x 69.9 cm
Bought from the Hitchcock, Cunliffe, Perceval and University Purchase Funds, with contributions from the Friends of the Fitzwilliam Museum, the National Art Collections Fund and the Victoria & Albert Museum, Grant-in-Aid, 1975
PD.115-1975

Lucy Harington, Countess of Bedford, *c.1606*
Isaac Oliver (died 1617)

Lucy Harington (1581–1627) married Edward Russell, 3rd Earl of Bedford, in 1594. She was a noted patron of literature and the arts (see page 252), and John Donne, George Chapman and Ben Jonson all addressed poems to her. It has been suggested that Oliver has shown her in the masque costume which she wore in a performance of *Hymenaei* performed at the marriage of Frances Howard to her first husband, the 3rd Earl of Essex, in 1606. Her richly embroidered dress is decorated with fruit and flowers, including pears, pansies, and pinks. The white highlights on her pearl bracelets, earrings and necklace have oxidized to black, as have the diamonds on her cross and the jewel on her lace cap. The gauze suspended from her cap would originally have shimmered with a silver sheen, but it has been damaged by over-cleaning. This is one of Oliver's most ambitious and successful miniatures.

Bodycolour and watercolour on card, circular, diam. 12.7 cm
Bought with money bequeathed by Mrs Coppinger Prichard in memory of her father, Thomas Waraker, LL.D, and with a grant from the National Art Collections Fund, 1942
3902

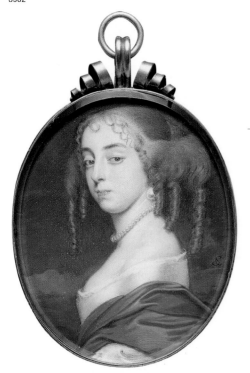

Portrait of an Unknown Lady, *c.1660*
Samuel Cooper (1608–1672)

Cooper was the elder son of John Hoskins's sister, Barbara. He and his younger brother, Alexander, were placed in their uncle's care as orphans and trained by him as miniature painters. Samuel continued to work with Hoskins until 1642, when he married and set up his own practice. He was famous throughout Europe as the leading miniaturist of his day. This portrait is one of his finest. Although the sitter is unidentified she must have moved in Court circles. Her hair is dressed in ringlets, known as 'Braganza curls' from the Portuguese fashion introduced by Charles II's wife, Catherine of Braganza. In France this style was referred to as 'à l'Anglaise'. Cooper has characterized his sitter with great aplomb, showing her clearly to be possessed of considerable temperament, with a seductive gaze and fully aware of her charms. Such self-confidence befits the lax circles of Charles II's court.

Watercolour on vellum on card, 6.7 x 5.5 cm
Bequeathed by L. D. Cunliffe, 1937
3826

Three children of King Charles I, *c.1647*
John Hoskins (died 1665)

Hoskins is well known for his copies in miniature of portraits by van Dyck. This was painted from life, however, whilst King Charles' children were in the care of the Earl of Northumberland after the surrender of the Royalist forces at Oxford in 1646. Princess Elizabeth (1635–1650) is shown aged twelve. James, Duke of York, later King James II (1633–1701), is wearing the blue ribbon of the Garter; he is about fourteen and his younger brother, Henry, Duke of Gloucester (1639–1660), must be eight. The Earl of Northumberland commissioned portraits of the Royal children from several artists, including Sir Peter Lely, whilst they were in his care. An earlier miniature of the King and Queen and all five of their children was painted by Hoskins for the King c.1641 and it is possible that Northumberland had this painted to send to Charles as a keepsake when he was in prison.

Watercolour on vellum on card, 8 x 11.9 cm
Bequeathed by L. D.Cunliffe, 1937
3877

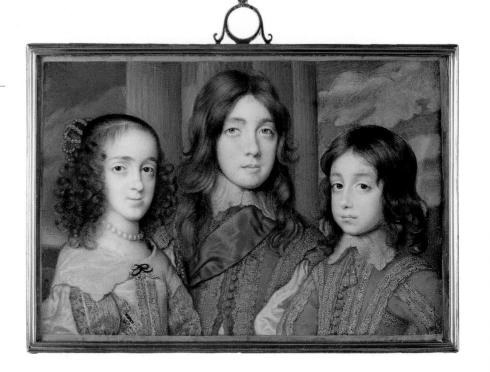

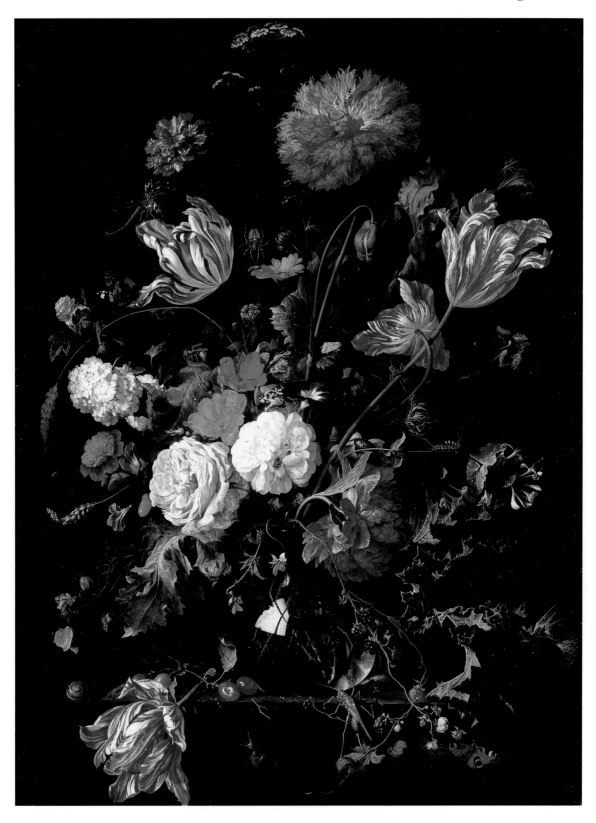

Flowers in a Glass Vase, _c._1660
Jan Davidsz. de Heem (1606–1683/4)

No painter had so profound an influence on the development of flower painting in the Netherlands in the seventeenth century as de Heem. He produced full-blown Baroque images with flamboyant blossoms far more elaborate than any of the works of his predecessors, and was equally good at manipulating paint to suggest the texture of leaf, petal and glass. Here the flowers seem to be fighting their way out of their confining niche into the far corners of the picture plane. Apart from this joyous, almost bombastic, wealth of form and colour there

are also passages of great delicacy and sensitivity. The dew drops on the roses, the bloom on the blackberries, the diaphanous wings of the dragonfly, all these are painted with extraordinary attention to truth. If his flower-pieces have any meaning additional to a love of exuberance it can only be to revel in the glories of the variety of God's creation. There are eight copies and copies after copies of this painting, showing how much it was admired in its day. The finest of them is by de Heem's pupil Abraham Mignon, himself well represented in the

Fitzwilliam and an extraordinary technician, but an artist who lacked de Heem's brilliant compositional inventiveness. Although a date of _c._1642/3 has been proposed for this painting, de Heem is not thought to have concentrated on flower painting alone until _c._1660.

Oil on wood panel, 93 x 69.8 cm
Bequeathed by A. G. Hartley, 1928
1487

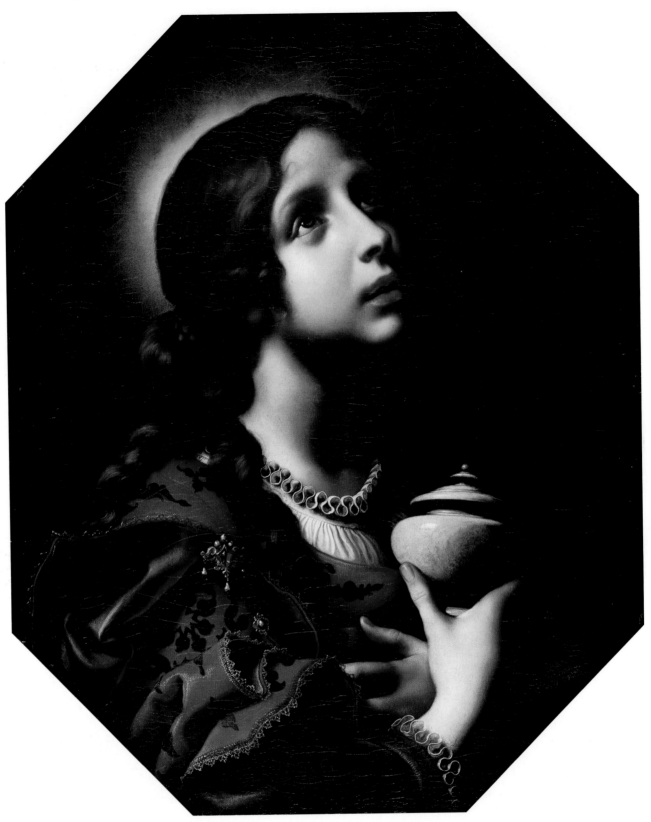

The Penitent Magdalene, 1650–51
Carlo Dolci (1616–1686)

The guiding force behind Carlo Dolci's art was an intense religiosity, which can be compared with that of his contemporaries, Guido Reni and Gianlorenzo Bernini. Many of his paintings are inscribed with prayers. On the back of this canvas he has written in Latin 'Let us rejoice in the God of our Salvation'. He has also quoted from Psalms 126, verse 5: 'They that sow in tears shall reap in joy . . .', an appropriate quotation for the Magdalene. The saint is recognized by her lavish clothes and jewels and by the

unguentarium she holds, an evident example of Dolci's skill as a still-life painter. The handling of the fabric gives a clear indication of Dolci's interest in early Netherlandish painting, and is an excellent example of his superb technique. The soft modulation of tones and colours are characteristic of his best work. Unusually Dolci painted the Magdalene with an aureole of light behind her head rather than with a halo. He was notorious for painting slowly: the brilliant surface finish he achieved required it.

According to an inscription on the stretcher the painting was begun on Mary Magdalene's saint's day (22 July) 1650 and completed on the last day of 1651. It was painted for the Martelli family in Florence.

Oil on canvas, 64.4 x 52.7 cm, octagonal
Bought from the funds of Miss I.M.E. Hitchcock's bequest, 1966
PD.4-1966

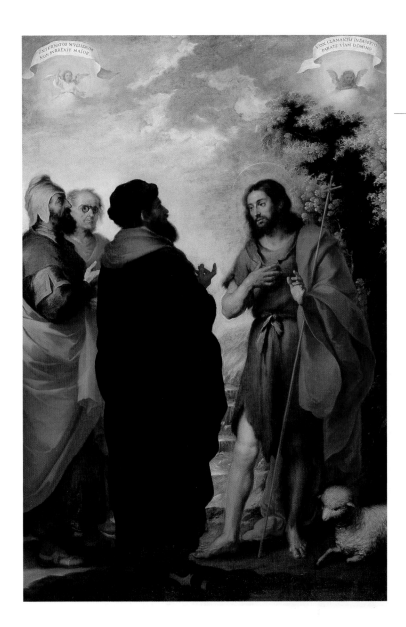

St John the Baptist with the Scribes and Pharisees, *c.*1655
Bartolomé Esteban Murillo (1618–1682)

One of four scenes from the life of St John the Baptist painted for the Shod Nuns of St Augustine in the convent of San Leandro in Seville, three of which are now known. The first in the series is probably the lost canvas, described in the nineteenth century as *St John the Precursor*, followed by this one in the Fitzwilliam, then *St John the Baptist Pointing to Christ*, now in Chicago, and finally *The Baptism of Christ*, now in Berlin. The Fitzwilliam painting shows John the Baptist on the right, wearing his camel hair skin, holding a cross and with the Lamb of God at his feet. To the left are the Pharisees and scribes asking him who he is. The answer to their question is revealed by the quotations from the Gospel of St Matthew, identified by his symbol of an angel, above to the left, and from the Gospel of St Mark, identified by his symbol of a lion to the right: 'Among them that are born of women there has not risen a greater (than John the Baptist)' and 'The voice of one crying in the wilderness, prepare ye the way of the Lord'. Murillo has idealized John's face, whereas the Pharisees have clearly Semitic features, and the man in spectacles can be assumed to be both learned and a scribe.

Oil on canvas, 261.2 x 178.8 cm
Bought from the University Purchase Fund, 1869
334

Below:
Oil on canvas, 87 x 112.5 cm
Bought from the Cunliffe Fund, with contributions from the National Art Collections Fund and the Regional Fund administered by the Victoria & Albert Museum on behalf of the Museums and Galleries Commission, 1987
PD.7-1987

The Three Maries at the Sepulchre, *c.*1684–5
Giovanni Battista Gaulli, known as Il Baciccio
(1639–1709)

When John, 5th Earl of Exeter, acquired this painting from Gaulli in 1684/5, Gaulli was the most highly praised painter in Rome and had just finished his masterpiece, the decoration of the ceiling of the Gesù. Gaulli's early success in Rome was guaranteed by the support of the sculptor Gianlorenzo Bernini. It is to his example that one turns to understand the elaboration of the drapery in Gaulli's figures: they are like Bernini's sculpture in paint. The composition is conceived of as a frieze, with the three Maries arriving at the empty tomb of Christ on Easter morning. Mary Magdalene is first, followed by Mary Cleophas, the mother of James the Less and Joses, and Mary Salome, the mother of James the Great and John. In the distance can be seen two saints coming towards the tomb, presumably Peter and John. To the right is a classical landscape reminiscent of the paintings of Nicolas Poussin. Gaulli was renowned for the richness of his palette, which is shown to great advantage here. The painting is expressive of a triumphant Catholicism, which characterizes the High Baroque in Rome.

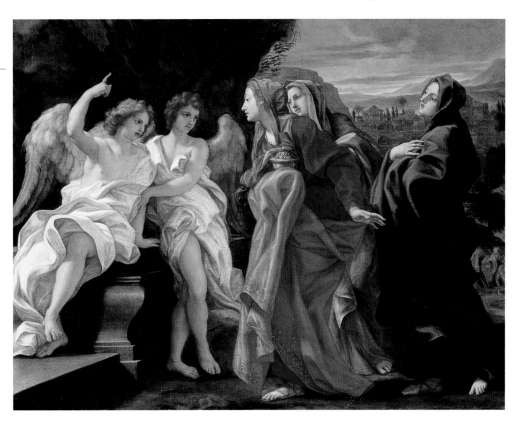

Right:
Rebecca and Eliezer at the Well,
c.1661–4
Nicolas Poussin (1594–1665)

The subject of this painting is taken from *Genesis* xxiv, 18–27. Abraham sent his oldest servant, Eliezer, to find a suitable bride for his son, Isaac. He finds Rebecca at the well outside the Israelite city of Nahor, and approaches her, requesting a drink both for himself and his camels. She complies without hesitation, and in performing this act of charity she reveals herself to be Isaac's future wife. The female companions shown on the right here are not mentioned in the Bible, but may derive from Josephus' account of the tale (*Antiquities*, I, xvi), which noted that all the other maidens refused Eliezer's request for water, 'on the pretence that they wanted it all at home'.

Poussin painted three compositions on this Old Testament subject, of which this was the last. The first, today in a private collection, represents the same moment in the biblical story, and was probably painted around 1627. A second, painted for his patron Jean Pointel in 1648 and now in the Louvre, depicts the moment immediately following this, when Eliezer presents Rebecca with jewels and asks her hand for Isaac on behalf of his master; interestingly, the Founder, Lord Fitzwilliam, bought a version of the latter (accession no. 316), that is now considered a copy. This painting was executed some time between 1661 and 1664, and is one of Poussin's last two religious works. Its severely linear design, solid figures, and restrained lyricism of movement and colour give the composition a weightiness that emphasizes the portentousness of the event that is about to unfold.

Oil on canvas, 96.5 x 138 cm
Bought from the Gow Fund and the
University Purchase Fund with
contributions from The Pilgrim Trust,
The Esmée Fairburn Trust, The American
Friends of Cambridge University,
The Goldsmiths Company, The Grocers
Company, Ciba-Geigy Plastics and with a
number of private donations encouraged
by the Fitzwilliam Museum Trust, and the
National Art Collections Fund, 1984
PD.38-1984

Classical Landscape, c.1653–7
Sébastien Bourdon (1616–1672)

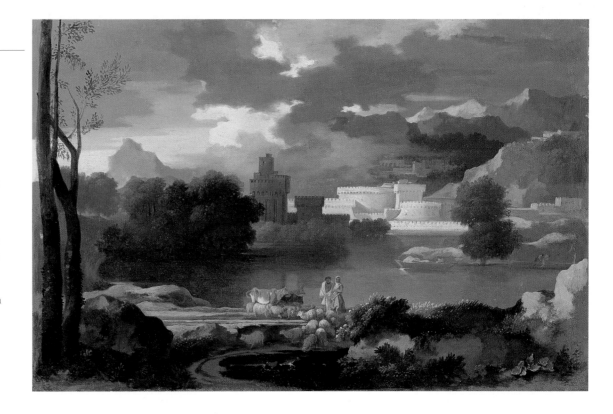

Born in Montpellier, Bourdon was
noted by his earliest biographers for
his lively, impetuous temperament
and the 'fire' of his genius. He visited
Rome at the age of nineteen, and
remained there for around a year,
before being forced to leave under
suspicion of being a Protestant
heretic. In 1652 he spent just under a
year in Sweden, but resettled in Paris
in 1654. After this date he was
inspired to paint some of his finest
works under the influence of Nicolas
Poussin (1594–1665); in this case the
composition shows the influence of
Poussin's landscapes depicting
episodes from the life of the Athenian
general, Phocion, painted in 1648.
It seems likely that it was executed in
Paris in the years immediately after
Bourdon's return from Sweden,
between 1653 and 1657. Bourdon's
landscapes were among his most
sought-after works, and extremely
popular among foreign collectors
throughout Europe, so that by the
nineteenth century some authors
complained that they were all but
unfindable in France. This small, but
imposing, landscape is considered

one of Bourdon's most exceptional
works on this scale. The particularly
luminous quality of the colour is due
to its being painted on a copper
ground.

Oil on copper, 20.3 x 31.8 cm
Bought from the Gow Fund, with Grant-in-Aid
from the Victoria & Albert Museum with a
contribution from Mr Clyde Newhouse, 1979
PD.15-1979

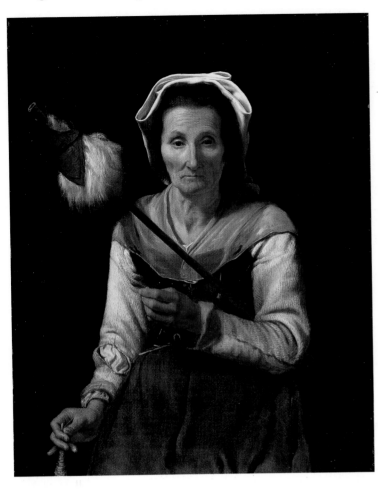

An Old Woman Spinning, c.1646–8
Michael Sweerts (1618–1664)

This profound character study of old age was painted by Sweerts when he was in Rome. The old woman is dressed in the clothes characteristic of a *contadina* or peasant woman from the countryside around Rome. She holds a distaff under her left arm and twists the strands of wool with her left hand, winding them on to the spindle, which dangles below, with her right hand. Sweerts has painted her with compelling realism. Her presence is palpable, like a painting by La Tour. Her skin is wrinkled and the craw of her neck is withered with age; she confronts the viewer full face, staring ahead from hooded eyes. Her clothes are depicted with great attention to detail. Contrasting textures define her bodice, sleeves and gauze-like shawl, where even the smallest details, such as the pins holding it together, are delineated with painstaking care. The painting originally may have been paired with a similar portrait of an elderly man. Sweerts came from Brussels and was in Rome from 1646 until at least 1652. In 1655 he was back in Brussels, and in 1661 he is recorded in Amsterdam. He joined a mission to China at the end of that year and visited Palestine and Tabriz in Persia in 1662. He then left the mission and made his way to Goa, where the Portuguese Jesuits had their headquarters. He died there two years later.

Oil on canvas, 43 x 34 cm
Bought from the Gow Fund, with contributions from the National Art Collections Fund and the Museums & Galleries Commission / Victoria & Albert Museum Fund, 1994
PD.145-1994

Interior with a Painter and his Family, c.1670
Jan Steen (1626–1679)

Steen is best known for his peasant scenes, much in the tradition of Pieter Bruegel, but he was also influenced by the *fijnschilder* painters from Leiden, and in several paintings he emulates their attention to fine detail and luscious surface textures. In this painting one can see why he had so great a reputation for depicting children. Rarely has an artist succeeded so well in suggesting concentration. The artist is looking at the glass vase of flowers set on a table carpet, while his hand moves in automatic response to what he sees. The boy is clearly fascinated by his father's correction of his drawing. The woman is sharpening a piece of graphite or charcoal, but her gaze is concentrated on her son's drawing. This forces the viewer to look not at the centre of the painting, but into the corner where the action is. The handling of paint pinpoints one of Steen's great qualities: his ability to give the impression of considerable detail by subtle use of colour and lighting. When one looks closely the table carpet is painted quite loosely and there is a blurred effect, but from a distance it has considerable weight and substance and appears as though it has been painted with painstaking care.

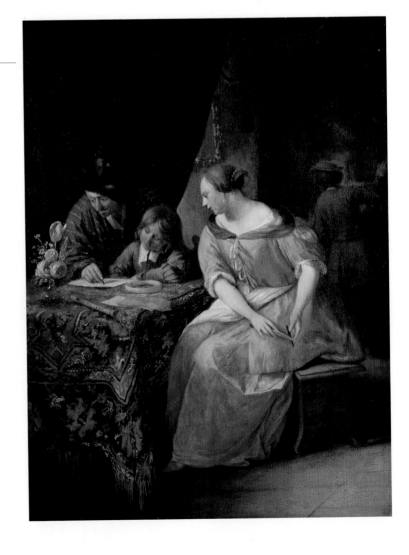

Oil on wood panel, 41.6 x 31.1 cm
Founder's Bequest, 1816

L'Umana fragilità (Human Frailty),
_c._1656
Salvator Rosa (1615–1673)

This is Rosa's most poetic rendering of a pessimistic theme that obsessed his maturity, that of the vanity of man's achievements and the transitory nature of life. It was probably painted towards the end of 1656, after both Rosa's brother and his infant son had died from the plague in Naples. Rosa has let his imagination run wild. The centre of the composition is dominated by a winged skeleton helping a child who sits in his mother's lap to write. What he writes sums up the message of the painting. The Latin words come from a poem by the twelfth-century writer Adam of St Victor: 'Conception is sinful; Birth a Punishment; Life, Hard Labour; Death Inevitable.' The sombre colouring throughout the painting recalls Rosa's Neapolitan training. Both mother and child have a sickly pallor, emphasized by the silver grey of the mother's robe. The owl is symbolic of dissolution. The child blowing bubbles, the thistle, whose seeds are so easily dispersed, and the short-lived butterfly suggest evanescence. The glass sphere on which the woman sits implies the vagaries of fortune and the fragility of worldly achievement, as does the lighted tow that will soon die down (traditionally it was ignited at the Pope's coronation to the accompaniment of the words 'Holy father, thus passes the glory of the world'). In the background to the right is a statue of Terminus, the God of Death; to the left is an obelisk, a funerary emblem, which has five reliefs referring to the Ages of Man. The head of the baby and the old man establish the theme; the fish represents hatred and death; the falcon, human vitality; the hippopotamus, the violence and discord in which man ends his days.

Oil on canvas, 197.4 x 131.5 cm
Bought from the L. D. Cunliffe Fund, 1958
PD.53-1958

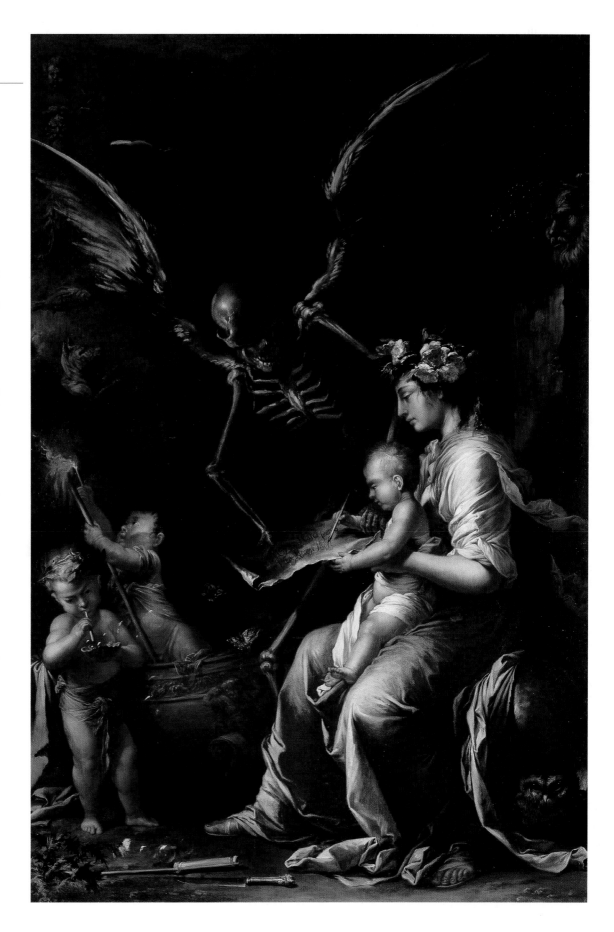

Portrait of an Unknown Man, c.1660–66
Frans Hals (1581/5–1666)

Hals's individuality was recognized in his own lifetime, when his portraits were described as 'very boldly painted after life'. His technique was idiosyncratic. Lighting his sitters from the left, he painted with loose brush-strokes to depict light on form, with few pigments (there are four in this painting: black, white, red and a yellow ochre), *alla prima*, or wet on wet, and very quickly. The overall effect is of tremendous vitality. His portraits have an immediacy and brilliance previously unknown in the Netherlands. When the Museum was bequeathed this portrait in the nineteenth century, the hat had been painted out and the background painted brown. Presumably the rakish angle suggested a degree of insouciance or debauchery unacceptable to early nineteenth-century taste. It is this casualness that appeals to the modern eye, combined with a tonal subtlety that was to have considerable impact on French painters of the later nineteenth century who rediscovered Hals, not least Manet and Ribot.

Oil on canvas, 79 x 65.4 cm
Given by Joseph Prior, 1879
150

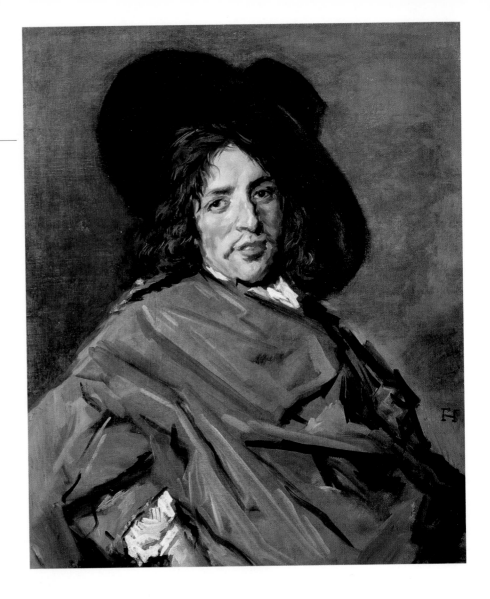

Left: *The Town Hall of Amsterdam*, 1674
Right: *The Groote Kerk at Haarlem*, 1674
Gerrit Adriaensz. Berkheyde (1638–1698)

Berkheyde was a leading exponent of townscape painting. In this pair of contrasting views he uses shadow to singular effect. Amsterdam's Town Hall was completed in 1665 and Berkheyde painted it many times. By leaving it in shadow he emphasizes the flatness of its facade, with its curious lack of a grand entrance. At the same time the darkness of the building, in contrast to the sunny square in which small groups of citizens meet for business or to pass the time of day, gives a sense of importance to it; not just architecturally, but also symbolically. The view of the Groote Kerk in Berkheyde's home town of Haarlem is taken from a more interesting viewpoint. The arcades of Haarlem's Town Hall act as a window onto the activities in the square, looking across the marketplace to the north-west facade of the Late Gothic church of St Bavo. The shadows of the columns define the foreground and the figures of the apprentices distract the eye, giving the viewer time to wonder what they are doing, before going on to admire the sunlight in the open expanse of the market square. Berkheyde was renowned for his contrasting pairs of views of Amsterdam's Town Hall and Haarlem's Groote Kerk. These are the best that survive.

Left:
Oil on wood panel, 40.3 x 32.3 cm
Founder's Bequest, 1816
44

Right:
Oil on wood panel, 40.2 x 32.7 cm
Founder's Bequest, 1816
47

Shipping before Dordrecht, 1651
Simon de Vlieger (*c.*1600/01–1653)

Seascapes are as integral to Dutch painting as landscape and townscape. In the late sixteenth century the most frequent type of sea painting showed a storm. De Vlieger painted many paintings of that type, but he was also one of the first artists to represent great state occasions at sea, the forerunner of Jan van de Cappelle and Willem van de Velde. This picture is among the most ambitious of his paintings of this type. It probably represents the visit of Prince Frederick Henry (1583–1647), stadholder and admiral general of the United Provinces, to the Dutch fleet at Dordrecht in June 1646, before the fleet set out for Flanders via Zeeland. In the background can be seen the Grote Kerk. The Dutch fleet is gathered together in the estuary of the River Thuredrecht, and in the foreground small boats are massed together, filled with people either watching or participating in the Prince's arrival. The cool silvery tonality of the painting is characteristic of de Vlieger and the limpid reflections in the sea anticipate van de Cappelle's mature work. In addition to painting seascapes, de Vlieger was a fine landscape painter and a great draughtsman. Van de Cappelle, who, like Rembrandt, was a collector as well as a painter, owned more than 1300 drawings by de Vlieger.

Oil on wood panel, 88.9 x 122.8 cm
Founder's Bequest, 1816
105

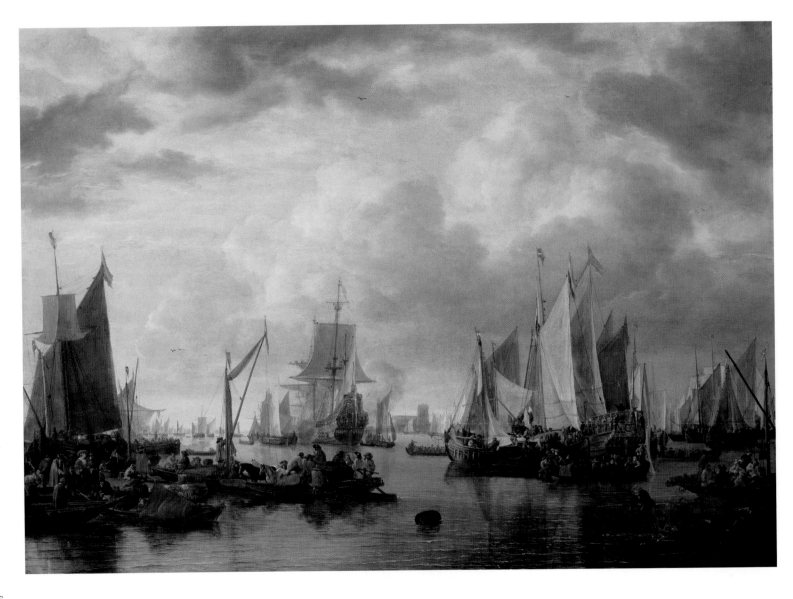

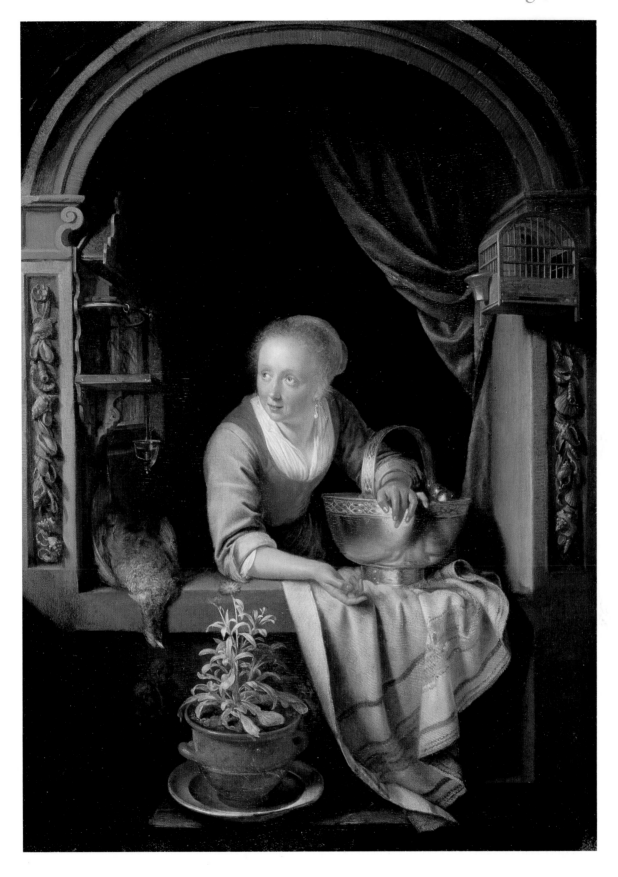

Woman at a Window with a Copper Bowl of Apples and a Cock Pheasant, 1663
Gerrit Dou (1613–1675)

Dou, who trained as a glass-painter and then worked in Rembrandt's studio from 1628 to 1631/2, specialized in painting small, exquisitely finished pictures of meticulous detail. He was the founder of the school of *fijnschilders* (fine painters) in Leiden. At first glance this painting can be read as a characteristic Dutch genre scene. A pretty young girl is looking out of a window with a brilliantly painted copper bowl of apples and a table carpet on a ledge with a daisy in a pot in front of her. To a contemporary eye the painting had a wholly different significance. The daisy, which symbolizes innocence, is in contrast to the loss of virginity implicit in the empty birdcage and the apples. To a seventeenth-century Dutchman a dead bird could symbolize copulation, the shells have connotations of gender, both male and female, from their shapes, and the implication is that the girl might be for sale. Dou's technique enraptures the eye in this charming play of seduction, where innocence is contrasted with experience.

Oil on wood panel, 38.5 x 27.8 cm
Founder's Bequest, 1816
175

Sketches of a Kitten, *c.*1712
Alexandre-François Desportes
(1661–1743)

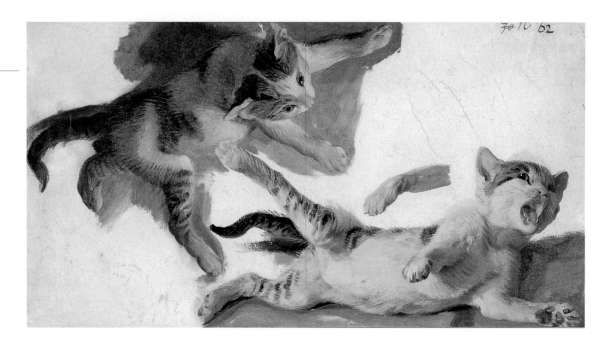

Desportes worked extensively as a portraitist at the beginning of his career, but by 1692 had established a considerable reputation as an animal painter. His hunting scenes were much in demand among collectors, and in 1700 he received his first royal commission for a series of five hunting scenes for the newly refurbished Menagerie at Versailles. In subsequent years he received regular commissions from the King for the châteaux of Marly and Chantilly, and for the royal apartments at the Tuileries. This enchanting study of kittens has been related to a finished painting, *A Fight Between a Dog and a Cat in a Kitchen Interior*, (1712; present whereabouts unknown). From 1692 Desportes made many such oil studies of animals, plants, flowers and landscapes, which, like this painting, show a vigour and directness of approach that appear strikingly modern.

This is one of many sketches in oil on paper sold by Desportes' descendants to serve as models for Sèvres porcelain. The numbers inscribed in brown ink, top right – probably

added by Desportes' nephew, Nicolas – seem likely to refer to the order in which the sketches were stored in portfolios in the painter's studio.

Oil on paper, 27 x 51.1 cm
Given by the Friends of the Fitzwilliam Museum, 1951
PD.1-1951

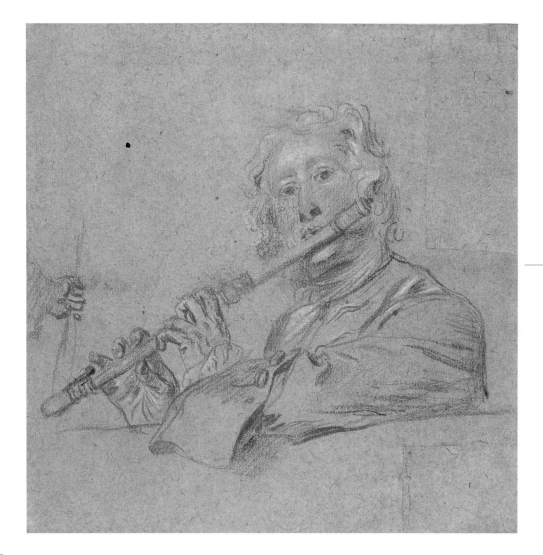

A Man Playing a Flute, *c.*1717
Antoine Watteau (1684–1721)

Watteau is said to have 'derived greater satisfaction from drawing than from painting'; his patron, Edme Gersaint, claimed often to have seen him 'mortified because his painting lacked the spirituality and truth which he was capable of with the crayons'. Watteau built up a repertory of drawings of figures, which he would sometimes use in more than one painting. This figure appears, with the addition of a hat, in *La déclaration attendue* (*c.*1717–18) in the Musée des Beaux-Arts, Angers, and, bare-headed, in another treatment of the same subject, *Le concert champêtre*, known only from an etching of 1727 by Benoît Audran.

Black, red and white chalks on buff paper, laid down, 17 x 17.3 cm
Bequeathed by Charles Haslewood Shannon, 1937
2265

***An Allegorical Monument to Sir
Isaac Newton***, 1727–30
Giovanni Battista Pittoni (1687–1767)
with Domenico (died *c.*1771) and
Giuseppe (died 1761) Valeriani

Newton died in 1727, when this
tribute to him was commissioned by
the Irish impresario Owen McSwiny,
who had left London for Italy after
bankruptcy. The painting was part of
a speculative venture consisting of 24
allegorical tombs commemorating
heroes from recent British history.
Outstanding Venetian and Bolognese
artists were employed to carry out
the paintings, whose subject-matter
was to be of McSwiny's own
'invention'. This one is a noble but
generalized allegory of Newton's
triumphs. Minerva and the Sciences
are led weeping by Fame to the urn
containing Sir Isaac's remains.
Mathematics and Truth (or possibly
Geometry) appear on a pedestal
surrounded by various figures
representing ancient and modern
predecessors of Newton, studying
globes, books and diagrams. The ray
of light that strikes through a prism
represents Newton's celebrated
experiment during his analysis of
light. The figures were painted by
Giambattista Pittoni; the background
is by the Valeriani, Genoese brothers
who specialized in *quadratura* or
illusionistic architectural painting.

Oil on canvas, 220 x 139 cm
Bought from the Cunliffe, Perceval and
Jones Funds, with contributions from the
Victoria & Albert Museum Grant-in-Aid,
the National Art Collections Fund, Trinity
and King's College Cambridge, the Faculty
of Physics, Cambridge University and an
anonymous benefaction, 1973
On loan to Trinity College (Wren Library)
PD.52-1973

Left:
**Huntsman with a Tufter on a Leash
('Le Limier')**, *c.*1726
Jean-Baptiste Oudry (1686–1755)

Oudry was one of the most successful and
productive painters working in the reign of
Louis XV. At the beginning of his career he
was a portrait and still-life painter, but in
the 1720s came to specialize in animal
painting, and hunting scenes in particular.
In 1726, thanks to the patronage of Louis
Fagon (1680–1744), Intendant des Finances,
he was appointed official painter to the
tapestry works at Beauvais. Eight years later
he became the artistic and financial director
there, a post he maintained until 1754; he
was also Inspector at the Gobelins tapestry
works from 1736. This is the only traceable
sketch ('*modèle en petit*') for a series of six
designs for *Les Chasses nouvelles*, one of the
first of his commissions in his official
capacity. These were to replace a series
woven at Beauvais in the 1660s and depicted
a wolfhunt, a staghunt, a foxhunt, a
boarhunt, a buckhunt, and – here – a tufter
scenting and putting up quarry. The first
five of these designs were adapted from
existing larger paintings on these themes by
Oudry; only the tufter was a wholly new
creation for the suite. The tapestry based on
this cartoon – like the other five in the suite
– is in the Residenz Museum, Munich.

Oil on canvas, 99.5 x 79 cm
Bought from the Abbott, Cunliffe, Gow, Zoë
Hadwen, Leverton Harris, Marlay, Perceval, and
University Purchase Funds with contributions
from the American Friends of Cambridge
University, the Regional Funds administered by
the Museums and Galleries Commission, the
Pilgrim Fund and Miss Helen Smailes, 1988
PD.20-1988

Above: **Before**, *c.*1731
Below: **After**, *c.*1731
William Hogarth (1697–1764)

Hogarth painted two pairs of small paintings on the
theme of sexual encounter. According to his own list
of paintings 'bespoke for 1731', a pair of paintings
with these titles were ordered by a 'Mr Thomson' on
7 December 1730. Thomson's identity remains in
doubt; it may be that he was acting as an agent for
someone involved in the frauds around this time
relating to the Commons Committee for the Relief of
the Charitable Poor. Another pair, now in the J. Paul
Getty Museum, Los Angeles, shows the same figures
in an indoor setting. Apparently painted 'at the
particular request of a certain vicious nobleman', that
pair is later in style, and less explicit in the observa-
tion of the figures. The outdoor setting of the present
pair shows the influence of contemporary French
paintings, especially the small *fêtes galantes* of Jean-
François de Troy (1679–1752).

Oil on canvas, (above) 37.2 x 44.7 cm, (below) 37.2 x 45.1 cm
Bequeathed by Arnold John Hugh Smith through the
National Art Collections Fund, 1964
PD.11-1964, PD.12-1964

A Capriccio of Roman Ruins, 1737
Giampaolo Panini (1691–1765)

Panini began his career as a decorator of interiors, but as early as 1716 he had won a reputation as a *vedutista* or view painter. These were heavily in demand among tourists, and he invented a new type of view-painting in which he placed real monuments in imaginary settings, a genre known as the *capriccio*. In this painting he has combined many of the most famous sites of ancient Rome. One can see the Temple of the Dioscuri, the Colosseum, a massive statue of a centaur, the Pyramid of Caius Cestius, the Obelisk of Augustus, the Arch of Constantine, the Arch of Titus and the Basilica of Maxentius. In the days before photography it was *capricci* of this type that reminded the tourist of what he had seen in Rome, albeit not in this juxtaposition. Panini enlivened his views with elegantly painted figures, some in imitation classical dress. His style, characterized by clarity of light and balanced composition, prevents such views from appearing humdrum or dull. This painting is one of a pair; the other is dominated by a view of the Pantheon, with the Farnese Hercules, Trajan's Column and the Medici Vase.

Oil on canvas, 36.8 x 69.2 cm
Bequeathed by Dr D. M. McDonald, 1991; received 1992
PD.107-1992

**A View at the Entrance of the
Grand Canal, Venice**, *c.*1741
Bernardo Bellotto (1720–1780)

The view looks towards the entrance
of the Grand Canal into the Bacino di
San Marco. It is taken from the
Campiello del Traghetto di Santa
Maria Zenobico, with part of the
Palazzo Pisani-Gritti on the left.
Across the Canal the facade of the
monastery and church of S. Gregorio
rises above a row of houses. The
principal Baroque church in Venice,
S. Maria della Salute, designed by
Baldassare Longhena, dominates the
skyline. To the left of Longhena's
church are the Seminario Patriarcale
and the Dogana, above which can be
seen the dome and bell-tower of
Palladio's S. Giorgio Maggiore. At
least five versions of this view are
known; one by Bellotto's uncle,
Canaletto, is also in the Fitzwilliam;
the others, of which the largest and
grandest in scale is at the J. Paul Getty
Museum, Los Angeles, are generally
considered to be by Bellotto. The
Fitzwilliam Bellotto is considered to
have been the first to be painted.
The view remains virtually the same
today, although the row of houses on
the right was demolished in the late
nineteenth century to construct the
Palazzo Genovese.

Oil on canvas, 59.3 x 94.9 cm
Founder's Bequest, 1816
186

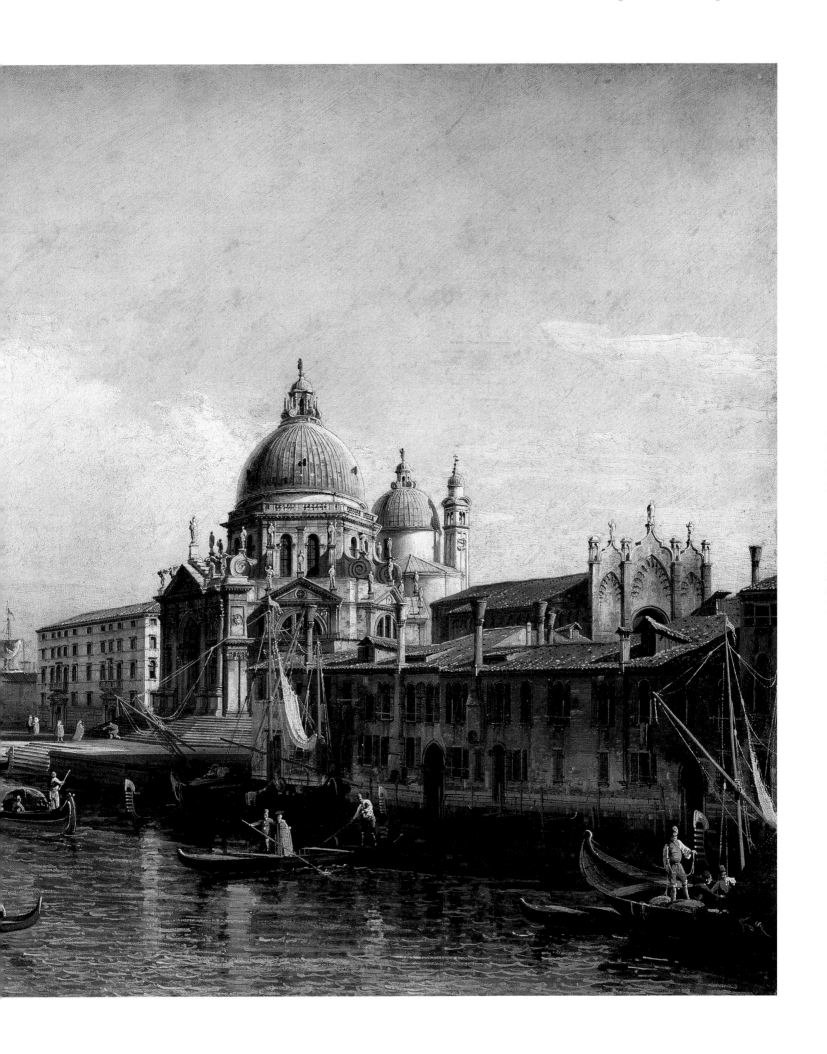

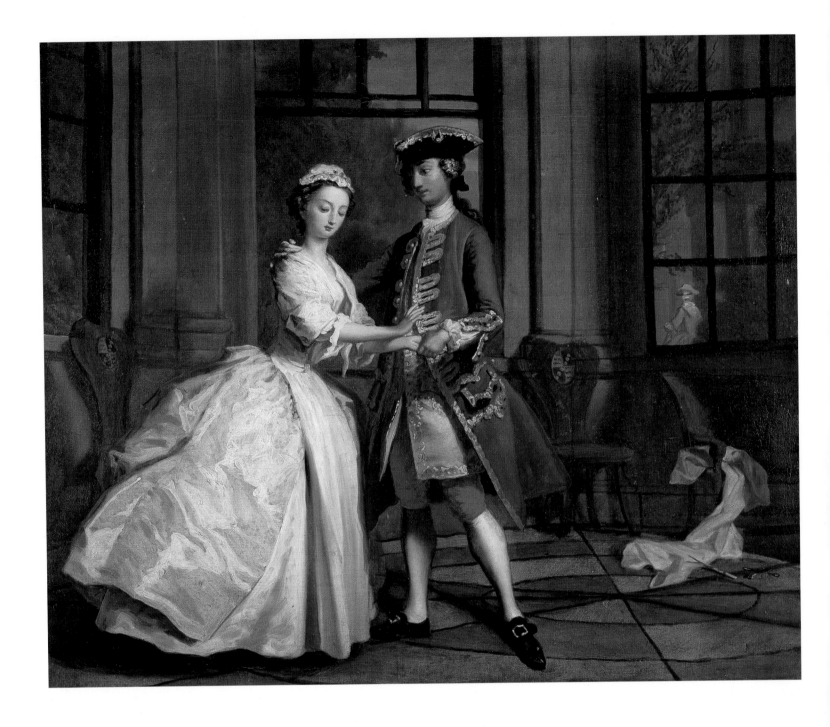

Pamela and Mr B. in the Summer-House, c.1744
Joseph Highmore (1692–1780)

This is one in a series of twelve paintings that illustrate scenes from Samuel Richardson's epistolary novel *Pamela; or, Virtue Rewarded* (1740–41). Three further paintings from the series are in the Fitzwilliam; the other eight are divided between Tate Britain and the National Gallery of Victoria, Melbourne. The 'sentimental novel' was the first literary genre that addressed itself to the taste and mores of a prospering middle class, and was enormously successful both in Britain and the Continent. Capitalizing on its popularity, Highmore exhibited ten of the series in his house in London in 1744, and the following year twelve prints after his paintings were published with titles in French and English and descriptions explaining the subject of each scene; a second set appeared in 1762.

The novel recounts, in the form of letters written mostly by a genteel lady's maid, Pamela Andrews, how her mistress's son, 'Mr B', sets out to seduce her, but fails, then reforms and, finally, marries her. Here, the rake reveals himself, and Pamela successfully rebuffs his first attempt on her virtue.

Oil on canvas, 62.9 x 75.6 cm
Bought from the Marlay Fund, 1920
M.Add.6

Heneage Lloyd and his Sister, Lucy, _c_.1748–50
Thomas Gainsborough (1727–1788)

Heneage Lloyd (1742–1776) and his sister Lucy (baptised 1740) were the children of Sir Richard Savage Lloyd of Hintlesham Hall, Suffolk. Heneage became a Captain in the Coldstream Guards; Lucy first eloped with a neighbouring baronet, Sir John Barker, and after his death in 1766 married James Hamilton, an equerry to the Duke of York, by whom she had two children. Suffolk-born, Gainsborough had moved from London back to Sudbury around 1748, but by 1750 he had settled in Ipswich. On grounds of style, and the apparent age of the sitters, this portrait can be dated to the early years of his residence in Suffolk. In it, he explores with great delicacy and charm a form of landscape painting with small figures that was popularized in London by Francis Hayman (1708–1776). The relationship of small, full-scale figures and decorative landscape was ultimately inspired by French Rococo painters, and in particular by engravings after the compositions of Antoine Watteau.

Oil on canvas, 64.1 x 81 cm
Given by Charles Fairfax Murray, 1911
710

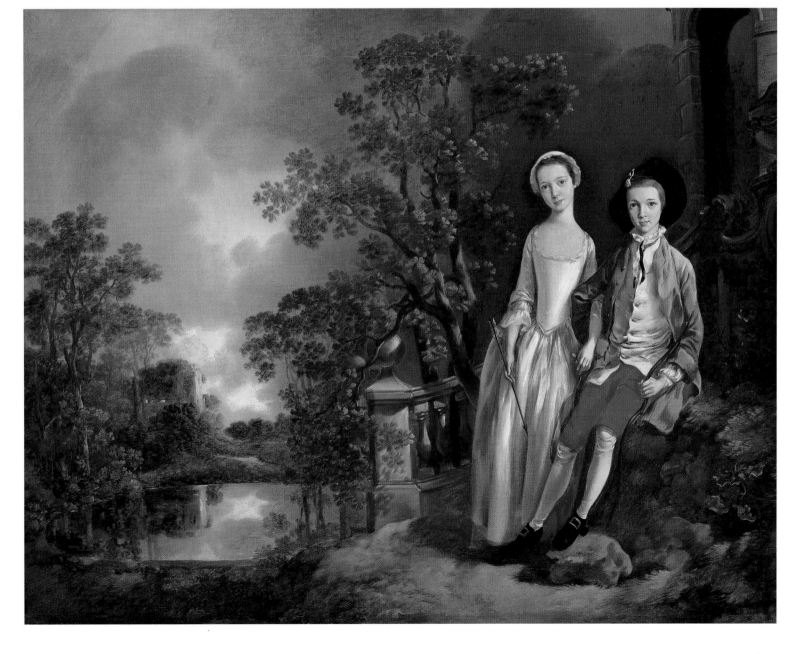

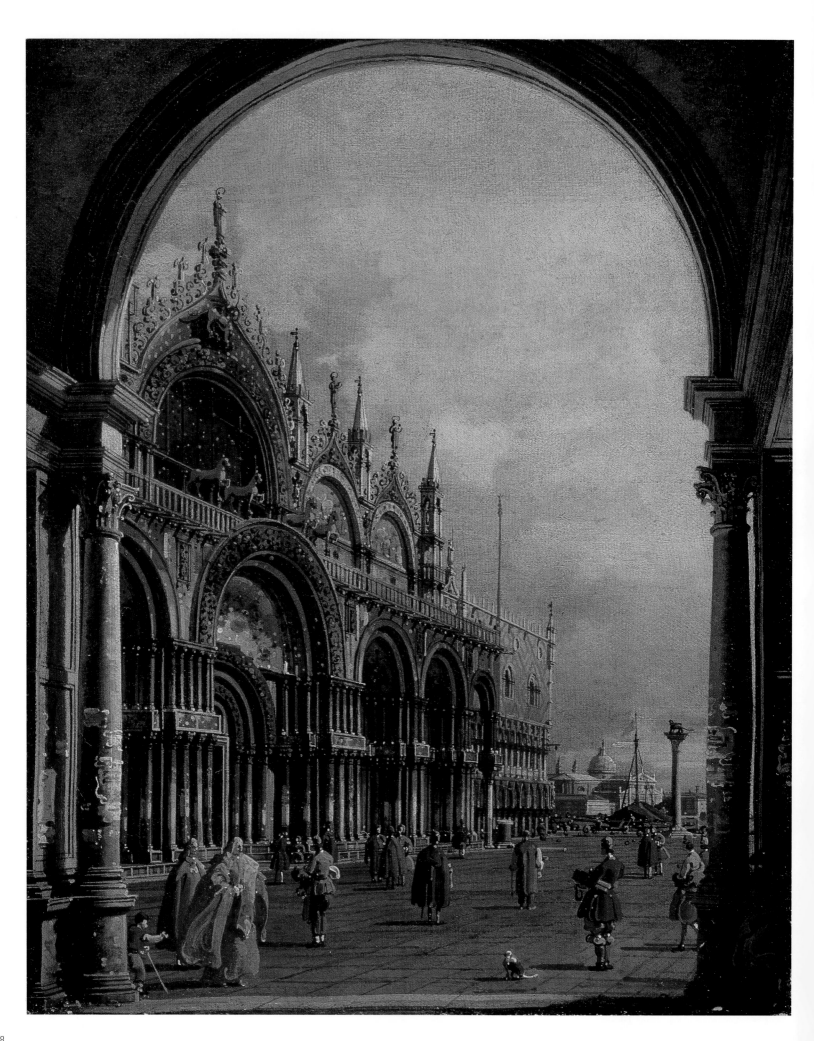

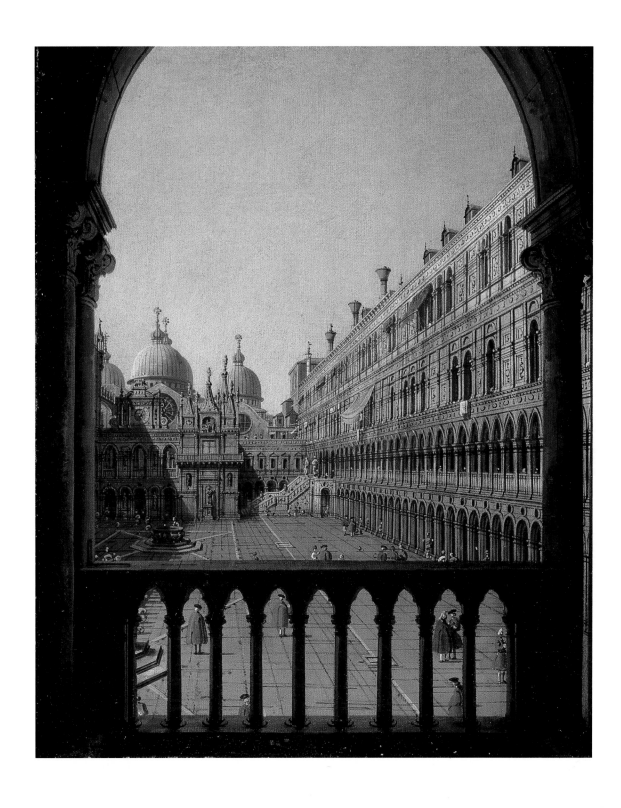

Left: *St Mark's, Venice*, c.1756
Above: *Interior Court of the Doge's Palace*, c.1756
Giovanni Antonio Canaletto (1697–1768)

Left:
Oil on canvas, 46.6 x 38.1 cm
Founder's Bequest, 1816
193

Above:
Oil on canvas, 46.6 x 37.5 cm
Founder's Bequest, 1816
194

These two little views of Venice are pendants, intended to complement one another. Each of them shows one of the most famous buildings in Venice from a rather unexpected viewpoint, through an archway. The front facade of St Mark's and a part of the exterior of the Doge's Palace are painted at an angle that leads the eye onward towards a view of the Church of S. Giorgio Maggiore and the column with the Lion of St Mark, the symbol of Venice. The interior court of the Doge's Palace is seen from a balcony in the upper gallery. One looks down towards Rizzo's Scala dei Giganti, crowned by Jacopo Sansovino's sculptures of Mars and Neptune and then up to the domes of St Mark's. Both paintings exemplify Canaletto's skill at perspective. His application of white highlights to the figures, which enliven both paintings, invites the eye to pause as it absorbs the scene. The unusual composition of each vista shows Canaletto's constant ability, even at so late a stage in his career, to find a fresh way of looking at a well-known subject.

Charles Compton, 7th Earl of Northampton, c.1758
Pompeo Batoni (1708–1787)

Charles Compton (1737–1763) succeeded his uncle George as 7th Earl of Northampton in December 1758, while still in Italy. Lady Mary Wortley Montagu (1689–1762), who met him during his stay, described him as 'lively and good natur'd, with (what is called) a pretty Figure'. By September 1759 Northampton was back in England, and married a daughter of the 4th Earl of Bedford. He was subsequently appointed Ambassador Extraordinary and Plenipotentiary to Venice (1761–3), and became a close friend of the young George III. He died in Italy of consumption in 1763, aged 26. By the time Batoni painted Northampton's portrait, he was on the threshold of becoming the most celebrated painter in Italy, and was especially favoured as a portraitist by foreign visitors on the Grand Tour. Typically for Batoni, the sitter is depicted full-length. Northampton, wearing a lynx-lined coat, stylishly tied at the collar, leans on books, designating him as a man of intellect, while embracing a greyhound, a symbol of fidelity that also alludes to the sitter's humanity. Despite Batoni's considerable fame (he also worked as a painter of religious and mythological subjects), his portrait prices were significantly lower than his London competitors during the 1750s and 1760s.

A Coastal Mediterranean Landscape with a Dutch Merchantman in a Bay, 1769
Joseph Vernet (1714–1789)

Vernet was among the most successful French painters of the eighteenth century. His landscape and marine paintings were highly prized by collectors throughout Europe, so that, by the 1760s, 'Immortal Vernet' was being compared by some critics to the legendary painters of antiquity, as well as to the great masters of the Italian Renaissance. He spent almost 30 years in Italy, moving to Paris in the early 1760s. Scenes of storms – and calms – at sea were his stock-in-trade, and he often painted them in sets of two or four, representing different times of the day. His paintings were especially valued for their high degree of realism. Vernet paid extraordinary attention to rendering light and atmospheric effects, which he claimed to have studied every day of his life. His groups of colourful and animated figures often add a particularly realistic note to his scenes; as one contemporary wrote, it was often possible to recognize their profession, nationality, and in some cases even their home town!

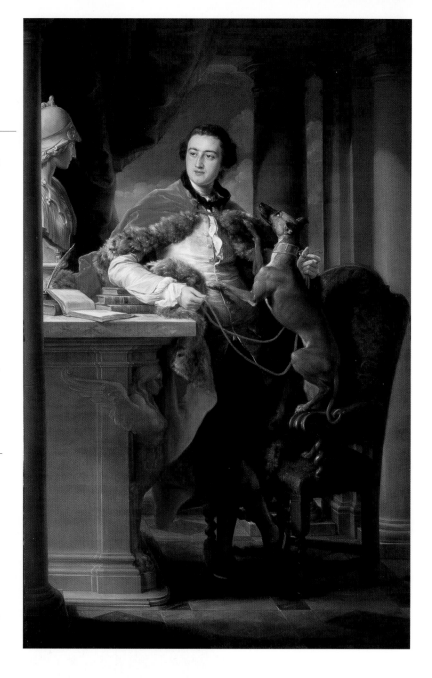

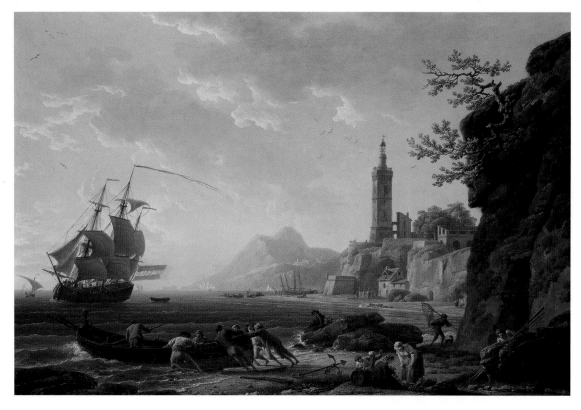

Above:
Oil on canvas, 237.7 x 149.2 cm
Bought from the Spencer George
Perceval Fund, 1950
PD.4-1950

Left:
Oil on canvas, 87 x 130 cm
Bequeathed by Dr D. M. McDonald, with a life interest to his wife, relinquished 1996
PD.23-1997

See enlarged detail on pages 8–9

Gimcrack, with John Pratt up, on Newmarket Heath, 1765
George Stubbs (1724–1806)

Gimcrack was one of the most famous racehorses in England in the second half of the eighteenth century. At just over fourteen hands, he was an unusually small colt, but with a spirit so indomitable that, in an eleven-year career, he won 28 of his 36 races. His pluckiness made him a favourite with race-goers, one of whom, Lady Sarah Bunbury, proclaimed him to be 'the sweetest little horse … that ever was'. Gimcrack made his debut at Newmarket in April 1765, where he won his first race carrying the colours of William Wildman, a Smithfield meat salesman. This painting may have been commissioned to celebrate that victory; it is not dated, but must have been painted during 1765, as an engraving after it was published early the following year. With the simplest of means, and in a highly restrained composition, Stubbs creates an image of extraordinary poise, which commemorates in perpetuity horse, rider and the place of their greatest triumph. He combines an intimate knowledge of equine anatomy with an extreme sensitivity to the landscape to create one of the masterpieces of British sporting art.

Oil on canvas, 100.3 x 127 cm
Bought from the Abbott, Fairhaven, Gow, Jones, Perceval, Webb and University Purchase Funds after a public appeal through the Friends of the Fitzwilliam Museum with subscriptions led by their Majesties the Queen and Queen Elizabeth, the Queen Mother and contributions from the National Heritage Memorial Fund, the Victoria & Albert Museum Grant-in-Aid, the National Art Collections Fund, the Pilgrim Trust and the British Sporting Art Trust, through Michael Tollemache, 1982
PD.7-1982

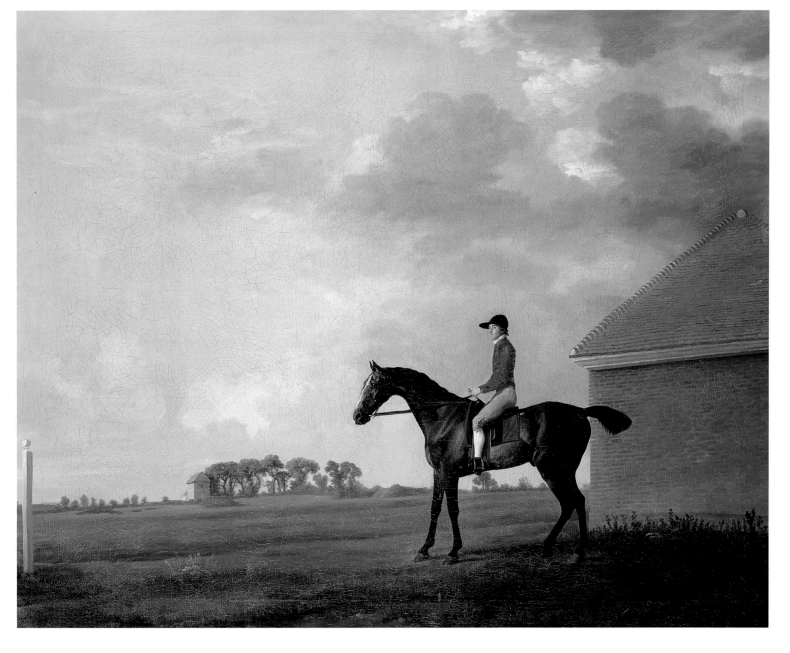

Study of a Building with a Vine on a Trellis to the Right, c.1759
Giovanni Battista Tiepolo (1696–1770)

The heat of the sun is apparent in the strong contrasts between light and dark on the walls of this building. It may be a convent in the Veneto. Tiepolo, who was one of the most brilliant of draughtsmen, has drawn this from below. A few strokes of the pen define the building's form, and it is modelled by subtle washes of brown ink; it cannot have taken more than a few moments to encapsulate its image. Tiepolo made several drawings of buildings in the Veneto near and around Udine, when he was working on the decoration of the Oratorio of S. Maria della Purità between August and September 1759. In all of them the sense of summer heat is evident, but none is more modern than this in the quirky angle from which he has chosen his composition.

Pen and brown ink, brown wash over black chalk
on paper, 11 x 31.6 cm
Bequeathed by Charles Haslewood Shannon, 1937
2241

Belladonna Lily, 1761
Georg Dionysius Ehret (1708–1770)

The Amaryllis belladonna is a beautiful bulbous plant from South Africa. Philip Miller, Ehret's brother-in-law, in charge of the Chelsea Physic Garden, describes it in his *Gardener's Dictionary* as having been brought to England from Portugal. The inscription on the drawing refers to Gerard George Clifford (1685–1760), a banker and director of the Dutch East India Company who lived near Haarlem and had a famous garden. The Swedish botanist Charles Linnaeus superintended it and employed the young Ehret to make some drawings for the *Hortus Cliffortianus* (1737), which describes the plants in the garden. This drawing was probably made for Margaret, Duchess of Portland, one of Ehret's principal English patrons. Ehret, the son of a gardener from Heidelberg, first trained as a gardener. He settled in England in 1736 and became the most important botanical draughtsman of his day, working regularly for Sir Hans Sloane (President of the Royal Society), Dr Meade (Royal Physician) and the Duchess of Portland. He is particularly appreciated for his botanical accuracy combined with a lively artistic sensibility.

Watercolour and bodycolour over graphite on vellum, 25.8 x 17.4 cm
Bequeathed by Major the Hon. Henry Rogers Broughton,
2nd Lord Fairhaven, 1973
PD.430-1973

Right:
Callistemon speciosus (Bottle Brush), 1812
Pierre-Joseph Redouté (1759–1840)

The Bottle Brush is native to Australia, New Zealand and Polynesia. Redouté's title, *Metrosyderos Glauca*, was coined to describe the hardness of the heart-wood of a species that numbers about 30 evergreen shrubs, trees and aerial-rooted climbers. Redouté drew this for the Empress Joséphine. In her garden at Malmaison her gardener, Bonpland, grew this plant from seed provided by Captain Baudin. It flowered for the first time in August 1811 and set fruit the same year. The beauty of the flower is almost entirely due to the very numerous, often brilliantly coloured stamens standing free one-half to one inch above the petals. To the right of the main drawing can be seen details: the open flower to show the insertion and disposition of the stamens; the young fruit to show the divisions of the calyx; a petal; a cluster of stamens. Redouté, the most renowned flower painter of his day had the distinction of working for both Marie-Antoinette and Joséphine.

Graphite, watercolour
with gum arabic and
bodycolour on vellum,
46.7 x 30.7 cm
Bequeathed by Major
the Hon. Henry Rogers
Broughton, 2nd Lord
Fairhaven, 1973
PD.122-1973, fol. 34

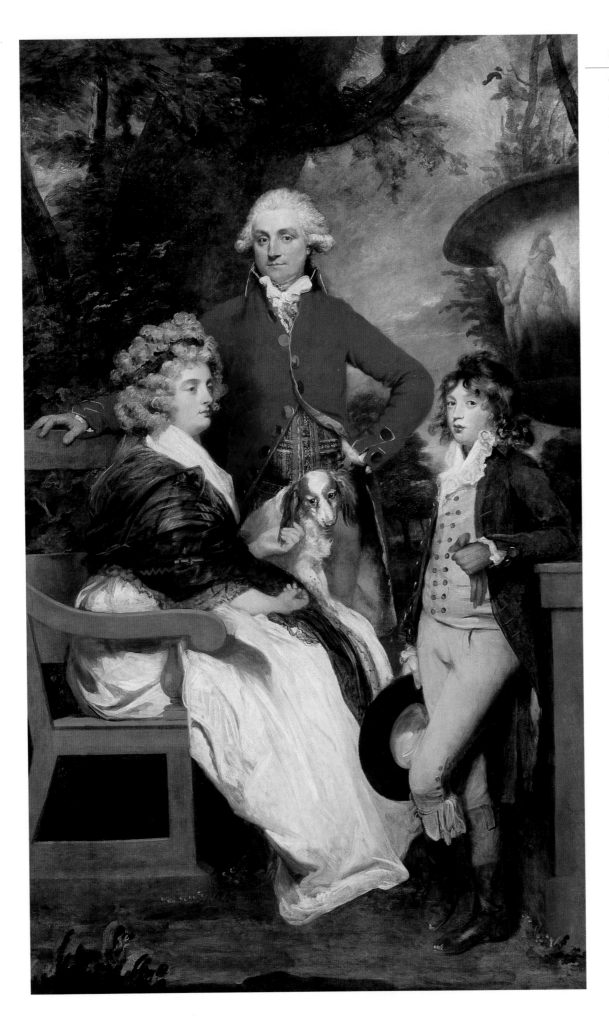

The Braddyll Family, 1789
Sir Joshua Reynolds (1723–1792)

The sitters in this group are Wilson Gale-Braddyll (1756–1818) of Conishead Priory, Lancashire, his wife Jane Gale, whom he married in 1776, and their son Thomas (1776–1862), who became Richmond-Gale-Braddyll, and rose to the rank of Major in the Lancashire Yeomanry. Entries in Reynolds's sitter-book record that the family sat to him eighteen times between the end of March and the end of May 1789. It is among the last pictures Reynolds painted, as in July the same year he was forced to give up painting due to a defect in his eyesight. Reynolds was not only a portraitist of distinction, but, as President of the Royal Academy, dominated artistic life in London in the last decades of the eighteenth century. His popularity as a society portraitist was to a large extent founded on his ability to depict his sitters in an apparently endless range of different poses and styles, a quality which frustrated his rival Thomas Gainsborough – 'Damn him, how various he is!'

Oil on canvas, 238.1 x 147.3 cm
Given by the National Art Collections Fund, from the Ernest Edward Cook collection, 1955
PD.10-1955

Left: **An Indian Prince**, 1788
Right: **An Unknown Frenchman**, 1790
John Smart (1741–1811)

Smart was one of the finest and most popular miniaturists of the eighteenth century, particularly known for his meticulous attention to detail. Unlike Richard Cosway (1742–1821), although equally fashionable, Smart neither attracted much patronage from the royal family nor was he appointed to the Royal Academy. This may be why he went to work in India. He arrived in Madras in 1785 and stayed for ten years. All the miniatures he painted in India include the letter 'I', added to his initials. In India Smart was painter to Muhammad Ali, Nawab of Arcot, and four miniatures of the Nawab are known. *An Indian Prince* is probably a portrait of the Nawab's grandson. Apart from his work for the Nawab, most of Smart's sitters were British officers, resplendent in their glamorous uniforms. The portrait of an anonymous Frenchman from his Indian period is a rare example of a sitter neither British nor Indian. He is identified as French by the cross of the Order of St Louis he wears.

Watercolour on ivory, 5.7 x 4.2 cm
Given by the Friends of the Fitzwilliam Museum, 1948
PD.16-1948

Watercolour on ivory, 5.8 x 4.4 cm
Bequeathed by Angus I. Macnaghton, 1993
PD.1-1993

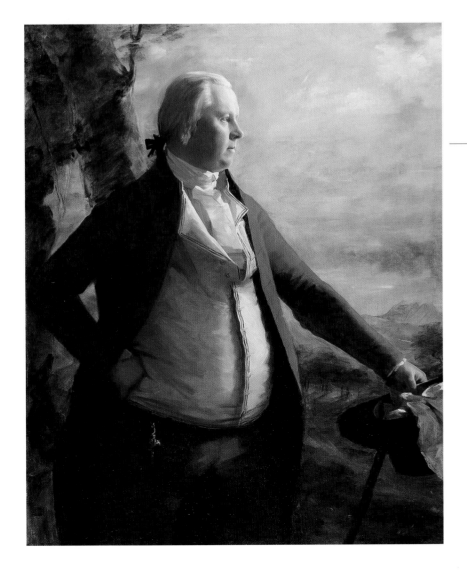

William Glendonwyn, 1790s
Sir Henry Raeburn (1756–1823)

Raeburn was the leading portrait painter in Edinburgh in the late eighteenth and early nineteenth centuries. He worked in a very spontaneous way, applying paint in bold gestures to a relatively coarse canvas, a method that gave his sitters a marked air of vitality. The style and costume of this portrait suggest that it was painted during the 1790s. Around this time Raeburn had become interested in the effects of *contre-jour*, a painterly device of lighting the figure from behind, which brought the sitter's contours and profile into sharp relief. He may also have had in mind the extraordinarily sensitive profile medallions by his compatriot James Tassie (1735–1799), as well as the exquisite pencil portraits in profile by another Edinburgh artist, John Brown (1749–1787), both of which enjoyed considerable contemporary popularity. This wonderfully luminous portrait is one of Raeburn's most accomplished essays in light. The light that dramatically picks out the sitter's girth is applied more softly to the definition of his kindly features, and with great subtlety in the pinpoint of white paint applied to the sitter's right eye.

Little is known of Glendonwyn. His name, the archaic form of Glendinning, is derived from a property in Westerkirk, Dumfriesshire, although his estate at Parton – possibly represented in the sketchy background – lay above the River Dee. He married in 1781; companion portraits of his wife and child are in an American private collection.

Oil on canvas, 124.8 x 101.6 cm
Bought from the University Purchase Fund, 1892
220

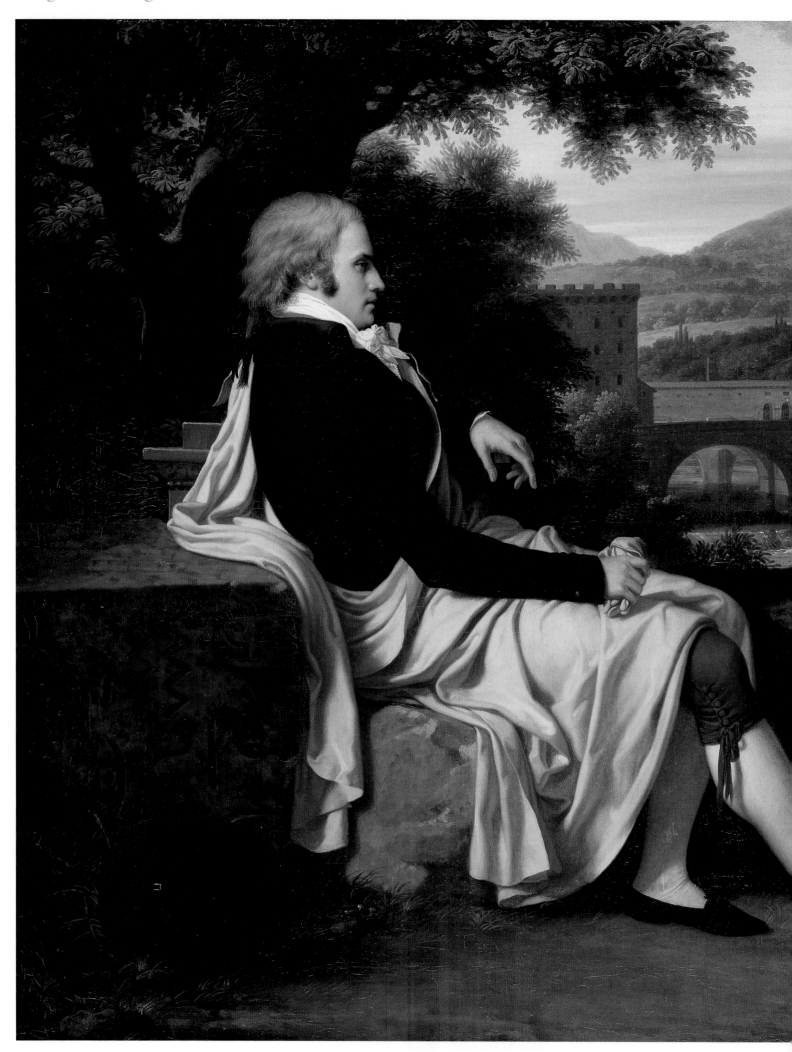

Joseph Allen Smith Contemplating Florence Across the Arno, 1797
François-Xavier, Baron Fabre (1766–1837)

Joseph Allen Smith (1769–1828) was born in South Carolina. In 1793 he travelled to Portugal and Spain, via London, and spent the next fourteen years travelling in Italy, Ireland, France and Russia, where he was welcomed by the Emperor Alexander as the first American to visit the country. He returned to the USA in 1807 and settled in Philadelphia, although he also owned plantations in the South. Smith was a keen collector of antiquities, gems and paintings. Compositionally, this portrait – one of five paintings he commissioned from Fabre while in Italy (1793–6) – is derived from the contemporary portrait of Goethe by Johann Tischbein (1751–1829), now in the Städelschen Institut, Frankfurt, for which Fabre owned a preliminary compositional sketch. Fabre studied under Jacques-Louis David, won the Prix de Rome in 1787, and moved to Florence in 1793. He remained there for much of his life, in part because his monarchist sympathies made it difficult for him to return to Revolutionary France. He worked primarily as a portrait painter of Italian aristocrats and foreign tourists, but also as a teacher and art dealer. In 1824 he returned to his native city of Montpellier, where he founded the museum that since 1828 has borne his name.

Oil on canvas, 70.9 x 90.5 cm
Given by the Friends of the Fitzwilliam Museum in celebration of their 75th anniversary, with the aid of a special gift from the Directors of Hazlitt, Gooden & Fox and contributions from the National Art Collections Fund, the Eugene Cremetti Fund and the Cunliffe, Perceval and University Purchase Funds, 1984
PD.16-1984

William Blake, 1821
John Linnell (1792–1882)

John Linnell met William Blake
(1757–1827) in 1818. He commis-
sioned Blake's *Illustrations to the
Book of Job* and the designs for an
edition of Dante's *Divine Comedy*
and introduced him to new patrons.
This patronage helped to save Blake
from poverty. The portrait has
vitality and immediacy; it gives a
strong sense of Blake's character –
both of his pugnaciousness and his
profound intellect. Linnell, who was
a reluctant miniaturist, painted with
a technique very different from his
contemporaries: rougher and freer,
with bold stippling. He painted a
more finished copy of this miniature
in 1861, which is now in the National
Portrait Gallery. The Fitzwilliam has
a large collection of original works by
Blake, several paintings and drawings
by Linnell, and the John Linnell
archive.

Watercolour on ivory, 13.3 x 10.6 cm
Bequeathed by T. H. Riches, 1935;
received on the death of his widow, 1950
PD.61-1950

Below:
The House of Death, 1795/*c*.1805
William Blake (1757–1827)

After developing idiosyncratic
methods of colour printing for his
illuminated books in the early 1790s,
Blake made a series of twelve large
colour prints. He described these
works as 'fresco', which is probably
more an indication of their ambition
as grand works for public display
than a description of their technique.
The process involved Blake drawing a
design in outline on a piece of thick
millboard; he then painted quickly
over this with thick opaque colours;
this was printed on paper before it
had time to dry, and the resulting
print was reinforced by hand with
pen and ink and watercolour. To
obtain another impression from the
same design he could either print it
again immediately before the colours
had dried, or he could repaint the
colours over the outline. Although
the initial designs were printed in
1795, some of the subsequent
impressions were printed around ten
years later. As many as three
impressions survive of each design:
two other impressions of this design
are in the British Museum and Tate
Britain. The Fitzwilliam print was
probably the last of the three to be
printed, and it introduces several
significant changes to the figures.
The subject is from Milton's *Paradise
Lost*, XI, 477–94, a vision of the
misery that will be inflicted on Man
now that Adam has eaten the for-
bidden fruit. Death hovers above his
'grim Cave' holding the Scroll of Law,
and looking very like the figure of
Urizen, creator of the material world
in Blake's illuminated books.
The 'monstrous crew' afflicted by
'Diseases dire' are attended by the
figure of Despair on the right.

Monotype printed in colours, finished
by hand in pen and ink, watercolour and
chalk on paper, 48 x 60.3 cm
Bequeathed by T. H. Riches, 1935
1769

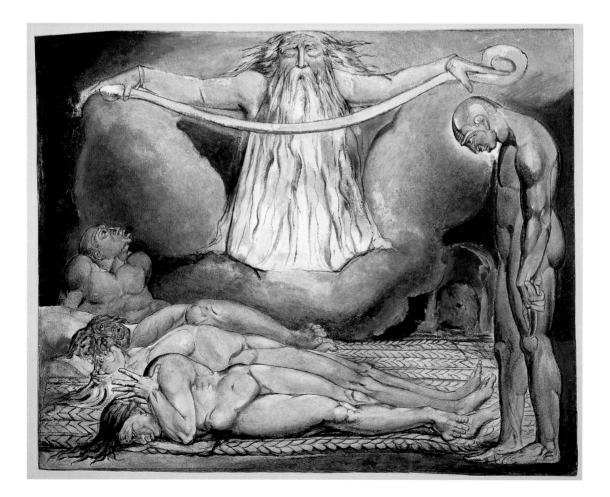

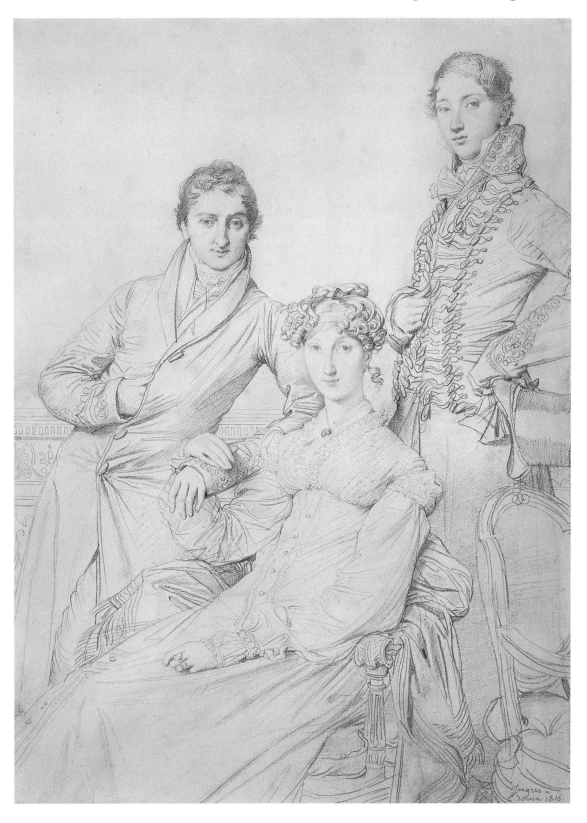

Mr and Mrs Joseph Woodhead and Mr Henry Comber
in Rome, 1816
Jean-Auguste-Dominique Ingres (1780–1867)

An agent for the Royal Navy, Joseph Woodhead (1774–1866) married Harriet Comber (1793–1872) at Sidmouth in October 1815. They travelled on their honeymoon with Mrs Woodhead's brother, Henry George Wandesford(e) Comber (1798–1883). This is one of the 'immeasurable quantity' of portrait drawings of British, French and other sitters that Ingres made in Italy between 1806 and 1820. Like Fabre and Batoni, he made a healthy living from Grand Tourists who wished to preserve the

memory of their visit. Ingres considered drawing to be the 'probity of art', and based his own style on the works of the Italian masters, Raphael in particular. This magnificent pencil drawing, with its intricate details of embroidery, lace and ringlets, is among his finest Roman works.

Graphite on paper, 30.4 x 22.4 cm
Given by the National Art Collections Fund, 1947
PD.52-1947

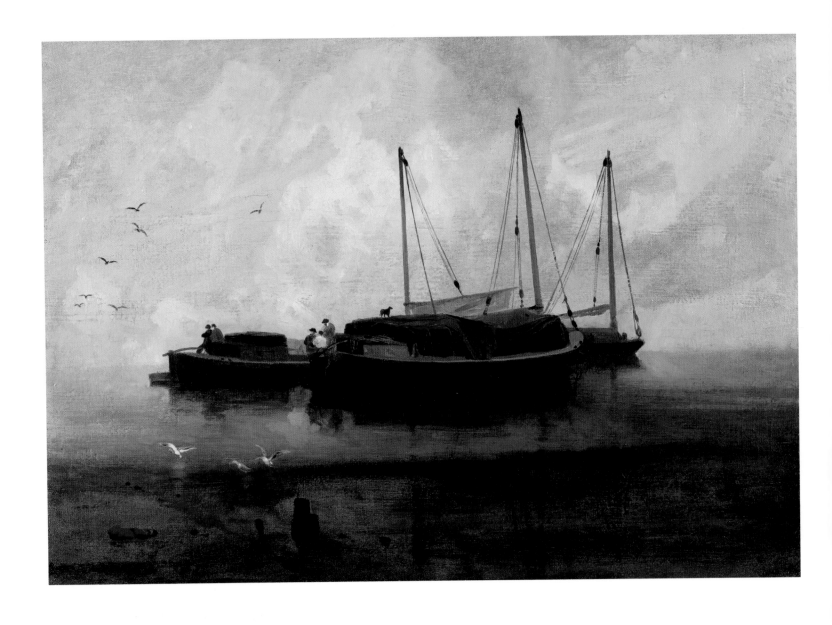

Wherries at Anchor on Breydon Water, *c.*1808–10
John Sell Cotman (1782–1842)

Cotman is better-known as a watercolour painter.
In 1806, however, after returning to Norwich from
London, he took up painting in oils, partly through
disappointment at having been rejected as a member
of the newly formed Society of Painters in Water-
colours. He continued to work in this medium for a
period of around four years; thereafter, his energies
were divided between his work as a printmaker and
drawing-master, and he gave up painting for over a
decade. Despite working in a medium that was at
once more opaque, and less spontaneous, than
watercolour, this painting has a saturated stillness
that is more often associated with his watercolours.
Wherries are shallow draught, single-sail boats
indigenous to the Norfolk Broads, with a tall mast
that allows the sail to catch the breeze above the trees.
Breydon Water, now an important bird sanctuary, is
an inland tidal estuary on Norfolk's east coast.

Oil on canvas, 51 x 73.5 cm
Bought from the Fairhaven and Cunliffe Funds with a
contribution from the National Heritage Memorial Fund, 1988
PD.9-1988

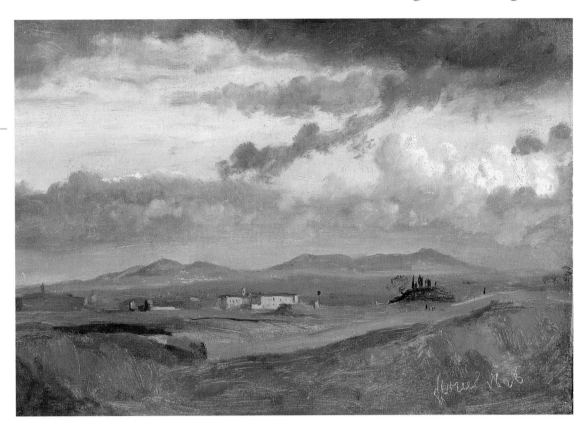

View of the Convent of S. Onofrio on the Janiculum, 1826
Jean-Baptiste-Camille Corot
(1796–1875)

Corot visited Italy for the first time in 1825, and remained there for three years, travelling as far south as Naples. He arrived in Rome in December 1825, and immediately felt as if a veil had been lifted from his eyes, sweeping away any existing artistic preconceptions: 'Here it is something else, I have become a small boy again, naïve, *ingénu*, sincere and modest, and … none the worse for it.' He spent the first weeks of his stay painting views of the city and its monuments. From the beginning of 1826, however, despite the onset of bad weather, he painted increasingly in the country-side around Rome, a landscape that had profoundly inspired his great seventeenth-century predecessors, Nicolas Poussin and Claude Lorrain. This view, from the Vatican hills, shows the convent of S. Onofrio, with Tasso's oak on its right; on the left the tower of the Palazzo Senatorio is visible, with the Alban Hills on the horizon. Corot set down his subject on canvas with a directness of approach that allowed him to preserve what he described as harmonious primitive colouring; as he wrote in his journal: 'whatever is finished at one sitting is fresher, better drawn, and profits from many lucky accidents, while when one re-touches this initial harmonious glow is lost.'

Oil on paper laid down on canvas, 22 x 33 cm
Given by Captain Stanley William Sykes, OBE, MC, 1960
PD.1-1960

The Oak and the Reed, 1816
Achille-Etna Michallon (1796–1822)

Michallon's subject is drawn from one of the fables by the seventeenth-century French author, Jean de La Fontaine. The mighty Oak, bragging of its strength, pities the Reed, which Nature has not empowered to withstand the ferocity of the elements. The Reed, however, demonstrates that it is precisely its supple-ness that allows it to survive the greatest of storms. A strong north wind whips up, and the tree, which attempts to stand firm against the force of the wind, is uprooted and dies, while the reed survives by its very pliability. Michallon, the son of a sculptor who had lodgings in the Louvre, was a precocious talent. He exhibited landscapes at the Salon from the age of sixteen, and in 1817 he was the first artist to be awarded the Prix de Rome for landscape painting. For a short time in 1821–2 he taught Camille Corot, but his early death prevented the fulfilment of his youthful promise. This is one of very few of his finished paintings to have survived.

Oil on canvas, 43.5 x 53.5 cm
Bought from the Gow Fund with contributions from the Museums and Galleries Commission / Victoria & Albert Museum Purchase Grant Fund and the National Art Collections Fund, 1991
PD.180-1991

Wounded Soldiers in a Cart, c.1817–18
Jean-Louis-André-Théodore Géricault (1791–1824)

Géricault made a number of paintings, drawings and lithographs that depict the troops and cavalry of Napoleon's army. This is one of a group of works depicting the miseries of the common soldier on the retreat from Russia during the harsh winter of 1812, a journey that decimated the army. Géricault plays on religious imagery to enhance the pathos of the scene by depicting the man being loaded on to the cart in the pose traditionally used for depictions of Christ being lowered from the Cross. Although the uniforms worn by the soldiers distinguish them as Napoleonic troops, their suffering and despair create a timeless image of compassion and profound humanity.

Oil on paper, laid down on canvas, 33.2 x 31 cm
Bequeathed by Arnold John Hugh Smith, through the
National Art Collections Fund, 1964
PD.10-1964

Comical Discovery, c.1825–8
Francisco de Goya y Lucientes (1746–1828)

The inscription below the drawing gives a clue to its purpose. A curtain has been drawn back to the right, revealing a pit in the shape of a human heart in which can be seen a mass of caricatured human faces; a 'comical discovery' indeed. The grimacing heads have been variously interpreted. Are they victims of the guillotine? Is this life after death? We do not know, but, as always with Goya, the image is potent, and once seen never forgotten. Late in his life, in exile in Bordeaux, Goya began work on what he described as a set of '*new* capriccios', which he probably intended to produce as etchings. The drawings he made in preparation for these were originally kept in two albums, but they have been separated and are now in collections around the world. The Fitzwilliam owns three of them.

Black crayon on paper, 19.3 x 15 cm
Bequeathed by Charles Haslewood Shannon, RA, 1937
2066

Odalisque Reclining on a Divan, late 1820s
Eugène Delacroix (1798–1863)

Paintings on orientalist themes were popular in nineteenth-century France, and Delacroix was among the artists most captivated by the exotic allure of the East. In 1832 he made a trip to North Africa in the suite of the Duc de Morny, and drew on the imagery he found there for the rest of his career.

This painting probably dates from the time Delacroix completed his monumental painting *The Death of Sardanapalus* (1828), now in the Louvre. It shares with the *Sardanapalus* a mood of sensual abandon, heightened by its intimate scale and remarkable freedom of handling. Pentimenti (re-workings of the paint) suggest that the woman

was originally depicted with her left arm across her torso before being given this less constrained final pose. Its first owner was Amable Paul Coutan (1792–1837), an artist and early patron of Delacroix, who bought several of his works during the 1820s. Delacroix appears to have bought back the painting at Coutan's sale in 1830 and kept it until his death.

Oil on canvas, 36.5 x 45.3 cm
Bequeathed by Percy Moore Turner, 1950 with a life interest to his wife; received 1957
PD.3-1957

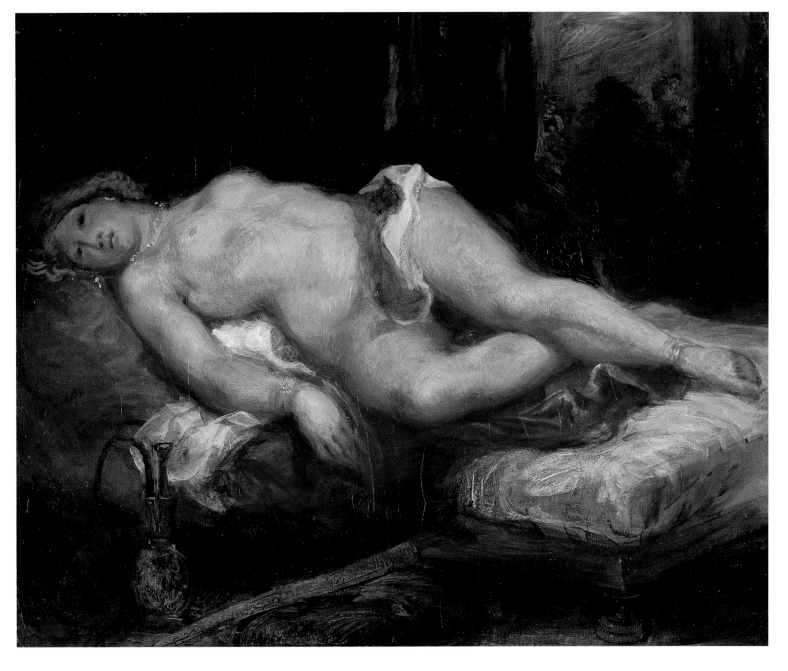

John Keats, 1818 or 1819
Joseph Severn (1793–1879)

This miniature of the Romantic poet John Keats was painted as a token of the poet's love to be given to Fanny Brawne. It is framed with a lock of Keats's hair. Unfortunately Fanny Brawne did not respond to Keats's passion. Keats moved to Rome in 1820 in the vain hope of curing his consumption, and Severn accompanied him. Keats died in Severn's arms on 23 February 1821. The Fitzwilliam owns a manuscript of Keats's *Ode to a Nightingale* (see page 238), written at Hampstead at a time when Keats and Brawne were friends and neighbours. A later version of this miniature, painted in oils, is in the National Portrait Gallery.

Watercolour on ivory, 10.8 x 8.3 cm
Bequeathed, through his Trustees, by
The Rt Hon. Sir Charles W. Dilke, 1911
713

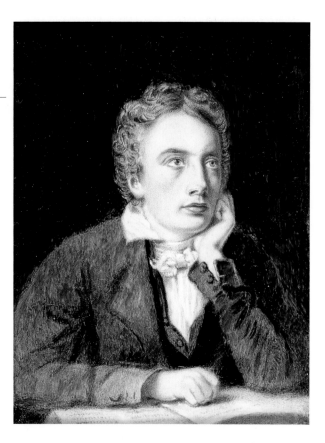

Below:
Venice, Calm at Sunrise, 1840
J.M.W. Turner (1775–1851)

Turner visited Venice on at least three occasions, in 1819, 1833 and 1840. This superb watercolour perfectly, and apparently effortlessly, captures the limpid atmosphere of *la Serenissima* at dawn. S. Giorgio and its distinctive campanile – which Turner could have seen from his hotel – can be distinguished on the left. During his two-week stay Turner made 180 summary sketches of the city in 'roll' sketchbooks, often returning to views and subjects he had drawn on earlier visits. This is one of a group of 25 drawings and watercolours presented to the University of Cambridge in 1861 by John Ruskin, Turner's most fervent champion and critic, with the intention that it should 'illustrate Turner's modes of work at various periods of his life'. Ruskin was keenly aware of Turner's affection for the city: 'Venice … was the joy of his heart, no less than his great teacher', he wrote; 'The Alps brought him always sadness, but Venice delight.'

Watercolour over black chalk with pen
and red ink on paper, 22.2 x 32.5 cm
Given by John Ruskin, 1861
591

The Magic Apple Tree, *c.*1830
Samuel Palmer (1805–1881)

This extraordinary watercolour is among Palmer's most intense and visionary works, and represents one of the highpoints of British Romantic art. It was painted midway through Palmer's stay in Shoreham, Kent (1826–35), a village 20 miles south-east of London. He was joined there by a group of artist-friends, the 'Ancients', who adopted as their watch-words 'poetry and sentiment'. Palmer's decorative detail reflects the influence of fifteenth-century printmakers, in particular Albrecht Dürer and Lucas van Leyden, whose work he much admired. As his son, A. H. Palmer, later pointed out, the scene, although based on direct observation, also combined classical references to Ceres, goddess of Agriculture, and Pomona, goddess of Fruits, with an evocation of the concluding verses of the 65th Psalm. The pastoral mood induced by the flock of sheep and pipe-playing shepherd was no doubt a product of Palmer's own knowledge of classical poetry, but also suggests the influence of *The Pastorals of Virgil* (1821), wood engravings by William Blake, whom Palmer first met around 1824. The source of Palmer's title is obscure, but seems likely to have been invented by his son, from whose sale it was acquired in 1928.

Pen and indian ink, watercolour, in places mixed with a gum-like medium on paper, 34.9 x 27.3 cm
Given by A. E. Anderson, in memory of his brother Frank, 1928
1490

The Chūshingura Drama Parodied by Famous Beauties: Act Two, *c.*1795
Kitagawa Utamaro (*c.*1756–1806)

This print is part of an album containing the only known complete example of this set of eleven prints, designed by Utamaro at the height of his powers and published by Ōmiya Gonkurō. The album formerly belonged to Edmond de Goncourt (1822–1896), who, in 1891, published the first book in the West on Utamaro, promoting his reputation in the Paris art world and romanticizing the lives of the courtesans, which were already glamorized beyond reality in Utamaro's prints. Goncourt's manuscript note states that he bought the album in 1885 from Tademasa Hayashi for 175 francs as a work of the greatest rarity. Hayashi was the leading Japanese dealer in Paris, and the source of many of the prints that influenced, and were collected by, the leading artists associated with Impressionism.

Kanadehon Chūshingura ('Treasury of the forty-seven loyal retainers') was the most famous of *kabuki* revenge plays and frequently appeared as a subject in prints. With playfulness typical of the *ukiyo-e* ('floating-world') culture of the Edo period, Utamaro represents the plotting and skirmishes of the warriors in the play by showing scenes in the lives of celebrated contemporary beauties who are named on each print. In this print, Oseya, a waitress from the Hiranoya teahouse, is shown cutting a spray of Japonica to arrange in the vase on the veranda, watched by the geisha Tomimoto Itsutomi. This parodies the 'Cutting down the pine tree' scene in which the loyal retainer Honzō hacks off a pine branch with his sword to demonstrate to his master the manner in which they should deal with the villain Moronao. This kind of visual metaphor, or *mitate*, often bringing a story fashionably up-to-date, was also manifest in the punning allusions of contemporary literature, such as *haiku* poetry.

Colour print from woodblocks on paper, 38.6 x 26.1 cm
Given by the Friends of the Fitzwilliam Museum, 1945
P.349-1945

Bando Mitsugorō IV as Sekibei and Onoe Kikugorō III as Somezome in the play 'Snow and Love Piled Up at the Seki-no-to Barrier Gate', *c.*1832
Utagawa Kunisada (1786–1864)

This is an example of the type of privately published print known as *surimono*, which employed thick, expensive paper and a variety of special printing effects not normally found on commercially published prints. *Surimono* were usually commissioned by individuals to mark special occasions or by poets whose allusive comic verse (*kyōka*) was woven into the form and content of the print. Kunisada designed several hundred *surimono* between the late 1810s and the mid-1830s, when an economic crisis brought a halt to such luxuries. Most of his designs depicted actors of the *kabuki* theatre and were produced in association with specific productions.

This scene is from a dance drama set at the barrier gate at the pass on Mount Osaka sometime in the ninth century, as performed at the Ichimura Theatre, Edo (the city now called Tokyo), in 1832. Sekibei, posing as a guardian of the barrier, is none other than the villainous Ōmoto no Kuronushi, who secretly plans to overtake the country. He gets drunk and deduces from the stars reflected in his drinking bowl that he will overthrow the emperor if he performs a ritual using burnt wood from the nearby giant black cherry tree. But when he tries to chop it down, he is halted by the appearance of the spirit of the tree in the guise of the beautiful courtesan Somezome (her name means 'dyed-black', like the tree). After a series of spectacular transformations, Somezome is victorious. The two poems on the print allude to the barrier gate. The second of these, by Shōeitei Tsukiyoshi, makes reference to the appearance of the actor Onoe Kikugorō playing the spirit of the tree: 'The ice of the mountains has melted and / Onoe lingers like haze. / He blooms like flowers at the barrier gate.'

Colour print from woodblocks, with metallic pigments, blind embossing and burnishing, printed on 2 sheets of paper, combined vertically, 41 x 18.2 cm
Given by E. Evelyn Barron, 1937
P.508-1937

Eight Sheraji or Lahore Pigeons and a Pigeon-cote on a Hill
Mughal School, early 18th century

The birds have been identified as Lahore or Sheraji pigeons. Many Indian miniatures concentrate on animals or birds rather than people, a tradition passed on from a Persian prototype. This is a particularly charming and peaceful scene. The scale of the pigeons is clearly out of proportion to the trees in the background. The pigeon-cote is in the form of a tent. The donors of this miniature gave an important group of Indian and Persian miniatures to the Fitzwilliam Museum as well as fine examples to both the British and the Victoria & Albert Museums. Their collection, which was made from the beginning of the twentieth century until Mr Manuk's death in 1946, remains the nucleus of the Indian and Persian miniatures in the museum.

Bodycolour and gold on paper, 21.2 x 13.2 cm
Bequeathed by P. C. Manuk and Miss G. M. Coles through the National Art Collections Fund, 1946; received 1948
PD.179-1948

Right
Rama Reclining against Sita, while his Brother, Lakshmana, Draws a Thorn from his Foot, c.1845
Kangra School, mid-19th century

Kangra is a large state in the Punjab hills. Stylistically the Kangra school is distinguished by its attention to decorative detail, delicacy of line and brilliance of colour. In this work Rama's wife, Sita, supports her husband, reclining on a grassy bank by a stream, and fans him, while his brother, Lakshmana, extracts a thorn from the sole of his foot. They are all wearing skirts and hats made of leaves. Alongside them is a dead deer, trussed by the feet, with a wound in its side, caused by an arrow. To either side of Rama and Lakshmana are their weapons, sheathed swords, and a bow with a quiver full of arrows, for each. The scene is taken from one of the two great Indian epics, the Ramayana, which features more regularly in the visual arts than the Mahabharata. The Ramayana is the story of Rama, the eighth incarnation of the Hindu God, Vishnu, who destroyed Ravana, the demonic king of Lanka.

Bodycolour on paper, 21.4 x 15 cm
Bequeathed by P. C. Manuk and Miss G. M. Coles, through the National Art Collections Fund, 1946; received 1948
PD.115-1948

***View of a Norwegian Lake Before the Sun
has Dissipated the Early Morning Mist***, 1833
Francis Danby (1793–1861)

Danby was Irish by birth, but is best remembered as the leading exponent of the Bristol school of painters. He moved to London in 1813, and from there to Bristol, where he married and settled. From around 1824, however, his career was itinerant, and he lived for periods in London, Paris, Switzerland, Norway and Exmouth, in Devon. Danby's views of Norway are among the rarest and most beautiful of all his paintings. He first visited Norway in 1825. This view was painted in Geneva, where Danby lived with his mistress and seven children from 1832 to 1836, working part-time as a boat-builder in an attempt to resolve his financial difficulties. Signed and dated 1833, it was probably the painting that Danby sent to the exhibition of contemporary art held at the Musée Rath in 1835; one reviewer considered it to be among the most beautiful paintings in the exhibition, 'so simple and tranquil is its poetry that none of the great masters would disclaim it.'

Oil on canvas, 43.1 x 61.3 cm
Bought from the Bartlett, Fairhaven, Holmes, Jones and University
Purchase Funds with contributions from the National Art Collections Fund
and the Regional Fund administered by the Victoria & Albert Museum
on behalf of the Museums and Galleries Commission, 1990
PD.10-1990

Right:
Young Man Reclining on the Downs, (?)1833–5
Claude-Félix-Théodore d'Aligny (1798–1871)

Aligny studied in Paris and first exhibited at the annual Salon in 1822. Two years later he went to Italy, where he met Camille Corot and Edouard Bertin, and like them became known as an exponent of *peinture claire* ('clear', or high-toned, painting). After his return to Paris in 1827 he continued to work with both painters in the Barbizon region, and later travelled to the Bernese Oberland, Italy and Greece. Aligny was recognized as one of a group of painters who specialized in *paysage historique*, a form of idealized landscape painting ultimately based on the example of Nicolas Poussin and Claude Lorrain. This painting is among Aligny's most informal and relaxed works; stylistically, it seems likely to date from around 1833–5, when Aligny was working in the forest of Fontainebleau.

Oil on paper laid down on canvas, 21.6 x 45.2 cm
Bequeathed by John Tillotson, 1984; received 1985
PD.119-1985

Samuel Woodburn, 1823–4
Sir Thomas Lawrence (1769–1830)

Samuel Woodburn (1786–1853) was a leading art dealer and one of the finest connoisseurs of his day. He is said to have been employed by the Founder of the Museum, Lord Fitzwilliam, to build up his collection, and compiled the inventory of his collection of prints and drawings. Woodburn was largely instrumental in forming Lawrence's superb collection of Old Master drawings, and for selling them in 1835–6 after Lawrence's death, when both the King and the nation declined to buy them, despite the bargain price. Lawrence began to make pastel portraits at the age of ten, and became the leading portrait painter of Regency England. From 1814 he enjoyed the patronage of the Prince Regent, and in 1815 received a knighthood; he became President of the Royal Academy in 1820. Despite this, he was always in debt – due both to his passion for collecting and to his dilatoriness – and when he died all his bequests were void. This portrait is characteristic of Lawrence's ability to combine the 'grand style' of eighteenth-century portraiture – that of Reynolds, especially – with a distinctly nineteenth-century sensibility.

Oil on panel, 109.2 x 83.5 cm
Given by Miss Woodburn, 1865
27

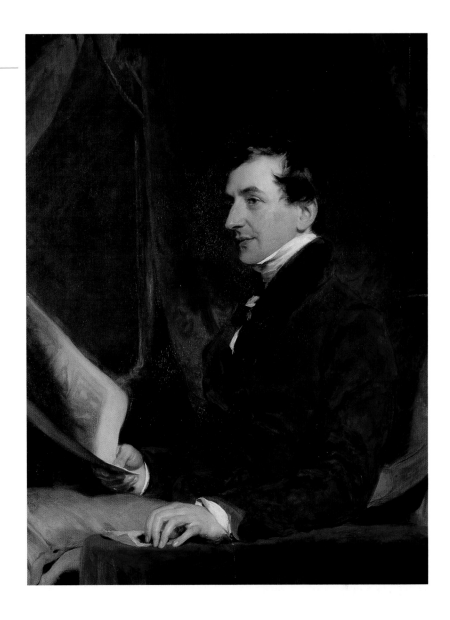

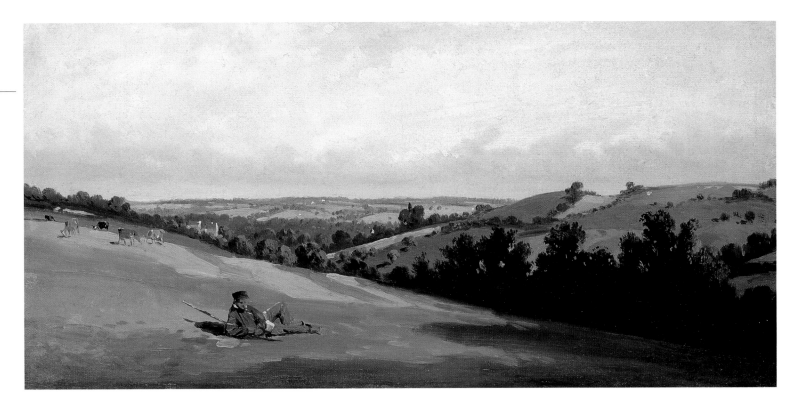

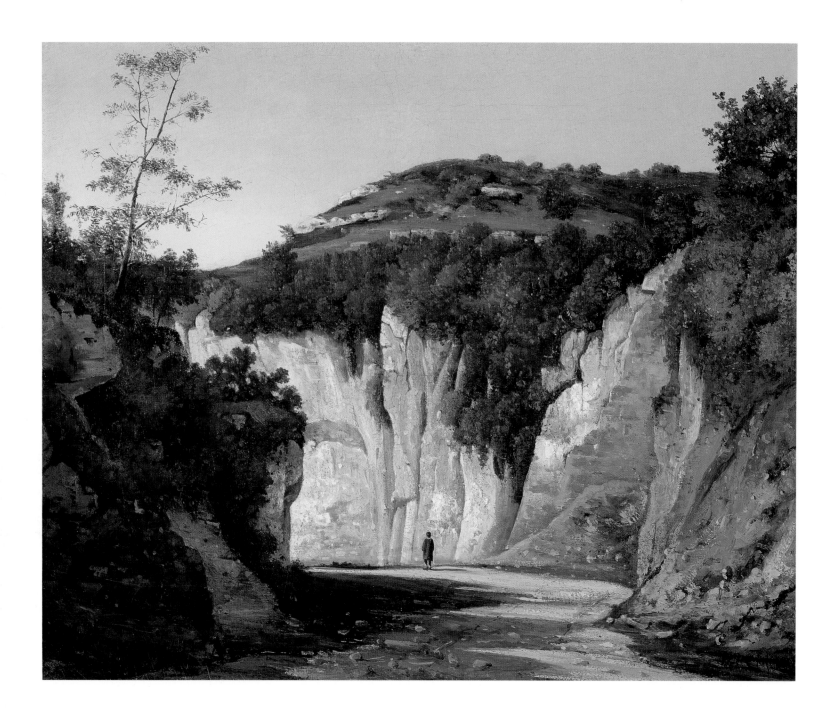

Near Crémieu, 1847
Henri-Joseph Harpignies (1819–1916)

After a relatively late start to his painting career, Harpignies went on to become one of the most successful landscape painters of the second half of the nineteenth century, and he was also a distinguished watercolourist. This painting was executed at a key moment early in his career, when Harpignies worked at Crémieu, near Lyons, in the late summer and autumn of 1847 with his teacher, Jean-Alexis Achard (1807–1884). Prompted by Achard, Harpignies concentrated on painting two separate subjects: one – this painting – a morning scene; the other an evening view, now in the National Gallery of Scotland, Edinburgh. In his journal Harpignies referred to the difficulty he encountered in rendering the 'devil of a little ash' that stands out against the horizon on the left and to his teacher's insistence that he persevere; that his

persistence paid off is clear from the fact that in later life he was dubbed the 'Michelangelo of trees'. In the 1850s Crémieu became a magnet for landscape painters, one of whom (Charles-François Daubigny) described it as, 'a magnificent country. It has an astonishing wildness [and] brings to mind Gaspard [Dughet], Poussin and Salvator [Rosa].'

Oil on canvas, 38 x 46 cm
Bequeathed by John Tillotson, 1984; received 1985
PD.140-1985

Beneath the Trees at Port-Bertaud: Children Dancing, 1862
Gustave Courbet (1819–1877)

In May 1862 Courbet made his first visit to the Saintonge district in western France. He was based at Rochemont, near Saintes, but made frequent visits to Port-Bertaud, where he met a number of artist-friends, including Camille Corot. In November of that year he worked at Port-Bertaud for a short time with Corot, painting landscapes in the Charente valley. The figures in this scene may represent the wife and children of a local portrait painter, Louis-Auguste Auguin (1824–1904); they appear in Corot's painting of the same scene.

Although Courbet had intended to spend only two weeks in the Saintonge area, he remained there for almost a year, enjoying not infrequent raucous drinking binges. Towards the end of Courbet's stay Auguin was in despair: 'our friend saunters about, sleeps, smokes, drinks beer, and does very, very little painting … his apathy pains me … the man is *weakness incarnate.*' In fact, Courbet was relatively productive during his time there, painting over 60 pictures. This one was included at an exhibition at Saintes Town Hall in January 1863 held in aid of the poor.

Oil on canvas, 67 x 52.1 cm
Given by the Very Revd Eric Milner-White, CBE, DSO, Dean of York in memory of his father, Henry Milner-White, Kt, LL.D, MA, of Pembroke College, Cambridge; 1951
PD.28-1951

The Bridesmaid, 1851
John Everett Millais (1829–1896)

Millais was one of the founder members of the Pre-Raphaelite Brotherhood in
1848, which included Dante Gabriel Rossetti and William Holman Hunt. This
painting is one of a number of his paintings on the theme of love (anticipated,
unrequited or fulfilled) and separation. However, its half-figure format is unique
in his work, as is the sitter's leonine mane of hair and her air of enraptured
absorption, although in the following decade Rossetti went on to make something
of a speciality of female figures of this type under the influence of Venetian
Renaissance masters. Hunt, who saw this painting in 1855 with its first owner,
described it as 'very queer … a girl all hair with a wedding-ring.' According to
Millais' own account, the subject represents a bridesmaid who summons up a
vision of her future husband by passing wedding cake through a small ring nine
times; her rapturous state of quasi-trance suggests she is on the verge of gaining a
vision of her beloved. The painting was at one time known as *All Hallow's E'en*
(31 October), a day on which superstitious practices were carried out in order to
predict marriage prospects. The orange-blossom on her corsage symbolizes purity,
fidelity and eternal love.

Below left: **White Cup and Saucer**, 1864
Below right: **White Candlestick**, 1870
Henri Fantin-Latour (1836–1904)

Fantin is chiefly known as a portraitist and painter of flowerpieces. A passionate
music lover – Wagner, Schumann and Brahms were favourites – he also produced
a number of imaginative 'fantasy' pictures based on specific pieces of music.
A remarkably poised composition, *White Cup and Saucer* was probably painted for
Fantin's friends and patrons, Mr and Mrs Edwin Edwards, during a visit to their
house in Sunbury-on-Thames. Fantin made three visits to England at the begin-
ning of the 1860s, and first stayed with the Edwards family in 1861. They acted as
agents for the sale of his work in Britain, and promoted his still-life paintings with
particular success. In a sense, this self-contained image encapsulates the restraint
with which Fantin himself lived: his studio in the rue des Beaux-Arts, on the left
bank of the Seine, was distinctly spartan, coolly lit with walls painted in grey.

 White Candlestick was painted in an extraordinarily eventful year for Fantin,
during which Fantin exhibited at the Salon his large group portrait, *Studio in the
Batignolles* (Musée d'Orsay), painted as a homage to his friend Edouard Manet,
and moved to the rue Bonaparte, sheltering there and at the Hôtel des États-Unis
with his father during the Seige of Paris (September 1870 to March 1871). This
painting was probably acquired by Edwin Edwards during a visit to Paris in March
1871, before the fighting of the Commune broke out, when he bought all that
Fantin had painted there during the Seige. The donor (who was given the work by
Mrs Edwards) is the figure represented in Alma-Tadema's painting *94 Degrees in
the Shade* (opposite).

Oil on panel, 27.9 x 20.3 cm
Given by Thomas Richards Harding, 1889
499*

Left:
Oil on canvas, 19.4 x 28.9 cm
Given by Sir H. F. Herbert Thompson, Bt,
1920
1016

Right:
Oil on canvas, 17.1 x 25.1 cm
Given by Sir H. F. Herbert Thompson, Bt,
1920
1019

94 Degrees in the Shade, 1876
Sir Lawrence Alma-Tadema
(1836–1912)

Dutch by birth, Alma-Tadema moved
to England in 1870. Four years earlier
he had come to London to be oper-
ated on by Sir Henry Thompson, a
specialist in urological complaints,
who also had aspirations as an artist.
Alma-Tadema became Thompson's
teacher and friend, and after he
moved to London their families even
spent vacations together; the
Fitzwilliam owns two portraits of
Thompson and his son, Herbert,
which Alma-Tadema painted on the
doors of a houseboat they shared
during the summer of 1875. Alma-
Tadema established a reputation for
painted scenes that imaginatively
recreated the daily life of ancient
Greece and Rome. Informal scenes
from contemporary life such as this
painting are comparatively rare in his
work. The young man shown lying
prone on the edge of a cornfield is
Herbert Thompson, engrossed more
in the theory than in the practice of
lepidoptery. Painted at Godstone,
Surrey, it depicts the sitter at the age
of 17, not long before he went up to
Cambridge to read law at Trinity
College; he later went on to become
an eminent Egyptologist.

Oil on canvas, laid down on panel,
35.2 x 21.6 cm
Given by Sir H. F. Herbert Thompson, Bt,
1920
1014

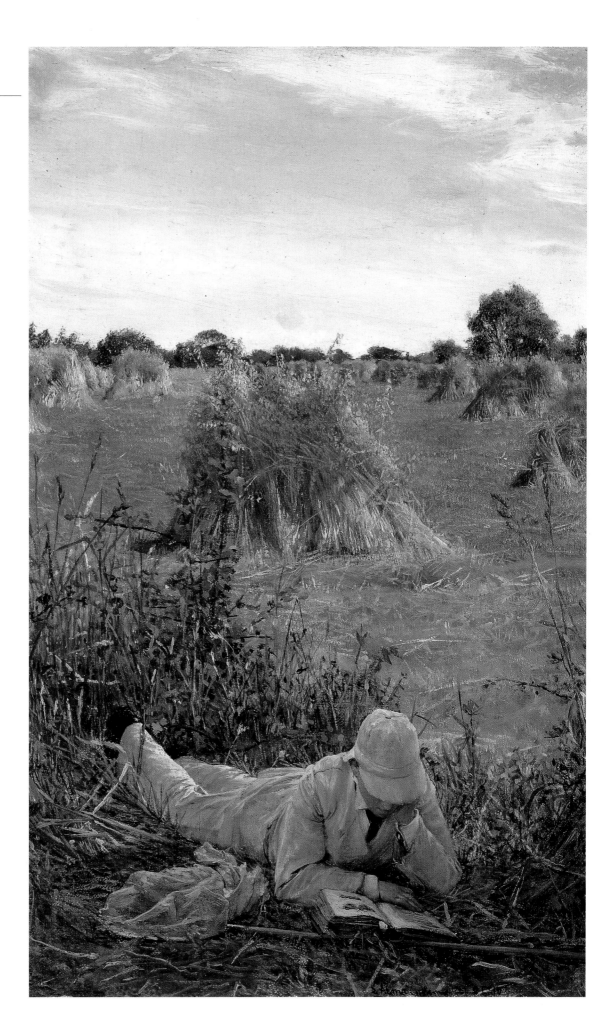

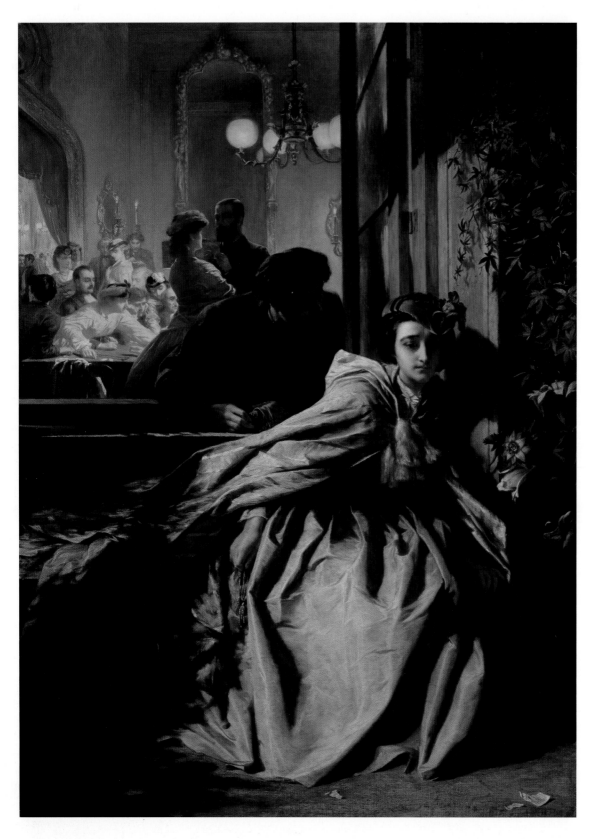

On the Brink, 1865
Alfred Elmore (1815–1881)

Elmore made his reputation as a painter of historical and literary subjects. This was his first painting dealing with a theme from contemporary life, and, more particularly, contemporary mores. A lady who has lost her fortune gambling sits on the brink of certain ruin and possible suicide. The man offers her the means of regaining her fortune at the table, but only at what one contemporary reviewer described as 'a fearful price'. Various elements hint at her dilemma: the hellish glow from the gaslit interior, the dramatic contrasts of light and shade, and the note that lays torn at her feet. The passion flowers on the right symbolize susceptibility; the lilies purity. The reverse of the canvas bears the inscription 'Homburg', suggesting that Elmore's inspiration may have been the Kurhaus Hesse-Nassau, a famous place in Homburg where rich and fashionable tourists flocked to the gambling rooms.

Oil on canvas on wood, 113.7 x 82.7 cm
Given by the Friends of the Fitzwilliam
Museum in memory of Dr A.N.L. Munby
with a contribution from the Victoria &
Albert Museum Grant-In-Aid, 1975
PD.108-1975

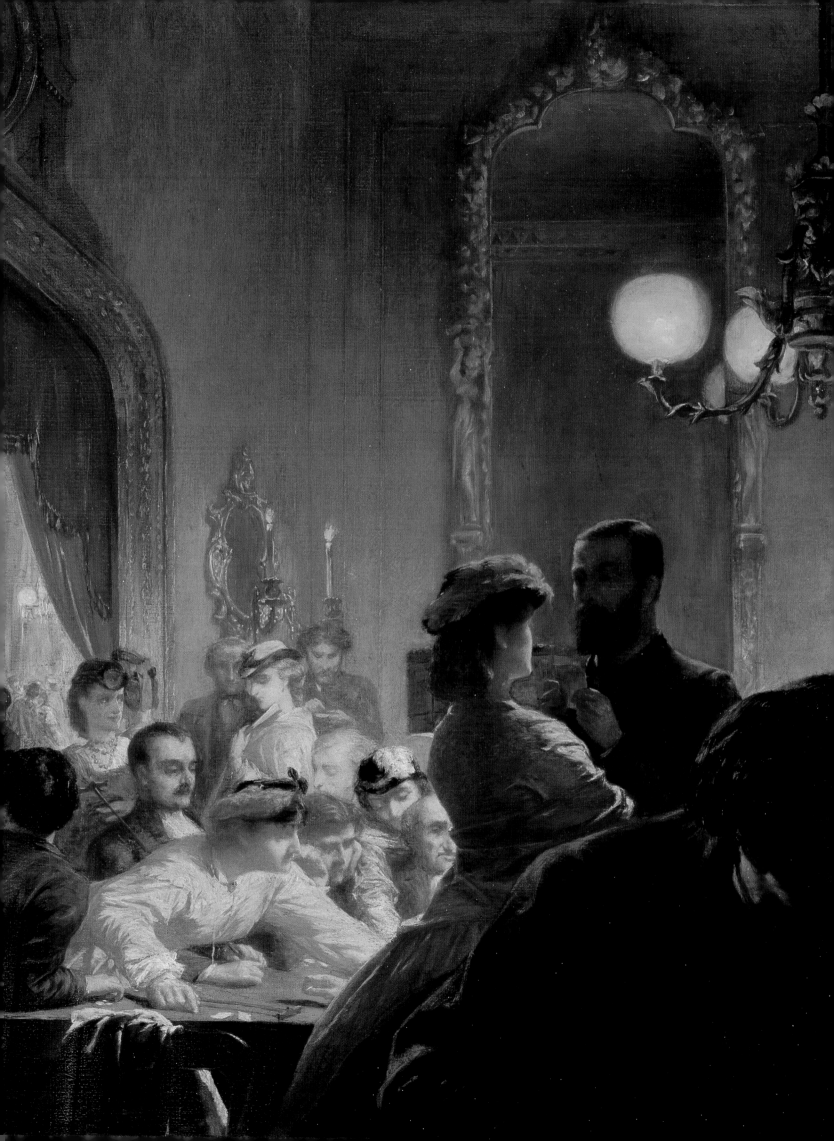

The Flood at Port-Marly, 1876
Alfred Sisley (1839–1899)

Port-Marly lies on the left bank of
the Seine, between Saint-Germain-
en-Laye and Bougival. Sisley painted
there from 1871, when he moved to
nearby Voisins-Louveciennes, and
sent two views of the town to the first
Impressionist exhibition in 1874.
Sisley first recorded the Seine in
flood there in 1872, and returned to
the subject after extensive flooding
occurred in the spring of 1876. This
is one of seven views of the town
under water that he painted in that
year – another of which he exhibited
at the second Impressionist exhibi-
tion in April 1876. The other six all
show the town downstream; this is
the only one of the group to show the
flooding from the opposite direction.

Oil on canvas, 46.1 x 55.9 cm
Given by Captain Stanley William Sykes,
OBE, MC, 1958
PD.69-1958

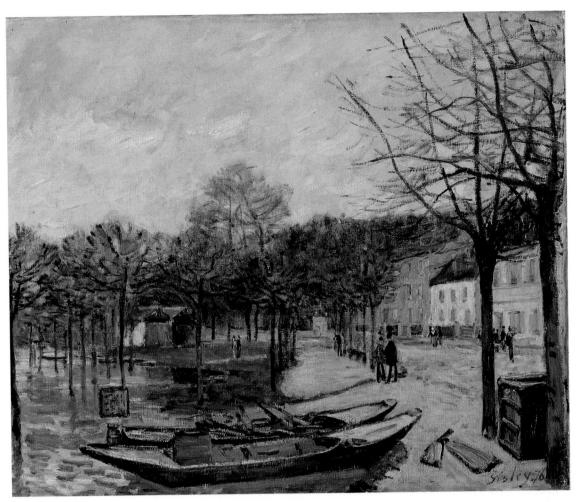

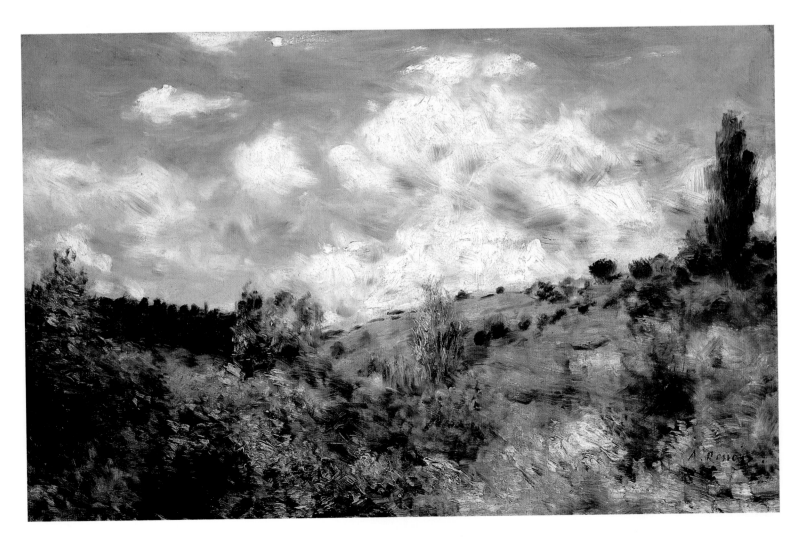

In the Garden at Pontoise: A Young Woman Washing Dishes, 1882
Camille Pissarro (1830–1903)

Pissarro's landscapes are frequently populated by rural figures, which add colour and life to his compositions. At the beginning of the 1880s, however, he began to paint figures on a much larger scale, and continued to work in this vein until the mid-1890s. Many depict women at work, in the fields, at the market, or in domestic surroundings. This scene was painted at Quai de Pothius, Pontoise, where Pissarro was living in 1882 before he moved to Osny at the end of the year. Almost invariably, critics perceived in Pissarro's change of direction an attempt to follow in the genre of rural figure painting initiated by Millet earlier in the century. Pissarro clearly found the comparison both irksome and curious,

claiming that, as 'an old Hebrew', he had no wish to imbue his figures with the religious sentiments of Millet's peasants. It is painted in what has been called Pissarro's 'proto-divisionist' technique, although closer inspection shows that the intermingled flecks of colour are applied with none of the rigour of Neo-Impressionist theory. In fact, after a brief period of experimentation with *pointilliste* technique, Pissarro came to consider that it inhibited artistic expression.

Oil on canvas, 81.9 x 64.8 cm
Bought from the Spencer George Perceval Fund,
with the help of the National Art Collections Fund, 1947
PD.53-1947

Left below:
The Gust of Wind, *c.*1872
Pierre-Auguste Renoir (1841–1919)

Landscape played an important part in Renoir's earliest paintings, but during the 1860s his work became increasingly dominated by the human figure. Towards the end of his life, he described landscape as, 'the painter's stumbling block', although he continued to be stimulated by 'the hand to hand struggle' with nature. This beautiful landscape is thought to represent a hillside near Saint-Cloud, to the west of Paris. However, rather than attempting to represent a specific tract of countryside, Renoir has endeavoured to record that most unpaintable of natural elements: air. Few of his paintings so perfectly echo in visual terms the sensual pleasures of the outdoors. Closer inspection shows that Renoir has reproduced this effect of freshness and spontaneity by using a range of subtle technical devices, blurring the edges of form and alternating the thickness of his paint and brushstrokes, and allowing the beige ground to counter a predominantly cool palette of greens and blues so as to give warmth to the sky. This painting was first exhibited at an auction of works held in Paris in March 1875, which also included works by Monet, Sisley and Berthe Morisot. Financially, the sale was an unmitigated disaster – Renoir achieved the lowest average sum of any of the exhibitors – and provoked extraordinary levels of public hostility. This is one of two paintings bought for 55 francs by the Swiss painter Auguste de Molins (1821–1890).

Oil on canvas, 52 x 82 cm
Bequeathed by Frank Hindley Smith, 1939
2403

Castel Sant' Elmo, from Capodimonte, c.1856
Hilaire-Germain-Edgar Degas (1834–1917)

For much of his life, Degas dismissed the efforts of his Impressionist colleagues to capture the fleeting effects of nature as an entirely empty exercise, and famously remarked that the landscape painters who plagued the countryside in their eagerness to paint before nature should be treated to a round of buckshot by a specially employed police force. Despite this, he painted, drew and made prints of landscapes in a variety of media throughout his career, and they form a discrete, but important group in his work. This luminous painting is one of a small number of landscapes Degas painted early in his career. He sailed to Naples in 1856, to stay with his grandfather and cousins, and from there made expeditions in the surrounding countryside. The view depicts the Castel Sant' Elmo and the adjacent monastery of S. Martino, and may have been painted from Capodimonte, situated on a nearby hill. It relates to a watercolour sketch made in one of the notebooks used during his Italian trip.

Oil on paper, laid down on canvas,
20 x 27 cm
Bought from the Gow Fund with contributions from the National Art Collections Fund and the Museums and Galleries Commission / Victoria & Albert Museum Purchase Fund, 2000
PD.18-2000

At the Café, c.1875–7
Hilaire-Germain-Edgar Degas (1834–1917)

Images of women dominate Degas' work. He is undoubtedly most famous for his depictions of ballet dancers, on stage and off, but he also made many paintings of working women – milliners, laundresses, prostitutes – that offered an entirely new and thoroughly modern vision of contemporary womanhood. This is one of a number of scenes of women in cafés that Degas represented in paintings, drawings and prints in the late 1870s. The two women have sometimes been described as prostitutes, their unchaperoned presence in a public place signalling their availability. However, Degas deliberately avoids any narrative, evoking instead, through the women's gestures and hidden expressions, a general air – or 'impression' – of secret distress, perhaps even despondency. Degas quickly acquired a reputation for producing images that were not open to clear explanation or interpretation; as an evidently frustrated reviewer wrote of his submissions to the third Impressionist exhibition in 1877: 'M. Degas abounds in irritating paradoxes. The idea of disconcerting the *bourgeois* is one of his most constant preoccupations.'

Oil on canvas, 65.7 x 54.6 cm
Bequeathed by Frank Hindley Smith, 1939
2387

Female Dancers in Violet Skirts, their Arms Raised, *c*.1895–8
Hilaire-Germain-Edgar Degas
(1834–1917)

Degas worked in a wide range of media throughout his career, but is especially noted for his extraordinarily inventive use of pastel. He began to use the medium in the 1850s, but evolved his complex and highly personal technique only later in his career, in the 1880s and 1890s. This pastel is one of a series of at least nine large-scale compositions showing dancers in similar poses. In each of the variants, Degas re-worked – and sometimes reversed – the poses of the two central figures, subtly modifying the background, angle of vision and position of the limbs, and in some cases added a third dancer. Although pastel was often used by artists to achieve greater spontaneity and fluency than was possible in oils, Degas's constant re-working of the surface in many of his late pastels meant that individual compositions could take months or, as in this case, years to complete, and the whole take on the thickly woven effect of tapestry.

Pastel and black chalk, perhaps with gouache over charcoal on two sheets of tracing paper joined together, laid down on paper, 90.9 x 52.1 cm
Accepted in lieu of estate duty by H.M. Treasury and allocated to the Fitzwilliam Museum, 1979
PD.2-1979

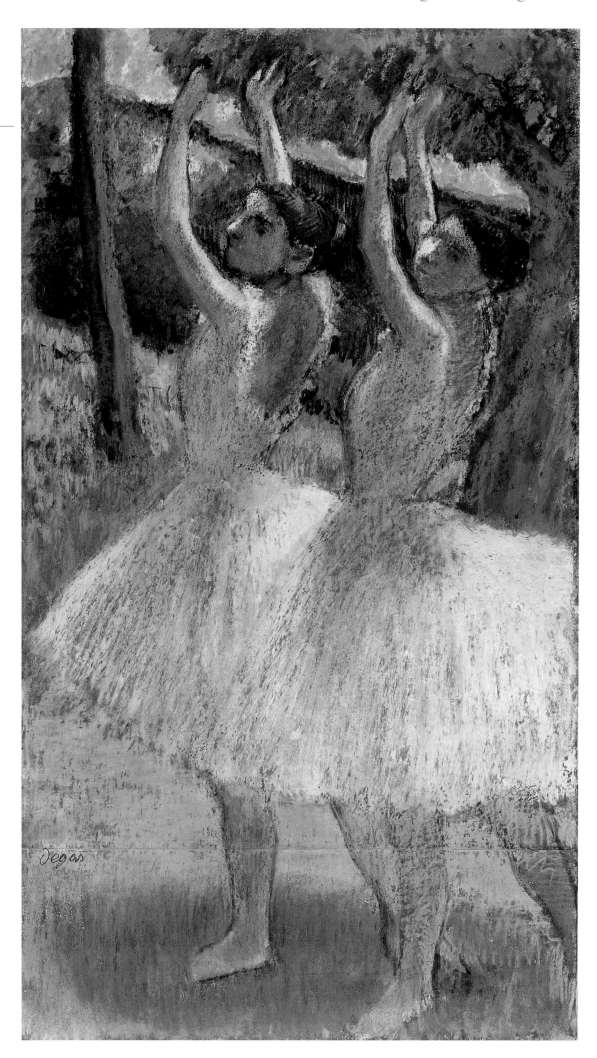

**Rocks at Port-Coton, the Lion Rock,
Belle-Île**, 1886
Claude Monet (1840–1926)

Monet explored the west coast of
Brittany for the first time in the
autumn of 1886. He stayed ten weeks,
based in the hamlet of Kervilahouen,
only 500 metres from the rugged
coastline. This is one of 39 paintings
made that autumn. Initially, Monet
was frustrated by the prolonged bad
weather and unpredictable tides.
However, he also welcomed the
challenge of his new environment –
the 'sinister, tragic' quality of the
Breton landscape. Compositionally,
this painting shows the influence of
Japanese *ukiyo-e* woodblock prints on
Monet's work, in particular certain
prints by Hokusai.

Oil on canvas, 65 x 81 cm
Accepted in lieu of Inheritance Tax by
H.M. Government and allocated to the
Fitzwilliam Museum, 1998
PD.27-1998

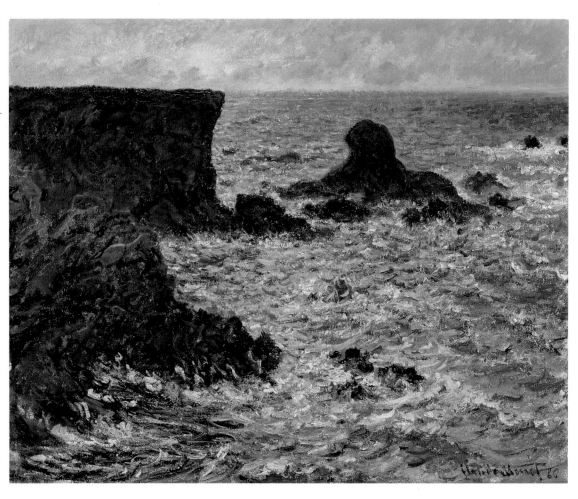

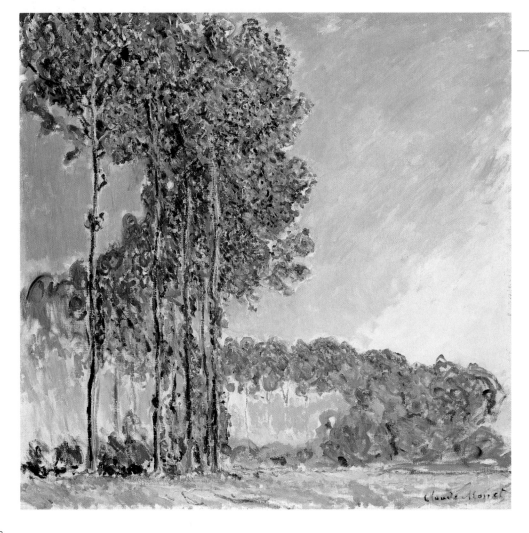

Poplars, 1891
Claude Monet (1840–1926)

Between the spring and autumn of 1891, Monet
painted a series of canvases of poplar trees on the
south bank of the Epte, at the edge of the Limetz
marsh, two kilometres upstream of his home at
Giverny. Working from a rowing-boat that he used
as a floating studio, he represented the poplars
under a variety of weather conditions throughout
the different seasons, concentrating on the sinuous
curves formed by the line of trees. Monet had barely
begun to work on the series when, in June 1891, the
poplars were put up for sale by the village; although
his plea for a stay of execution was turned down by
the mayor, Monet came to a financial arrangement
with the timber merchant, which left the trees stand-
ing long enough for him to finish painting them.
This is one of only two in the series to be seen from
the marsh.

Monet began to exhibit his paintings in series at
the beginning of the 1890s. The critical praise he
received for his exhibited series of grainstacks in
1891 encouraged him to proceed with a second
series representing poplars, which he painted over
the remaining months of the year. By the beginning
of 1892 he had completed 23 canvases, 15 of which
were shown as a discrete series at the beginning of
March 1892.

Oil on canvas, 89 x 92 cm
Bequeathed by Captain Stanley William Sykes, OBE, MC,
1966
PD.9-1966

Children Paddling, Walberswick, 1894
Philip Wilson Steer (1860–1942)

Steer was a key figure among a group of innovative painters known as the 'British Impressionists'. He studied at the Académie Julian and the Ecole des Beaux-Arts in Paris in the early 1880s, and on his return to England became, in 1886, one of the founder members of the New English Art Club, an exhibiting body set up to challenge the conservatism of the Royal Academy. Throughout his career he made regular summer excursions to explore new painting grounds, and in the late 1880s and early 1890s was drawn to the coastal landscapes of northern France, around Étaples, and to the beaches of the Suffolk coast. This painting is among the most captivating of Steer's early beach scenes. It reflects something of the Impressionist interest in capturing the effects of light; however, its apparent spontaneity of execution is deceptive, for the composition was evolved over five years, with the central figure in the red skirt added at a relatively late stage. The critic George Moore, previously opposed to Steer's use of strong, pure colour, was enchanted by this painting, particularly the 'delicious happy opium blue, the blue of oblivion'.

Oil on canvas, 64.2 x 92.4 cm
Given by Lady Daniel, in memory
of her husband, Sir Augustus Moore
Daniel (1866–1950), 1951
PD.18-1951

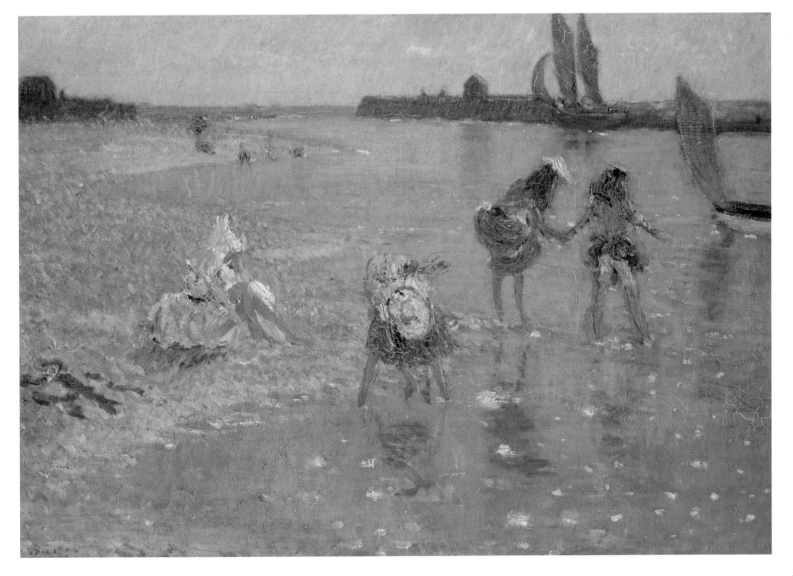

Promenade, 1895
Pierre Bonnard (1867–1947)

Bonnard designed six folding screens between 1890 and 1919, but this was the only one realized in printed form. In 1894 he wrote to his mother, 'I'm making a screen for the Champs de Mars (Salon des Indépendents). It's the Place de la Concorde, where a young mother passes with her children; [there are] some nannies, some dogs, and at the top, making a border, a waiting station of carriages, all of which is placed on an off-white ground that looks indeed like the Place de la Concorde when there is dust and it resembles a mini-Sahara … Anyway it will be for the present time the eighth wonder of the world.' *Promenade* was made first as a painting in distemper, and then remodelled as a colour lithograph in the following year; both were exhibited in Bonnard's first one-man show at the Durand-Ruel gallery in 1896. Fewer than 30 of the edition of 110 sets of prints seem to have survived, probably because many were used as screens and suffered damage.

Bonnard was known among the group of artists who called themselves *Nabis* ('Prophets') for his study of Japanese art; they gave him the nickname 'Le Nabi trés Japonard'. *Promenade* was the first of his screens to float the subject across the divided panels, recalling the Japanese screens recently imported into Paris that created the taste for this format. Other elements of the design reflect the influence of Japanese woodcuts: the cropping of figures at the edge of the sheets, the use of flat planes of colour, and the asymmetrical balance of the composition. The use of expanses of blank background to evoke the space of the Place de la Concorde was a device developed from the work of the Impressionists and their circle.

Lithograph printed in colours on four panels of paper, each panel 137.3 x 46.3 cm
Given by J. W. Freshfield, 1944
P.145-1944

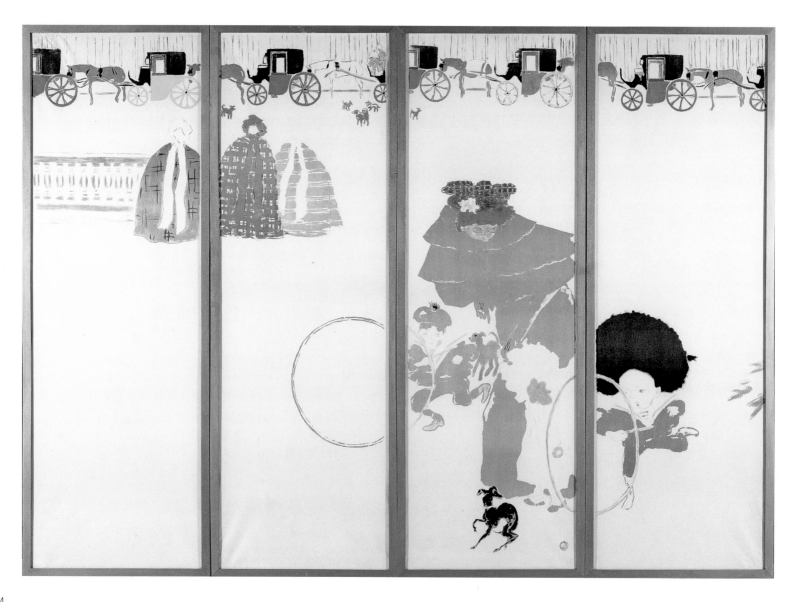

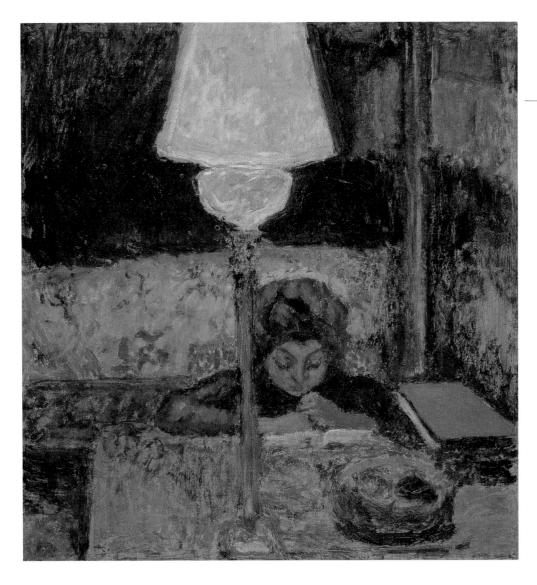

The Oil Lamp, *c.*1898–1902
Pierre Bonnard (1867–1947)

In the 1890s, Bonnard, like Vuillard (see below), made a speciality of painting small-scale domestic interior scenes, often populated by members of his family or immediate circle. Towards the end of the decade, he broke away from the flatness and frontality of his paintings of the late 1880s and early 1890s, and structure, rather than pattern-making, became his principle artistic concern. This is one of a group of interiors that Bonnard painted between 1898 and 1903 that include oil lamps as prominent compositional elements. Often, the lamp dominates the foreground, suspended above a table, and bathing the figures huddled beneath it in the glow of its sulphurous yellow light; elsewhere – as here – it creates an emphatic vertical rupture that relegates the human presence to the background, so that the reader is squeezed between the horizontal and vertical axes into the lower corner of the composition. The relatively subdued palette is characteristic of Bonnard's work after around 1894, Although the sombre tonalities may be explained by the fact that much of the room is in shadow, one of the noted effects of the introduction of different forms of artificial illumination in late nineteenth-century interiors was a growing preference for more faded fabrics and less assertive colours in wall and floor coverings.

Oil on panel, 55.3 x 51.8 cm
Accepted in lieu of tax by H.M. Government and presented to the Fitzwilliam Museum, 1998
PD.28-1998

Woman Reading in the Reeds, St Jacut-de-la-mer, 1909
Edouard Vuillard (1868–1940)

This enchanting image – captured with evident spontaneity while the sitter was engrossed in a book – was painted on the so-called 'emerald coast' of Brittany. The figure in the reeds is Lucy Hessel, wife of the picture dealer Jos Hessel, whose firm, Bernheim-Jeune, handled Vuillard's work from around 1900. Lucy became Vuillard's close friend and confidante, and a powerful influence in his life. Each year from 1901 until the outbreak of the Great War of 1914–18, she and her husband invited Vuillard to accompany them and their friends to various locations in Normandy, Brittany and the countryside around Paris. This is one of a large group of works that Vuillard painted during the summer of 1909, and exhibited in Paris in the autumn of that year. This work was executed in distemper (*peinture à la colle* in French), a medium made from pigment mixed with a glue-based size. He used it extensively for large-scale decorative projects in the 1890s, but adopted it for smaller works only from around 1907. Here he exploits to the full the directness the medium allowed to create the stippled pattern-making on the dress and wonderful calligraphic sweep of the reeds.

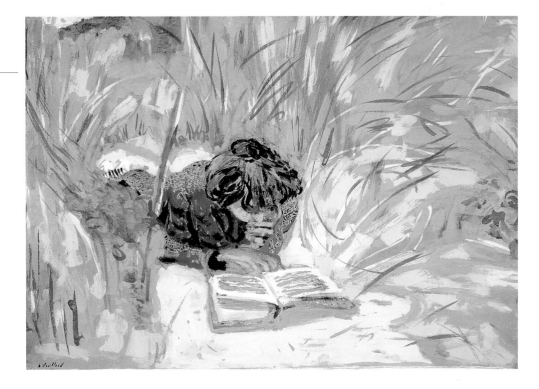

Distemper on paper, 44.5 x 64.6 cm
Given by E. Vincent Harris in memory of his wife, Edith, 1967
PD.11-1967

The Studio Under the Eaves, 1903
Henri Matisse (1869–1954)

In the early part of 1903, Matisse and his family were staying at Bohain-sur-Vermandois in a vacant property owned by his father in the rue Fagard. This is one of a number of paintings he made in an attic room, lit by a north-facing casement window, which doubled as a studio. The painting shown on the easel is thought to be his *Bouquet on a Bamboo Table* (New York, Museum of Modern Art), one of the first paintings Matisse sold at the Salon des Indépendents. This was a particularly gloomy period in Matisse's life, when he was beset with personal and financial difficulties. Matisse believed that that the artist ultimately had to draw on his or her own spiritual resources to address the constraints of material existence: 'Drawn always towards the light … I escaped from the cramped space surrounding my motif [subject-matter] so as to reach out in spirit beyond myself, beyond the motif, beyond the studio, beyond even the house itself to a cosmic space in which you would no more feel walls hemming you in than would a fish in the sea.' He considered this painting to be 'one of my best pictures … What depth (and) suppleness in the shadows … '.

Oil on canvas, 55.2 x 46 cm
Bequeathed by Arnold John Hugh Smith,
through the National Art Collections Fund, 1964
PD.14-1964

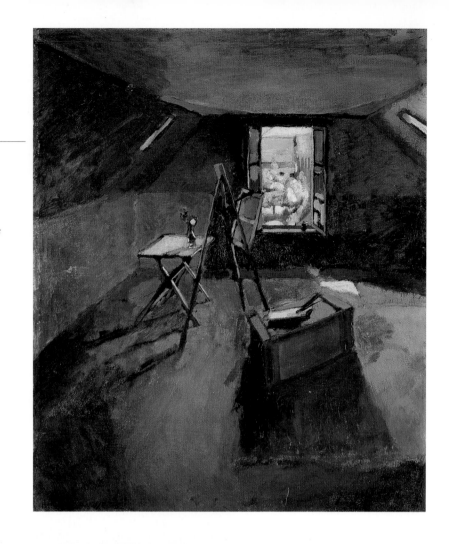

Oil on canvas, 45.7 x 50.8 cm
Given by Mrs Maurice Hill, 1990
PD.103-1990

Sir William Nicholson, 1909
Augustus John (1878–1961)

Nicholson (knighted in 1936) was a painter of portraits, figure-subjects, still-lifes and landscapes, and John's friend. John's original idea for this portrait had been to offset Nicholson's 'rare beauty' by painting a 'huge nude girl' at his side; in the event he modified the idea to include one of his own paintings, set on end, on which he rests his left arm. Although this portrait was considered to be unconvincing as a likeness of the sitter, it was – and continues to be – widely admired as a superb piece of painting. The image John created is one of refined belligerence. Nicholson's delicately raised finger and haughty air brilliantly complement the defiant glare with which he meets – or confronts – the viewer; as one commentator wrote, he could even pass for a 'gentlemen pugilist' (in fact, both John and Nicholson were boxing fans). Artist and sitter seem to have been mutually satisfied by the result: John considered it for many years to be his finest portrait, while Nicholson acknowledged that, 'John's snapshot of me is capital, and everyone else seems to agree.' Nicholson finally paid John the relatively insignificant fee (probably £100) which the latter had asked for the portrait, after several years' delay. He lent it to the Fitzwilliam for some years (1919–33); when it was acquired for the Museum in 1933, Nicholson split the proceeds of the sale (£1000) with John.

Oil on canvas, 190.2 x 143.8 cm
Given by Miss S. R. Courtauld, 1933
1641

Left below:
Mornington Crescent Nude, 1907
Walter Richard Sickert (1860–1942)

Sickert lived abroad for much of the period 1898 to 1905, but in that year settled in London, taking rooms at 6 Mornington Cresent, Camden Town. In the years immediately after his return to London he began to paint subjects inspired by his urban locality: scenes from music-halls and theatres and figure subjects and nudes set in the often seamy interiors of the area in which he lived. Sickert had an aversion for the sort of academic painting that used mythological subject-matter simply as an excuse to paint legions of prettified, and coldly titillating, nudes; they were, he claimed, 'not only repellent, but slightly absurd' – even his great hero Ingres made their squirming ivory bodies look like nothing more than a 'dish of macaroni'! His own approach to painting the nude was both less idealized and more direct. Like Degas, whom he befriended in Paris in the early 1880s, he depicted his female nudes with an uncompromising realism, which some contemporaries found scabrous and demeaning. This is one of a series of at least six nudes that Sickert painted in 1907. That he intended the group principally as a means of exploring different effects of light is clear by the fact that he described them as a 'set of Studies of illumination'; as he later wrote: the 'chief source of pleasure in the aspect of the nude is that it is in the nature of a gleam – a gleam of light and warmth and life.'

Matadero, Segovia, (?)1936
William Nicholson (1872–1949)

Nicholson ran a flourishing portrait painting practice in London in the 1920s and '30s, but he also travelled widely – to India, France and South Africa. He made his first visit to Spain in 1933, and came to consider the country – outside his studio in St James's – to be his 'spiritual home', returning there annually for the next three years. This was probably painted in 1936, when Nicholson was invited by friends to spend part of the spring in Segovia. The *matadero* was a slaughterhouse on the outskirts of the city; the square tower of Segovia's cathedral can be seen in the background. According to Marguerite Steen, who accompanied him on the trip, 'It was the Matadero which captured William, grimly mounted on its pale gold bluff above the Eresma and Clamores rivers: a thing so complete in placing, in design and in dramatic values that his enthusiasm took me by surprise … '. Nicholson seems to have struggled to complete a large version (now lost) of this subject for about a year after his return to London, although he sold this painting, the 'small version', at an exhibition of his work in London in 1936.

Oil on panel, 37.7 x 45.7 cm
Given by Emanuel Vincent Harris, OBE, RA
in memory of his wife Edith, 1967
PD.10-1967

Self-portrait with Patricia Preece, 1937
Stanley Spencer (1891–1959)

Spencer met Patricia Preece in 1929, two years after she had settled in Cookham, Berkshire, and was captured by her vitality and commitment as an artist. She became his lover, and when his divorce from his first wife, Hilda Carline, became absolute, on 25 May 1937, he married Preece four days later. Spencer claimed to be unable to understand 'this possessive business. I consider it a sign of intelligence in me that I should notice that with many women I can reach the most intense state of being & awareness (which is life) & in each case it is utterly sincere.' This is one of two self-portrait compositions which Spencer referred to as his 'double nudes'. The other, the 'Leg of Mutton nude' in Tate Britain, shows Spencer squatting behind his wife, who lies naked with a joint of meat placed next to her thigh. Spencer described painting this picture as being like an ant crawling all over his lover's body; in fact, his fascination for Patricia's crevices, folds and contours is such that he even crops part of her head. The intensity of the image is increased by the shallow, claustrophobic picture space, which very deliberately allows for no distraction between sitters and viewer. Patricia's gaze – vacant, absorbed, and decidedly melancholic – seems to suggest that she, too, sees no escape.

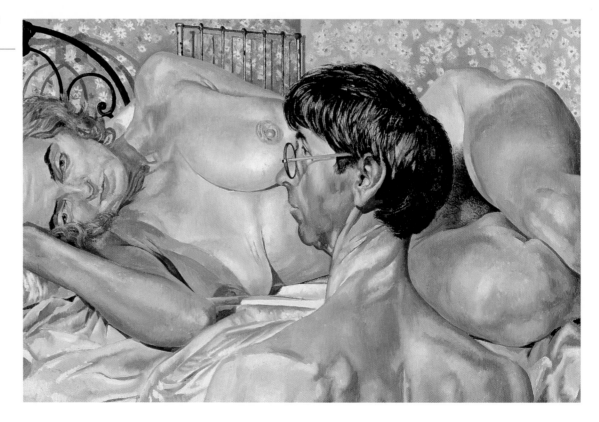

Oil on canvas, 61 x 91.2 cm
Bequeathed by Wilfred Ariel Evill, 1963
PD.966-1963

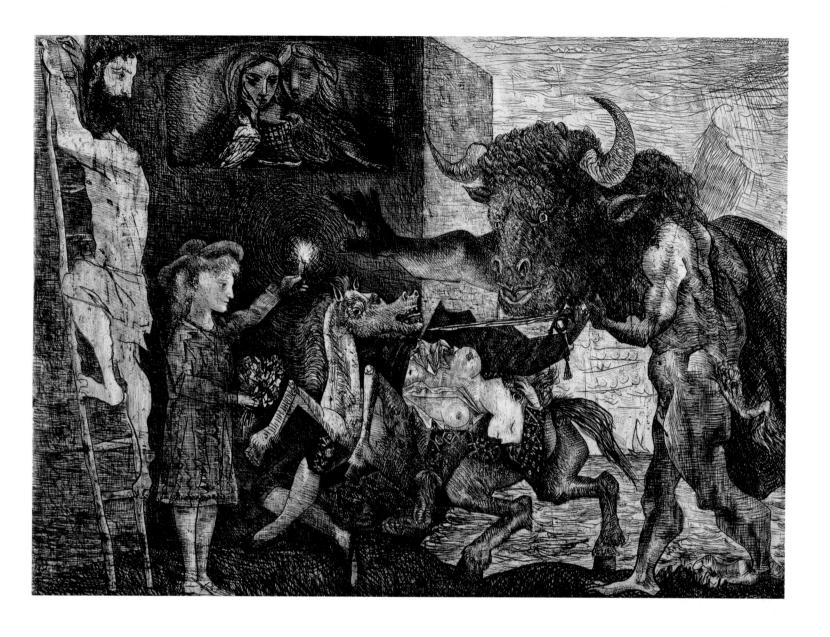

La Minotauromachie, 1935
Pablo Picasso (1881–1973)

Picasso's masterpiece in printmaking brings together many of the motifs that the artist had been using in the 1930s in his plates for the *Vollard Suite*, especially the figure of the Minotaur – half bull, half man – that often appears as a metaphor for the artist himself. Picasso worked on this plate with the printer Roger Lacourière in Paris from 25 March to 3 May 1935; no complete edition was ever printed. Attempts by recent commentators to tie the meaning to Picasso's fear and jealousy of the pregnancy of his mistress Marie-Thérèse take little account of the powerful universality of the theme of violence confronting innocence. On the left the bearded figure and ladder recall the iconography of Christ's deposition from the cross; in the tower is a twin representation of Marie-Thérèse with the doves (symbols of peace and love); in the centre a mare, entrails hanging out, carries on its back another Marie-Thérèse figure recalling the slain female bullfighters in the *Vollard Suite*; on the right the Minotaur's path of destruction is blocked by his fear of the light of innocence held by the girl on the left.

The donor in 1936 wrote that it evoked movingly 'the present troubles in Spain' leading up to the Spanish Civil War. Many of the motifs in this print reappeared in Picasso's monochrome mural *Guernica*, a powerful indictment of the bombing of the Basque town of Guernica in April 1937.

Etching, engraving and grattoir on paper,
49.5 x 69.2 cm
Given by Helen M. Inman, 1936
P.11-1936

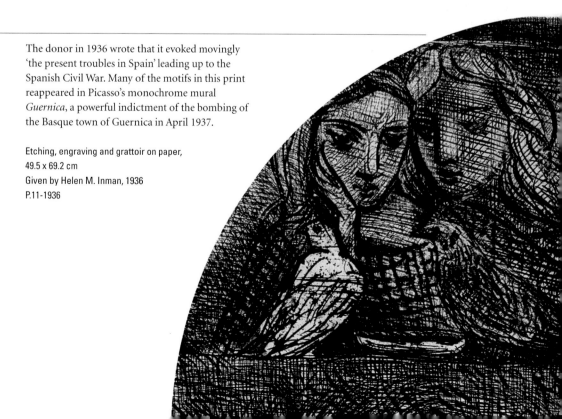

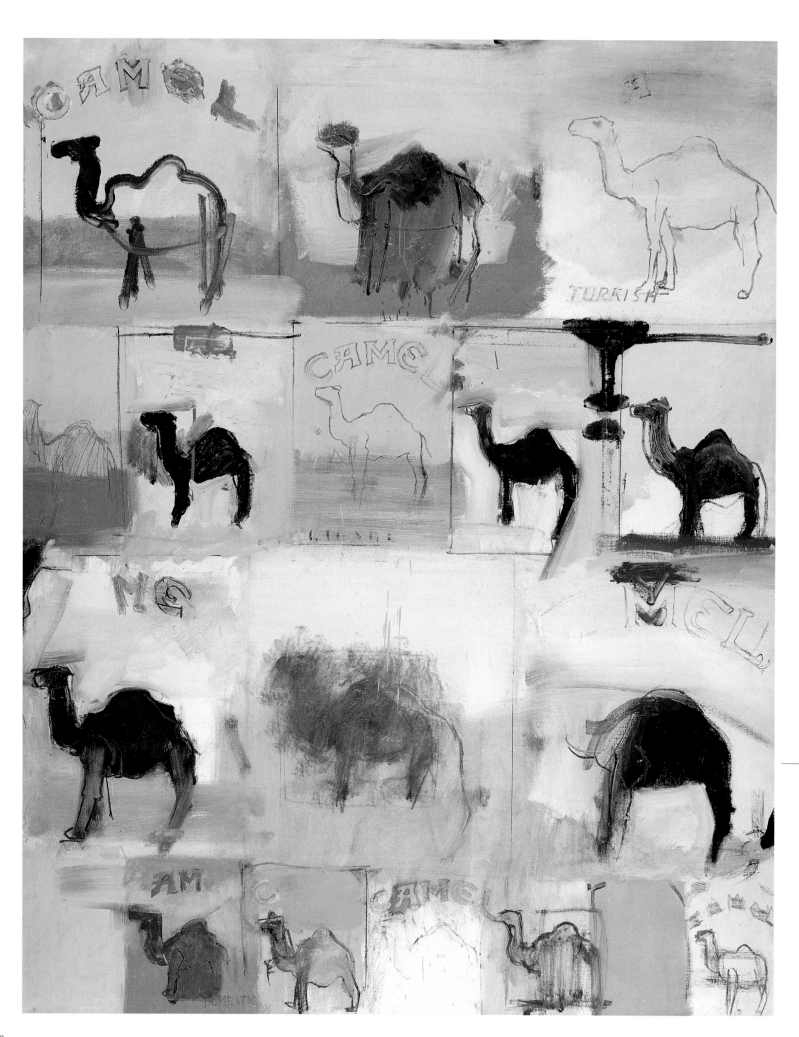

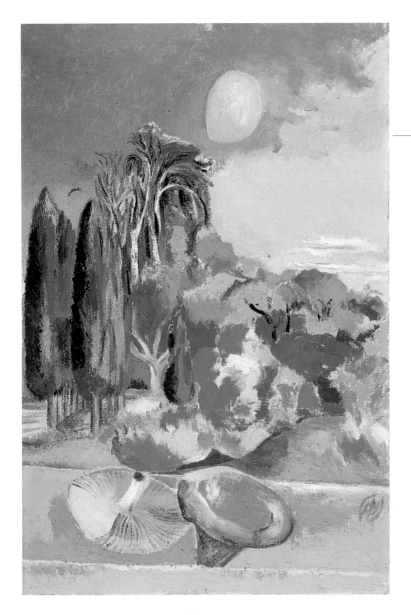

November Moon, 1940
Paul Nash (1889–1946)

At the outbreak of war in 1939, Paul and Margaret Nash left their Hampstead home for a flat in Oxford. Nash suffered from severe attacks of bronchial asthma, and it was both to escape the damp of Oxford and to find subjects to paint that he liked to visit his friends outside the city. This is one of a series of paintings and watercolours made in the garden of Hilda Harrison's house, Sandlands, on Boar's Hill, Oxford. Although the painting records accurately such features of the Sandlands garden as the avenue of cypress and 'flame shaped bushes' near the path leading down to the wood, Nash's principal intentions are symbolic; he himself described certain landscapes as transcendental. The autumn garden is divided into two zones by the light of the moon (a symbol of fertility) and the sun (a symbol of life), although it is the moon that dominates. The fungus that appears in the foreground is a symbol of death; the convolvulus beside it is a sun (life)-seeking flower.

Below:
Painting 20/7/74, No. 3/3, 1974
Sean Scully (born 1945)

Scully was born in Dublin and moved with his family to England in 1949. He studied at Croydon College of Art and at Newcastle upon Tyne University, where he also taught. He studied at Harvard in 1972, moved to New York in 1975 and become an American citizen in 1983. Scully is one of the most sensitive and subtle of abstract painters, with a finely controlled and beautiful sense of colour. His tonal juxtapositions are extremely effective and expressive, working within a careful grid. This canvas is divided into 12 rectangles by narrow vertical and horizontal bands.

Above:
Oil on canvas, 76.2 x 50.8 cm
Given by the Contemporary Art
Society, 1955
PD.6-1955

Right:
Acrylic on canvas, 121.9 x 121.9 cm
Bought from the University and
Gulbenkian Purchase Funds, 1975
PD.105-1975

Left:
Camels, *c.*1961
Larry Rivers (1923–2002)

Born in New York, Rivers was a saxophonist before he took up painting. For *Camels*, as for a number of paintings, he took the familiar cigarette packet as his starting-point. Its shape, lettering and the image it carries are multiplied in a rough grid-like pattern, sketchily drawn and freely painted in colours that approximate to the sandy oranges and browns of the original. The composition is characteristically witty, and the handling of paint is very free, loose and translucent. Works like *Camels* prefigure the Pop Art movement in Britain in the 1960s.

Oils and collage on canvas,
162.5 x 129.5 cm
Bought from the Cun1iffe Fund with Grant-in-Aid
from the Victoria & Albert Museum, 1979
PD.12-1979

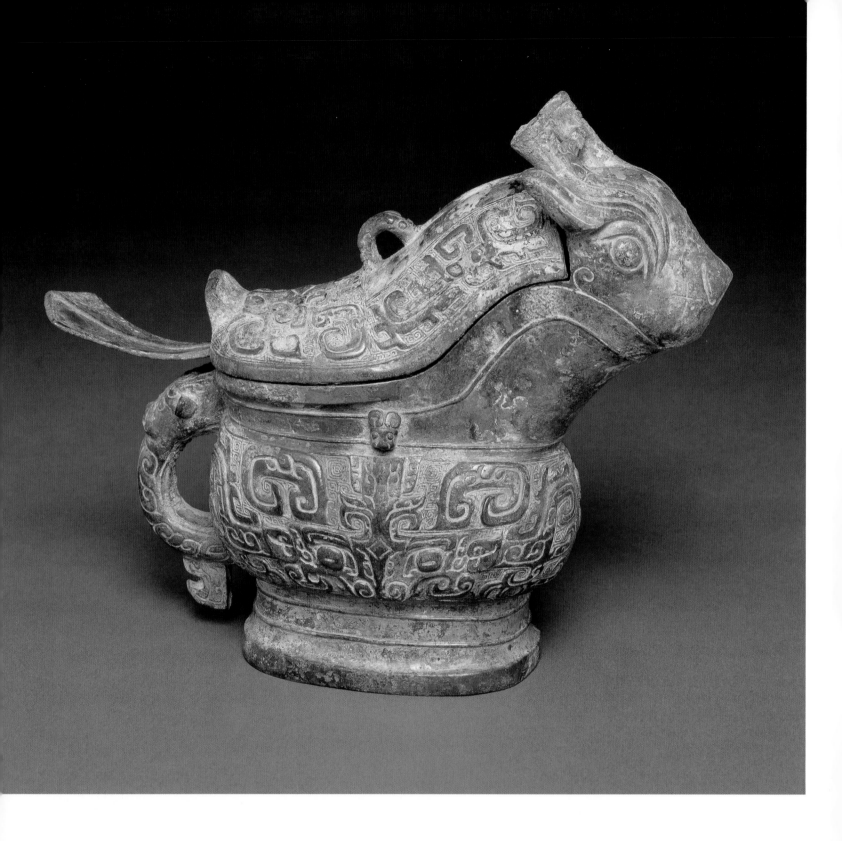

Spouted ritual wine vessel (*guang* or *gong*)
Chinese, second half of early Western Zhou period
(*c*.1050–975 BC)

Bronze vessels are the most outstanding artefacts surviving from the earliest Chinese dynasties of Shang (*c*.1600–1050 BC) and Zhou (1050–256 BC). They demonstrate the existence of sophisticated bronze-casting techniques, using piece moulds to produce complex forms with integral relief decoration. The majority of the bronzes were intended as containers for wine and food. They were used to hold offerings in ancestor cult rituals, and were also deposited in tombs, where most of them have been found. Wine vessels seem to have been particularly prized, as they are frequently found near the deceased in the burial chamber.

This example is a *guang*, a pouring vessel that appeared during the late Shang period when zoomorphic forms were popular. The head is probably that of a deer or ox, and on the sides are symmetrical horned masks with protuberant eyes known as *taotie*, which occur on many Shang and Zhou bronzes. The division of the body into two compartments, and the accompanying spoon that forms the tail, suggest that it was used for mixing libations of wine. An inscription reads: 'Shou Gong made this sacred vessel for Father Hsin, may it be preserved for ever.'

Bronze, h. 21.7 cm
Bequeathed by Oscar C. Raphael, 1941
O.188-1946

Upper part of a female *haniwa* figure
Japanese, Kofun period, 6th century

This fragment of a *haniwa* figure of a woman is made of coiled and smoothed clay with pierced slits for the eyes and mouth, and an applied clay nose, and jewellery. Remnants of the original colouring can be seen on her face. It was made during Japan's Kofun Period (*c.*250–600 AD), named after the *kofun*, huge keyhole-shaped mounds in which the ruling elite were interred. The mounds enclosed a stone burial chamber in which the stone or wood coffin and grave goods were placed. Clay sculptures, known as *haniwa* ('circles of clay'), were placed in groups on the summit or around the mounds where they were visible. Initially they were in the form of large cylinders, but by the late fourth century, models of buildings, animals, armour and other possessions were in use. Human figures, including nobles, warriors, shamans and male and female servants became common in the fifth and sixth centuries. The arrangement of the *haniwa* on the *kofun* varied from area to area, and their ritual function is not yet clear. Their use was abandoned when Buddhism became the dominant religion in the seventh century, and different burial practices were adopted.

Red earthenware, hand built, with traces of pigment, h. 31.6 cm, w. 27 cm
Given by Mr and Mrs Conrad Abrahams-Curiel
in memory of their daughter, Eleanora
C.397-1991

Circular box and cover
Chinese, Zheijiang province, Yue ware, 9th to 10th centuries

During the Tang dynasty (818–907), potters in south-east China developed a very fine, hard stoneware with a pale olive-green glaze, which became known as Yue ware, after the ancient kingdom in which the kilns were situated, now in northern Zheijiang province in south China. Production continued and its quality improved during the Five Dynasties period (907–60), despite the political upheavals of the time. This box, probably a container for incense in a Buddhist temple, was almost certainly made in one of the important kilns around Shanglinhu (Shanglin Lake) in Yuyao province of the kingdom of Wuyue (Zheijiang province). The box was thrown in two parts, and then modelled and incised to resemble two lotus flowers, with the stalk of the uppermost one forming the handle. Its contours are enhanced by the protruding upward tilting tips of the petals. The delicate olive-green surface, reminiscent of jade, resulted from the reaction of traces of iron in the glaze to high-temperature firing in a reducing kiln, that is, one starved of oxygen by damping down the fire and reducing admission of air.

Stoneware, thrown, modelled and incised under glaze, h. 11.6 cm, d. 10.1 cm
Bequeathed by Oscar C. Raphael, 1941
OC.24-1946

Guan jar
Chinese, Yuan dynasty, *c.*1330–68

The Mongul Yuan dynasty ruled China from 1279 to 1368. During this period the manufacture of porcelain developed into a major industry at Jingdezhen in Jiangxi province, in south central China. The most significant and influential development between the 1320s and 1350s was the increasing use of underglaze cobalt-blue decoration. The cobalt used at Jingdezhen was imported from Iran, and after preparation was painted directly onto the moulded or thrown body. After glazing the ware was fired at about 1280°C to 1300°C. The finished porcelain was eye-catchingly beautiful, with complex designs in gradations of blue contrasting with the body. The splendour of Yuan blue and white porcelain is accentuated by the substantial size of many of the dishes, *meiping* vases and bulbous wine jars known as *guan*. This example is decorated with a pair of mandarin ducks, symbolic of happy marriage, swimming between lotus and other aquatic plants. Other popular motifs included scrolling foliage and flowers, especially lotus or peony, mythical animals, fish and auspicious symbols.

Porcelain painted underglaze in blue,
h. 30.5 cm
Bequeathed by Oscar C. Raphael, 1941
OC.93-1946

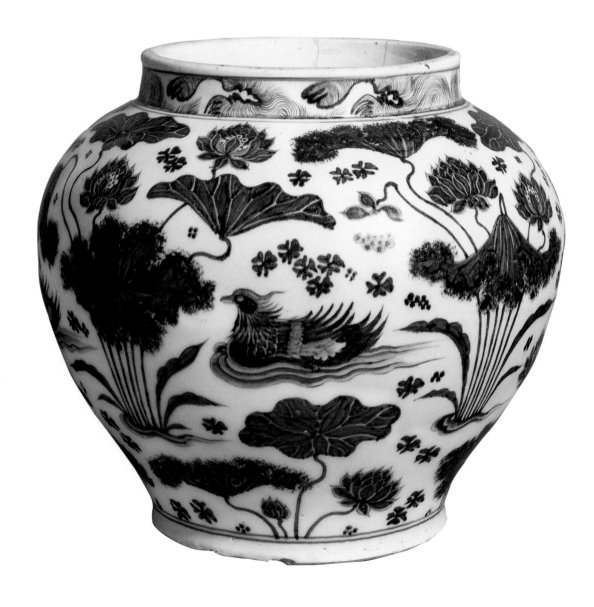

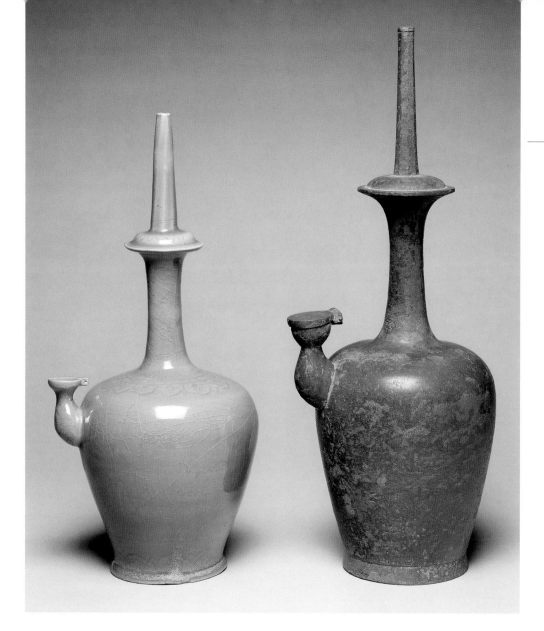

Two kundika (water sprinkler)
Korean, Koryo dynasty, 12th century

The education of the aristocracy in Korea during the Koryo period was strongly influenced by Confucianism, but the dominant religion was Buddhism, which had been introduced from China in the late fourth century. Numerous Buddhist temples and monasteries were built during the Koryo period, and were lavishly endowed with sculptures and other religious artefacts. Many of those used in rituals were cast in bronze. They included temple bells, often of immense size, incense burners, and tall spouted vessels called *kundika* or *chongbyong*, which were used for sprinkling water to purify the ground. The *kundika* was of Indian origin, and had been brought with Buddhism to China and Korea. This form with a faceted mouth, a typically Korean feature, was common during the second half of the eleventh century and the twelfth. The vessel was filled through the squat spout in the body, which was closed by a hinged lid. Koryo potters imitated bronze *kundika* in stoneware with pale blue-green or grey-green celadon glaze, which was admired by connoisseurs in Korea and China. This example has subtle underglaze decoration of incised cloud scrolls and peonies, flying cranes among clouds, and ducks and geese between willow trees and reeds.

Left: Stoneware with incised decoration under celadon glaze, probably Sadang-ri kilns, *c.*1100–50, h. 34.7 cm
Right: Bronze, h. 41.2 cm
Given by Mr and Mrs G. St. G. M. Gompertz
O.2-1984, C.55-1984

Recumbent buffalo
Chinese, possibly Ming dynasty (1368–1644) or later

Jade, known as *yu* to the Chinese, has been used in China for ritual artefacts and ornaments since the fourth millennium BC. This placid recumbent buffalo is carved from true jade or nephrite, which was used before the late Ming dynasty when jadeite, also termed jade, began to be imported from Burma. In a pure state both stones are white, but are more commonly found in shades of green, and yellow to reddish brown. The buffalo is one of the largest jades in a Western collection, weighing 25.4 kgm (56 lb). Before 1900 it was situated in the Winter Palace in Beijing, together with a rare black jade horse, and a white jade dragon-horse, also in the Fitzwilliam. The buffalo was then dated to the Han dynasty (206 BC–AD 220), but recent scholarship favours the late Ming or early Qing dynasty. After the Boxer Rising in 1900, the buffalo and its companions were removed to the British Legation, and were sold to a Chinese official who later exchanged them for some jewels. The new owner brought them to Britain, where they were acquired before 1915 by Oscar Raphael, a notable collector of Chinese art.

Green jade (nephrite), l. 43.2 cm
Bequeathed by Oscar C. Raphael, 1941
O.31-1946

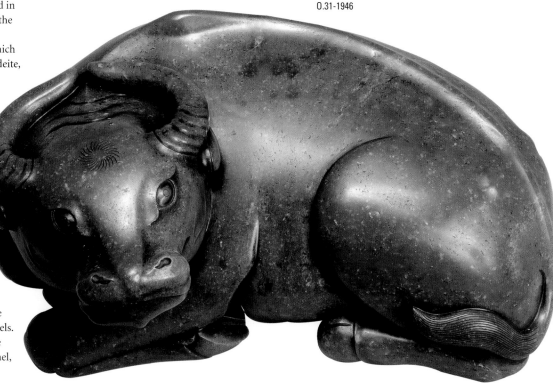

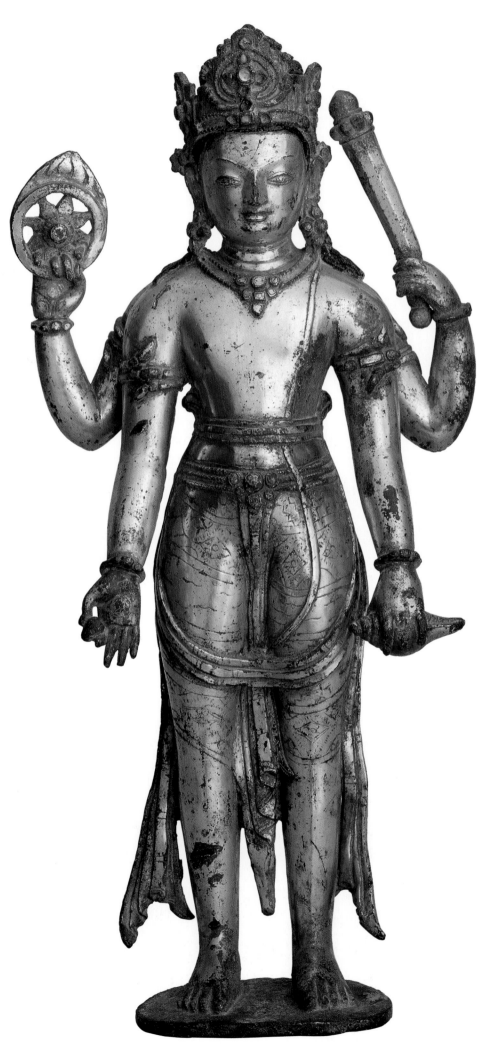

Vishnu
Nepal, 12th to 14th century or earlier

In Hinduism, Vishnu, the preserver of the universe, is the second of a triad of gods, the first being Brahma, the creator, and the third, Shiva, the destroyer. This rare and finely detailed Nepalese statuette represents Vishnu in the most typical way, with four arms, holding respectively the conch shell on which was blown the primordial sound; the flaming wheel of life and death; the lotus seed of creation; and the mace that destroys illusions. His softly rounded physique and broad, serene face indicate that the statue was made between the twelfth century and the fourteenth. The figure is solid-cast, and originally had an aureole attached to its back between the shoulder blades. A tang under each foot was inserted into a base. The god may have been accompanied by separate casts of his consort Lakshmi, and an anthropomorphized form of Garuda, his mythical avian mount.

High-copper bronze, incised, gilt, set with gems and painted; h. 34 cm to base (38.5 cm including tangs), w. 16 cm, d. 7 cm
Purchased with the Cunliffe Fund, with contributions from the Regional Fund administered through the Victoria & Albert Museum, the National Art Collections Fund, and the Ancient India and Iran Trust
O.1-1980

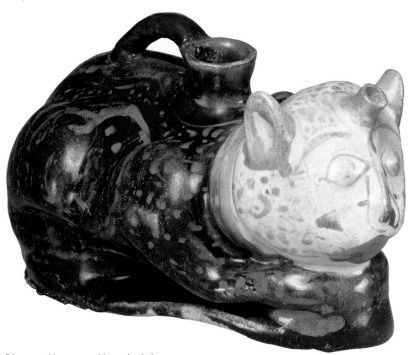

Fritware, with opaque white and cobalt-
blue glazes, decorated with copper lustre,
h. 10.6 cm, w. 10.1 cm, l. 18.4 cm
Bequeathed by Oscar C. Raphael, 1941
OC.164-1946

Ewer in the form of a cat
Iran, probably Kashan, late 12th or early 13th century

This realistically modelled cat ewer is one of a small class of figurative
ceramics made in Iran between the late twelfth century and the
Mongol invasions in 1220. They include hawks, bulls, lions, monkeys,
camels and riders on horseback. Some may have been purely
decorative. A few bulls and camels have vases on their backs, and the
zoomorphic ewers were probably for water or wine. The function of
the smallest ewers is uncertain. The narrow spout on this cat's
forehead suggests that it might have been used for perfume. The
figures are made of moulded frit or stone-paste, a ceramic developed
in the Middle East in the eleventh century. It contained white clay,
ground quartz, and glaze materials, which produced a hard white body
when fired, and provided a good base for coloured glazes or painted
decoration. This cat is decorated over the fired glazes with metallic
lustre, which required another low-temperature firing in a smoky,
oxygen-reduced atmosphere to fix it to the surface. Lustre decoration
was a wholly Islamic technique developed in Abbasid Iraq in the ninth
and tenth centuries, and then in Fatimid Egypt (969–1171). It was
probably taken to Syria and Iran by Egyptian potters or decorators in
the mid-twelfth century.

Mosque lamp
Egypt or Syria, Damascus, *c*.1355

Egypt and Syria were united in the fourteenth
century under Mamluk rule from Cairo, where many
religious buildings were erected by the sultans and
their officials. The mosques and mausoleums were lit
by oil lamps in glass holders, which were suspended
from the domes by chains attached to lugs on their
sides. Mosque lamps of this shape decorated with
coloured enamels had become standard by the late
thirteenth century. The Arabic inscription on the
lower part of this example states that it was made by
order of Shayku al-Nāsirī (d. 1357), an amir who
built a mosque, monastery and tomb in Cairo
between 1349 and 1356. On the neck the inscription
is broken by his emblem, a red cup, indicating that
he was cup-bearer to the Sultan. In addition to their
practical and decorative functions, mosque lamps
had a symbolic role. Like a number of others, this
one bears a passage from the Qu'ran, XXIV.35,
known as the Sura (chapter) of Light: 'God is the
light of the heavens and the earth. The parable of His
light is as a niche, in which there is a lamp.'

Glass, blown and enamelled, h. 35.3 cm
Given by the National Art Collections Fund in
commemoration of the centenary of the
Fitzwilliam Museum's opening in 1848
C.4-1949

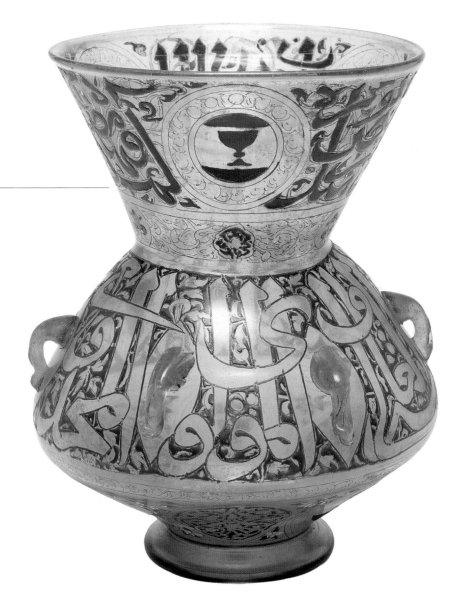

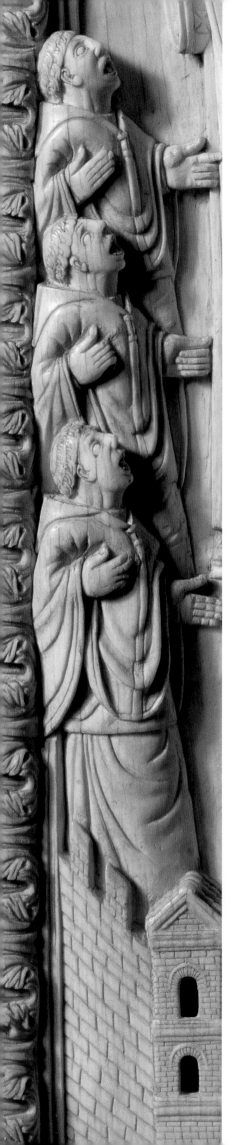

Panel from a book cover
Lotharingian, late 10th century

Ivory carving was revived at the court of Charlemagne in Aachen in the late eighth century, and it remained an important medium for sculpture throughout the early Middle Ages. The narrow rectangular format of this tenth-century Lotharingian relief was derived from late Roman consular diptychs: hinged writing tablets showing the consul performing his duties, which he presented to his supporters and friends on entering office. The panel is exceptional as the earliest known representation of choral singing. It depicts a bishop or archbishop about to celebrate Mass, with five deacons behind him, and in front of him seven canons singing. On a desk to his left is an open book inscribed in Latin with the introit to the Roman Mass for the first Sunday in Advent, beginning 'Unto thee, I raise my soul', sung as the celebrant processed into the church. He raises his right had to indicate that he is ready to begin the service. The panel probably adorned the cover of a liturgical book, such as a Gradual, a choir book used in the Mass. Another panel showing the celebrant standing in front of the altar, probably carved in the same workshop, is in the Liebieghaus Museum, Frankfurt.

Ivory, 33.7 x 11.4 cm
Bequeathed by Frank McClean
M.12-1904

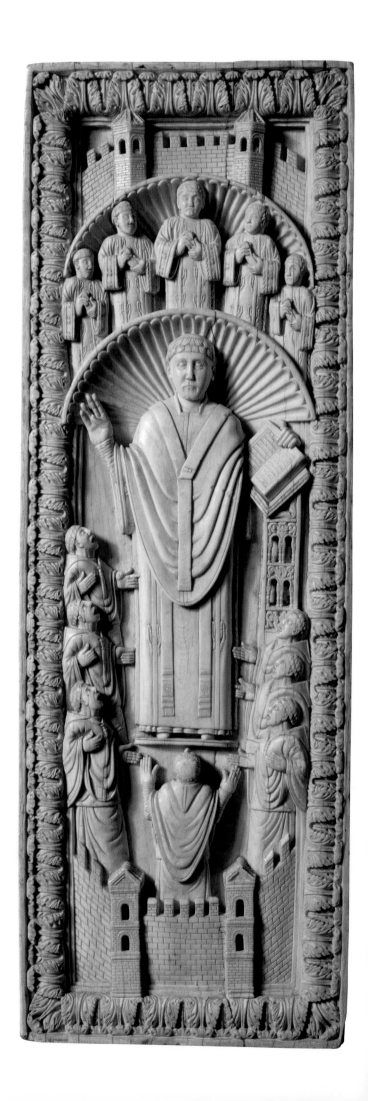

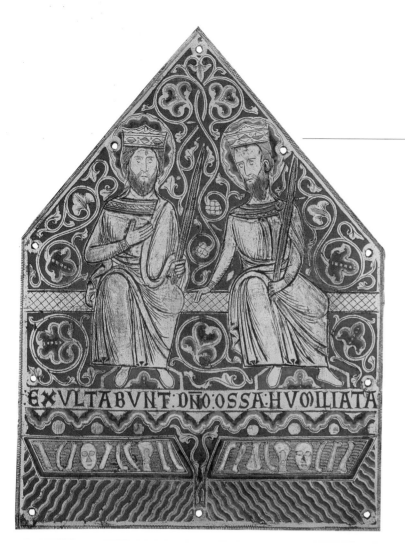

Pentagonal plaque from a reliquary
French, Limoges, *c.*1200–20

During the Middle Ages, relics of Christian saints and martyrs were housed in reliquaries made of precious materials, which emphasized their venerable status. This plaque probably formed the gable end of a church-shaped reliquary with a sloping roof. It was made at Limoges in central France, which by the late twelfth century had became the most important European centre for champlevé enamelling, and exported its products widely. The engraved design depicts two figures, identified as martyrs by their palms, seated above open coffins surrounded by waves. This suggests they may be two of the Four Crowned Martyrs, who according to legend, were enclosed alive in lead coffins, and drowned in the Tiber on the orders of the Emperor Diocletian (AD 284–305). The existence of another plaque of similar design in a private collection supports this supposition.

The inscription below the figures, EXVLTABVNT DÑO OSSA HVMILIATA (The humiliated bones shall rejoice in the Lord), is from Psalm 50,10 in the Latin text of the Bible, known as the Vulgate. The background is filled by foliated scrolls in a blue enamel ground, the predominant colour in Limoges work from *c.*1200, and mystically associated with Heaven.

Copper, champlevé, engraved, enamelled
and gilt, 24 x 17.7 cm
Bequeathed by Frank McClean
M.31-1904

Chasuble
English, early 16th century

For many generations this chasuble was owned by the Huddlestone family of Sawston Hall, Cambridgeshire. According to family tradition, it was associated with Lady Isabelle Neville, wife of Sir William Huddlestone and niece to George Neville (1432–1476), Bishop of Exeter and later Chancellor of England and Archbishop of York. However, the simplicity of the style and technique of the applied embroidery motifs (seraphim, fleur-de-lys and water flowers), and of the orphrey (Saints John the Baptist, Anthony and Jerome), together with the shields of the diocese of Exeter, Ely and the Abbot of Westminster, suggests that the chasuble was made in the early sixteenth century rather than in the fifteenth. At some time it has been cut, reshaped and edged with late seventeenth- or early eighteenth-century metal thread bobbin lace. During conservation, fragments of a painted late medieval wall cloth were found, inserted as stiffeners and supports for the later garment.

Silk velvet, polychrome silk and metal thread embroidery
with spangles and metal thread lace
Purchased with the Gow Fund
T.9-1986

Gold, enamelled *en ronde bosse*, l. 6.7 cm,
on a later wooden base
Bequeathed by L. D. Cunliffe, 1937
M/P.22-1938

The Annunciation
Probably Burgundian, or French, Paris, *c.*1400–50

This tiny gold Annunciation is decorated with
opaque white, and translucent blue, red and green
enamels applied directly to the surface. This tech-
nique, described as *émail en ronde bosse*, was
perfected in France and Burgundy around 1400.
The figures of the Virgin and the Archangel Gabriel
are surrounded by a low fence of twisted gold wire,
which creates an enclosed garden, a symbol of the
Immaculate Conception. Royal and noble inventories
of the late fourteenth century and the fifteenth show
that devotional objects incorporating figures and
gemstones existed in large numbers, but very few
survive. One example is the Reliquary of the Golden

Thorn in the British Museum, which bears the arms
of Jean, duc de Berry (1340–1416), and is thought to
be Parisian work of *c.*1405–10. The origin of this
Annunciation is uncertain, but aspects of the figures
and enamelling suggest that it was Burgundian
rather than French. It was formerly in the Spiritual
Treasury of the Imperial Habsburg Court in Vienna.
However, during the 1860s it was sent for repair to
a dealer, Salomon Weininger (1822–1879), who sold
the original, and returned a copy to the Treasury.
This fraud remained undetected until the twentieth
century, but Weininger was imprisoned in 1876 for
another offence.

St Christopher carrying the Christ Child
Flemish, probably Antwerp, *c.*1500

The use of wood for religious sculpture was
widespread in Europe during the Middle Ages. Oak,
walnut and lime wood were favoured in northern
Europe, and in most areas separate figures and
altarpieces were primed and painted. This Flemish
image of St Christopher carrying the Christ Child,
probably made in Antwerp *c.*1500, still retains a
considerable amount of its original polychromy.
The legend of St Christopher had been popularized
by *The Golden Legend* by Jacobus de Voragine
(1230–1298). It told how the giant Christopher
helped travellers to cross a river near his home.
One day as he carried a child over the river, the
child became increasingly heavy, and, on reaching
the bank safely, it revealed to Christopher that it
was Christ, and that he been carrying the burden of
the whole world as well as its Creator. This incident
led to Christopher becoming the patron saint of
travellers, and the belief grew up that whosoever saw
his image on a certain day would be protected from
death and injury. Consequently a painted or three-
dimensional image of the Saint was often placed
opposite the entrance of churches, where everyone
who entered would see it.

Wood, carved in the round, and painted in polychrome,
h. 60.2 cm, w. 21.6 cm
Given by Mrs Sigismund Goetze
M.5-1943

Right:
Tapestry: The Adoration of the Magi
Flemish, Tournai, *c.*1500

By the late fifteenth century Brussels
was increasingly the main centre of
high-quality tapestry production.
Nevertheless, despite the local
political instability created by the
struggle between the French and
Burgundian rulers, weaving in
Tournai prospered until a rapid
decline in the sixteenth century.
Its workshops produced sets of
tapestries, both to commission and
as general stock. This tapestry has no
identifying marks and entered the
Fitzwilliam without any provenance.
However, the subject-matter, the
range of colours used and the
pictorial style are characteristic of the
output of Tournai, and suggest that
it was made there. A very similar
tapestry is now in Leeds Castle, Kent.
Compared to the strong, clear
colours of the Fitzwilliam's example,
that at Leeds is much lighter (faded?)
in tone, although both use a typically
restricted palette. Both have a
straightforward composition with
easily identifiable figures.

Wool with silk details, 287 x 180.5 cm
Bequeathed by C. B. Marlay
MAR.T.30-1912

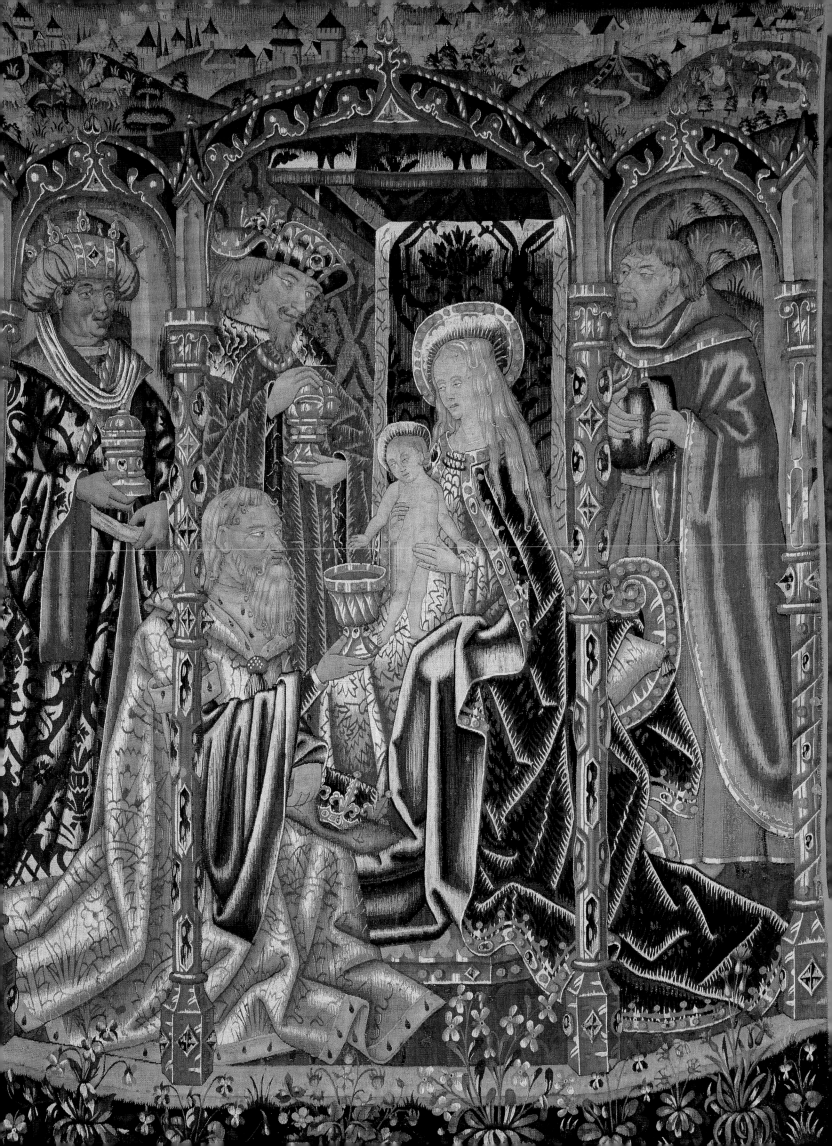

Tazza, with the Lion of St Mark
Venice, *c*.1500

Fifteenth-century Venetian glassmakers working on the island of Murano, notably
Angelo Barovier (d. 1460), developed clear, almost colourless soda-glass known as
cristallo. Although admired for its transparency, *cristallo* invited the application of
colourful decoration in enamels, and was made even more luxurious by the
application of gold leaf. Wide shallow bowls standing on a low foot, known as
tazze, were one of the common shapes in production at the end of the fifteenth
century and in the early sixteenth. Many of them were 'half-moulded' to produce
ribs on the underside of the exterior before being blown, tooled and rotated to
open them out into their final form. Contrary to what one might imagine, the
borders of gold leaf and enamels were applied before this last step took place. The
central medallion might be decorated with a coat of arms or an emblem. This
tazza has the winged lion of the Evangelist St Mark, which Venice had adopted as
her emblem after the relics of the Saint were taken there from Alexandria in 828.

Glass, gilded and enamelled, diam. 28.8 cm
Bequeathed by C. B. Marlay
MAR.C.116-1912

Mercury
Giovanni Francesco Rustici (1474–1554)
Florence, *c*.1515

This bronze portrays Mercury, the messenger of the
gods, as a lithe muscular youth poised to take flight.
According to Giorgio Vasari in his *Lives of the Most
Eminent Painters, Sculptors and Architects* (1568),
this Mercury was commissioned from Rustici in
1515 by Cardinal Giulio de' Medici for the top of a
fountain in the great court of the Medici palazzo in
Florence. A pipe inserted into one leg took water up
through the torso and out through Mercury's
nozzle-shaped, pursed lips. In his right hand he held
a wand with four projecting wings which the force
of the water spun around. As late as 1925 this wand
or a replacement was still present, as were the small
feathered wings that identified the bronze as
Mercury. The figure is in the realistic style of the
fifteenth century, and is more akin to the work of

Antonio Pollaiuolo than of sixteenth-century
sculptors such as Michelangelo. But Vasari's later
date is probably correct, for the Medici were
banished from Florence in 1494, and did not
return until 1512. Sculpture and furnishings
from the Medici palazzo were sequestrated or
sold during that period, and it is doubtful
whether a statue as small as this would
have remained there.

Copper alloy, probably bronze, on a breccia
marble ball, figure h. 47.9 cm
Bequeathed by the Hon. Mrs Pamela Sherek,
from the collection of the late Lt-Col. the Hon.
M. T. Boscawen, DSO, MC in his memory:
M.2-1997

Dish from the Isabella d'Este service
Painted by Nicola di Gabriele Sbraghe (active 1520–1537/8)
Urbino, *c.*1524

The introduction of *istoriato* (story) decoration drawn from either the Bible, classical literature or history was the most significant development in Italian maiolica during the early sixteenth century. It coincided with the increasing use of plates and dishes at table, and made maiolica attractive to educated and wealthy patrons. This is one of 21 complete dishes surviving from a service that belonged to Isabella d'Este (1474–1539), who was a notable art collector and the widow of Francesco Gonzaga,

4th Marchese of Mantua. Isabella's ownership is indicated by the presence of the Este–Gonzaga arms in the centre, and by two of her personal devices or *imprese*: XXVII, and a crucible containing gold bars. In Italian the first device sounded like 'You are defeated' referring to her opponents, and the second symbolized incorruptibility. The service was decorated by Nicola di Gabriele Sbraghe (active 1520–1537/8), the most talented maiolica painter in Urbino in the 1520s. This dish illustrates the myth of Peleus

and Thetis. The iconography was based on a wood-cut illustration in a popular Italian paraphrase of Ovid's *Metamorphoses,* first published in Venice in 1497. But Nicola's rendering of the figures was more sophisticated, and he added an illusionistic landscape background.

Tin-glazed and painted earthenware, h. 3.8 cm, diam. 30.2 cm
Purchased with the Glaisher Fund
EC. 30-1938

Plaque: *Aeneas and the Sybil in the Underworld*
Limoges, by the Master of the Aeneid Series, *c*.1530

The *Aeneid*, an epic poem by the Roman poet Virgil (70–19 BC) describes the journey of the Trojan hero Aeneas and his companions to Italy, and culminates in the legendary founding of Rome. At one stage of his journey Aeneas was guided by the Cumaean Sibyl through the Underworld to visit his dead father, Anchises. This Limoges painted enamel plaque illustrates Tartarus, where various characters are shown in torment, such as Tityus being pecked by a vulture (bottom right). This is one of 82 recorded plaques illustrating episodes from the *Aeneid*, probably made *c*.1530. The scenes were copied, though not slavishly, from woodcut illustrations to Books I–IX of the *Aeneid* in the complete works of Virgil, edited by Sebastian Brandt, and published by Johann

Grüninger in Strasburg in 1502. This influential work was the first printed book to have illustrations of the *Aeneid*, and the characters shown in the plates were labelled to assist readers to understand the text, a feature repeated by the enameller. The original location of the plaques is unknown, but they were probably displayed in a frame, or set into the panelling of a study, where their theme would have been appropriate.

Copper, enamelled, and gilded, h. 22.4 cm, w. 20 cm
Given by the Friends of the Fitzwilliam Museum
M.7-1945

The Adoration of the Magi
Flemish, *c.*1540

In the *Adoration of the Magi* the infant Christ is worshipped by three wise men or kings from the East, who bring him gifts of gold, frankincense and myrrh, symbolizing kingship, divinity and suffering. In art this event is an opportunity to contrast Christ's innocence, and the modest status of his parents, with a display of worldly wealth in the persons of the kings. Their sumptuous costume in this unusually large and finely carved alabaster relief is consistent with a date of *c.*1540. The presence of a rosary, not normally associated with the *Adoration of the Magi*, but an attribute of St Dominic, whose Order promoted its use, suggests that the relief was made for a Dominican church. The origin of the relief is debateable. On stylistic grounds it appears to be Flemish, but the initials *A.H.* (by the Virgin's foot) do not conform to those of a known sculptor working in Mechelen, the chief centre for alabaster carving in the Southern Netherlands.

Alabaster, with traces of paint and gilding,
h. 78.5 cm, w. 68.5 cm, d. 20 cm
Mark: A.H.
Purchased with the Cunliffe, Leverton Harris and Marlay Funds, with contributions from the Regional Fund administered through the Victoria & Albert Museum, and the Eranda Foundation
M.3-1980

See enlarged detail on pages 122–3

Embossed steel with gilded details,
h. 31.4 cm, w. 20.2 cm, d. 29.3 cm
Given by the Friends of the Fitzwilliam Museum with
a contribution from the National Art Collections Fund
M.19-1938

Parade burgonet
Milanese, c.1540–45

Although rather worn and lacking its cheek pieces, this burgonet is an impressive representative of the embossed and gilded parade armour worn by the ruling class during the Renaissance. Its shape and decoration were inspired by Roman armour, and the lion's mask fall piece is reminiscent of a gladiator's visor. It is not a visor, however, having no holes in the eyes, and must have been worn raised, rather than down, as shown here. The sides of the skull are embossed respectively with winged nude half-figures of Fame and Victory terminating in acanthus leaves and foliated scrolls. The comb has a row of trophies, and, on the right side, an open book inscribed in Greek 'By these things to the stars', indicating that through Fame and Victory the wearer would gain immortality. Since 1935, when it surfaced at a sale of 'theatrical junk', this burgonet has been attributed to the workshop of Filippo Negroli and his brothers in Milan, one of the greatest armour producers in Europe in the sixteenth century. But recently this attribution has been questioned on stylistic grounds.

Ewer
Paris, with date letter for 1585–6

Sixteenth-century French silver is now extremely rare, despite frequent mentions in contemporary documents. This ewer can be attributed to Paris because it bears the warden's mark of the Paris goldsmiths' guild, which incorporates a year letter for 1585–6. The ewer may have been used, but is more likely to have been displayed on a *dressoir* (buffet) with other silver-gilt vessels at meal times. Possibly it was accompanied by a basin, but the pairing of ewers and basins was not *de rigueur* at that time. Its antique form with a high handle, and eclectic decoration over the entire surface, are typical of the Mannerist style in silver. The sides are chased with oval frames enclosing allegorical figures of the three Pauline virtues, Faith, Hope and Charity, and one of the four cardinal virtues, Fortitude, an appropriate choice in a period of religious persecution. Between the medallions and on the neck are grotesque masks, fruit, nude figures and sea monsters of antique origin. The overall design is comparable to a drawing of a ewer by Etienne Delaune (1518–1583) in the Bibliothèque Nationale, Paris, except for its handle, which is in the form of two serpents issuing from a cornucopia.

Silver-gilt, embossed, and chased, with cast handle,
h. 29.5 cm, diam. of foot 8.2 cm
Bequeathed by L. D. Cunliffe, 1937
M/P.10-1938

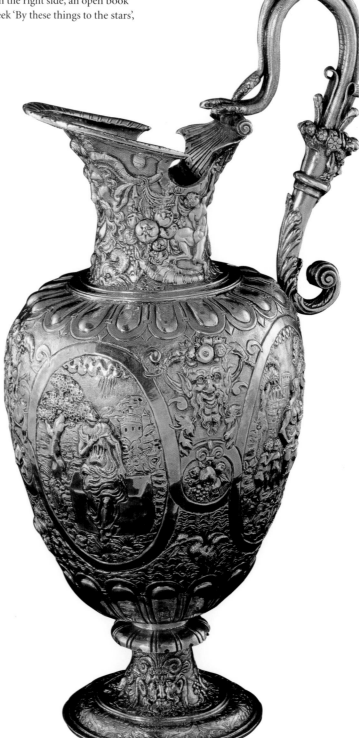

Goblet

**Glasshouse of Giacomo Verzelini (1522–1606),
probably decorated by Anthony de Lysle
London, 1578**

English glass technology in the sixteenth century
was less advanced than on the Continent, and
luxury drinking vessels of colourless glass known as
cristallo were imported from Venice. Demand
outstripped supply, and in 1567 Jean Carré from
Antwerp set up a glasshouse in London to produce
Venetian-style glass. By 1571 he had been joined by
Giacomo Verzelini, a Venetian, who had worked in
Antwerp for many years. On Carré's death in 1572,
Verzelini took over the running of the glasshouse,
and in 1574 was granted a patent giving him the sole
right to make and sell Venetian-style glass for 21
years. Two years later he was granted denization, and
remained in England for the rest of his life. This
goblet is one of nine attributed to Verzelini's
glasshouse on the basis of their diamond-point
engraved decoration, which incorporates dates
between 1577 and 1586. The deep bowl is engraved
with a stag, a unicorn and hounds, with cartouches
below enclosing the owners' initials *RT* and *AT*
entwined by lover's knots, and the date 1578. This
was probably the work of Anthony de Lysle, a
Frenchman recorded in London in 1583 as a 'graver
in puter and glass'.

Dark soda glass, diamond-point
engraved , h. 21.6 cm
Purchased with the Beves,
Marlay and Glass Duplicates
Funds and Grant-in-Aid from the
Victoria & Albert Museum
C.4-1967

Bacchus

**Willem Danielsz. van Tetrode
(*c*.1520/25–1580)
Rome or Delft, *c*.1562–72**

Willem van Tetrode's bronzes were
extolled by his contemporaries in
Italy and northern Europe, but after
his death he sank into obscurity until
rediscovered by art historians in the
twentieth century. Born in Delft, he
spent much of his working life in
Italy, where he was recorded in
Florence in 1548. He returned Delft
in 1566 or 1567, but by 1574 had
moved on to Cologne. He died in
Arnsberg, Westphalia, in 1580. The
Mannerist style assimilated by van
Tetrode in Florence and Rome is
evident in the athletic body and vine-
bedecked coiffure of this elegantly
posed Bacchus. The god holds up a
bunch of grapes in his left hand, and
probably held a drinking cup, or
another bunch of grapes, in his right.
His downward gaze may seem
puzzling, but the model was derived
from an antique marble of a satyr
teasing a panther with a bunch of
grapes. The presence of a separately
cast panther beside van Tetrode's
Bacchus is indicated by the mention
of moulds for an antique Bacchus
and a tiger (*sic*) by 'Tettero' in an
inventory taken in 1624 of the
workshop of a Delft goldsmith and
collector, Thomas Cruse.

Bronze, cast and chased, h. 50.5 cm,
w. 15.5 cm, d. 17 cm
Bequeathed by C. B. Marlay
MAR.M.204-1912

Nautilus shell cup
English; London, 1585–86

From 1497 onwards the Portuguese voyages of discovery to India and the East led to a gradual increase in imports of oriental manufactured goods and exotic natural materials. These included coconuts and shells, which fuelled a fashion for mounting them in silver-gilt as fanciful cups. These were not for use, but formed the highlights of groups of ornate vessels displayed to impress guests, or collections of rare objects to be admired in the privacy of their owner's study. Nautilus shell cups were especially popular, and they survive in many European collections. The outer layer of the shell was usually removed to reveal the nacreous surface below, which might be engraved or carved. The oriental figures, buildings and trelliswork on this example were probably executed in China. The marine imagery employed on the mount – the lobster (is it one?) clasping the volute of the shell, the sea monsters amid waves on the foot, and the three-dimensional figure of a man astride a dolphin that supports the shell – is similar to the decorative repertory employed by Antwerp goldsmiths. A number of these had emigrated to London to escape religious persecution in the Low Countries after the sack of Antwerp in 1576.

Nautilus shell with decoration probably engraved in China, mounted in silver-gilt
with maker's mark, *TR* in monogram, h. 24.4 cm, l. 19 cm
Bequeathed by L. D. Cunliffe, 1937
M/P.4-1938

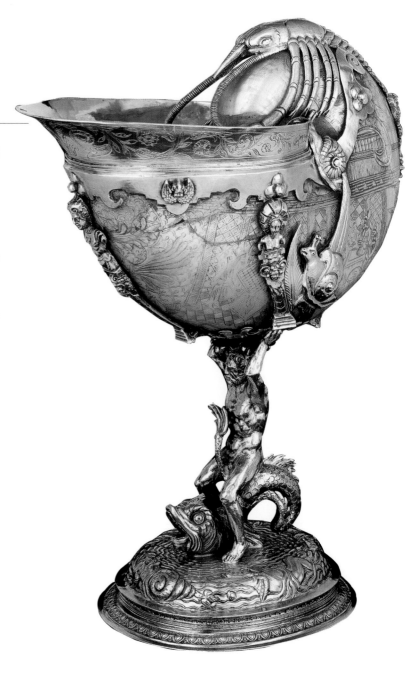

Jug
Isnik, *c.*1580–91

Isnik in northern Anatolia became an important pottery centre in the late fifteenth century, when its potters invented a new type of white fritware coated with fine white slip and painted underglaze in blue. Although early Isnik ware was influenced by Chinese porcelain, its decoration incorporated distinctively Ottoman motifs derived from book-binding, calligraphy and textiles. By the mid-sixteenth century, exuberant floral designs of tulips, hyacinths and large serrated saz leaves had evolved. Turquoise, purple and green were added to the palette, and finally, in the 1550s, a vivid 'sealing wax' red. The simple design of hyacinths and stylized pomegranates on this jug illustrates the charm of these bright colours against a white ground. Isnik pottery began to reach England during the sixteenth century, and imports probably increased after a grant of commercial privileges by Murad III in 1580 made it easier for English merchants to trade with Turkey. At that time it was fashionable to mount imported ceramics in silver-gilt to protect their edges and enhance their appearance. This jug is one of three known whose mounts bear London date letters – for 1586–7, 1592–3 and 1597–8 respectively – which provide a guide to the dating of Isnik ware with comparable decoration.

Fritware, slip-coated, and painted underglaze, h. 25.4 cm
Mounts, London, 1592–3; maker's mark: *IH*
Purchased with the Leverton Harris Fund and from the bequest of Albert Leopold Reckitt
M.16-1948

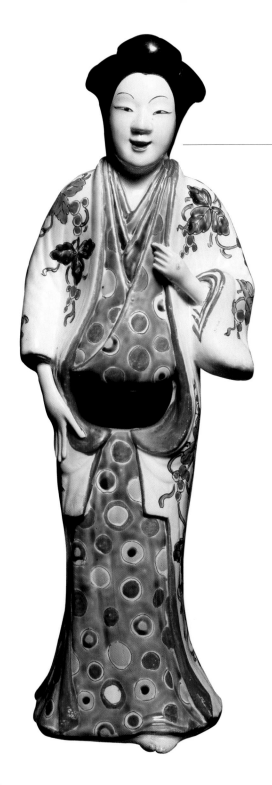

Figure of a *bijin* (beautiful lady)
Japanese, Arita; Kakiemon style, *c.*1680–1700

Despite Japan's proximity to China, porcelain does not appear to have been made in Japan until the early seventeenth century. The industry developed in Arita on the west of Kyusho island, where there were sources of china clay and stone. By the 1640s polychrome enamel decoration had been introduced, and its production was stimulated when the Dutch – after 1639, the only Europeans Japan permitted to trade directly with it – began to export porcelain to Europe in 1659. The exports during the later part of the century included tableware such as cups and dishes, vases and jars for ornamental use, and figures of mythical and real animals, and of people. This standing *bijin* (beautiful lady) wears a kimono decorated on the back with trailing vine sprays. The colouring, and the vine pattern on the kimono, are in the style traditionally associated with the Kakiemon family of enamellers in the late seventeenth century, although it has recently become evident that they were not the sole executants. A mould for a *bijin* of similar type was found on the site of the modern Post Office in the enamellers' quarter of Arita in 1988.

Hard-paste porcelain decorated overglaze
in enamels, h. 38.7 cm
Given by the Friends of the Fitzwilliam Museum
C.3-1961

Tsuba with cut-out dragon
Japanese; Fukui in Echizen province,
18th to first half of 19th century

During the peaceful Edo period (1600–1868), samurai wore a pair of swords (*daishō*) with finely decorated mounts as symbols of their rank. *Tsuba*, the projecting hand-guards between the blade and hilt, were produced by specialist makers. Most of those in Western collections came from the longer of the pair of swords, the *katana*. *Tsuba* were traditionally made of forged iron, but softer metals were also employed. They were decorated by cutting out the background of the design, or by applying decoration in various alloys. Themes included flora and fauna, subjects from Japanese mythology, and the animals known as the 'Twelve Earthly Branches', which preside over the years, months and hours. These were popular decorative motifs on domestic and military equipment. This *tsuba* is cut out to show a dragon, the most powerful of these creatures. It was made in Echizen province by a member of the Kinai family, who specialized in iron *tsuba*, and often used a cut-out dragon motif.

Iron, signed in Japanese characters,
Kinai of Echizen, diam. 9.9 cm
Bequeathed by J. E. Helm
HELM.13-1946

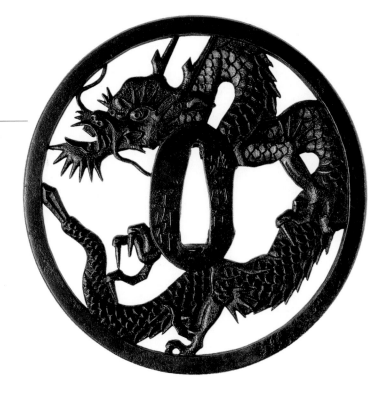

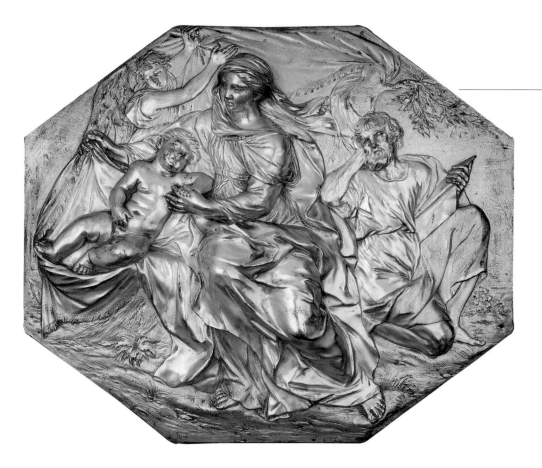

Plaque: *Rest on the Flight into Egypt*
Alessandro Algardi (1598–1654)
Italian, Rome, *c.*1635–40

Alessandro Algardi trained as a sculptor in Bologna, and after working briefly at Mantua moved to Rome in 1625. By the mid-1630s major commissions were beginning to come his way, and by the 1640s he was recognized as the city's most outstanding sculptor after Bernini. This octagonal relief of the *Rest on the Flight into Egypt* shows the Virgin tenderly holding out a cloth to shelter the sleeping Christ Child while Joseph sits further back holding a book. Joseph rests his head pensively on his hand, possibly reflecting on the prophesies concerning Christ's destiny. This relief can be attributed to Algardi on the basis of an engraving after it by Edward Le Davis (*c.*1640–*c.*1684), which bears an inscription citing Algardi as author. This evidence is supported by similarities between the composition and two drawings showing variants of the subject, one in the Royal Collection and the other in the Metropolitan Museum of Art, New York. The relief's popularity is shown by the existence of more than 20 versions, most in bronze or other metals, of which this cast is considered the finest.

Copper alloy, probably bronze, cast, chased and gilt,
h. 29.3 cm, w. 35.5 cm
Given by Miss Alys Kingsley
M.1-1939

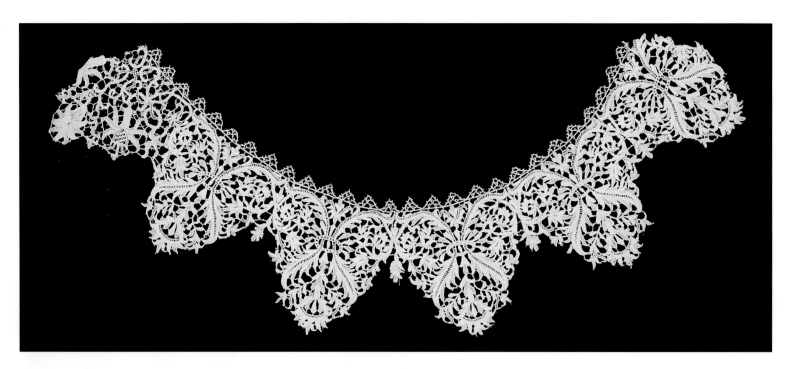

Collar
Italian, Venice, 1625–50

In the sixteenth century the phrase *punto in aria* was used for cutwork embroidery but by the seventeenth century it had come to mean a freely formed needle lace exemplified by this scalloped collar. Although the design is elaborate, the technique and quality of the linen thread meant that this type of lace was frequently used for furnishings and ecclesiastical vestments, as well as for costume accessories. The robust and solid appearance of needle lace was fashionable early in the century. This collar is a good example of an uncommon lace made at a time when bobbin lace was beginning to establish its dominance in a booming market led by extravagant court fashions. As ruffs and standing collars gave way to a softer style of neckwear in the form of falling bands, the softer finer Flemish bobbin lace replaced the heavier needle laces.

Linen; needle lace, w. 62 cm, h. 13 cm
Given by Mrs Dendy Marshall
T.18-1950

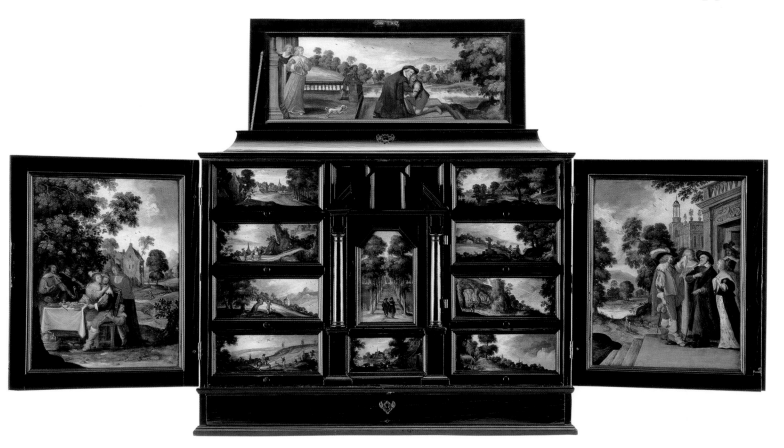

Cabinet
Flemish, Antwerp, *c.*1640

Cabinets used for the storage of writing materials and documents or collections of treasured possessions were the most prestigious class of furniture in the seventeenth century. Essentially a rectangular box enclosing a series of drawers or compartments concealed by locking doors, they were inventively decorated with exotic woods, marquetry, tortoise-shell and other materials. This cabinet is typical of those made in Antwerp in large numbers between the 1620s and the 1660s. Their chief attraction is the decoration of the interior surfaces with colourful oil paintings, which delight the eye when the doors of the dark ebony-veneered exteriors are opened. The fronts of the small compartments of this cabinet are painted with figures in landscapes, while the two doors and the underside of the lid in the top show episodes from the story of *The Prodigal Son*, possibly by Frans de Momper (1603–1660). The central door conceals a 'perspective' – an illusionistic compartment with a chequered floor, and mirrors – which was a feature of Antwerp cabinets. Here the central wall is painted on one side with a gentleman, and on the other a lady, who are visible only in the mirrors on the side walls.

Ebony, bone and mirror; oak panels painted in oils,
h. 66.5 cm, w. 82.2 cm, d. 36.9 cm
Given by Louise Nichols, Birgit Carolin and
Hélène Mitchell in memory of their parents,
Johannes Herman and Hélène Warning,
and their grandparents, Robert and Hélène de Vos
M.54-1997

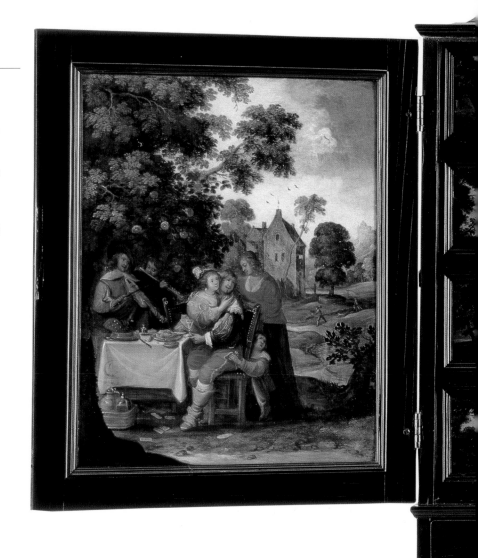

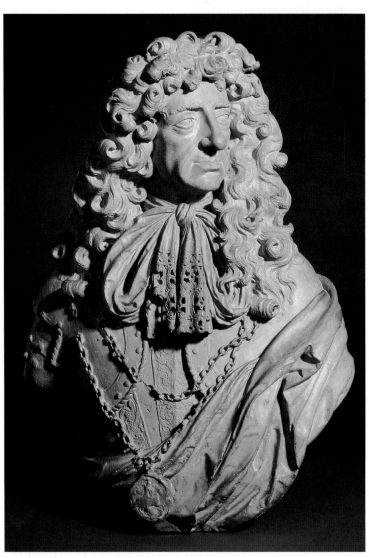

Charles II
Attributed to John Bushnell (*c.*1606–1701)
English, *c.*1678

Portraits of Charles II abound in various media, but this bust is notable because so little English seventeenth-century terracotta sculpture has survived. The bust was at the Serjeants-at-Law's Inn in London's Chancery Lane when the Inn was closed and dismantled in 1877. It therefore seems likely either that it was commissioned for the Inn, which was rebuilt between 1669 and 1677, or that it was donated by one of its members. The King is shown clean-shaven with a deeply lined face, closely resembling painted portraits of the late 1670s and early 1680s. He wears a lace cravat and the Garter medallion of St George on a double chain over armour. The piercing of the cravat and the deeply hollowed curls of the luxuriant periwig resemble the treatment of these features on more costly marble busts. Waist-length busts were by then old-fashioned, but the sharp turn of the head, characteristic of Baroque portraiture, shows that the sculptor was acquainted with contemporary Continental busts. This suggests that the bust could have been commissioned from John Bushnell, who had spent some ten years working in the Netherlands, France and Italy during the 1660s. On his return to England he obtained several important commissions, including two statues of the monarch, but his erratic temperament affected his work, and he died bankrupt.

Terracotta, h. 78.5 cm
Given by Sir Bruce S. Ingram, OBE, MC
M.1-1948

Slipware dish
Thomas Toft (active 1663–89)
Staffordshire, *c.*1662–85

Trailed slipware was being made in north Staffordshire by the 1640s, and was at its peak between *c.*1670 and 1730. Decorative dishes seem to have been one of the most popular lines made by potters in Burslem and the nearby villages, and many bear names or initials assumed to be those of the potter. After throwing, or moulding, the fronts of the dishes were coated with white or dark brown slip, and the motifs and border were slip-trailed in different coloured clays. Then powdered lead ore was sprinkled over the surface, and during firing formed a clear yellowish glaze. Over 30 dishes survive bearing the name of Thomas Toft. Most of them are decorated with loyal images of the monarch or the royal arms, and it seems likely that the couple on this one represent Charles II and Catherine of Braganza, who were married in 1662. But the dish may have been made some years after that, for Toft's only known dated dishes were made in 1671 and 1674.

Slipware, diam. 42.5 cm
Bequeathed by Dr J.W.L. Glaisher
C.207-1928

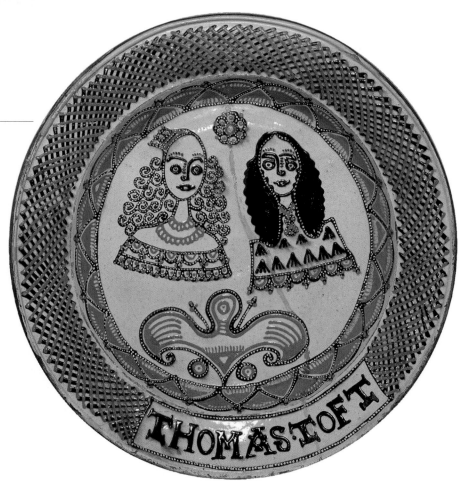

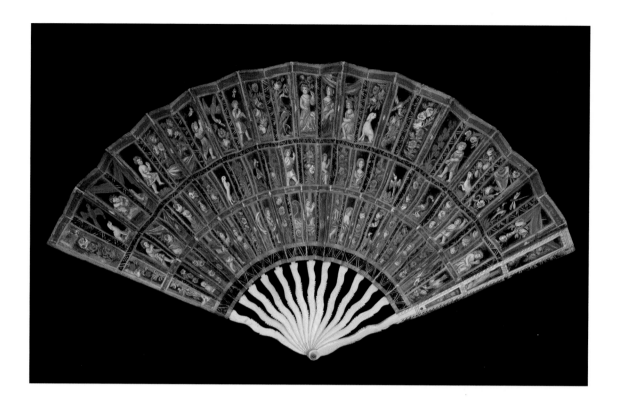

Mica fan
European, late 17th century

Folding fans with pleated leaves were introduced into Europe from the Far East in the sixteenth century, and their use was widespread by the mid-seventeenth century. The sticks and guards were usually made of wood, bone, ivory or tortoiseshell, and the leaves of fine skin, paper or silk. Fans with translucent mica inserts had been made since the late sixteenth century, but examples with leaves made mainly of mica are now extremely rare. Only three examples are known that are strictly comparable to this one, which is constructed of three rows of mica panels, naïvely painted with children, dogs, birds and rose sprays, and mounted between strips of painted and gilt paper. This example is one of over 500 fans and unmounted fan leaves, both European and Oriental, acquired from the late Anne, Countess of Rosse. They had been amassed by her father Colonel Leonard Messel (1872–1953), who was among the earliest English collectors to value fans for their historical and aesthetic interest rather than viewing them simply as costume accessories or family heirlooms.

Painted mica mounted in paper, with bone sticks and guards, l. 25.8 cm (guards), w. 45 cm (open)
Given by the Friends of the Fitzwilliam Museum with a grant from the National Heritage Memorial Fund
M.359-1985

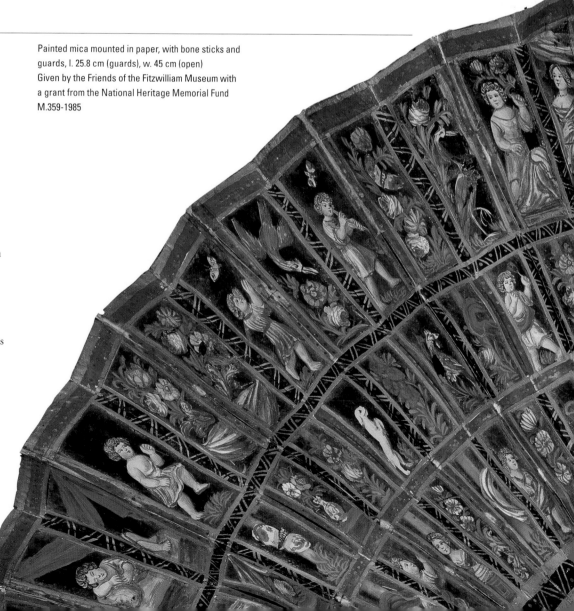

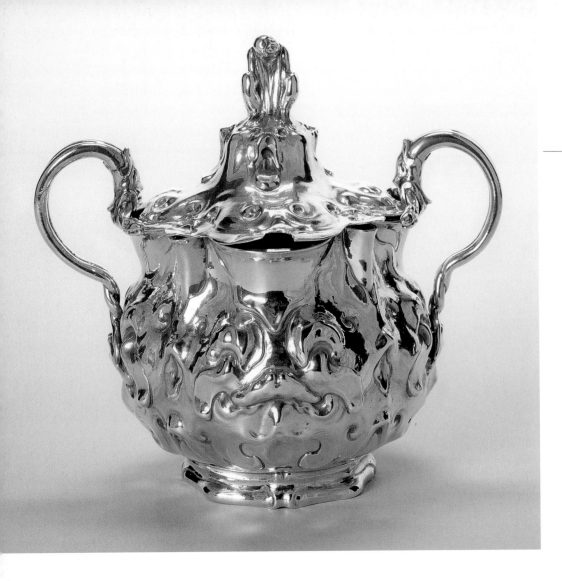

Two-handled cup and cover

Attributed to Christian van Vianen (*c*.1600/05–1667)
London, *c*.1660–65

In the Restoration period in England, posset (a drink made of milk curdled with ale or wine) was served in two-handled cups, known as porringers. Silver porringers usually had a cover, and were sometimes accompanied by a salver. This one is unusual in being decorated in the auricular style, characterized by undulating forms reminiscent of an ear. Grotesque fish-like and human masks seem to emerge from its rippling surface. The handles are in the form of serpents, and on top of the cover is a mysterious crouching figure. The cup is unmarked, suggesting that it was made by an immigrant craftsman who was not admitted to the Goldsmiths' Company. The most likely is Christian van Vianen, who came from an illustrious Utrecht family of silversmiths, and was an accomplished exponent of the auricular style. Van Vianen worked in London between 1632 and 1643 in the pay of Charles I, and returned in 1660 when he was appointed 'Silversmyth in Ordinary' to Charles II. The porringer is comparable to one in a book of designs by his father, Adam van Vianen (*c*.1568–1627), published by Christian in Utrecht in 1650.

Silver, embossed and chased, with cast foot, h. 18.6 cm, w. 20.3 cm
Purchased with the H. S. Reitlinger Fund, and grants from the National Art Collections Fund, and the Museums and Galleries Commission Purchase Grant Fund administered by the Victoria & Albert Museum
M.2-1999

Posset pot

George Ravenscroft, probably the Savoy Glasshouse
London, *c*.1677–8

This simple posset pot is one of the most significant pieces in the Fitzwilliam's outstanding collection of English glass. At the base of its spout is an applied raven's head seal, indicating that it was made in the London glasshouse of George Ravenscroft (1632–1683). Ravenscroft, a merchant who had spent several years in Venice, set up a glasshouse in the Savoy off the Strand in 1673, and in 1674 was operating another at Henley-on-Thames. In that year he was granted a patent for seven years for the manufacture of 'Christaline Glasse glass resembling Rock Crystall'. However, although his glass was initially clear, it soon developed crizzling. This defect was pronounced cured in 1676, and in 1677 Ravenscroft made an agreement with the Glass Sellers' Company, stating that the perfected glass would in future be marked with a raven's head, to distinguish it from other glass. Analyses of glass with the raven's head seal indicate that the improvement was achieved by adding increasing quantities of lead oxide to the 'batch'. In 1679 Ravenscroft withdrew from glassmaking, and after the expiry of his patent in 1681, other glassmakers continued the manufacture of 'lead-crystal'.

Faintly crizzled lead-glass, h. 7 cm
Mark: raven's head seal on base of spout
Bequeathed by Donald H. Beves
C.564-1961

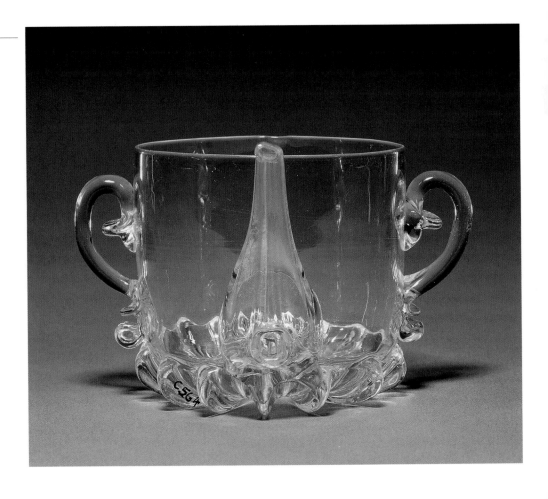

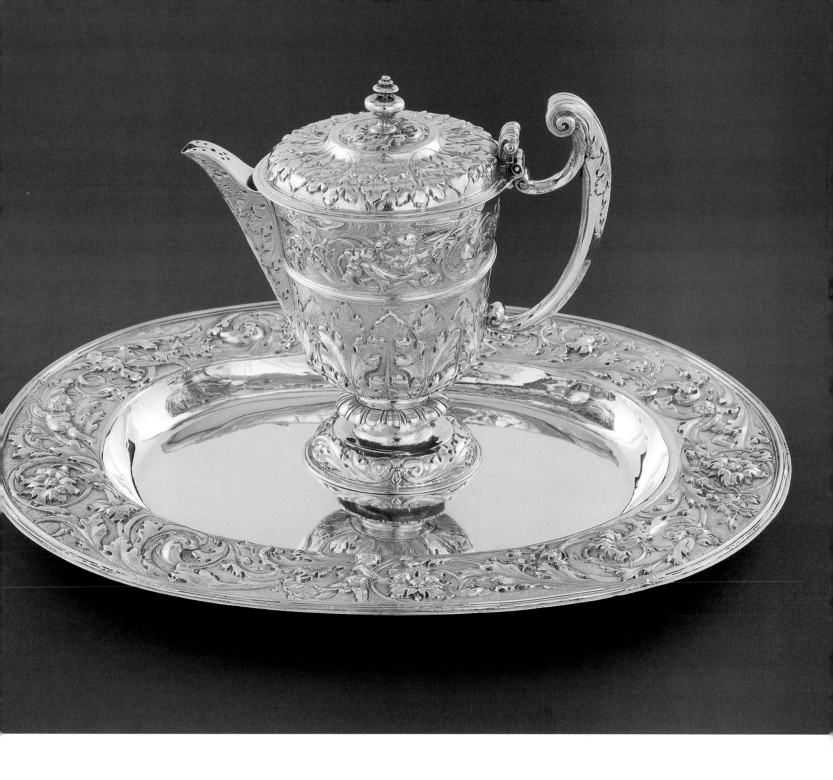

Ewer and basin
Probably Paris, *c.*1656–8

The forms of this silver ewer and basin, and their decoration of acanthus leaves and *putti* amid scrolling foliage in the style of designs by Jean Lepautre (1618–1682), are comparable to Parisian work of about 1650–75. But they are unmarked, and their attribution to Paris is therefore uncertain. This is tantalizing, because French silver of that period is extremely rare, much of it having been destroyed in melts ordered by Louis XIV later in his reign to raise funds for his military campaigns. According to family tradition, the ewer and basin were given by the King to Sir William Lockhart of Lee (1621–75) while he was Cromwell's ambassador to Paris, between April 1656 and March 1657. After Cromwell's death in 1658 Lockhart delivered Richard Cromwell's

greetings to the King, and remained in France until 1660. A royal gift made by a goldsmith working in the Galerie du Louvre need not have been marked, but a gift at that date cannot be confirmed because the *Listes des presents du Roi* do not cover this period. Alternatively Lockhart, like many other foreign diplomats in Paris, may have purchased silver to take home, which for illicit reasons was not marked.

Silver, embossed, chased and matted; ewer: h. 19.8 cm; basin: l. 41.5 cm, w. 30.2 cm
Purchased with the Golland and Rylands Funds with a grant from the B. N. Stuart Bequest to the National Art Collections Fund
M.468 & A-1985

Applied Arts

Raised work panel with scenes from the story of David and Bathsheba
English, 1700

Three-dimensional or raised-work embroidery was popular during the latter half of the seventeenth century. Although technically challenging, it was usually domestic rather than professional work, executed by the more competent female embroiderers. Frequently panels of raised work were used to cover caskets, as surrounds for looking-glasses, or simply as decorative pictures. They generally illustrated biblical or classical stories, or depicted royal or renowned characters. This exceptionally large example tells the Old Testament story of David and Bathsheba in a series of pictorial vignettes. Some are worked in fine silk stitching on silk, others include not only a variety of threads – silk, linen, metal and purl – but also pearls, strands of feathers, mica, cotton-wool wadding and wooden moulds for the hands, feet and faces. Needle-lace techniques were used not only for semi-detached costume details, but also for architectural and landscape features. This panel was made when the fashion for embroidery of this kind was on the wane, giving way to a more naturalistic and flat style of work. Perhaps the image had taken some years to complete, and possibly it was the *tour de force* of the two sisters whose initials *AB* and *EB* are inscribed with the date.

Satin-faced silk, worked in linen, silk and metal threads, purl, seed pearls, feathers and mica, 46 x 57.5 cm
Given by Mrs L. G. Utting
T.5-1954

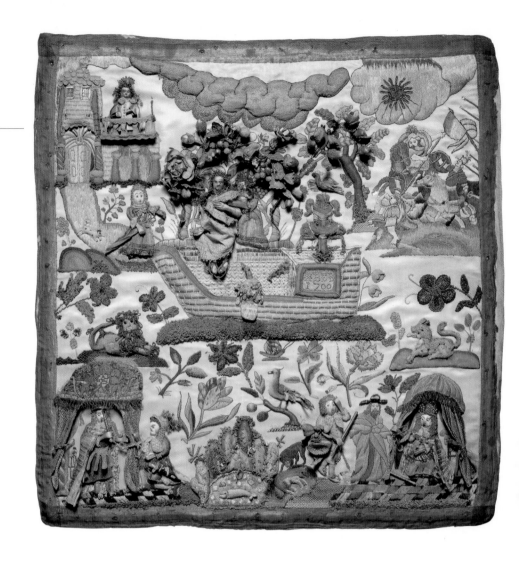

Casket
English, *c.*1650–75

A casket's complex embroidered panels would have been mounted by a cabinet-maker, but worked by a young girl of perhaps about twelve years old. Records provide the information that competent girls worked a coloured then a whitework sampler, often followed by pictorial embroidery for a casket. Familiar scriptural or classical themes were popular subjects. Here the Five Senses are depicted on the top, doors and sides, with Orpheus on the back. The Elements decorated the inner panels. Time with an Hourglass fills the central arch of the drawers, with floral and fruit motifs on the remainder. Hunting and pastoral scenes appear on the narrow bands. Ivory satin was the usual ground fabric. It was probably bought from a shop or supplier with the motifs ready drawn. Draughtsmen or drawers used and adapted pattern books, herbals and biblical and classical prints for pictorial embroidery, whether produced for stock or to commission.

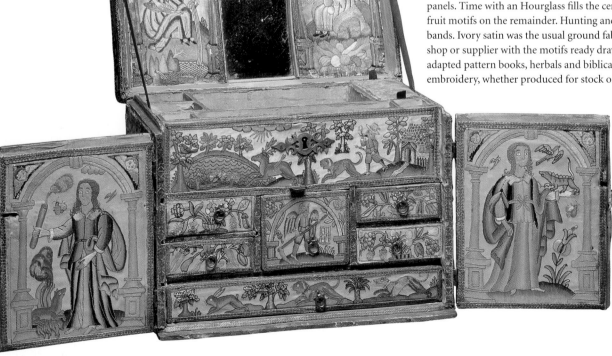

Silk, polychrome silk embroidery, h.23.6 cm, w. 27.1 cm, d. 16.5 cm
Given by Mrs W. D. Dickson
T.8-1945

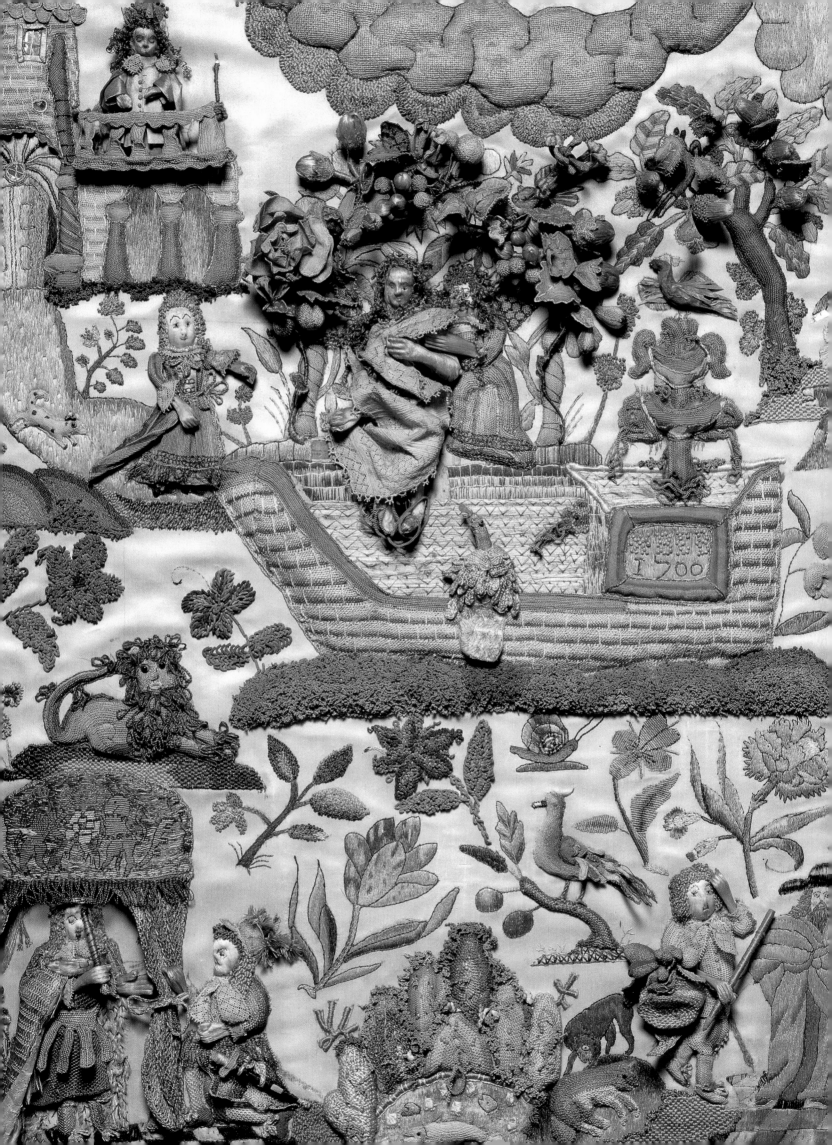

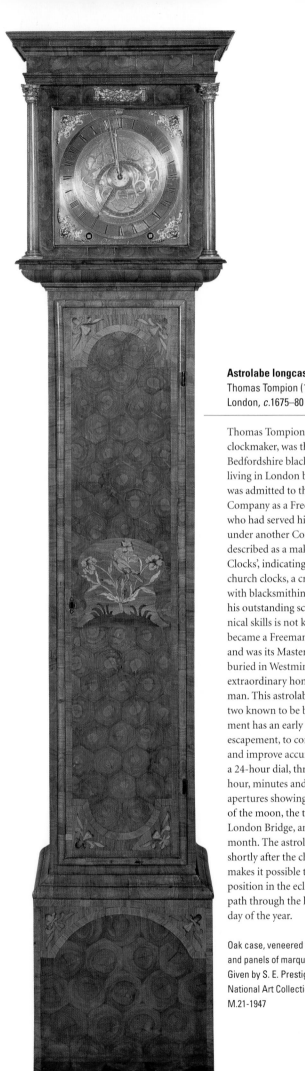

Astrolabe longcase clock
Thomas Tompion (1639–1713)
London, c.1675–80

Thomas Tompion, England's greatest clockmaker, was the son of a Bedfordshire blacksmith. He was living in London by 1671, when he was admitted to the Clockmakers' Company as a Free Brother – a man who had served his apprenticeship under another Company – and was described as a maker of 'Great Clocks', indicating iron turret or church clocks, a craft often combined with blacksmithing. How he acquired his outstanding scientific and technical skills is not known. In 1674 he became a Freeman of the Company, and was its Master in 1703. He was buried in Westminster Abbey, an extraordinary honour for a craftsman. This astrolabe clock is one of two known to be by him. The movement has an early form of anchor escapement, to control the pendulum and improve accuracy. The 'face' has a 24-hour dial, three hands telling the hour, minutes and lunar time, and apertures showing the age and phase of the moon, the time of high tide at London Bridge, and the day of the month. The astrolabe disc, added shortly after the clock was made, makes it possible to track the sun's position in the ecliptic (its apparent path through the heavens) for each day of the year.

Oak case, veneered with olive wood, and panels of marquetry, h. 194.5 cm
Given by S. E. Prestige through the National Art Collections Fund
M.21-1947

Table clock with *grande sonnerie* striking
Thomas Tompion (1639–1713) and Edward Banger (c.1669–1720)
London, c.1706

This sumptuous table clock was made by Tompion and Edward Banger, a former apprentice who had married Tompion's niece, Margaret, and was his partner between 1701 and 1708. It has an eight-day *grande-sonnerie* movement striking the quarter hours on six bells, a technical achievement requiring great ingenuity on the part of the maker. Apertures in the arch above the dial show the date and day of the week with their appropriate deities below. The clock is one of four *grande-sonnerie* clocks by Tompion and Banger with French-style cases of almost similar design. The oak carcase is veneered with reddened turtleshell, and is lavishly embellished with gilt-brass mounts, including *putti* amid scrolling foliage, female busts and vases, and, on the summit, a figure of Apollo, the god who drove the chariot of the Sun through the heavens each day. The backplate is engraved with floral decoration and is numbered 436, indicating that it was made about 1706.

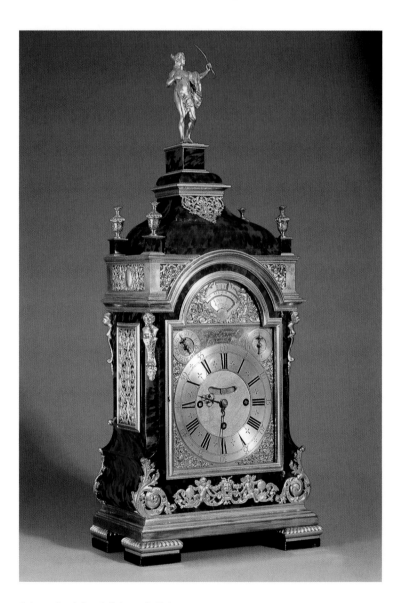

Oak, tortoiseshell and gilt-brass, h. 79.4 cm
Bequeathed by S. E. Prestige
M.4-1965

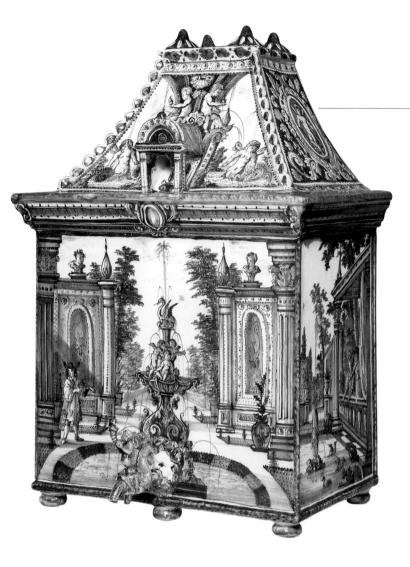

House-shaped cistern
Delft, the 'Greek A' factory, *c*.1700

The decoration of delftware was at its finest in the late seventeenth century and early eighteenth. Much of it was painted in blue in imitation of oriental porcelain, for which there was an insatiable demand, but European subjects were also popular. This cistern in the shape of a large Dutch house is one of the most charming pieces in the Museum's collection of over 400 pieces of delftware. Its outer walls are not decorated to resemble a house, but display three views of the courtyard and formal garden that might have been seen from its windows. The roof lifts off so that it can be filled with water, and the silver spigot in the shape of a dolphin ridden by a merman blowing a conch shell fits into a mask on the front, where it appears to be part of the sculptural decoration of the central fountain. The cistern is monogrammed *AK* for Adriaen Kocks, who was proprietor of the Greek A factory in Delft between 1686 and his death in 1701. It was one of the most flourishing potteries in the city, and counted William of Orange, and his wife, Mary Stuart, among its patrons.

Tin-glazed and painted earthenware with silver spigot, h. 42.3 cm, w. 30 cm, d. 24 cm (including tap)
Bequeathed by Dr J.W.L. Glaisher
C.2416-1928

Punch-bowl and cover (with replacement top)
Probably Liverpool, 1724

Early eighteenth-century Liverpool was a thriving port that was increasing in size and importance. The first delftware pottery was established there in 1710, and by 1725 there were four. This punch-bowl was probably made by one of these rather than in London or Bristol, the other main centres of production. The inside is painted with the arms of Liverpool and the cover bears the inscription 'THOMAS BOOTLE / ESQUIRE MEMBER / OF PARLIAMENT / FOR LIVERPOOLE / 1724'. Thomas Bootle (1685–1754), a Liverpool lawyer, was elected to Parliament in 1724 after two unsuccessful attempts, and in 1726 became Mayor of Liverpool. He stood for Parliament again in 1727 and held the seat until 1734. The bowl was inherited by his niece and was passed down in the family until 1910. Delftware punch-bowls were made in great numbers between the 1680s and late 1770s, and very large bowls are not uncommon. This one, however, is exceptional in having a three-part cover. The lowest part has a bowl-like depression in the top, covered by the foot of a smaller bowl and cover, possibly for sugar lumps cut from a cone. Like much English delftware of this date, it is painted in imitation of oriental blue and white porcelain.

Tin-glazed and painted earthenware, h. 59 cm
Bequeathed by Dr J.W.L. Glaisher
C.1716-1928

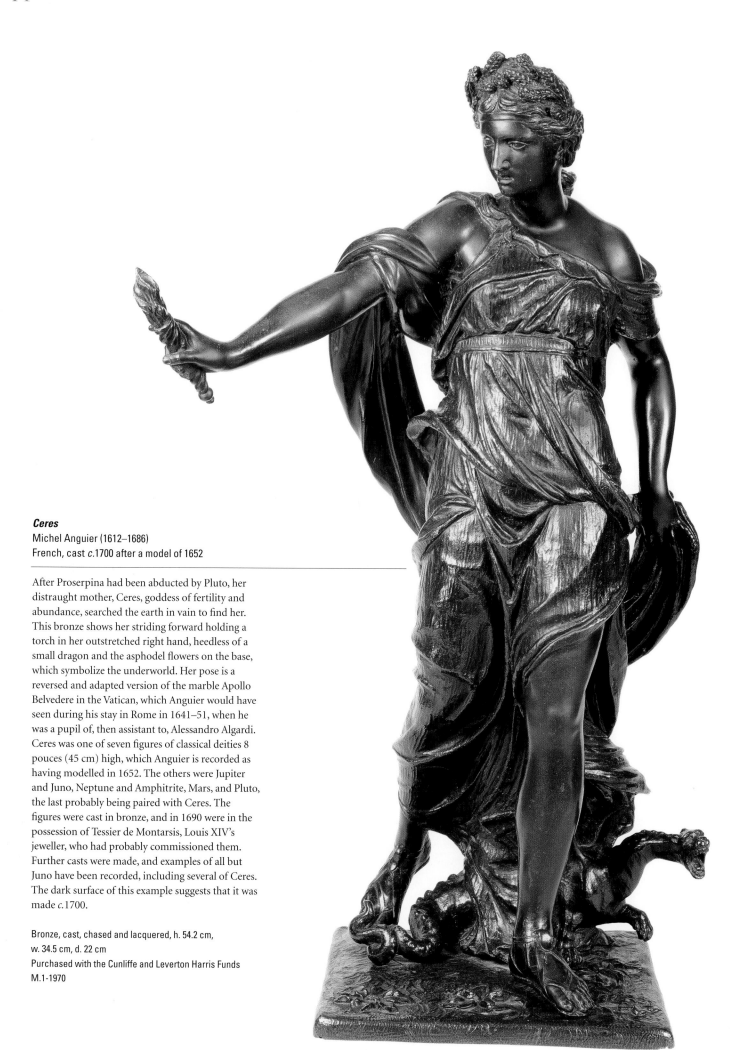

Ceres
Michel Anguier (1612–1686)
French, cast *c*.1700 after a model of 1652

After Proserpina had been abducted by Pluto, her distraught mother, Ceres, goddess of fertility and abundance, searched the earth in vain to find her. This bronze shows her striding forward holding a torch in her outstretched right hand, heedless of a small dragon and the asphodel flowers on the base, which symbolize the underworld. Her pose is a reversed and adapted version of the marble Apollo Belvedere in the Vatican, which Anguier would have seen during his stay in Rome in 1641–51, when he was a pupil of, then assistant to, Alessandro Algardi. Ceres was one of seven figures of classical deities 8 pouces (45 cm) high, which Anguier is recorded as having modelled in 1652. The others were Jupiter and Juno, Neptune and Amphitrite, Mars, and Pluto, the last probably being paired with Ceres. The figures were cast in bronze, and in 1690 were in the possession of Tessier de Montarsis, Louis XIV's jeweller, who had probably commissioned them. Further casts were made, and examples of all but Juno have been recorded, including several of Ceres. The dark surface of this example suggests that it was made *c*.1700.

Bronze, cast, chased and lacquered, h. 54.2 cm,
w. 34.5 cm, d. 22 cm
Purchased with the Cunliffe and Leverton Harris Funds
M.1-1970

Ganymede and the Eagle
Massimiliano Soldani-Benzi (1656–1740)
Florence, completed by 25 June 1717

Massimiliano Soldani-Benzi, known as Soldani, was an outstanding medallist, who was appointed Master of Coins and Custodian of the Mint in Florence by Cosimo III, Grand-Duke of Tuscany, in 1688. During his long occupancy of this post he also produced bronze sculpture, mainly of erotic themes from classical mythology. This table bronze portrays Ganymede, a beautiful Trojan shepherd, who was seduced by Zeus disguised as an eagle, and was carried to Mount Olympus to become his cupbearer. Here, Soldani makes Ganymede a willing participant in the abduction. He leans back, placing his arms around the eagle's shoulders and wing in preparation for take-off, while Cupid gives him a gentle push, and his dog gazes up in bewilderment. The contrast between Ganymede's smooth, relaxed body, and the tension in the bodies of the animals, whose plumage and hair are beautifully detailed, is typical of Soldani's work. A companion group, *Leda and the Swan*, echoes the composition in reverse. Terracotta models for both bronzes had been created by 1714, and at least three pairs were cast between 1716 and 1718. This bronze and its pendant formed the second pair, which was sold in June 1717 to Giovan Gualberto Guicciardini of Florence.

Copper alloy, probably bronze, cast and chased, h. 31.5 cm, l. 37.5 cm, d. 19.5 cm
Given by John Winter, in memory of his father, Carl Winter, Director of the Fitzwilliam Museum, 1946–66
M.59-1984

George Frideric Handel
Louis François Roubiliac (1702–1762)
London, 1738

Born in Lyon, Roubiliac trained as a sculptor in Dresden with Balthasar Permoser and worked for Nicholas Coustou in Paris before moving to London c.1730. He appears to have worked for Thomas Carter and Henry Cheere, and by 1738 had his own workshop in St Martin's Lane. This highly detailed terracotta was the model for his first major work, a marble statue of the composer Handel (1685–1759) commissioned by Jonathan Tyers, the proprietor of Vauxhall Gardens. On its installation there in April 1738, visitors to the Gardens were astounded by the realism of the statue, and it established Roubiliac's reputation as one of England's foremost sculptors. Public statues of living persons other than monarchs were rare in England, and the informality of Handel's attire and pose were strikingly different from male funerary effigies. The guide to the Gardens in 1752 described the statue of Handel as Apollo, but some visitors, such as the Hanoverian Count von Kielmanseg in 1760 identified it as Orpheus, who charmed the wild beasts by playing Apollo's lyre to them. By 1751 the terracotta was owned by Roubiliac's close friend, the painter Thomas Hudson, an indication of the growing appreciation of models as expressions of a sculptor's genius.

Terracotta, h. 47 cm
Given by Captain E. G. Spencer Churchill, MC
M.3-1922

153

Nobody
London, 1675

This rare figure of a pipe-smoker represents Nobody, an invisible person who for centuries has been a convenient stooge for everyone else's careless mistakes. The figure was probably derived from an illustration of Nobody forming the frontispiece to a play, *No-body and Some-body*, published in London in 1606. It showed Nobody as a bodyless man whose head and arms protruded from the top and sides of his voluminous breeches, and this image persisted until the delftware figure was made. Strangely, however, the painter of this Nobody decorated the breeches with buttons, as if they were a doublet. The underside of the base is initialled *M/ME* for a man and wife, and is dated 1675. A different figure of Nobody dated 1682 is at Colonial Williamsburg, Virginia, and a third is in the Victoria & Albert Museum, where there is also a Chinese porcelain copy, probably made later in the century or in the early eighteenth century. Both the last two have hats, and it seems likely that this Nobody had one too. All the figures are hollow, and may have been novelty containers that were later used as ornaments.

Tin-glazed and painted earthenware, h. 23.3 cm
Bequeathed by Dr J.W.L. Glaisher
C.1433-1928

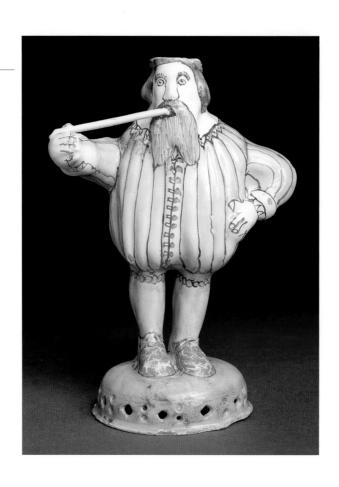

Pew group
Staffordshire, *c.*1740–50

The term 'pew group' describes an appealing class of salt-glazed stoneware figures of men and women who sit in twos or threes on high-backed settles. They were adeptly assembled from hand-modelled strips and rolls of clay, with some press-moulded parts, and details in brown clay or slip. Consequently, each of the recorded groups is unique. Their makers are unknown, but it seems certain that they were made in north Staffordshire, which was the most important area for the manufacture of white salt-glazed stoneware. Their costume suggests that the figures were made during the 1740s. This group shows a couple sitting decorously apart, the man playing a kind of bagpipes and the woman holding a lapdog. She sits bolt upright wearing an open robe over a striped stomacher, behind which she has tucked her fan. Her companion's wig is made of tiny curls of clay, and the many button-holes on his stiff-skirted coat are outlined in brown slip. His *rigatoni*-like legs end in substantial buckled shoes. Viewed from the side, the figures are strongly three-dimensional. Their expressions are slightly humorous, but that may not have been intentional.

White salt-glazed stoneware with details in brown slip,
h. 16.5 cm; w. 16.5 cm
Bequeathed by Dr J.W.L. Glaisher
C.779-1928

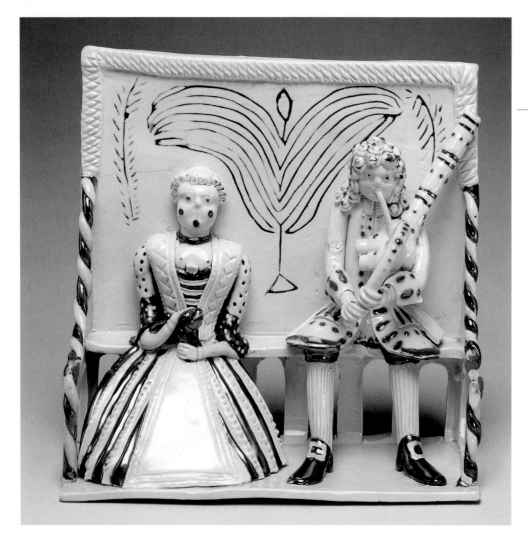

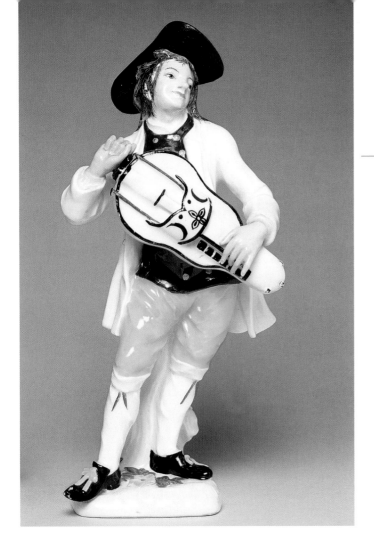

Hurdy-gurdy player
Modelled by Peter Reinicke (1715–1768)
Meissen, Saxony, c.1745

This youthful hurdy-gurdy player is one of a set of lively Meissen porcelain figures of the 'Cries of Paris' modelled by Peter Reinicke, or by Reinicke and the factory's master modeller, Johann Joachim Kaendler, between 1745 and 1747. They were copied or adapted from engravings by the Comte de Caylus (1692–1765) after drawings by Edmé Bouchardon (1689–1762), which were issued in Paris in sets of twelve between 1737 and 1746 under the title *Etudes prises dans le bas Peuple ou les Cris de Paris*. This figure is a transposed version of the eighth print of the fourth set issued in 1742. In comparison with the original drawing of an impoverished boy musician, the Meissen figure is as smart as paint, with bright yellow breeches, brown waistcoat and black hat and shoes, all of which accentuate the whiteness of the porcelain. His exaggerated pose is partly due to the need to be supported by the tree-trunk behind him. The back is as finely modelled as the front, because Meissen figures were intended to be seen in the round when used as table decoration.

Hard-paste porcelain painted in enamels,
h. 20.2 cm
Given by the 2nd Lord Fisher and Lady Fisher through the National Art Collections Fund
C. 32-1954

Below:
Soft-paste porcelain painted in enamels,
hen: h. 25.3 cm; dish: l. 48.7 cm
Mark: a red anchor
Bequeathed in memory of Robert Gelston, Limerick by his brother Dick Gelston, 1957
C.3&A&B-1958

Hen and chickens tureen and stand
Chelsea, Lawrence Street factory,
c.1755–6

Porcelain and faïence tureens in the shape of animals were fashionable throughout western Europe during the mid-eighteenth century. This example rests on a large dish decorated with sunflowers, leaves and other flowers. It was not modelled from nature, but based on a print made c.1658 by Francis Barlow (1626–1702). The tureen was made at the Chelsea porcelain factory established in 1744–5 by Nicholas Sprimont, a London silversmith born in Liège. The factory made porcelain for the luxury market, selling its products through London warehouses, chinamen and annual sales. In the 1755 sale, lot 50 on the first day was described as 'A most beautiful tureen in the shape of a HEN AND CHICKENS, BIG AS THE LIFE IN A CURIOUS DISH ADORN'D WITH SUNFLOWERS.' It was one of ten offered for sale, and a further four were included in the Chelsea sale of 1756. The English fashion for such tureens was short-lived, and very few examples of large Chelsea animal tureens have survived. The Museum is fortunate in having also a pair of rare fighting cocks, a rabbit, and a carp on a dish.

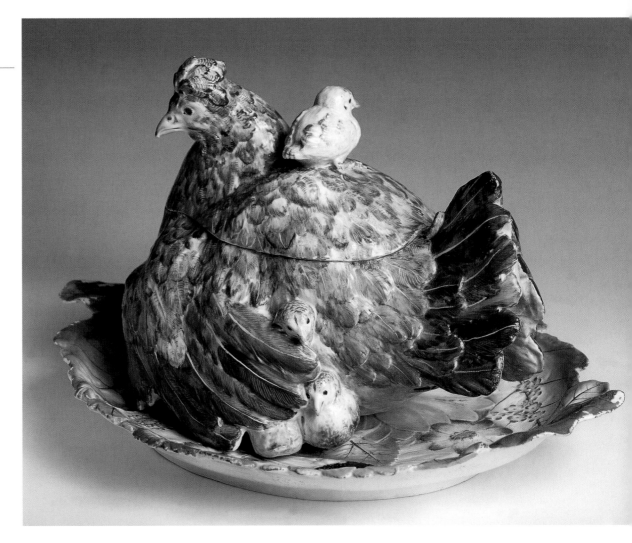

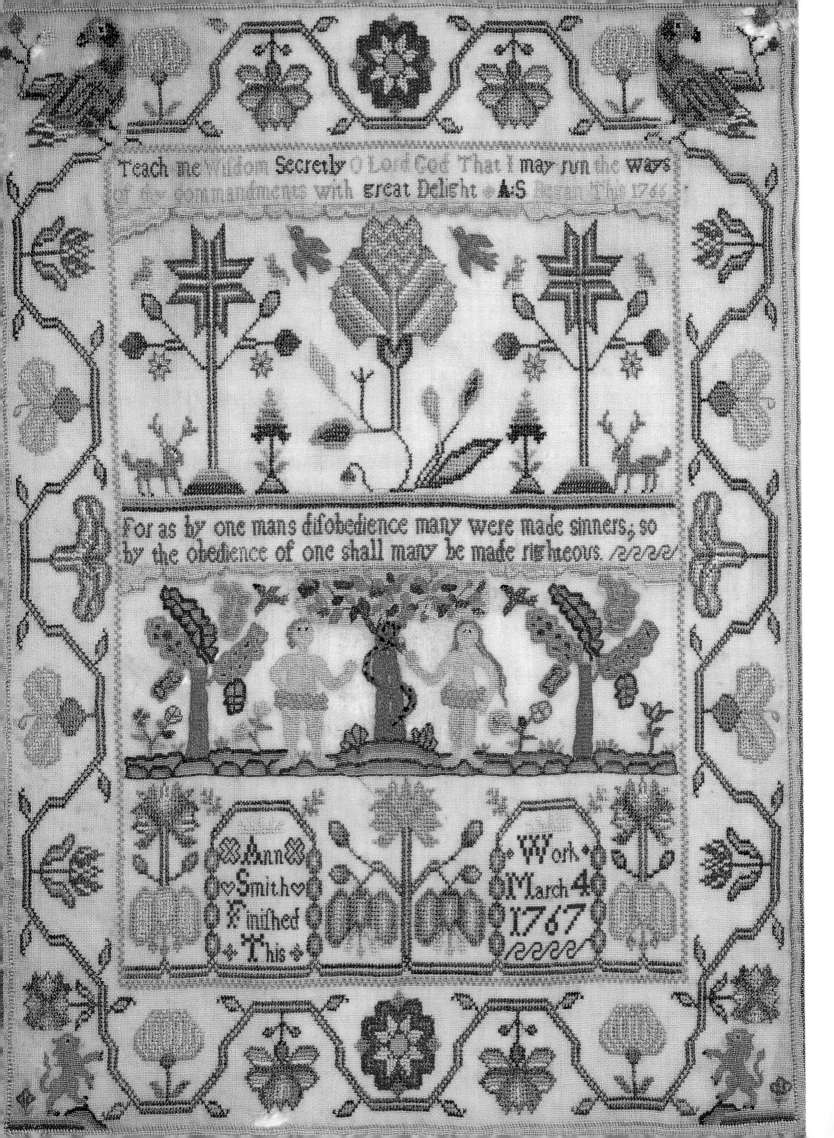

Teach me wisdom Secretly O Lord God That I may run the ways
of thy commandments with great Delight A.S began This 1766

For as by one mans disobedience many were made sinners; so
by the obedience of one shall many be made righteous.

Ann Smith Finished This

Work March 4 1767

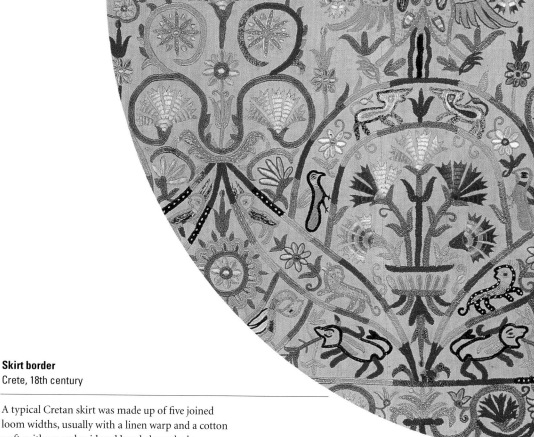

Left:
Sampler
English, 1766–7

Several features of this sampler are
typically eighteenth century. Most
obvious is the enclosing floral border,
which has within it a conventional
inscription of name and dates and a
morally uplifting verse. The use of a
woollen rather than linen ground
cloth, and a relatively limited reper-
tory of stitches are also indicative of
the period. However, the division of
the main field into horizontal sections
harks back to the band samplers of
the seventeenth century. The bands
comprise traditional but very stylized
roses, and buds, carnations and
possibly honeysuckle; the lower band
is closer to a seventeenth-century
arcaded repeat pattern, while the
upper is more eighteenth century in
style, with symmetrically arranged
motifs either side of a large central
flower spray. The depiction of the
Temptation of Adam and Eve had also
been popular on earlier samplers and
pictorial embroideries, and continued
to be so into the nineteenth century.

Wool with polychrome silk embroidery,
31.5 x 43.25 cm
Bequeathed by Mrs H. A. Longman
T.37-1938

Skirt border
Crete, 18th century

A typical Cretan skirt was made up of five joined
loom widths, usually with a linen warp and a cotton
weft, with an embroidered band along the lower
edge. Sometimes the bands are relatively narrow
with monochrome embroidery, while wider bands
usually have vibrantly polychrome work. It is
believed that little traditional embroidery was
worked after the early nineteenth century, and the
exact role of the embroidered skirt has not been
firmly established, although it was almost certainly
for bridal or festive wear. Crete was ruled by the
Venetians from the thirteenth century and then by
the Ottoman Turks from 1669. The patterns found
on most embroidery attributed to Crete seem to be
derived from Italian pattern sources, adaptations of
designs used for lace and woven textiles as well as

embroidery. This complex border comprises a
repeat pattern of flower vases within stylized leaf
and ribbon bands containing animals, birds, fish and
flowers. Above, a cockerel alternates with a double
eagle head, and below is a wavy flower band. The
colour scheme changes from one end to the other,
dominant red giving way to a palette of light greens,
blues, yellow and creams.

Linen and cotton, polychrome silk embroidery, 54.5 x 352 cm
Given by George de Menasce
T6-1948

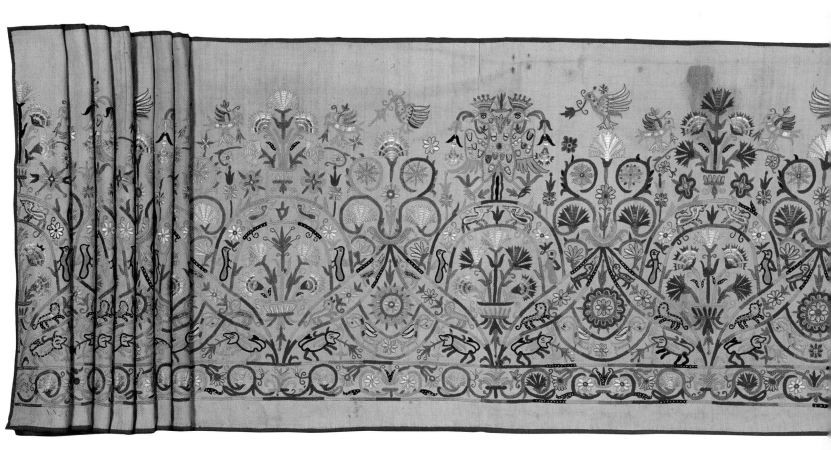

Watch and chatelaine

Case by Stephen Goujon, London, 1761–2, chased by George Michael Moser
(1706–1783), movement by William Webster (active 1734–66)
London, 18th century

Chatelaines, known as 'chains' in the eighteenth century, were used to attach watches and seals or small *nécessaires* containing sewing or writing requisites to a lady's waist. This chatelaine has two attached seals, and a locket containing woven hair with the words TOT SEUL ME FIXE (I am constant to you alone) on an enamelled ribbon, indicating that it was a token of love. The gold outer case of the watch is decorated with 'Venus Presenting Arms to Aeneas', an episode in Virgil's *Aeneid*, watched by a river god (right), and surrounded by Rococo scrolls and basket work. It is signed 'G. M. Moser fᵗ' for George Michael Moser, the most outstanding London gold chaser of the mid-eighteenth century, and a founder member of the Royal Academy in 1768. A Swiss, born in Shaffhausen in 1706, he moved to Geneva in 1725 and to London c.1726. By the late 1730s he was established as an independent gold chaser, and from then until the late 1770s he decorated gold boxes and watchcases for leading watchmakers, including George Graham, the Ellicot family, and William Webster.

Gold, embossed and chased, overall l. 14.1 cm
Given by Miss Whitehurst
M.1-1836

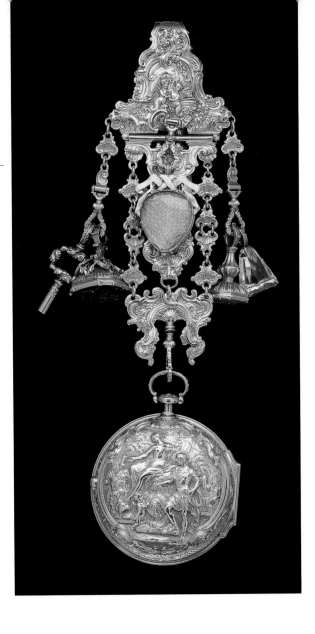

Goblet

Decorated by William Beilby (1740–1819)
English, Newcastle upon Tyne, c.1762

The large bucket-shaped bowl of this goblet was enamelled by William Beilby (1740–1819). On the front are the Royal Arms, and on the reverse, the Prince of Wales' feathers and motto, with 'WBeilby Junr. Ncastle invᵗ & pinxᵗ' below. The goblet probably commemorated the birth of the future George IV in 1762, and if not decorated then, was presumably completed before the death in 1765 of William Beilby senior, a goldsmith and jeweller in Gateshead. William junior had been apprenticed in 1755 to John Hazeldine, a Birmingham enameller and drawing master, and if he served his apprenticeship to full term, would have been free to return home in 1762. During the 1760s he seems to have made a speciality of colourful Rococo-style armorials, but much of his later work was in white. According to the wood engraver Thomas Bewick, who was apprenticed in 1767 to William's brother Ralph (1743–1817), a seal engraver, William taught enamelling on glass to another brother, Thomas (1747–1826), and to his sister Mary (b. 1749). The glasses the Beilby family used were probably made locally, for although the glass industry in the North-east concentrated on bottle and window glass, there were at least two Newcastle glasshouses producing drinking glasses in the 1760s.

Enamelled lead-glass with opaque twist stem, h. 21 cm
Bequeathed by D. H. Beves
C.570-1961

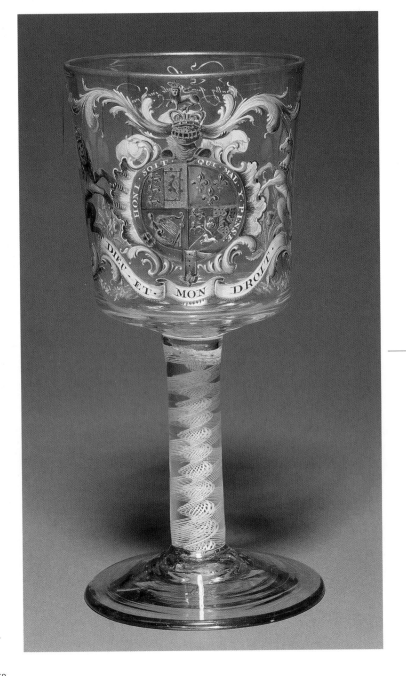

Commode with drawers
Attributed to Pierre Langlois the Elder (d. 1767)
London, probably *c*.1766–7

This commode has been attributed to Pierre
Langlois, and dated to the mid-1760s because of its
similarity to a pair of commodes with scagliola tops
at Woburn Abbey, Bedfordshire. These were
commissioned from Langlois by the Marquess of
Tavistock (1739–67), son of the 4th Duke of
Bedford, and after both his and Langlois' deaths, the
latter's widow received payment in 1768. These
commodes differ greatly from the Rococo furniture
decorated with floral marquetry with which
Langlois is associated. Their form is rectangular
instead of serpentine, and their ormolu mounts
were derived from classical architectural ornament.
The top of this commode (below) is a surprise, for it
is veneered with a marquetry landscape, comparable
to those on furniture by the German cabinet-maker
Abraham Roentgen, who visited London in 1766.
Possibly it was executed by his journeyman, Johann
Michael Rummer (1747–1812), who was also in
London in the mid-1760s. The ormolu mounts are
likely to have been supplied by Dominique Jean,
who had married Langlois' daughter in 1764. Daniel
Langlois, whose name is inscribed under one
drawer, was still a child at this time, and is unlikely
to have been involved in its manufacture.

Pine veneered with rosewood and various exotic woods,
with ormolu mounts and legs, h. 90 cm, w. 127.5 cm,
d. 60.5 cm
Bequeathed by L. G. Cunliffe, 1937
M/F.11-1938

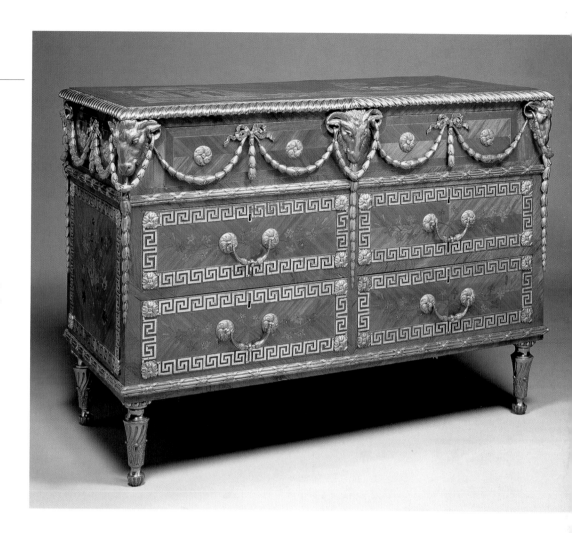

Pierre-Louis-Marie Maloët
Jean-Baptiste Pigalle (1714–1785)
Paris, c.1775–85

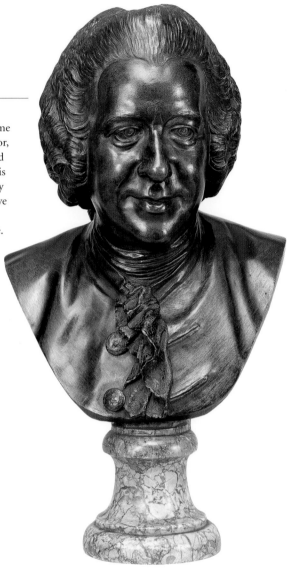

The eminent French physician Pierre-Louis-Marie Maloët (1730–1810) practised and taught in Paris, and was an early advocate of the use of electricity in the treatment of nervous illnesses. In 1773 he was appointed physician to Louis XV's daughters, the princesses Adelaide and Victoire, whom he followed into exile in 1791. After the Revolution he returned to France, and in 1804 became one of Napoleon's four doctors. He probably sat to Pigalle during the last decade of the sculptor's long career, which had been launched in 1744 when he was received into the French Académie on presentation of his marble statue of *Mercury Attaching his Winged Sandals* (Louvre). Highlights of his later work included a dramatic monument to the Maréchale de Saxe (1753), and a full-length nude of the aged Voltaire (1776). Pigalle was an outstanding portraitist, but made only about 25 busts, including one of Madame de Pompadour (1751), and, unusually for a sculptor, a self-portrait. Maloët is shown in the informal and natural manner that Pigalle adopted for busts of his bourgeois sitters. The verisimilitude is enhanced by the slight turn of the head, the many small reflective planes on the surface that suggest movement, and the carefully chased details of the wig and costume.

Bronze, cast and chased, supported on a marble socle, h. 61 cm, w. 55 cm
Purchased with the Gow Purchase Fund with Grant-in-Aid from the Victoria & Albert Museum and a contribution from the National Art Collections Fund
M.1-1979

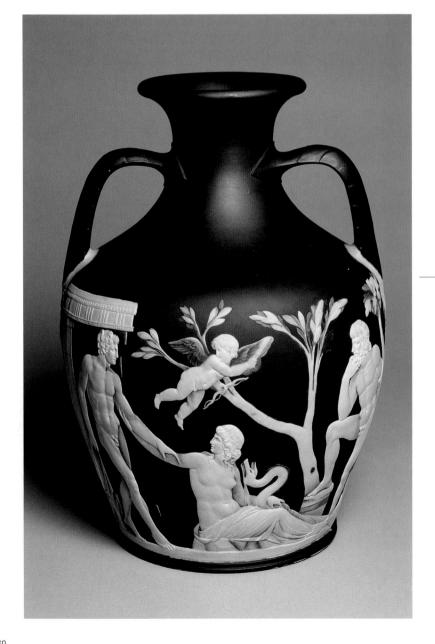

Wedgwood copy of the Portland Vase
Josiah Wedgwood (1730–1795)
Etruria, Staffordshire, 1789

This Portland Vase copy commemorates the friendship between two remarkable eighteenth-century Englishmen: Josiah Wedgwood (1730–1795) the potter, who described himself in 1769 as 'Vase Maker General to the Universe', and Erasmus Darwin, FRS (1731–1802), physician, scientist and poet. The vase is made of jasper, a fine white stoneware developed by Wedgwood between 1772 and 1775, which could be tinted with metallic oxides to produce black or other colours. The original vase of dark blue and white cameo glass dating from the first century BC had been rediscovered in Rome in the late sixteenth century. In 1786 it was lent to Wedgwood by the Duke of Portland, who had recently purchased it at the sale of his late mother's collection. Three years passed before Wedgwood and his chief modeller, William Hackwood, fired the first satisfactory copy in the late summer of 1789, a great technical achievement. Shortly afterwards Wedgwood sent a Portland copy to Dr Darwin in Derby, almost certainly the vase illustrated, for Darwin is not known to have owned another. After Darwin's death at Breadsall Priory, Derbyshire, the vase and its travelling case were passed down in the Darwin family until 1963, when it was lent to the Museum.

Black jasper with applied white jasper reliefs, h. 25.2 cm w. 19.1 cm
Purchased with the Cunliffe Fund, a grant from the National Heritage Memorial Fund, and Grant-in-Aid from the Victoria & Albert Museum
C.20-1984

A Poet's Monument Attended by Two Female Mourners
Simon-Louis Boizot (1743–1809)
French, 1790

Boizot was born at Gobelins, where his father was a designer in the royal tapestry factory. He trained in the studio of the sculptor Michel-Ange Slodtz, and having won the Prix de Rome in 1762, spent five years in Rome from 1765. Back in Paris, he exhibited for the first time at the Salon of 1773, and was admitted to the Académie in 1778. During his career he executed commissions for churches and public sculpture, but he was most successful as a portraitist, and in his skilful composition of intimate figure groups. This terracotta is characteristic of his graceful Neoclassical style. The delicacy of the modelling and fine detail of hair and drapery suggest that it was not conceived as a model for a larger monument in a different medium, but as a finished sculpture in its own right. The older woman may represent Erato, the Muse of lyric poetry, for the lyre on the front of the pedestal supporting the funerary urn suggests that the ashes it contained were those of a poet. Possibly, it was commissioned to commemorate Antoine Bertin (1752–1790), a cavalry captain, whose volume of elegiac poems, *L'Amour* (1780), earned him the accolade of the 'French Propertius'.

Terracotta, signed and dated on the back of the terracotta 'BOIZOT / SCULPTOR / REGIS. / FECIT ANNO 1790'; on original carved and partly gilded wood socle, h. 41 cm, w. 36 cm
Purchased with the Cunliffe and Perrins Funds, and contributions from the National Art Collections Fund and the Museums and Galleries Commission's Purchase Grant Fund administered by the Victoria & Albert Museum
M.55-1997

Plate from the Empress Catherine service
Painted by Charles-Nicolas Dodin and Niquet;
gilded by Jean-Pierre Boulanger, *père*, and
Henri Prévost
Sèvres porcelain manufactory, 1778

This plate belonged to a magnificent dinner
and dessert service for 60 settings commis-
sioned from Sèvres by the Empress Catherine
II of Russia (1729–1796) in 1776, and des-
patched to her in June 1779. The service was
accompanied by a matching tea and coffee
service, and in all 800 pieces were ordered.
It was the first Neoclassical service made by
the factory, and new shapes were specially
designed for it. The 288 dessert plates, for
example, had smooth rims, instead of the
usual shaped outlines. The service
conformed to the Empress's wish that its
decoration should incorporate cameos, of
which she had an immense collection.
The plates feature a crowned floral *E* for
Ekaterina with a gold *II*, and have a *bleu
celeste* ground with borders of floral sprays
flanking a band of *bleu celeste* overlaid by
gold *rinceaux*. This is interrupted by three
heads in oval medallions, and three larger
figure scenes painted to resemble hardstone
cameos. On this plate the latter are mytho-
logical subjects from Ovid's *Metamorphoses*:
'Apollo and Daphne'; the 'Competition
between Apollo and Marsyas', and the
'Flaying of Marsyas'. The heads were transfer-
printed before painting, a technique not
previously employed at Sèvres.

Soft-paste porcelain decorated with a turquoise
ground, painting in enamels, and gilding,
diam. 26.6 cm
Bequeathed by L.C.G. Clarke, 1960
C.51-1961

Decimal clock
Pierre Daniel Destigny (apprenticed 1787; d. 1855)
Rouen, *c*.1798–1805

This rare Neoclassical clock is a relic of an ill-fated
attempt to force the citizens of France to tell the
time in a different way. In 1793 the Revolutionary
government ordered the reform of all kinds of
measurement on a decimal basis. This included the
introduction of a new calendar with twelve 30-day
months, divided into three 10-day weeks. Days were
divided into 10 hours of 100 minutes, and each
minute was divided into 100 seconds. Minutes were
therefore longer, and seconds were shorter, than
before. Not surprisingly the public found it difficult
to adapt to the new system, and consequently some
decimal clocks have two dials, one telling decimal
time and the other, duodecimal time, as this one
does. By the probable date of the manufacture of
this clock, decimal time was already being
abandoned, and on 1 January 1806 the Gregorian
Calendar was restored.

Pine case veneered with mahogany, with dials showing
decimal time and duodecimal time, h. 48.3 cm
Movement with 'dead-beat' escapement, and a half
decimal second pendulum, with gridiron compensation
Given by Mrs Sigismund Goetze
M/F.4-1943

Two Hares
English, late 18th century

Pictorial embroidery has a long and varied history, ranging from the secular eleventh century Bayeux Tapestry (actually needlework) to the magnificent medieval vestments of Opus Anglicanum, from the complexities of seventeenth-century raised work to the relative simplicity of eighteenth-century canvas work. This late eighteenth-century example reflects a particular contemporary fashion for 'needle painting'. This was a form of free-style embroidery with erratic stitching attempting to imitate the techniques of painting. Sometimes familiar portraits or landscapes were adapted, sometimes smaller-scale embroideries of simpler subjects were worked, as in this example. This light-hearted depiction of hares is believed to have been designed by

William Blake and worked by the wife of his friend, Thomas Butts. Hares and rabbits appear in several similar embroideries, such as a fine-silk needle painting of a rabbit that hangs at Parham Park, Sussex, and some years ago *A Hare with three Leverets* was auctioned and attributed to the most famous exponent of this technique, Mrs Mary Linwood.

Linen embroidered in polychrome crewel wools
and yellow silk, 58.75 x 51.1 cm
Allocated by H.M. Treasury through the Minister
of the Arts in lieu of capital taxes on the death of
Sir Geoffrey Keynes
T.3-1985

Applied Arts

Napoleon I

Antoine-Denis Chaudet (1763–1810);
cast by Honoré Gonon; chased by
Charles Stanislas Caneleurs
Paris, 1808

When the painter Jacques-Louis
David met Napoleon Bonaparte
(1769–1821) for the first time in 1797
he enthused to his pupils 'O! My
friends, what a beautiful head he has.
It is pure, it is great, it is as beautiful
as the antique. … There is a man to
whom altars would have been raised
in ancient times.' Chaudet's herm-
form bust gives permanence to
David's impression, and it was the
image adopted by Napoleon as his
official portrait when he became
Emperor in 1804. The date of the
original model is uncertain, but a
replica in the Musée de Tours is
inscribed 'Chaudet An XI' (23
September 1802 to 23 September
1803). Numerous marble copies were
made at Carrara during the Empire,
and it was also reproduced in Sèvres
porcelain. A few bronzes were cast in
Paris for presentation to important
persons by the Emperor. The
Fitzwilliam's cast of 1808 belonged
to Dominique-Vivant Denon
(1747–1825, Baron 1812), who had
accompanied Napoleon on his
Egyptian campaign in 1798–9, and
was appointed Director General of
French Museums in 1802. A year after
his death, when his collection was
sold by auction, the bust was acquired
by Horatio Walpole (1783–1858), 3rd
Earl of Orford of the second creation.

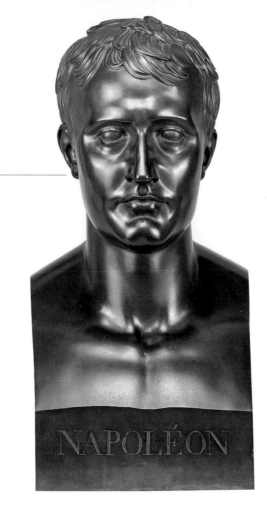

Bronze, h. 56 cm, w. 30.5 cm, d. 26 cm
M.1-1866

Below:
Cabinet
George Bullock (1778 or 1782/3–1818)
London, 1817

An obituary of George Bullock in the *Annals of the
Fine Arts* (1819) described him as 'a man of very
remarkable powers', an opinion corroborated by
current knowledge of his versatility, and entre-
preneurial skills. Initially a wax modeller and
sculptor in Birmingham, he established a furnishing
business in Liverpool in 1804, and in 1806 leased a
Mona Marble quarry on Angelsey. In 1812 he moved
to London, where his genial manner, and the high
quality of his furniture won him many friends and
clients. Among his most notable commissions was
the provision of furniture and furnishings for the
use of the exiled Napoleon Bonaparte at Longwood
on St Helena. This cabinet, one of three
commissioned from Bullock by the 4th Duke of
Atholl (1755–1830), was invoiced on 12 July 1817.
Like much of Bullock's furniture it features native
materials: larchwood and Glen Tilt marble from the
Atholl estates, whose light colouring contrasts with
the ebony plinth and ebony and brass boulle-work
panels on the doors. Applied gilt-brass mounts on
the top, the corners of the panels, and front pillars
contribute to its opulent character. A tracing of
Bullock's design by Thomas Wilkinson, now in
Birmingham City Art Gallery, shows that he
envisaged it standing below a mirror.

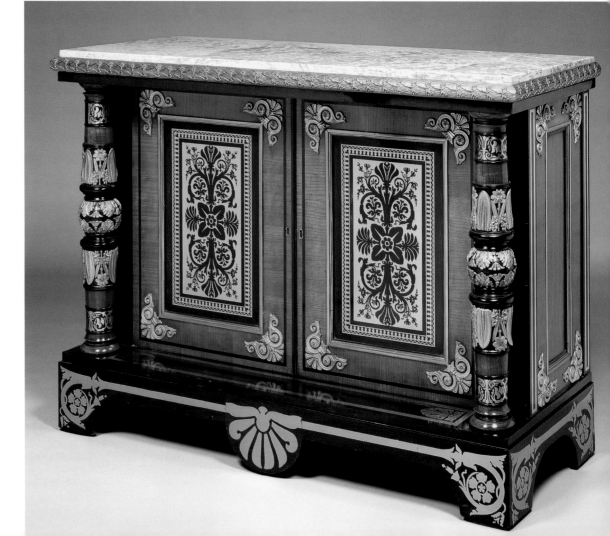

Larchwood and ebony with brass mounts
and boulle-work, and top of Glen Tilt
marble; interior fitted with two sets of six
drawers on sliding runners, h. 86.8 cm,
w. 120 cm, d. 46.6 cm
Purchased with the Gow Fund and
contributions from the National Art
Collections Fund and the Regional Fund
administered by the Victoria & Albert
Museum
M.16-1980

Campana-shaped vase
Designed by Johann David Schubert
(1761–1822; painted by Heinrich
Schaufuss (1760–1838)
Meissen, Saxony, 1815

This Meissen vase belonged to
Rudolph Ackermann (1764–1834),
the London publisher and proprietor
of the famous 'Repository of the Arts'
in the Strand. Ackermann was born
in Saxony, but lived in London from
the mid-1780s, and was granted
British citizenship in 1809. After
Napoleon's victories at Jena and
Auerstadt in 1806 he worked privately
to relieve distress in Germany, and in
1814 was appointed joint-secretary of
the Westminster Association, which
raised £100,000 to alleviate hardship
caused by the Battle of Leipzig. In
1816 in recognition of his charitable
work, the King of Saxony gave
Ackermann this specially commis-
sioned vase, which was presented to
him by Baron St Just, the Saxon
ambassador in London. It is a superb
example of Neoclassical porcelain.
The sides are decorated with a frieze
after a relief on the Arch of
Constantine in Rome showing the
Emperor Trajan (AD 98–117)
instituting his *alimenta* for child
support, titled and described below in
Latin. The subject, rare in art, was
highly appropriate for the recipient,
as were the cornucopiae and bunches
of corn in the top border, symboli-
zing peace and plenty.

Hard-paste porcelain, enamelled and
gilded, h. 43 cm, diam. of rim 26 cm
Mark: crossed swords underglaze in blue;
'A' over '8' impressed
Purchased with the Sir Richard Jessel
Fund, and with contributions from the
Friends of the Fitzwilliam Museum and
the National Art Collections Fund
C.7-1995

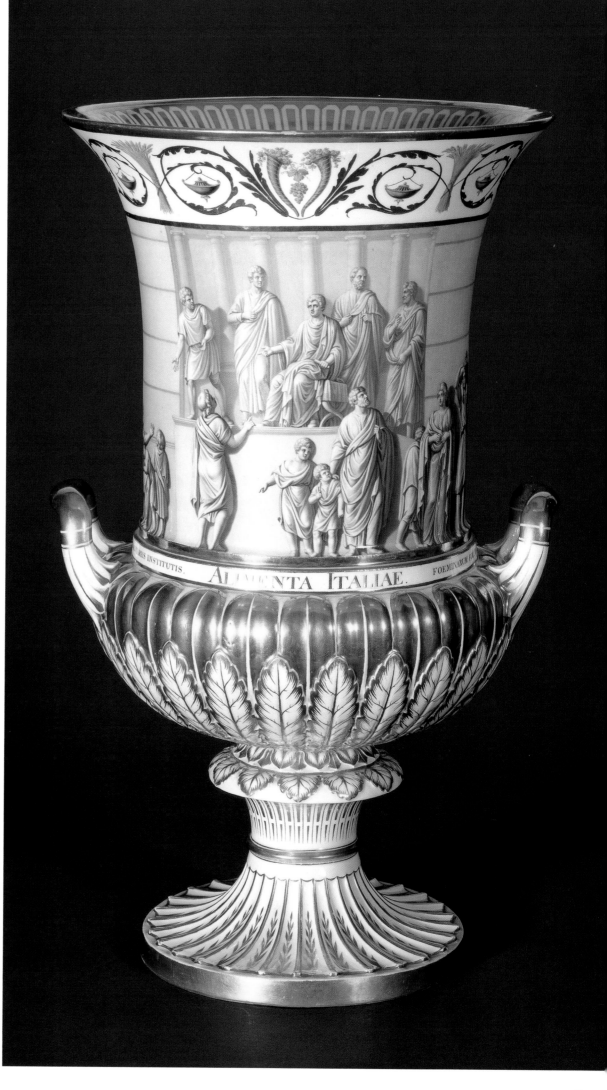

John Horne Tooke
Sir Francis Chantrey, RA (1781–1841)
English, 1819

When Chantrey exhibited his plaster model for this bust of his friend John Horne Tooke (1736–1812) at the Royal Academy in 1811, the sculptor Joseph Nollekens described it as 'the best bust of all busts'. Public acclaim followed, and Chantrey's career as a sculptor was thus assured after several years as a portrait painter, struggling to make ends meet while studying at the Royal Academy Schools. The marble bust was commissioned in 1818 by George Watson Taylor MP, and was completed in 1819. It was never paid for, and remained in Chantrey's possession until his death, when Lady Chantrey presented it to the Museum 'as one of my husband's best works'. It is indeed an extra-ordinarily penetrating portrait of a man, one who had spent time in prison for supporting independence for the American colonies during the Revolution, and was already suffering from his last illness at the time he sat to Chantrey. The informality of Tooke's dress, and his natural unaffected gaze is reminiscent of busts by Roubiliac, and this avoidance of theatricality was to be characteristic of Chantrey's finest later portraits.

Marble, h. 67 cm
Given by Lady Chantrey
M.1-1861

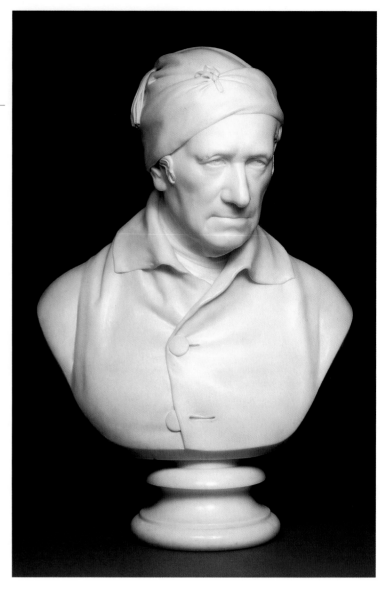

The Bride
Copeland, Stoke-on-Trent, 1873

About 1845 Minton's and Copeland & Garrett in Stoke-on-Trent both developed a new soft-paste porcelain body for figures. It was creamy-white, lent itself well to slip-casting, and had a smooth surface that was easy to clean – an important asset at a time when coal fires made dusting a daily task. Copeland called their version Statuary Porcelain. The name Parian, the generic term used today, was taken by Minton from Paros, a Greek island famous for its marble quarries. The resemblance of Parian to marble contributed to its commercial success, for high-quality reproductions of sculpture were viewed optimistically as a means of improving public taste. Many Parian models were reductions of famous antique marbles, such as the Apollo Belvedere, or works by respected contemporary sculptors. Copeland's *The Bride* was based on the head of *The Veiled Vestal*, a full-length marble of 1847 by Raffaelle Monti (1818–1881), a Milanese living in London, who was renowned for his female figures with illusionistic veils. The bust was offered as a two guineas prize in the Ceramic and Crystal Palace Art-Union annual draw in 1861, and became so popular that it remained in production for many years.

Statuary porcelain (Parian), slip cast, h. 38 cm
Marks: 'R.Monti / 1861 / CERAMIC / AND / CRYSTAL PALACE ART UNION'
and 'COPYRIGHT RESERVED / COPELAND / o / 73'
Given by the Friends of The Fitzwilliam Museum
C.7-1969

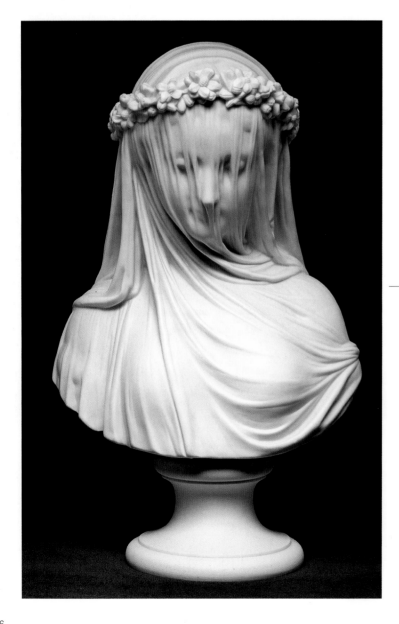

Decanter
Designed by William Burges; mounts,
London, 1865, by Josiah Mendelson
and George Angell

William Burges (1827–1881) was one
of the most talented English
architects of the High Victorian
Gothic Revival. His eclectic taste, love
of vivid colouring, and super-
abundant inventive powers brought
forth a stream of idiosyncratic
designs for buildings and domestic
objects. This decanter demonstrates
his flair for combining disparate
elements to create an aesthetically
satisfying whole. Its glass body is
encased in mounts inspired by gem-
studded medieval book covers, while
the animals engraved on the foot are
reminiscent of the borders of Gothic
manuscripts, and the cover is
crowned by a Chinese rock crystal
lion. This decanter was one of two
forming a set with a cup made by
George Hart in 1862; Burges had
conceived the decanters' design by
1858. The Latin inscription on this
one indicates that it was paid for with
the fee that Burges received for his
winning design submitted in 1856
for the Crimea Memorial church in
Constantinople. Burges displayed,
and occasionally used, the decanters
and cup in the dining-room of Tower
House, his Gothic Revival home in
Kensington, into which he moved
in 1878.

Green glass, mounted in silver set with
malachite, semi-precious stone, cloisonné
enamels, coral cameos, intaglios,
classical coins, ivory and rock crystal,
h. 27.3 cm, w. 19 cm
Purchased with the Perceval Fund and
the Regional Fund administered by the
Victoria & Albert Museum
M.16-1972

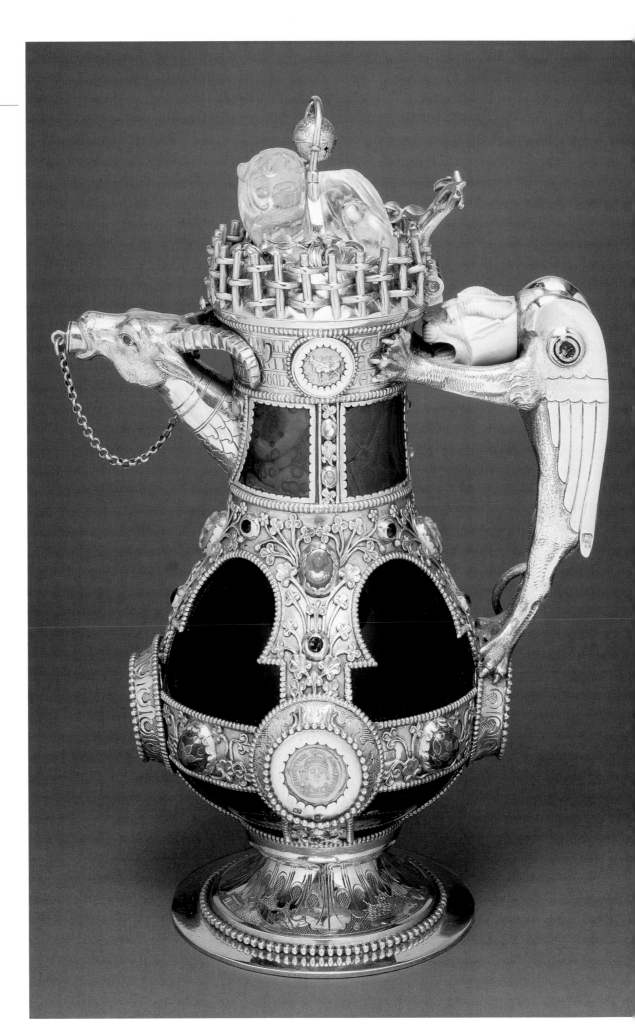

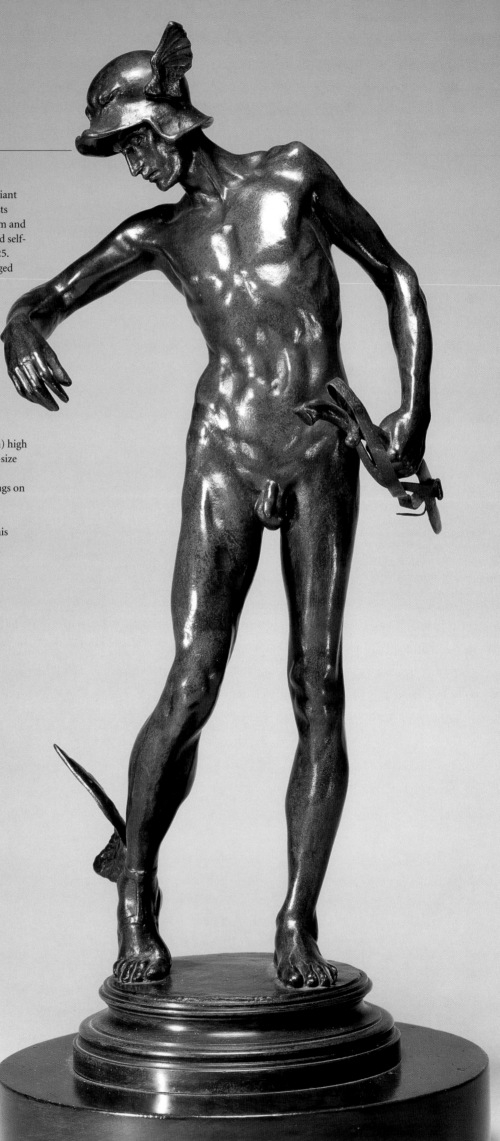

Perseus Arming
Alfred Gilbert (1854–1934)
English, after 1882

Alfred Gilbert played a crucial role in the
development of the English 'New Sculpture'
movement of the late nineteenth century. Brilliant
and versatile in the mould of Renaissance artists
such as Donatello and Cellini, his perfectionism and
extravagant lifestyle resulted in bankruptcy and self-
imposed exile in Bruges between 1901 and 1925.
This bronze of *Perseus Arming* formerly belonged
to the painter Sigismond Goetze, who was a
supportive friend to Gilbert after his return
to England in 1926, and was the executor of
his will. Gilbert first left England to study
in Paris in 1876, and in 1878 moved to
Rome. While visiting Florence he was
enthralled by Renaissance bronzes, and
by the potential of the lost-wax casting
process, a technique little used in England.
Perseus Arming was modelled and cast in
plaster during the winter of 1880–81, and in
1882 Gilbert exhibited a bronze 73.7 cm (29 in) high
at the Grovesnor Gallery in London. This half-size
example was cast later. It shows Perseus as a
beautiful young man glancing down at the wings on
his heels to ensure that he is equipped for his
adventures. To Gilbert the bronze had an
autobiographical significance, as a symbol of his
own preparation for a career as a sculptor.

Bronze, h. 35.5 cm
Given by Mrs May Cippico
M.4-1951

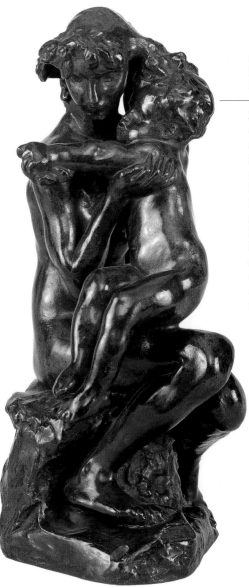

Frère et soeur
François Auguste René Rodin (1840–1917)
French, modelled 1890

Frère et soeur was conceived by Rodin in 1890 and cast during his lifetime. It shows a young girl seated somewhat awkwardly on a rock while tenderly holding a child on her knee, a theme related to a *Mother and Child* made in the 1870s when he was living in Brussels. This bronze was bequeathed to the Fitzwilliam by Guy Knowles, who had known Rodin since his childhood. With it he left a note describing how the bronze came into his possession, which, incidentally, shows both Rodin's irritable disposition and his generosity: 'I was in R's studio when the first cast was delivered &, expressing my admiration, asked if I could buy it. R. called me every sort of name – "As soon as a man does something he is reasonably pleased with, some B.F. comes along and wants to take it away", so I calmed him down, gave him lunch & didn't refer to it again. A month or so later a packing case arrived in London. It was the "Frère et Soeur", cast & a note from R. saying "I was quite wrong. When a man does something which arouses the enthusiasm of the man who sees it, then that is the man who should possess it." It was a gift to me.'

Bronze, h. 39 cm, w. 22 cm, d. 20 cm
Bequeathed by Guy F. Knowles
M.2-1959

Dancer (Arabesque Over the Right Leg, Left Arm in Front)
Edgar Degas (1834–1917)
Paris, *c*.1882–95

Degas was one of the most influential sculptors of the late nineteenth century and early twentieth, but his work exists only in the form of wax and mixed-media models, and a few plaster casts. The bronzes through which his sculpture became widely known were not cast until after 1919 by the bronze founders A.-A. Hébrard & Cie, who fortunately preserved the models. Degas made three-dimensional models for his own satisfaction as a means of increasing his understanding of movement, and giving greater expression to his drawings and paintings. The models of women are not posed with a viewer in mind, but are shown behaving naturally. Unselfconsciously nude, they wash or dress, as if, as Degas said, 'you were watching them through the keyhole'. The models of dancers form two groups. Some are shown dressing, or doing what dancers do when not dancing, like examining their feet or easing their backs. Others are caught in movement or hold a classical ballet position with intense concentration. This example is one of a series showing dancers in arabesques.

Red wax and wire, h. 23.6 cm
Given by Mr and Mrs Paul Mellon in honour of Professor Michael Jaffé, Director 1973–90
M.6-1990

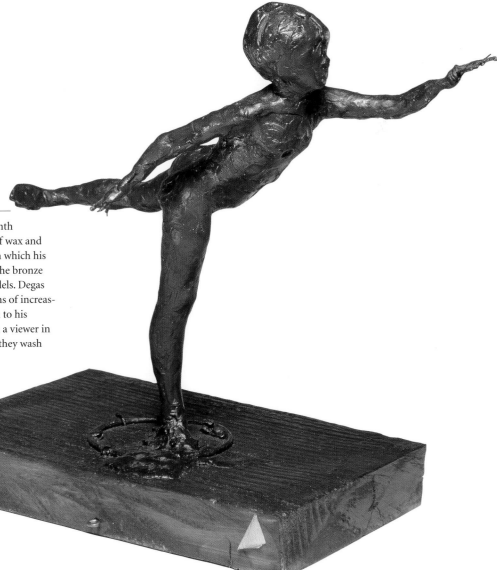

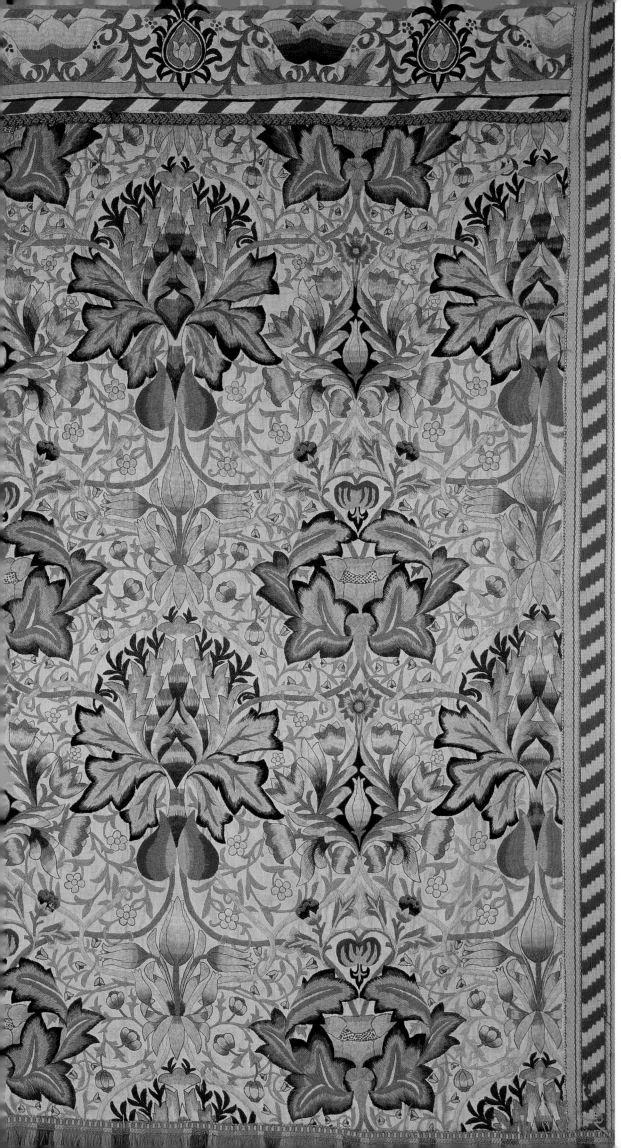

Embroidered wall-hanging (detail)
Designed by William Morris (1834–1896)
English, 1877

In 1877 Mrs Godman of Smeaton Manor, Northallerton, Yorkshire, received the design she had commissioned from Morris & Co. for a series of embroidered wall panels. The design was called *Artichoke*, and she traced it onto linen panels and for the next quarter of a century worked it in crewel wools. Although a repeat pattern, her subtle variations in the arrangement and combination of the coloured threads give the whole a spontaneity that would be absent from a more rigidly observed repetition. This, the largest of the three panels in public collections (the others are in the Victoria & Albert Museum and the William Morris Gallery, Walthamstow), illustrates the complexity and quality of the enormous embroidery task that Mrs Godman accomplished. Morris's earliest schemes for large-scale embroideries date back to the time of his marriage to Jane Burden in 1859, and the furnishing of their new home, the Red House in Bexley, Kent. Two decades later, simpler designs for smaller panels made better commercial sense, and many were drawn up by workshop assistants. Reduced versions of *Artichoke* exist, some worked with silks, all with similar variations of colour and shading.

Linen, with polychrome wool embroidery,
213.5 x 983.6 cm
Purchased with the Adnitt, Marlay,
University Purchase, and Webb Funds,
and Grant-in-Aid from the Victoria & Albert
Museum
T1-1979

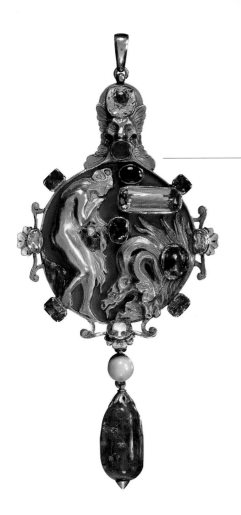

Pendant: *The Descent of Psyche into Hell*
Designed by Charles Ricketts (1866–1931), made by Carlo & Arthur Giuliano
London, 1904

Charles Ricketts designed this pendant as a gift for Maria Appia and her cousin, the poet and wood engraver Thomas Sturge Moore (1870–1944), who were married in 1904. It was completed on 5 March 1904, and like several other jewels that Ricketts designed at the beginning of the century, it was made by the London jewellers Carlo & Arthur Giuliano, then directed by Arthur Giuliano (1864–1914). The back is enamelled in neo-Renaissance style with interlacing circles and the recipients' initials *TM* over *MA*. The front shows 'Psyche Descending into Hell', an episode in the story of Psyche told by Apuleius in *The Golden Ass*. The design was based on one of Moore's illustrations for an edition of the story published by the Vale Press in 1897. Ricketts was fascinated by gemstones, and used them lavishly here. The centre and circumference of the pendant are set with projecting sapphires, emeralds, chryso-lites, a large pink topaz and a garnet, and at the bottom there is a pearl and a large emerald drop. Little wonder that he described it as a pendant 'which will tear all lace and scratch babies'.

Gold, enamelled, and set with gemstones, and a pearl,
h. 12.8 cm, w. 5.9 cm
Purchased with the Leverton Harris Fund
M.4-1972

Creamware dish
Josiah Wedgwood & Sons, Etruria, Staffordshire,
painted by Alfred Powell (1865–1960)
English, *c.*1908

The design on this creamware dish is reminiscent of textile designs by William Morris, particularly his tapestry *The Forest*. It was painted by Alfred Hoare Powell (1865–1960), who had become imbued with Morris's ideals while training as an archi-tect. Powell practised as an architect, and undertook conservation projects, including work at Queen's College, Cambridge, in 1903. In that year he submitted a design for pottery decoration to the Wedgwood firm, then looking for a designer to revitalize its decorating department. This began an association with Wedgwood as designer and decorator that continued until Powell's extreme old age. After some training at Wedgwood's factory at Etruria, in 1906 Powell set up a studio at 20 Red Lion Square, London, where he and his wife, Louise Lessore, decorated pottery sent to them from the factory, and held exhibitions of their work. They also made regular visits to Etruria, where they trained 'paintresses' to execute simpler designs for large-scale production. Unlike some of Alfred's decorative dishes, this one is not unique. Another has a pair decorated in the centre with a peacock instead of an owl.

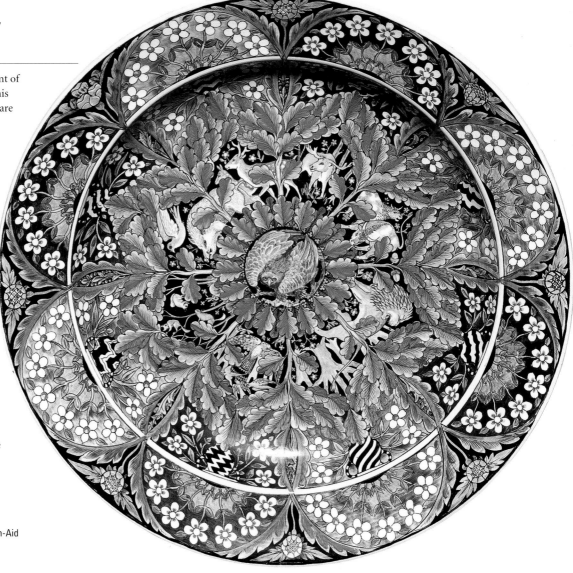

Cream-coloured earthenware, diam. 47 cm
Mark: WEDGWOOD impressed, AP monogram,
and 455 in black
Purchased with the Leverton Harris Fund and Grant-in-Aid
from the Victoria & Albert Museum
C.49-1972

Head of Isabel

Alberto Giacometti (1901–1966), cast by Susse Frères, Paris, 1962
Paris, 1936

Giacometti produced the *Head of Isabel* during a period of intense preoccupation with drawing and modelling from life between 1935 and 1940. He had recently broken with the Surrealists, with whom he had associated since 1929, and had not yet developed the attenuated figures that won him international acclaim after the Second World War. The head is an exploration of form rather than character, and its static frontal pose, impassive expression and voluminous hairstyle suggested its secondary title, 'The Egyptian Woman'. A second head of the sitter, completed in 1938, is in the Sainsbury Centre at the University of East Anglia. The existence of these two heads is remarkable, for Giacometti destroyed much of his work at this time. His sitter was a talented English painter, Isabel Delmer, *née*

Nicholas (1912–1992), the wife of Sefton Delmer, the foreign correspondent of the *Daily Express*. Before her arrival in Paris in 1934 to study at the Académie de la Grande Chaumière, she had worked as an assistant and model for Jacob Epstein, and continued to model in France. While sitting to Giacometti she formed a close friendship with him, and after the War lived with him briefly, before her second marriage to the composer Constant Lambert.

Bronze with brown patina, h. 29.1 cm
Signed *Alberto Giacometti*, foundry stamp
Purchased with the A. A. Webb Fund and grants from the National Art Collections Fund and the Museums and Galleries Commission purchase grant Fund administered by the Victoria & Albert Museum
M.50-1997

Family Group

Henry Moore (1898–1986)
English, 1944

Henry Moore was the most important English sculptor of the twentieth century. As a student in Leeds and London he admired the solidity and power of pre-classical and non-European sculpture, and from the outset of his career in the mid-1920s he abandoned the representational idiom that had characterized European sculpture since the Renaissance. In the 1930s Moore's work was influenced by both Abstraction and Surrealism, but the human form, remained central to his work, especially the reclining female figure, and the mother and child. In 1944 and 1945 Moore made a series of drawings and terracotta sketch models of family groups of a mother and father with one or two children. These were initiated by a commission from Henry Morris, Director of Education for Cambridgeshire, for a large bronze for Impington Village College, designed by Walter Gropius and his partner Maxwell Fry. This project was never realized, but several of the small sketch models were cast in bronze.

Bronze. Signed MOORE. 1/7, h. 17.8 cm, w. 13.2 cm
Bequeathed by Miss Diana E. Hunter
M.409-1985

Vase
Hans Coper (1920–1981)
English, *c.*1966–70

Hans Coper emigrated to England
from Germany in 1939, but did not
begin a career as a potter until 1946,
when he joined Lucie Rie as an
assistant at her studio in Albion
Mews, London. He took lessons in
throwing from Heber Matthews at
Woolwich, and collaborated with Rie
in making tableware. As the econo-
mic situation improved, both potters
were able to develop their own very
different idioms. In 1959, needing
more space, Coper moved to the
Digswell Arts Trust in Hertfordshire,
and later worked in west London
and at Frome in Somerset. Although
Coper's pots were thrown, they
became increasingly sculptural and
totemic in appearance. This plum-
shaped vase illustrates the technique
he evolved of assembling pots from
separately thrown components.
Other characteristic forms included
flattened discs, spade and thistle
shapes on cylindrical bases,
shouldered vessels with wide, flat
rims, and slender pointed forms like
arrow-heads. They usually had a
white or black body and were
decorated with contrasting creamy-
buff or brownish-black slips, which
Coper abraded to create texture and
shading. The finished pots were
radically different from earlier studio
pottery in being uncompromisingly
modern and urban in character.

Stoneware, h. 27 cm
Mark: HC monogram in oval seal
Given by the Friends of the Fitzwilliam
Museum
C.36-1972

Moonlight, 1983
Designed by Sir Howard Hodgkin (b. 1932), woven in the
West Dean Tapestry Studio, Sussex, by Valerie Power
English, 1983

Between 1982 and 1984, different weavers produced a suite of four tapestries after variants of Howard Hodgkin originals. They were commissioned and then given to the Contemporary Art Society by an anonymous donor. This example was woven by Valerie Power in the West Dean Tapestry Studio near Chichester. In the 1970s Hodgkin's work was moving towards more decorative patterning and rich colours, with a greater interest in textures. *Moonlight*, the woven interpretation of another medium, exemplifies how the use of a controlled but vibrant palette and simple shapes can produce a strong visual impact. That impact is perhaps made all the greater by the size of the tapestry, considerably larger than Hodgkin's predominantly small-scale paintings. A coloured lithograph of *Moonlight*, printed by Judith Solodkin and coloured by Linda Sparling at the Soho Press, New York, was published by Bernard Jacobson in 1980.

Cotton warp, wool weft, 119.4 x 148.6 cm
Given by the Contemporary Art Society
T.2-1986

Baby Bud Pumpkin Box
Kate Malone (b. 1959)
English, 1998

Kate Malone's exuberantly colourful pots appear to be bursting with *joie de vivre*. Their character reflects her optimistic outlook on life, and their forms and decoration are inspired by her fascination with the organic world of fruits and vegetables. Some of her work has obvious links with Staffordshire Rococo pottery of the mid-eighteenth century, such as pineapple teapots and melon-shaped tureens, but Malone's pots are primarily decorative and symbolic rather than functional, and they are often very large. Their glossy variegated surfaces are achieved by the use of either multiple fired earthenware glazes that produce two-tone cellular effects, or, as on *Baby Bud Pumpkin Box*, crystalline glazes that require very careful monitoring of the firing temperature. Most of Malone's pots are moulded, which means she can produce small editions of the same form, but their random glaze effects ensure that each one is an individual.

Earthenware (T Material), moulded and hand-built, with crystalline glaze (one of an edition of 20),
h. 24 cm, d. 24 cm
Given by Nicholas and Judith Goodison through the National Art Collections Fund
C.4-2001

Reindeer carving
Dordogne region of France; Upper Palaeolithic,
Magdalenian V, *c*.12,000 BC

This engraving, along with two others from the
same source, is the earliest example of art in the
Fitzwilliam. Along with contemporary cave
paintings and other forms of rock art, such
engravings provide some of the earliest known
proof of humans' desire and ability to draw.
Animals, including horses, bison, deer and
mammoths, are the most popular subjects of
Palaeolithic art. Engravings like these may have
possessed a magical significance, promoting the
successful hunting of the animal depicted. The
reindeer shown here is particularly well realized,
caught in a very characteristic pose with his head
turned back along his flank.

Limestone flake, h. 5.9 cm
From Laugerie Basse, Dordogne
Bequeathed by Professor Miles Burkitt
GR.5.1973

Stone mace heads
Predynastic, Nagada III (*c*.3200–3000 BC)

In addition to being effective weapons,
maces were symbolic of the power of the
king of Egypt. There are many scenes from
the earliest period of the unification of
Egypt under King Narmer to the Roman
period, some 3000 years later, showing the
king smiting his enemies with these
weapons. The examples illustrated here
show the two main forms of mace head: the
disc mace head, which is flat at the top, and
the pear-shaped mace head. Both types were
attached to wooden rods; illustrations
suggest that the wood was hammered
through the mace head in order to secure it.
These mace heads are part of a single
deposit excavated by the British School of
Archaeology in Egypt in the late nineteenth
century. They were left at the temple by
King Narmer, one of the first kings of
Egypt, and are part of a large collection of
objects now housed in major museums
throughout the world.

Stone, average h. *c*.5–8 cm
From the main temple deposit at Hierakonpolis
E.27–32.1898 etc.

Faience and limestone figurines, stone palette and jar

Predynastic, Nagada III (*c.*3200–3000 BC)

The Fitzwilliam Museum is fortunate to have from Hierakonpolis a collection of carved stone vessels and palettes, faience and limestone figurines and jewellery. There are even fragments of a possible wig that once adorned a statue, in the form of moulded faience tubes. Many of the objects contain a reference to scorpions, which perhaps allude to the Scorpion king, a predecessor of Narmer. Animal imagery was important to the early Egyptians and appears in several forms within the Hierakonpolis main temple deposit. Other objects, such as the representation of a dwarf, carved from limestone, allow us to see some of the earliest forms of figurines from Egypt.

Palette: h. 17 cm
From the main temple deposit at Hierakonpolis
E.8.1898, E.13.1898, E.10.1898, E.18.1898, E.91.1898, E.15.1898

179

Cycladic marble figurines
Islands of the Cyclades (southern Aegean),
c.3000–2000 BC

In the third millennium BC the Cyclades were the home of a highly creative people, whose most remarkable artistic achievements were their stone vessels and figurines. Quarries on the islands of Naxos and Paros were important sources of marble throughout antiquity. Early Cycladic artists and craftsmen, however, carved on a small scale and probably used the large marble pebbles readily available on their island beaches. They did make limited use of bronze tools, especially towards the end of the period. But most of their tools would have been types of stone – emery for hammers, obsidian for fine incising and smoothing, and pumice for polishing and shining. Enormous skill and patience would have been required to carve the carefully proportioned, skilfully schematized and perfectly finished figurines, which reduce the human form so elegantly to so few key components. We do not know what they were for, or even whether their subjects are human or divine. Most of the figurines are female, and some are clearly pregnant, suggesting in some cases a connection with fertility; some still bear traces of painted decoration, and the position of their feet shows that they were designed to lie rather than stand. Most were found in graves, but some in settlements, so they may have been used in both funerary and domestic cult rituals.

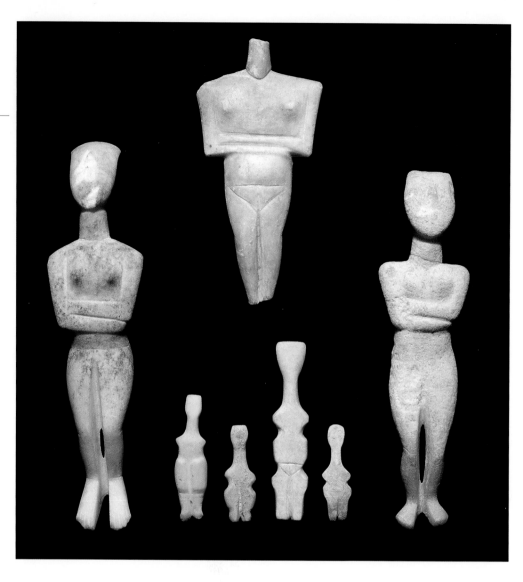

Limestone statuette of a bound captive
Egyptian, Old Kingdom, Dynasty 3 (2686–2637 BC)

The bound captive was a common theme of the Egyptian repertory from the early dynasties. Later it became a more general motif that was used in funerary art, placed below the feet of the deceased. This example is early in date. The subject is a Libyan, identified as such by his long hair. He rests on his knees, his feet bound and broken, with the result that they are placed in an unnatural position; his arms are tied behind his back, forcing the head upwards. Like many of these depictions the pain is quite apparent on his face. In the Old Kingdom such representations are commonly part of the symbolic decoration of thrones, thresholds or burial chambers of rulers. A small attachment at the top of the head, now broken, would suggest that this particular piece served as part of a larger object rather than simply standing alone. It is carved in some detail on both sides, suggesting that it was intended to be viewed from all angles.

Limestone, h. 11.2 cm
Purchased through the University Purchase Fund
E.5.1972

Centre top:
From Amorgos, h. 25.8 cm
Given by Prof. R. G. Bosanquet
GR.33.1901

Left:
From Melos, h. 24 cm
Given by the Friends of the Fitzwilliam Museum
GR.17.1924

Right:
From Amorgos, h. 18 cm
Given by Prof. R. G. Bosanquet
GR.33a.1901

Centre bottom:
Group of four, said to be from Paros, h. 8.6, 6.5, 12 and 6 cm
Given by the Friends of the Fitzwilliam Museum
GR.8a–d.1933

Faience tiles

Egyptian, Old Kingdom, Dynasty 3 (reign of Djoser: 2667–2648 BC)

Faience consists of a mixture of silica (crushed quartz pebbles), alkali or soda, and lime and remained a popular medium throughout Egypt's history. These tiles, along with the objects from the Deposit of King Narmer at Hierakonpolis (see pages 178–9) are among the earliest examples of the material, and illustrate how quickly Egyptian craftsmen mastered its manufacture. These small faience tiles once decorated the underground funerary apartments of King Djoser, the builder of the Step-Pyramid. It has been estimated that the number of tiles totalled 36,000. In addition to their decorative purpose, their appearance is believed to imitate reed matting, which is a reference to the 'field of reeds' in the afterlife. The bright blue colour is typical of faience, but may also have been used specifically to refer to the blue of the primeval waters, where it was believed the King was reborn. The tiles were threaded together with papyrus rope and then fixed to the walls with plaster.

Faience, each tile: h. 5.5 cm
From the Step Pyramid, Saqqara
Given by R. G. Gayer-Anderson
E.GA.4359.1943 etc.

See enlarged detail on pages 176–7

Red-polished ware bowl, with animal-head and sun-disc attachments
Cyprus, *c*.2500–2075 BC

Red-polished pottery is one of the earliest wares known from Bronze Age Cyprus. The variegated black and red effect is often found, and probably deliberate; the blackened areas of the pot (usually, as here, the interior and the upper part) may have been sunk in sand or soil inside the kiln in order to deprive them of the oxygen that produces the standard red-brown finish. The pot was hand-made,

built up from coils of clay. It was then polished or burnished with a pebble, the separately made attachments were joined on with a solution of clay, and a sharp tool was used to incise the decorative lines and zigzags around the rim and on the body. The sun-disc and horned, probably bull-head, attachments are both allusions to powerful forces in the natural world; the sun, and strong, fertile

animals, of which the bull is the prime example, were of huge importance to early communities. Of special interest are the three incised figures of 'stick-men' with animal headdresses of antlers or curling ram's horns. These figures recall later Cypriot evidence for priests wearing animal headdresses, and also for the ritual attested in Cypriot sanctuaries of mounting animal horns on high poles.

Fired clay, h. 17.2 cm
From Vounous, Tomb 91
Given by J. R. Stewart
GR.5y.1939

Clay tablet inscribed in Linear B script
Late Bronze Age, made on Crete *c*.1375 BC

Linear B is a script used to write the Greek language from *c*.1550 to 1200 BC in the great palaces of the Mycenaean world, such as Knossos, Pylos, Mycenae, Tiryns and Thebes. The script was deciphered in 1953 by a young British architect, Michael Ventris, and a classical scholar, John Chadwick. Their discovery has had far-reaching consequences, drastically influencing our understanding of Mycenaean culture and society. Linear B combines syllabic signs with pictograms for individual objects. Most of the surviving

documents record details of the industrial and economic processes and transactions organized in and around the palaces. The tablets show that the palace officials ran major industries producing luxury goods, such as perfumed oil, chariots and fine textiles. This particular tablet relates to the perfumery industry and records a transfer of coriander between a perfumer named Twinon and a man named Kyprios, who appears on other documents and may have been the official in charge of this industry at Knossos.

Coriander was used in perfumery as an astringent that would make oil receptive to scents; the 'six units' of coriander referred to on this tablet would be enough to treat nearly 5,000 gallons of oil.

Clay, l. 12.1 cm
From the final destruction levels of the
'Palace of Minos' at Knossos, Crete
Given by Sir Arthur Evans
GR.1.1911

Unfinished carnelian gem
Egyptian, New Kingdom, Dynasty 18
(reign of Akhenaten: 1352–1336 BC)

Art in ancient Egypt was revolutionized during the reigns of Amenhotep III and IV (who later became Akhenaten). This small, unfinished gemstone is a good example of the changes that took place. First, artists altered the proportions that for 1500 years had remained relatively unchanged. The way in which the royal family was portrayed was also replaced with much more natural, family scenes. The Fitzwilliam's gem is such a scene. Akhenaten and his principal wife, Nefertiti, kiss each other affectionately and are accompanied by the princesses, one of whom is embraced by her mother. The swollen abdomens and elongated heads are typical of Amarna art. Even the King, Akhenaten, was portrayed with these feminine attributes, and Nefertiti copied her husband's portrait type, which resulted in very similar images for the royal couple. This was probably a deliberate policy that stressed the importance of the royal couple, through whom the Aten (or sun-disc) was worshipped.

Carnelian, h. 5.7 cm
From Egypt, probably Tell el-Amarna
Given by R. G. Gayer-Anderson
E.G.A.4606.1943

Sapphirine chalcedony intaglio:
a cow suckling her calf
Late Bronze Age, made either on Crete or
on the Greek mainland, 1500–1300 BC

Seals of various kinds were used in the Aegean world from the early third millennium onwards. The best were carved in hard stones like this, using a fine bow drill. Stamped into soft clay, such seals might be used either as a mark of private ownership or to record the inspection or approval of a palace official. Many of the designs show animals or plants. Here the relationship between cow and calf is both sympathetically observed and turned to artistic advantage, with the two sizes of animal and the cow's natural curving movement cleverly used to fill the circular field.

Sapphirine chalcedony, w. 2.2 cm
Formerly Ricketts and Shannon Collection
Shannon Bequest
GR.118.1937

Fragment of a granite statue of Senusret III
Egyptian, Middle Kingdom, Dynasty 12 (reign of
Senusret III: 1870–1831 BC)

Senusret III was a powerful and influential ruler,
who in many respects reunified Egypt following a
series of divisions between rival families. The
portrait that the ruler adopted for his many
representations was unusual in that it was non-
idealized, presenting him with lines and wrinkles on
his face, heavy eyes and a generally weary expression.
His face is instantly recognizable, and was imitated
by his successor Amenemhat III in a slightly less
exaggerated form. Portraiture served to link
members of dynasties, and it is generally thought
that non-idealized images were psychological rather
than realistic portraits, revealing the personality or
character of an individual rather than his true
appearance. The subject could easily be recognized
as the King of Egypt by the *nemes* headcloth and the
uraeus or cobra that once adorned his brow. This
would have been part of a full-length statue; the
body is unfortunately lost.

Granite, h. 32.3 cm
Given by F. W. Green
E.37.1930

Copper alloy wand in the form of a uraeus
Egyptian, Middle Kingdom, Dynasty 13 (1773–1650 BC)

This copper alloy wand was found 'tangled in hair'
alongside a statue that held a similar magical
instrument. The group came from a tomb that was
excavated by James Edward Quibell underneath the
later temple of Ramesses II at Thebes. The potency
of the *uraeus* or cobra can be seen on many Egyptian
royal and divine representations, where it appeared
on the brow of the subject in order to protect

that person. Many goddesses also appear in cobra
form, and it is likely that this object was intended to
be atropaic, warding off evil, as well as serving a
religious purpose. This wand was first beaten into
shape and then incised. The break at the middle of
the tail is where the magician would have held it in
his or her hands.

Copper alloy, h. 7 cm, l. 16 cm
From Tomb 5, the Ramesseum, Thebes
Given by the Egyptian Research Account
E.63.1896

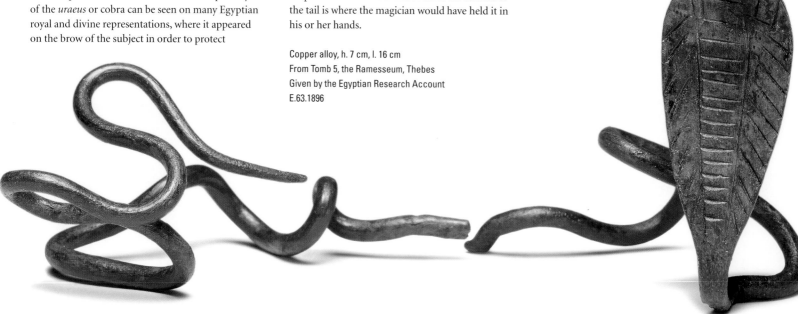

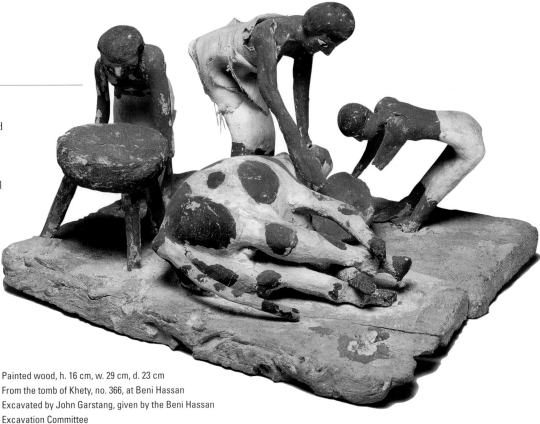

Model of butchers at work
Egyptian, early Dynasty 12 (*c.*1980–1900 BC)

Throughout history cultures have placed great importance on ensuring the continual supply of agricultural produce. In ancient Egypt this extended to provision of food for the afterlife, so that the inclusion of model figures involved in food production became standard practice in burials of the Middle Kingdom (*c.*2040–1750 BC). This model shows two men slaughtering a bull by cutting its throat, the same method used in Egypt today. Nearby is a third man, working at a small table. The tomb of Khety from which it came, together with several other models, items of pottery and Khety's coffin, had remained undisturbed until its excavation in 1902–3.

Painted wood, h. 16 cm, w. 29 cm, d. 23 cm
From the tomb of Khety, no. 366, at Beni Hassan
Excavated by John Garstang, given by the Beni Hassan
Excavation Committee
E.71c.1903

Serpentine *shabti* (funerary figurine)
Egyptian, Dynasty 12 (1985–1773 BC)

Although this small figurine is uninscribed, it was found in a 12th dynasty tomb at the necropolis of Hu. From this period onwards Egyptian burials were provided with individual figurines in the form of mummies made of different materials, such as faience, stone, wood, wax and metal. These were the first *shabtis* (also known at different periods as *shawabtis* and *ushabtis*), magical figures intended to take the place of their owner when called on to do any hard work, particularly agricultural work, in the afterlife. Over time, the practice of including *shabtis* in a burial became more elaborate: spells were written on them, their numbers increased, and they had special containers. Eventually, a full set consisted of 365 ordinary *shabtis* (one for every day of the year), and 36 overseer *shabtis* (one for every ten normal *shabtis*).

Serpentine, h. 16.5 cm
From tomb W38, Hu (Diospolis Parva)
Excavated by W.M.F. Petrie, given by the Egypt Exploration Fund
E.252.1899

Copper alloy *ushabti*
Egyptian, Dynasty 21 (reign of Psusennes: 1039–991 BC)

This *ushabti* is inscribed with the name of king Psusennes. His tomb was among those of the royal family of the 21st and 22nd dynasties at Tanis, excavated during the Second World War, many of which were found intact. Their discovery attracted little attention at the time, and they are frequently overlooked. *Shabtis* continued to be included in burial equipment until the 4th century BC.

Copper alloy, h. 7.3 cm
From the tomb of king Psusennes at Tanis
Bequeathed by Sir Robert Greg
E.149.1954

Fragment of a pottery vessel with a painted figure of Bes playing pipes
Egyptian, New Kingdom, Dynasty 18
(reign of Akhenaten, 1352–1336 BC)

Bes was a popular god throughout Egyptian history and appears in the form of statuettes, lamps, amulets and furniture fittings. He was a god who protected women in childbirth, from the jealousy of other women, and who looked after new-born children. He also offered more general protection against snakes. His appearance may well have been influenced by his roles. He is shown as a dwarf with a broad, exaggerated face, from which he usually sticks his tongue. Around his neck is a leonine collar. In the later Ptolemaic and Roman periods Bes often appears as a soldier with a shield and sword. He is also given a companion – Beset – who has the same dwarf-like form and face, but who appears in the female form. Here, he decorates a large pottery vessel. The bright blue painted decoration is typical of pottery dating to Dynasty 18 and has been especially linked to the city of

Tell el-Amarna, built by Akhenaten and where he ruled with his principal wife, Nefertiti, for about 18 years.

Pottery, height 21.3 cm
Said to be from Tell el-Amarna
Given by R. G. Gayer-Anderson
E.G.A.6188.1943

Limestone ostrakon decorated with a sketch of a stonemason
Egyptian, New Kingdom, late Dynasty 19 to early Dynasty 20 (c.1200–1153 BC)

An *ostrakon* is a reused piece of stone or pottery, usually decorated with a sketch or covered with a text. Letters, tax receipts and spells all appear alongside excerpts from literary texts, perhaps suggesting that they were practice pieces for scribes. A large number of *ostraka* (the plural form) were found at the workman's 'village' of Deir el Medina. The site was a substantial settlement, housing the craftsmen who constructed the royal tombs in the New Kingdom. Many *ostraka* from the site show elaborate sketches, often on both sides, which were probably doodles. The example illustrated here (top) shows a bald-headed stonemason, identifiable by his wooden mallet and copper alloy chisel. On the reverse (below) is a depiction of a worshipper who kneels in front of a snake goddess, probably Meretseger, who was specially revered at Deir el-Medina. Below this drawing is a dedication text.

Limestone, height 15 cm
From Egypt, perhaps Deir el-Medina
E.G.A.4324a.1943

Ivory griffin plaque
Phoenician, 9th–8th century BC

Fort Shalmaneser consisted of a palace, storerooms and an arsenal for the Assyrian army. Several hundred ivory plaques and inlays were found there in a storeroom; they would originally have been attached to items of wooden furniture, such as thrones or chests. Many of the ivories were once inlaid with precious stones, removed when the palace was sacked in the seventh century BC; the hollow eye of this griffin, for example, would once have held a coloured stone. How the ivories came to Nimrud is uncertain: it used to be assumed that they arrived as tribute or booty, but a recent suggestion proposes that Phoenician craftsmen might have been employed to carve them in situ. Certainly, biblical references to Phoenician ivory carving suggest that it was a luxury art with an elite clientele, drawn mainly from members of the foreign aristocracy. Many forms of griffin – mythological winged creatures that combined the body of a lion with the head of an eagle – appear in Near Eastern art: this example may have been one of a pair peacefully flanking a sacred tree, but others are shown in battle, sometimes trampling on the enemy.

Ivory, height 15 cm
From Fort Shalmaneser, Nimrud (ancient Kahlu), northern Iraq
Given by The British School of Archaeology in Iraq
WAE.9.1961

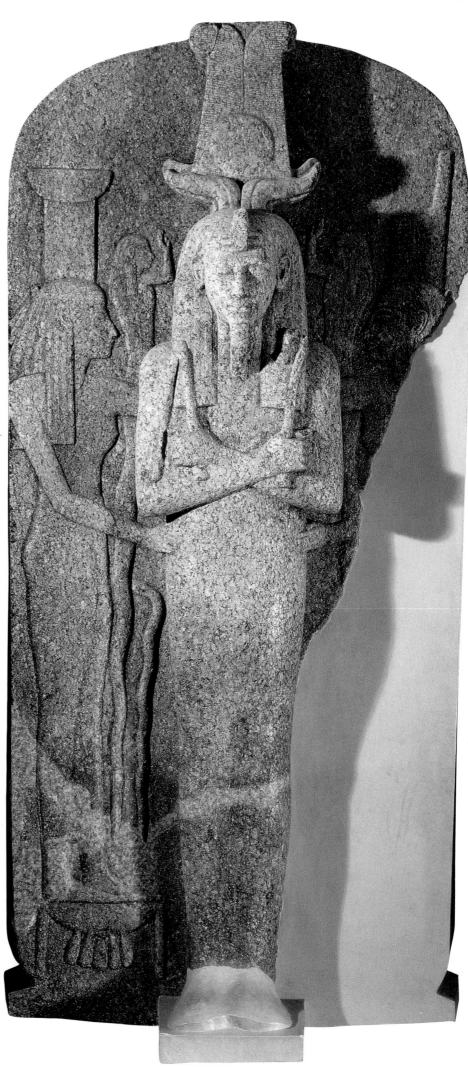

Granite sarcophagus lid of Ramesses III
Egyptian, New Kingdom, Dynasty 20 (reign of
Ramesses III, 1184–1153 BC)

This imposing granite sarcophagus lid was given to
the Museum by the infamous circus strongman and
agent for Egyptian antiquities, Giovanni Belzoni.
Today the cartouche-shaped lid stands upright, but
originally it would have lain horizontally on top of a
large granite coffin to protect the deceased king; the
coffin is now in the Louvre in Paris. The image is
that of Ramesses III in the form of the Egyptian god
Sokar-Osiris, who protected the gateway to the
afterlife, as shown by the mummy-form, the crook
and flail and the crown consisting of two plumes,
horns and a sun-disc. The link with Osiris is entirely
appropriate because the deceased king was believed
to be an embodiment of the god. A number of
protective cobras appear with the king. The uraeus
adorns his brow. Two cobra goddesses stand by the
side of the king with raised hands in a protective
gesture. There is also a long snake running around
the edges of the coffin, whose mouth and tail join at
the top. In addition to the serpents, there are two
women on the outer section of the coffin: Isis, who
was the sister and wife of Osiris, and her sister,
Nephthys; the goddesses can be identified by their
human form and also by their crowns, which spell
their names. Nephthys stands on the hieroglyph for
gold, a mineral used in the embalming process. Isis
also appears on the inside of the coffin, carved in
lower relief.

Granite, height 290 cm
From Tomb 11 in the Valley of the Kings, Thebes
Given by G. B. Belzoni
E.1.1823

Alabaster relief: King Ashurnasirpal II prepares to pour a libation
Assyrian, 883–859 BC

Ashurnasirpal II was one of a line of highly energetic kings whose military campaigns brought great wealth and power to Assyria. The mud-brick walls of the new palace he built at Nimrud were lined with carved stone reliefs glorifying the king and his exploits. On this panel the king forms an imposing figure as he lifts a fluted libation bowl (*phiale*) to pour an offering to the gods. His hair and beard are elaborately curled, his thick garments magnificently fringed and tasselled. Bracelets and earrings emphasize his wealth and status, while the long bow in his left hand and the sword hanging from his waist suggest his prowess as a warrior. The lengthy cuneiform text, carefully inscribed over the smoother, flatter parts of the relief, records the king's titles, his early conquests and the extent of his realm, besides describing how he rebuilt and resettled his capital city.

Alabaster relief, h. 2.275 m
From the palace of
Ashurnasirpal II, Nimrud
(ancient Kahlu), northern Iraq
Additions to Marlay Bequest
WAE.45.1927

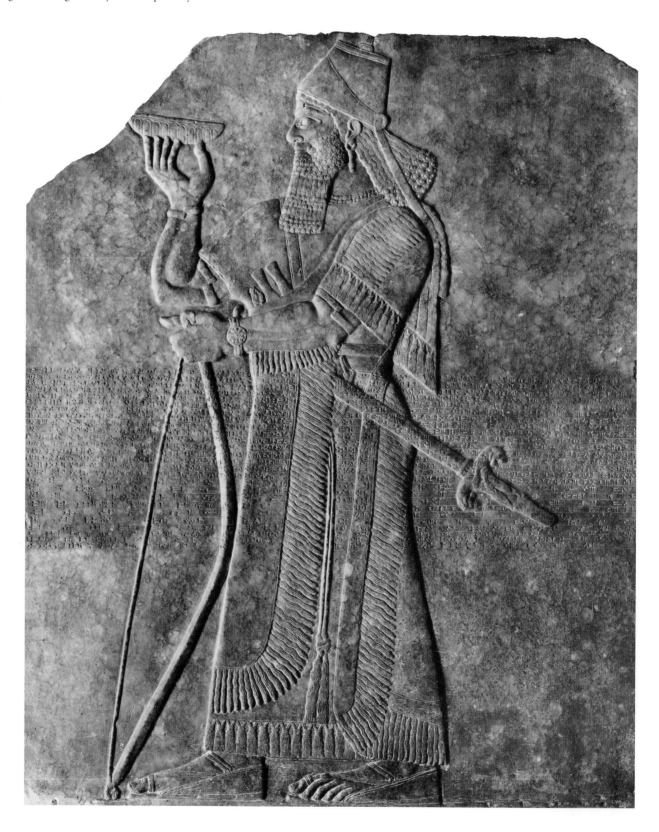

Bronze horses and a fired clay jug
Greek, Geometric period, 8th–7th centuries BC

Greek culture of the period between about 900 and 700 BC is known as 'Geometric' after its most characteristic and prolific form of art: clay vases decorated with geometric patterns such as single or multiple zigzags, hatched chevrons and meanders. This jug, covered from top to bottom with a rich network of patterns, is a good example of both the decorative style and the characteristically high standards of potting and firing at this time. The curving, broken meander on the shoulder is especially well-adapted to the shape. The dark colour of the pot may result from the potter's misjudgement of firing temperatures, or from the smoke of a funeral pyre. One measure of increased social and economic activity in this period is the rising number of dedications made in sanctuaries. Small bronze horses like these three were a popular dedication at this time, perhaps because the possession of a real horse would have been a mark of wealth and status. Characteristic of these finely cast horses are the alert set of their heads, their long, slim legs, ground-skimming tails and exaggeratedly tapered waists.

Bucchero vessels
Etruscan, 7th–6th centuries BC

Bucchero ware achieves its distinctive, lustrous black appearance through being fired in a reducing atmosphere, that is, one in which the supply of oxygen to the kiln was restricted. This results in the production of black, as opposed to red, forms of iron oxide in the clay. The reducing process might also be assisted by introducing organic material into the kiln; this would burn up to form carbon. Between the seventh and fifth centuries BC, several of the Etruscan cities, including Cerveteri, Veii, Tarquinia, Chiusi and Volterra, produced both plain and decorated bucchero vessels in a wide variety of elegant shapes, thrown into prominence by the sombre colour-scheme. Decoration could be added with incised or dotted lines, with roller stamps or through the addition of mould-made elements. The shapes of some vessels, including the *kantharoi* and *kyathoi* with their fragile-seeming handles, may derive from metal forms.

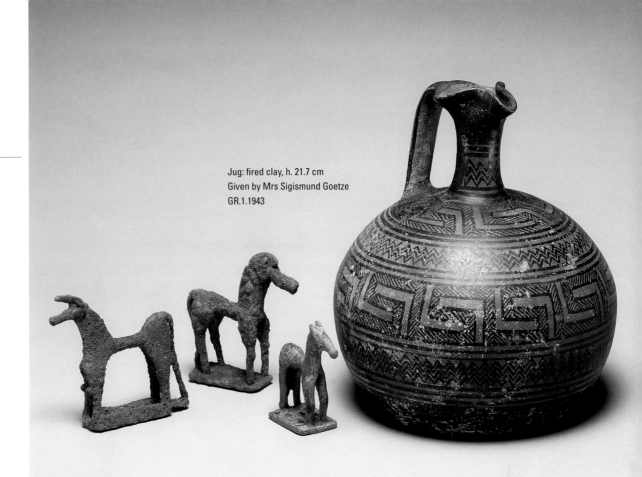

Jug: fired clay, h. 21.7 cm
Given by Mrs Sigismund Goetze
GR.1.1943

Horse (left): bronze, h. 8.1 cm
From Pherae
Given by Dr Winifred Lamb
GR.6e.1927

Horse (centre): bronze, h. 8.5 cm
From Sparta
Given by the Greek Government
GR.16.1923

Horse (right): bronze, h. 6 cm
Given by Dr Winifred Lamb
GR.3.1957

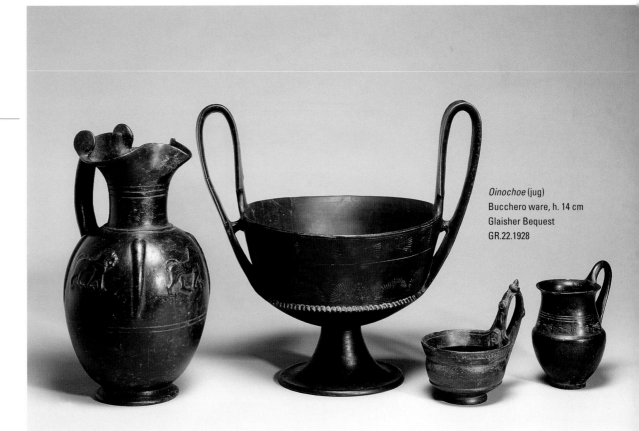

Oinochoe (jug)
Bucchero ware, h. 14 cm
Glaisher Bequest
GR.22.1928

Oinochoe (jug)
Bucchero ware, h. 30.8 cm
Formerly Barrett Collection
GR.20.1952

Kantharos (high, strap-handled drinking cup)
Bucchero ware, h. 32.5 cm
Formerly Revelstoke Collection
GR.3.1935

Kyathos (dipper)
Bucchero ware, h. 10.4 cm
Formerly Barrett Collection
GR.19.1952

Black-figured amphora with a wheeling chariot
Athenian, *c.*520–500 BC; related to the Lysippides Painter

The black-figure technique of vase-painting, perfected at Athens in the sixth century BC, was essentially one of silhouette and incision. The black parts of a black-figured vase were coated with a fine slip of the same clay that was used to form the body of the vase. Interior details of figures, such as manes or muscles, could then be incised through the black with a sharp engraving tool, with extra details added in white or purplish-red. In the course of a carefully controlled three-stage firing process, the areas coated with slip turned and remained black, while the uncoated areas ended up red. This amphora's painter has skilfully manipulated the technique to suggest both the solid mass and the individual components of a wheeling four-horse chariot (*quadriga*). The charioteer (in white), driving a warrior into battle, pulls on the reins so that the leading horses rear up and paw the air, while the heads of the three nearest to the viewer are tossed together.

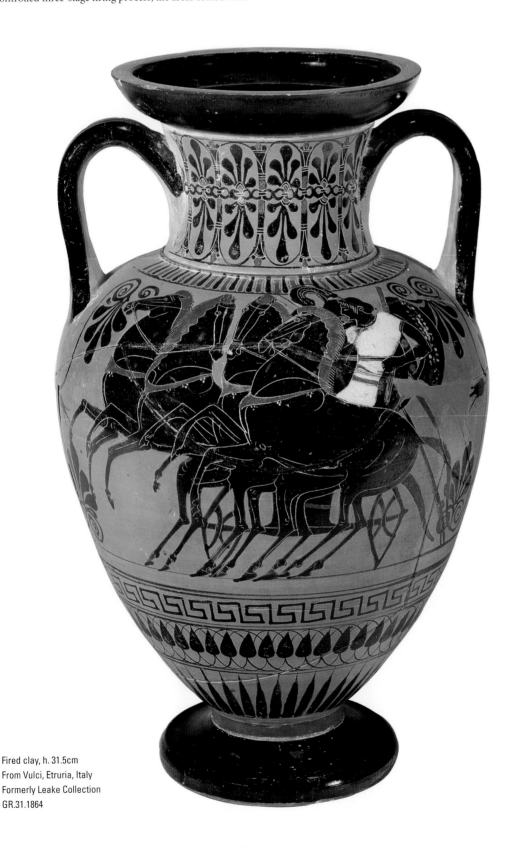

Fired clay, h. 31.5cm
From Vulci, Etruria, Italy
Formerly Leake Collection
GR.31.1864

Detail from the interior of a red-figured cup with a reclining banqueter
Athenian, *c.*500 BC; attributed to the Nikosthenes Painter

The red-figure technique, essentially the reversal of black-figure, was invented at Athens *c.*520–500 BC. Many Greek vases were used at aristocratic male drinking parties, *symposia*, and so it is appropriate that many of them bear *symposium*-related scenes. The reveller on this cup wears a leafy wreath and holds a large, Persian-style drinking horn in his left hand. His open mouth and the gesture of his right hand suggest he may be singing, perhaps to the music of the pipes removed from the animal-skin case hanging above his feet.

Fired clay, diam. of tondo 10 cm
Given by the Friends of the Fitzwilliam Museum
GR.1.1927

White-ground *lekythos*: a youth at a tomb
Athenian, *c.*440 BC

In the white-ground technique, the vase was coated in a kaolin-rich white slip, with figures drawn on top in outline and washes of colour. The white-ground technique was not so robust as black- or red-figure, and was used almost exclusively on vases that ended up either as sanctuary dedications or in tombs. This youth, muffled to the eyes in his dark red cloak, stands beside a tall grave monument (*stele*). He is probably the owner of the *stele*, the dead person, whose grave is being visited by a woman who approaches from the other side of the monument.

She carries a sash, an offering that she will add to those already tied around the *stele*. The elegantly shaped *lekythoi* contained perfumed oil offered as a gift to the dead; many of them bear poignant funerary scenes, in which the busy activity of the living is contrasted with the silent stillness of the dead.

Fired clay, h. 36 cm
Formerly Ricketts and Shannon Collection
Shannon Bequest
GR.36.1937

Copper alloy figure of a Nubian king
Egyptian, Dynasty 25 (747–656 BC)

The Kushites came from modern-day Sudan and
ruled Egypt as its 25th dynasty. Like many foreign
rulers, they enthusiastically supported and promoted
Egyptian culture, appearing in art as pharaohs.
The Kushite men were unusual amongst Egypt's kings
because they adopted a special form of attribute
hitherto reserved for royal women and goddesses.
This statue illustrates this feature, the double *uraeus*
in place of the usual single cobra. It is thought that
the double form may be a reference to the joining of
the Kingdoms of Kush and Egypt. The statue is made
from parts that were cast separately. Joins can be
seen on the shoulders for the arms (the right is now
missing), and the crown is detachable. The king
strides forwards in the traditional Egyptian stance
with one arm outstretched, probably originally
holding a staff. It is likely that this statue would have
been supported by a base, perhaps inscribed in
honour of the king or with the name of the person
dedicating it.

Copper alloy, h. 31 cm
Bequeathed by Sir Robert Greg
E.74.1954

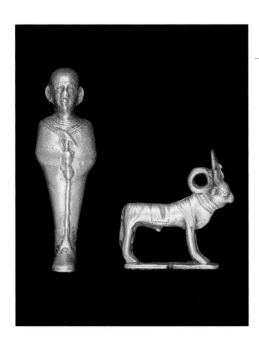

Two silver amulets
Egyptian, Late Period or Ptolemaic

In ancient Egypt amulets were worn to protect both the living and the dead, and they appear in a variety of forms and materials. These are of silver and represent two related gods from Memphis, a city that was often the capital of Egypt and home to many ruling houses. Ptah was a creator god and craftsman. He was a principal god at the site and appeared in a mummified form. Memphis was also home to the Apis bulls, who were believed to be the living representative of Ptah on earth. The bulls lived in stalls at the site and were paraded in front of tourists. When they died they were embalmed at a special site and then taken to a burial chamber, where they were worshipped as Osiris–Apis or the dead Apis bulls. The King usually met the cost of these expensive burials. Following the death of a bull a nationwide search ensued to find a replacement with the required special markings.

Left:
Ptah: Ptolemaic period (323–30 BC)
Silver, h. 4.4 cm
Bequeathed by Sir Robert Greg
E.159.1954

Right:
Apis: Late Period or Ptolemaic (664–30 BC)
Silver, h. 2.7 cm, w. 2.8 cm
Given by G. D. Hornblower
E.55a.1939

Limestone sculptor's model
Egyptian, Ptolemaic period (323–30 BC)

Sculptors used models for two different reasons. The first was to formulate the portrait type that would be used for the king, and the second to disseminate the accepted image to workshops throughout the land. There are sporadic examples from the 3rd to 1st Millennia BC, but two periods in particular have yielded a greater amount than usual. It is clear that during the Amarna period, artists experimented with models before formalizing the royal image, and that there is a visible development of style over the 17-year period. The example illustrated here dates to the Ptolemaic period. The early Macedonian rulers copied the portraits of the last Egyptian dynasty (30) in order to create a link with their new country's native rulers. This particular bust has an unfinished uraeus on the brow, and the grid marks that were used to ensure the correct proportions are still visible on the lappets of the wig. It probably represents Ptolemy I or II.

Limestone, h. 11 cm
Given by R. G. Gayer-Anderson
E.G.A.3209.1943

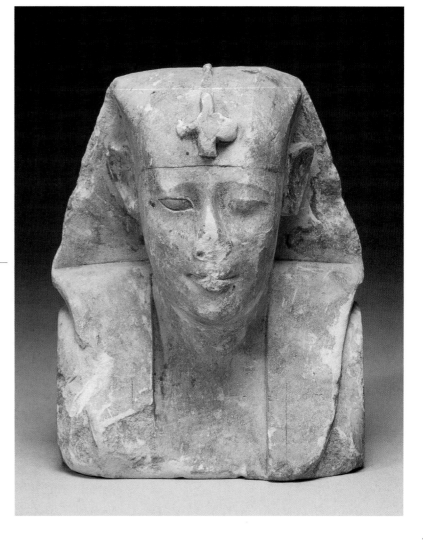

Asklepios
Athenian, 4th century BC

The snake-twined staff on which this figure leans makes him immediately identifiable as the god Asklepios, in whose cult and healing rites snakes played an important role. There were long-established sanctuaries of Asklepios in many parts of the Greek world, but his cult was established in Athens only in the late fifth century BC, not long before this relief was carved. The fragment comes from a votive plaque offered to the god by one of his worshippers in thanks for, or in anticipation of, a cure. Here Asklepios was originally accompanied by his daughter Hygieia, the personification of Health, traces of whose hand can be seen on his right shoulder. The worshipper himself, probably accompanied by members of his family, would have been shown on a smaller scale than the gods, approaching them from the (now missing) right-hand side of the relief. The carving is of exceptionally high quality for this type of relief: especially fine is the treatment of the god's *himation* (mantle), beautifully carved so that its twists and folds give a thoroughly three-dimensional impression of weight and volume.

Pentelic marble, h. 48.2 cm
Formerly Ricketts and Shannon Collection
Shannon Bequest
GR.98.1937

Below:
Actor with goose: h. 14.7 cm
Formerly Ricketts and Shannon Collection
Shannon Bequest
GR.85a,b,d.1937

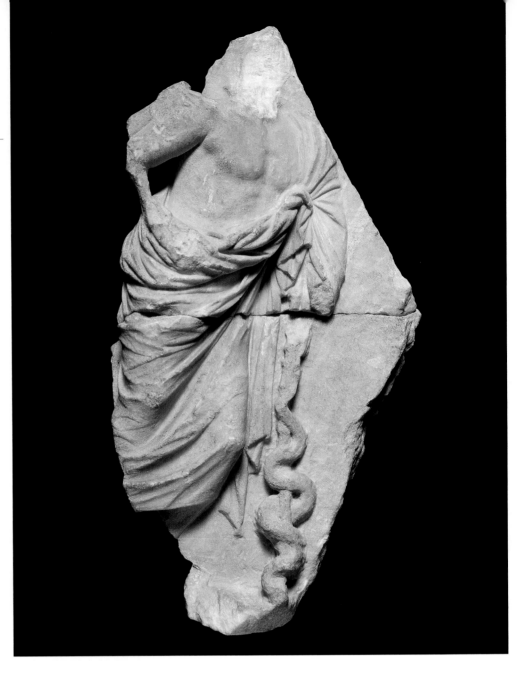

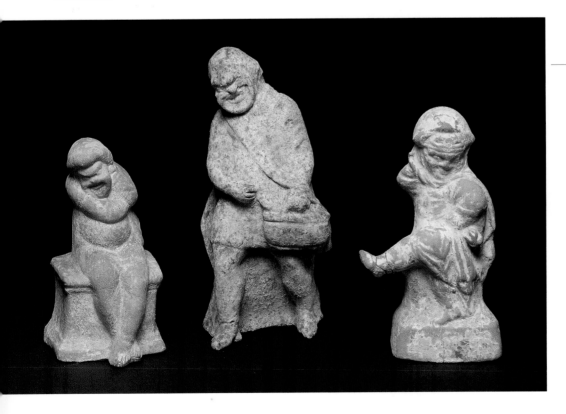

Three terracotta actors
Greek, probably made on the Greek mainland, 4th to 2nd centuries BC

These terracotta actors represent popular characters from the comic stage. The short and stocky dancer (right), a male actor dressed as a woman, is perhaps a parody of the graceful, draped female dancers who are also portrayed in bronze or terracotta at this time. The figure seated on an altar (left) represents a runaway slave taking refuge from an irate master; the hand held to the ear suggests he is pretending to be deaf. The striding figure with a goose in his basket (centre) has been identified as a cook, bringing home the dinner. Terracotta figures of this sort can provide valuable information on the costumes, masks and stage gestures of comic actors. Such figures became popular in the early 4th century BC, a time when terracottas in general were undergoing major developments in terms of their subjects, functions and technique. Far more of them are now found in tombs, and a much wider repertory of subject-types develops. At the same time the figures become more fully three-dimensional; most are made in two moulds, back and front, and so can be viewed from more than one angle.

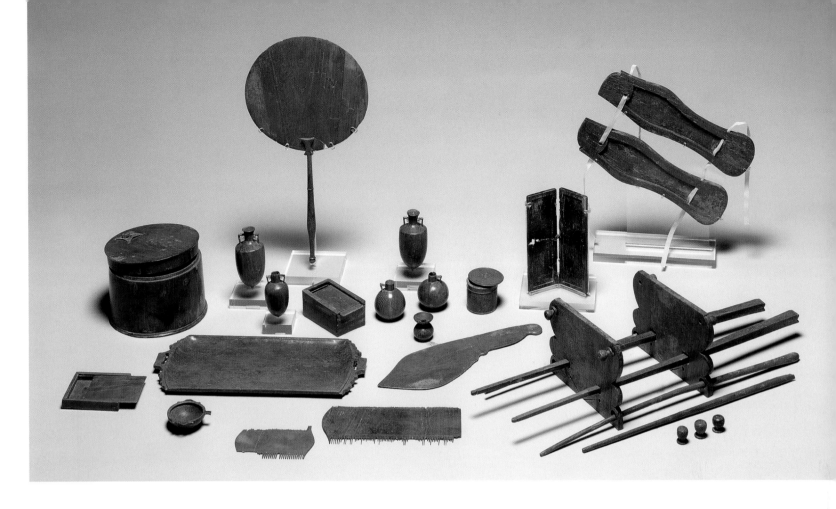

Greek and Roman jewellery
4th century BC to 1st century AD

The gold ring and the toggle pin are probably the earliest items in this group. The ring could have been worn simply as a piece of decorative jewellery, but as the device is cut in intaglio, it is likely also to have been used as a personal or official seal. The sacred nature of the subject, a woman dropping grains of incense into an incense burner, suggests the possibility that the ring might once have belonged to a priestess. The toggle-pin, with its intricate decoration, demonstrates the skilful use of filigree and granulation by 4th-century Greek jewellers. It could have been used to pin a cloak on the wearer's shoulder. The two pairs of earrings illustrate an important development in taste and technique. Animal-head earrings were a long-lasting fashion, which may originally have been adopted from the Near East. But while the earlier, kid-headed, pair are made purely of gold, the later, dolphin-headed examples incorporate two sorts of coloured stones. This eye-catching practice originated in the Late Hellenistic period and became more popular and widespread in the Roman era.

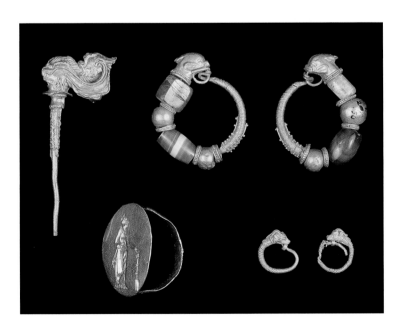

Above:
Ivory, l. of tray 21.5 cm
Purchased through the Gow, Greg and Hitchcock Funds, and through the Victoria & Albert Museum Grant-in-Aid
GR.2.27c.1980

Left:
Gold toggle pin, the end decorated with the forepart of a griffin, l. 4.6 cm
From South Russia
Formerly Nelidov Collection; given by Miss S. R. Courtauld
GR.9j.1931

Bottom left:
Gold ring engraved with a woman at an incense burner, h. of bezel 2.3 cm
Said to be from Crete
Formerly Nelidov Collection; given by Miss S. R. Courtauld
GR.9k.1931

Top right:
Pair of gold earrings with kid-head terminals, h. 2.3 cm
From Luxor, Egypt
Given by Mr A. Gow
GR.1.1928

Bottom right:
Pair of gold earrings with dolphin-head terminals, the hoops threaded with beryl and agate beads, h. 2.5 cm
Given by the family of F. W. Green
E.20.1950

Ivory toilet and writing utensils, tomb group
Roman, probably made in Italy in the 1st century AD

The group includes several small pots and bottles, cosmetic boxes, a model mirror, fine-toothed combs, a tray, a broad, knife-shaped spatula, and two sets of writing tablets, one shaped like a pair of women's sandals. The curious object consisting of two thin plaques linked by four tapered rods has been interpreted as a device for unrolling and reading sections of a papyrus scroll; it is, however, difficult to imagine that it would have been very easy to use in this way. An alternative explanation is that it might be an implement connected with some form of weaving. One interesting feature of this group of objects is their combination of 'real' and 'symbolic' items: the combs, for example, and the writing tablets, could have had a practical function, but most of the bottles and boxes are much too small to have been of any real use, while real mirrors need to be made of metal in order to provide a polished, reflecting surface. The assemblage therefore mixes genuine objects of the type an affluent and literate person might have used in life with others that are essentially decorative or symbolic.

Upper part of a caryatid
Roman, made in Greece in the 1st century BC

This fragment is part of a colossal full-length figure of a young girl. She originally stood with both arms raised to support the cylindrical chest (*cista*) that she carries on her head. She was one of a pair of figures that formed the supporting columns of a gateway to the inner area of the sanctuary of Demeter, the goddess of corn, crops and fertility. This gateway was given to the sanctuary by the Roman consul Appius Claudius Pulcher between *c.*54 and 48 BC. The girl and her companion probably represent priestesses of Demeter, whose secret rites were celebrated at Eleusis. Their faces, however, may have been idealized portraits of the donor's daughters.

In the course of time the gateway collapsed, but this figure remained visible and was drawn and described by travellers to Greece as early as the seventeenth century. Nor was the association with Demeter forgotten, and in fact the local people revered her as an image of the goddess herself, piling manure around her and believing that her presence ensured the fertility of their fields. In 1801 the statue was purchased by Professor E. D. Clarke and shipped back, with some difficulty, to Cambridge.

Pentelic marble, h. 209 cm
From the Sanctuary of Demeter at Eleusis, near Athens
Given by E. D. Clarke
GR.1.1865

Mosaic niche
Roman, probably made at Baiae near Naples,
southern Italy, AD 50–100

This niche, which may originally have housed a fountain, would have formed an eye-catching architectural feature in the wall of a courtyard or garden in an opulent Roman villa. Fountain niches were partly supposed to resemble natural or artificial grottoes, which is why shells were a popular decorative motif; here a scallop-shell design decorates the roof of the vault, while real cockle-shells frame the borders of the arch and the lower

edge of the garden wall. The garden scene may have been inspired by contemporary painting: very similar designs have been found at Pompeii. In this garden, a variety of trees and bushy shrubs spread their branches to the sky, the individual leaves carefully delineated with enormous skill by the mosaicist. A tame peacock sits on a low wall at the front, and three white birds, perhaps domestic doves, prepare to alight in the leaves above.

Idyllic scenes like these were designed to encourage the viewer, relaxing in an enclosed, domestic space, to imagine him- or herself in an environment that was superficially 'natural', though actually still reassuringly tamed and dominated by man.

Coloured glass, marble, rosso antico, shell, h. 112 cm
Formerly Ponsonby Collection; given by M. Marks
GR.159.1910

197

Terracotta rattle
Egyptian, Roman period, 1st century AD

This small figure contains a single pellet but is not the usual form of rattle, commonly called a *sistrum*, that was used in ancient Egypt by priests and gods. The corpulent, naked woman with pendulous breasts is a known type of terracotta figurine from Roman Egypt and was probably associated with fertility. The Fitzwilliam's rattle shows the subject with splayed legs, possibly indicating that she is giving birth, or, alternatively, presenting herself in an overtly sexual way. For these two reasons, it seems likely that this rattle served a very specific purpose or was used for a particular ritual.

The piece was mould-made from Nile silt clay in two halves that were then joined. It is possible that it was originally painted.

Terracotta, h. 7 cm
From Antinoe
Given by the Egypt Exploration Society
E.86.1914

Seated Buddha
Gandhara (modern Pakistan), 1st to 3rd centuries AD

The historical Buddha ('enlightened one') was born as a prince named Siddhartha Gautama in the kingdom of the Shakyas in northern India. The exact dates of his life are uncertain, but by the mid-third century BC his ideas had become extremely influential not just in India but also in Ceylon, China and the North-west frontier region of Gandhara (today in Pakistan). Gandhara lay on an important east-west trade route, and was well known to the Greeks by the fifth century BC. Conquered by Alexander the Great in 329–325 BC, it was subsequently ruled by Indo-Greek kings until the early first century AD. As a result of the various cultures that either passed through or settled in the area, the sculpture of Gandhara evolved a distinctive style that combines Greek, Roman, Indian, Chinese and Central Asian influences. Here the treatment of the Buddha's hair and drapery are clearly reminiscent of classical work, while his pose and facial features seem distinctively eastern.

Dark grey schist, h. 35.7 cm
Given by the Morton family in memory of Harold Hargreaves and his daughters, Mary Morton and Elizabeth Capstick
O.1-2003

Sandstone relief of the Emperor Domitian
Egyptian, Roman period, AD 81–96

The Romans conquered Egypt in 30 BC, after which time the country became a province without a resident king. The ruler was an essential part of Egyptian religion, ideology and society, and so priests continued to adorn temples with images of their new pharaohs and to undertake the usual tasks of tending to the gods on their behalf. Domitian never visited Egypt, but he showed a keen interest in Egyptian cults, supporting sanctuaries to the goddess Isis in Italy and showing himself as the Pharaoh on a number of statues. This temple relief is purely Egyptian in style and comes from one of the temples built in Egypt during his reign. Domitian (on the viewer's right) makes an offering to the ram-headed god Khnum. The emperor carries a sceptre in the form of a god (possibly Heh, the god of eternity). The hieroglyphic inscription reads '… of Amun-Ra' and the cartouche reads 'Caesar' and then the emperor's name.

Sandstone, h. 15 cm, w. 28 cm
From Deir el-Haggah
Purchased through the Greg Fund
E.1.2003

Roman marble cinerary chest
Probably made at Rome, *c.*AD 25–50

Cinerary chests and sarcophagi survive in large numbers, reflecting the emphasis laid by traditional Roman morality on the importance of the family and the need to show conspicuous respect to the ancestral dead. Until the second century AD cremation was the normal practice, with the ashes placed in chests or urns that were then set in niches in family tombs. The rich decoration of this example is extremely fine, with its heavy swags of fruit in high relief set above lively low-relief pairs of birds. The inscription is less well-carved and not very literate; it states that the freed-woman (that is, former slave) Aelia Postumia acquired the chest for herself and for her husband.

Marble, h. 46 cm
Acquired in Italy
Given by Dr. J. Disney
GR.56.1850

Roman marble sarcophagus
Rome, *c.*AD 125–150

This sarcophagus is an early example of the new sort of funerary sculpture made necessary by the widespread change from cremation to burial that took place in the early second century AD. The relief scene shows the triumphant return from India and the East of the wine-god Dionysus, whose initiates anticipated a glorious life after death. The youthful god (standing in his chariot on the left) is a minor figure in the scene, which is dominated in the centre by his drunken followers and at the right by the magnificent, eye-catching elephant.

Marble, l. 2.216 m
From Arvi, Crete
Given by Admiral Sir Pulteney Malcolm
GR.1.1835

Painted wooden mummy portrait of Didyma
Egyptian (Antinoopolis?), Roman period, AD 130–150

This painted wooden panel was originally part of a mummified body. Like many of the mummy portraits, the panel was probably separated from the body at the site where it was excavated, and its exact provenance is also unknown. It has been suggested that the portrait may have been found at Antinoopolis because the way in which it is shaped is typical of other portraits from this site. The image is that of a young boy, who wears the Egyptian Horus or side lock that was associated with youth, but who also wears a Roman dress of a tunic with *clavi* (the purple bands). Thus, the subject appears with Roman and Egyptian attributes. Around his neck is a gold or copper alloy torque with either an amulet case or pendant. Confusingly, however, the subject has a name more commonly associated with girls. The Greek inscription identifies her as the seven-year-old Didyma.

Wood, h. 34.8 cm
Bequeathed by Miss P. M. Cook
E.5.1981

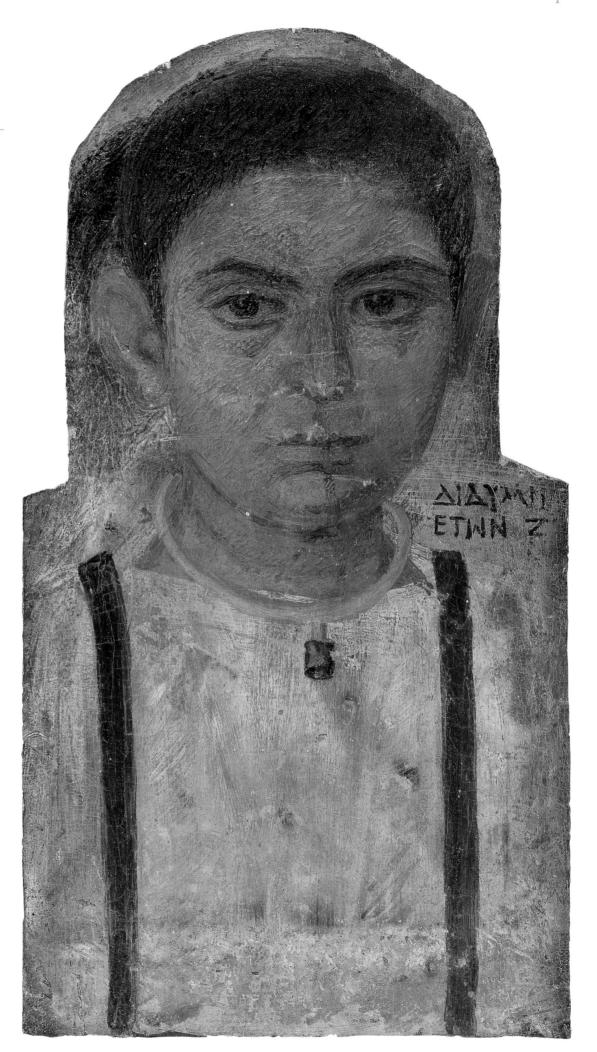

Glass vessels

Roman, made in the eastern Mediterranean, 2nd to 4th centuries AD

Glass is a remarkably beautiful and versatile material. It is made from a mixture of soda, silica and lime: soda occurs naturally in the form of natron, while silica is sand, in which lime is also often found. The discovery that glass could be 'blown' to shape was probably the single most significant development in the history of glass manufacture from antiquity to the present day. Blowing was first developed in Syria and Palestine in the mid-first century BC. From here the technique spread rapidly throughout the Roman empire and soon the use of translucent, pale coloured glass was widespread. It was cheap and colourful and, unlike bronze or silver, it was easy to clean and did not impart unpleasant flavours to food and drink.

The square blue bottle shown here was blown into a mould, while the other two were free-blown. The sides of the large flask were squeezed in while the glass was still soft, and then the snake-thread decoration was applied. The spiral and zigzag patterns on the body seem random at first glance, but actually they are very carefully made and placed. The threads have been slightly flattened ('marvered') and then combed to produce a roughly ridged effect that contrasts with the fine, smooth surface on which they lie.

Left:
Square blue bottle
Glass, h. 16.3 cm
Given by Sir William Elderkin
GR.27.1955

Centre:
Pale green flask with applied
snake-thread decoration
Glass, h. 25 cm
From Marion, Cyprus
GR.61.1876

Right:
Pale green jug with purple thread
on handle
Glass, h. 16.4 cm
From Palaipaphos, Cyprus
Given by the Cyprus Exploration Fund
GR.132.1888

Head of Antinous

Roman, c.AD 130–140

Antinous came from Bithynia in north-west Asia Minor. His beauty attracted the attention of the Emperor Hadrian, whose constant companion he became, and whom he accompanied on a visit to Egypt in AD 130. A few weeks into the trip, Antinous drowned in the Nile. Much speculation has surrounded his death. Was he murdered? Was it an accident? Or did he sacrifice himself for the sake of the ageing Hadrian's health? Where Antinous drowned, Hadrian founded a new city, Antinoopolis. An obelisk, now in Rome, chronicles Antinous' deification; his cult statues showed him in an Egyptian guise. He also appears in the guise of the classical gods. Here he is shown as Dionysos. This statue was found in 1769, at Hadrian's immense villa at Tivoli, just outside Rome. Here the Emperor commissioned many statues of his companion to decorate various areas, including a shrine to Osiris–Antinous, meaning the deceased Antinous.

Marble (nose, lips, chin, parts of wreath and bust restored),
h. 41 cm
Said to be from Hadrian's Villa at Tivoli, Italy
Formerly in the Collections of the Marquis of Lansdowne
and Ricketts and Shannon
Shannon Bequest
GR.100.1937

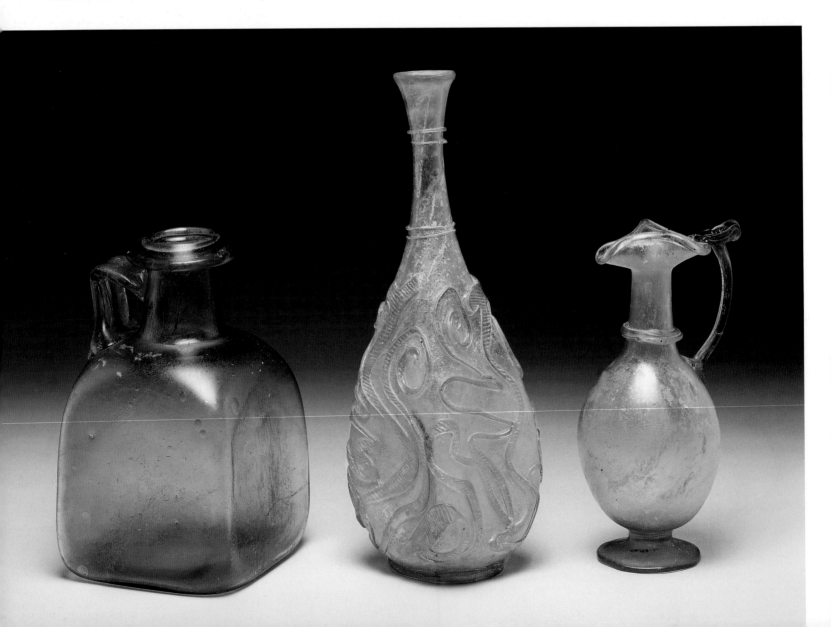

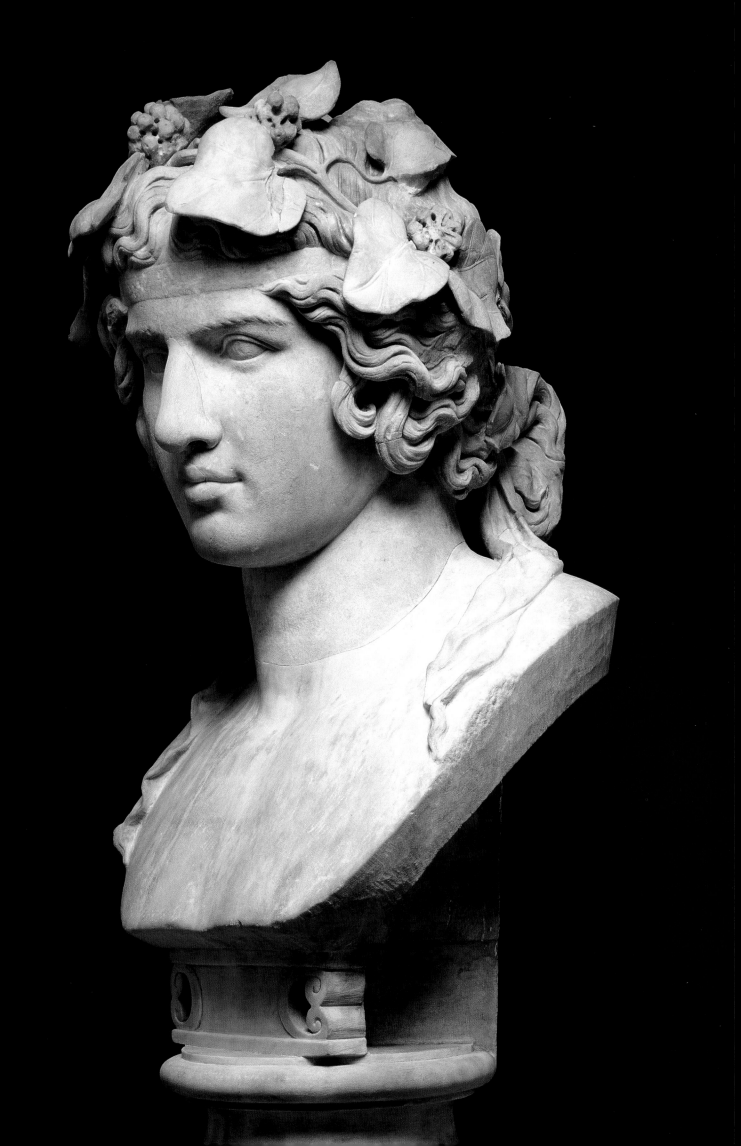

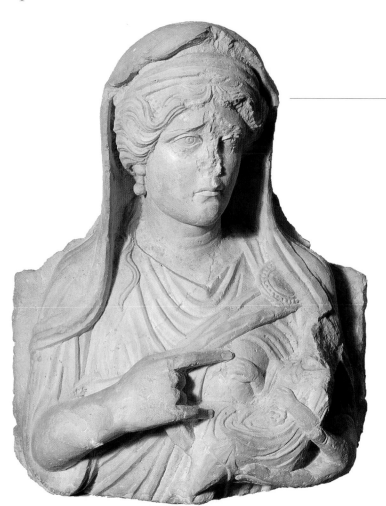

Stone reliefs showing a mother and child and a funerary banquet
Palmyra(?), Syria, 2nd to 3rd centuries AD

The oasis city of Palmyra grew rich through the caravan trade that linked the Persian Gulf with the Mediterranean Sea. The city attracted a wealthy and cosmopolitan population of merchants and traders from all parts of the Near East, and towards the end of the first century AD it was incorporated into the Roman Empire. A series of rich tombs, built outside the city in the second and third centuries AD, are decorated with sculpture that shows a blend of Eastern and Western influence and style. The mother and child relief would have sealed one of the rock-cut tomb compartments where the bodies of the dead were laid. The mother, richly dressed in a double tunic with her cloak drawn up over her head as a veil, and decked out with fine jewellery including earrings and a large circular brooch at one shoulder, offers her breast to the child who lies on her arm. The larger relief, with its banquet scene, may have been one of a group that would have made the walls of a tomb chamber recall the typical dining-room of a Greek or Roman house. The dead man reclines on a mattress embroidered with flowers, feasting in the presence of his wife and sons. He wears Eastern, perhaps Parthian-style, boots and trousers beneath his long tunic and cloak, while his sons are shown in Western (Greek) dress of tunics and mantles.

Limestone, h. (mother and child) 57 cm,
(funerary banquet relief) 53.7 cm
Said to be from Palmyra
GR.9.1888 and GR.6.1888

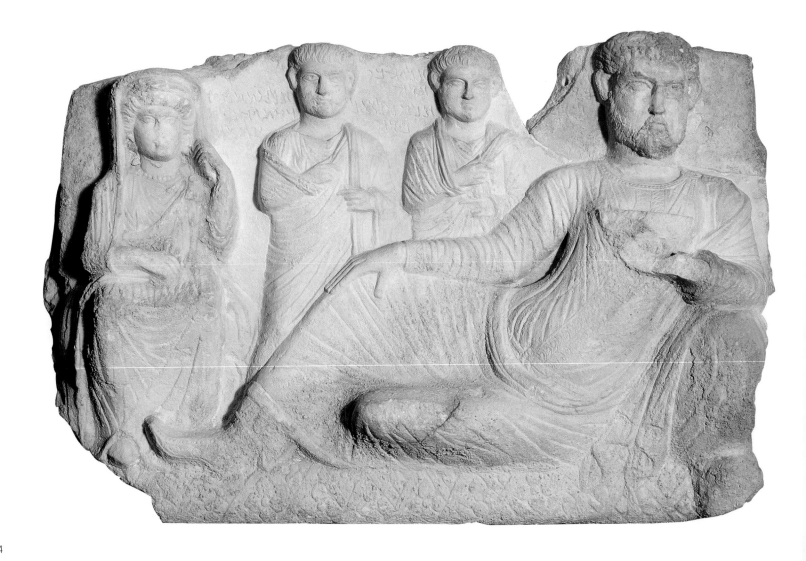

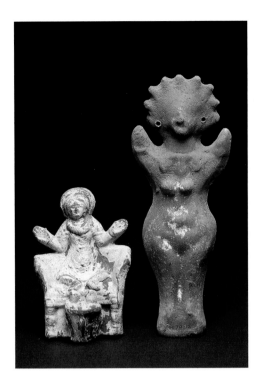

Terracotta figures of women with hands raised in prayer
Egyptian, Roman and Late Antique period

Although these terracotta figures are sometimes referred to as dolls, excavated examples have been found in tombs and sanctuaries as well as houses, suggesting a religious function. The arms are raised above the head in prayer and many, such as the earlier Roman example illustrated here (left), offer fruit or bread. The offerant wears a wreath around her head and her neck, suggesting a connection with festivals. She wears a loosely fitted garment and sits in a position common to this type of figurine, with knees splayed outwards. Many Roman examples show the woman naked, perhaps suggesting a link with fertility. The Late Antique figure (right) is more stylized in appearance, but a close inspection reveals that she wears a similar dress and either a necklace or amulets. Like the Roman example this figure would have been coated with a plaster wash on which pigment was painted to show individual features such as clothing, jewellery and facial features. Both are mould-made in parts and then joined before firing. Many such figures were manufactured at temple sites, serving visitors who would buy them as votive offerings or take them home and place in their personal shrines.

Left:
Egypt, Roman period, 2nd century AD
Terracotta, h. 16.7 cm
Purchased through the Greg Fund
E.1.1995

Right:
Shurafa, Late Antique period, 4th century AD
Terracotta, h. 28 cm
Given by the British School of Archaeology in Egypt
E.184.1912

Marble gravestone with a Cufic inscription
Egyptian, Islamic period, AD 869–70

Following the Arab invasion in AD 642, the capital of Egypt was moved to a new-founded city called el-Fustat, which is close to modern-day Cairo. Many Roman and Coptic (Christian) objects continued to be made and used, but the new culture and language dominated Egypt. Cufic is a form of old, ornamental Arabic. The relief once decorated the grave of a woman named Hujjat who was daughter of a Persian man named Abdhar Rahiam. She died in the month of Muharram in year 256 of the Islamic calendar, which was from 9 December 869 to 8 January 870. The inscription is formulaic and states that Hujjat was a devout follower of Allah (God). The block itself is made from an imported marble called *pavonazetto*, which was popular in the Roman period. The size and rough working of the back of this stone also suggest that it was a re-used block that originally decorated the inside of a Roman building.

Marble, h. 58 cm
From Old Cairo
Given by F. W. Green
E.57.1914

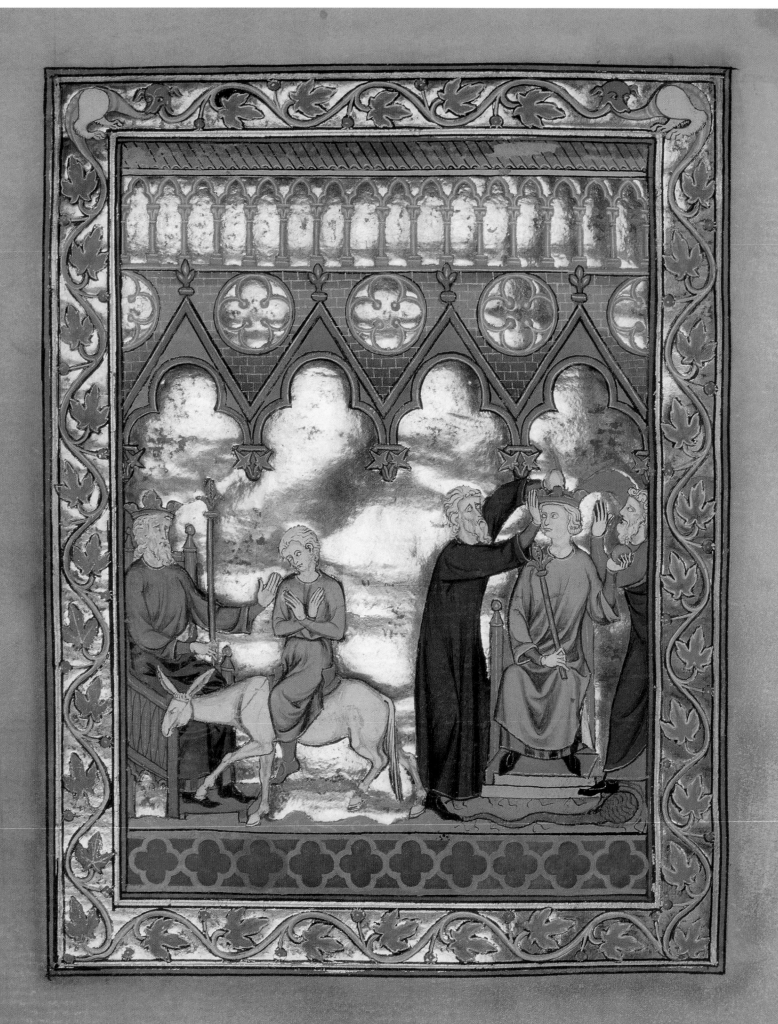

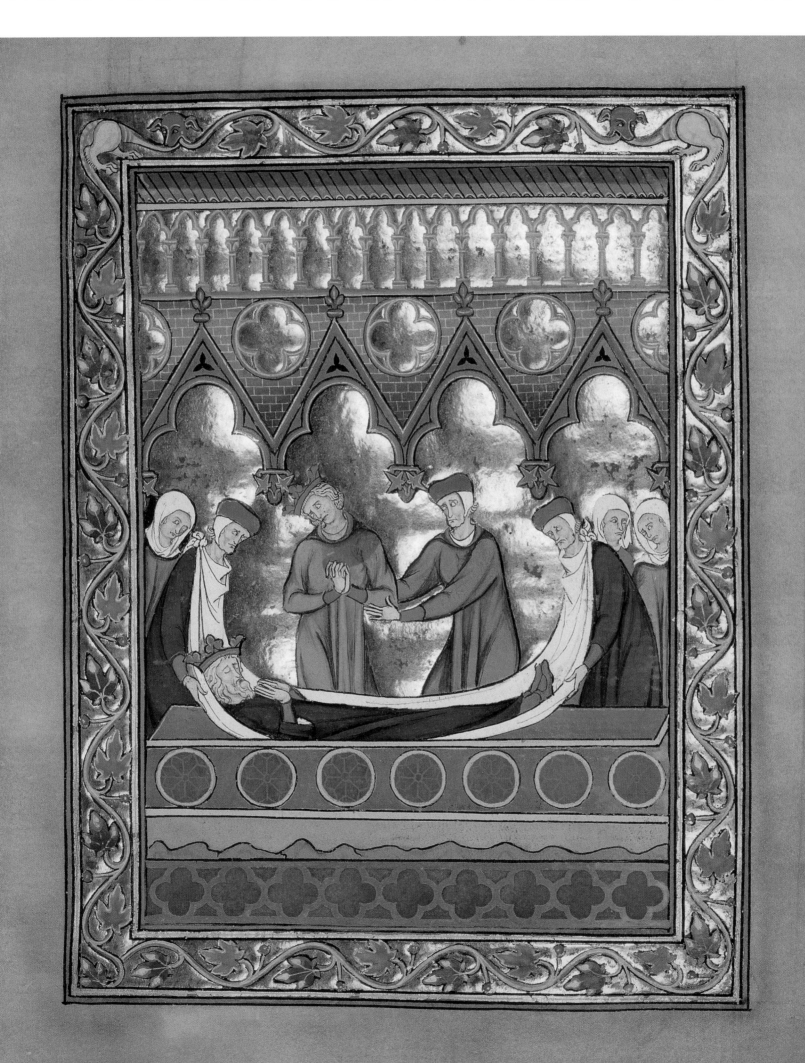

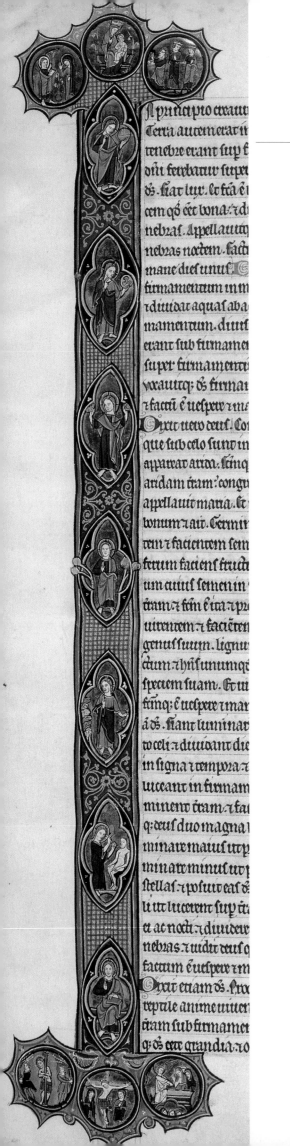

The story of Creation and Salvation
Parisian Bible, *c.*1260

The Fitzwilliam Museum preserves the finest collection of illuminated manuscripts to be found in a museum outside the Vatican. Its nucleus is the Founder's bequest of some 130 volumes. This Bible was the first item described in the 1895 ground-breaking catalogue of the collection by M. R. James, the Museum's Director, famous for his scholarship as much as for his ghost stories. In the course of the thirteenth century, Paris became the leading intellectual and artistic centre of Europe. With the royal court providing a discerning clientele, and the University attracting an international elite of scholars and students, the production of manuscripts was transformed into a thriving business. The bestseller was the Bible, its text standardized and divided into the chapters still in use today. Thousands of pocket-size copies were produced. This one is exceptional. Its size, formal Gothic script, shimmering gold and exquisite illumination are the hallmarks of a deluxe manuscript.

Gold leaf and tempera on parchment, 38 x 24 cm
Founder's Bequest, 1816
MS 1, fol. 4r

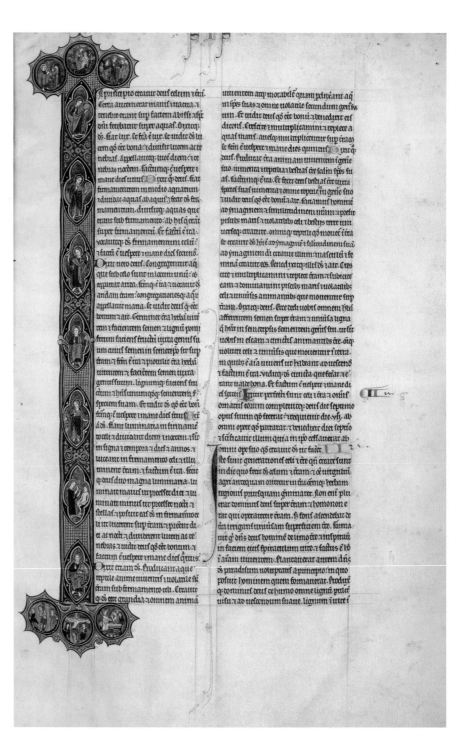

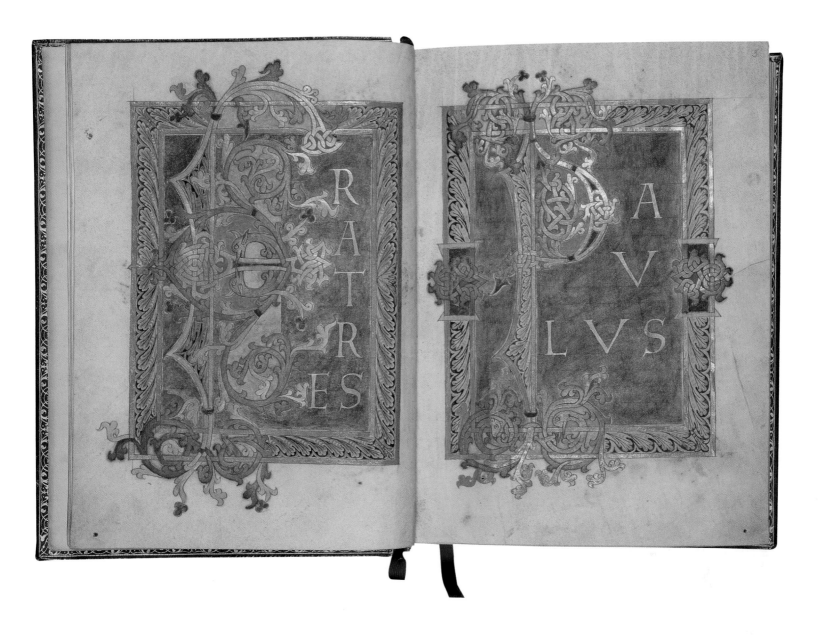

Gold and purple opening to the Christmas readings
The Reichenau Epistolary, late 10th century

Containing the readings from St Paul's Epistles for major feasts, this is one of the most important manuscripts for the history of the Western liturgy. The ornate gold and silver letters on purple-dyed parchment signal a book fit for a king. Characteristic of manuscripts produced at the courts of the late Roman and the Byzantine Empire, they came back into fashion during the ninth-century cultural revival known as the Carolingian Renaissance. Its patron, Charlemagne, restored the Western Empire through conquest and learning. Books, the main instruments of his reforms, were gathered, copied and disseminated throughout the Frankish Empire from centres such as Aachen and Reichenau. This and many other early medieval treasures came to the Fitzwilliam with the bequest of Frank McClean, providing a perfect balance to the Founder's collection of predominantly Late Gothic and Renaissance material. This was an act of extreme generosity from one of the wealthiest nineteenth-century collectors: if 'Money' entered the sales room, few of his peers stood a chance.

Gold ink and tempera on parchment, 27 x 19.5 cm
Bequeathed by Frank McClean, 1904
MS McClean 30, fols 2v–3r

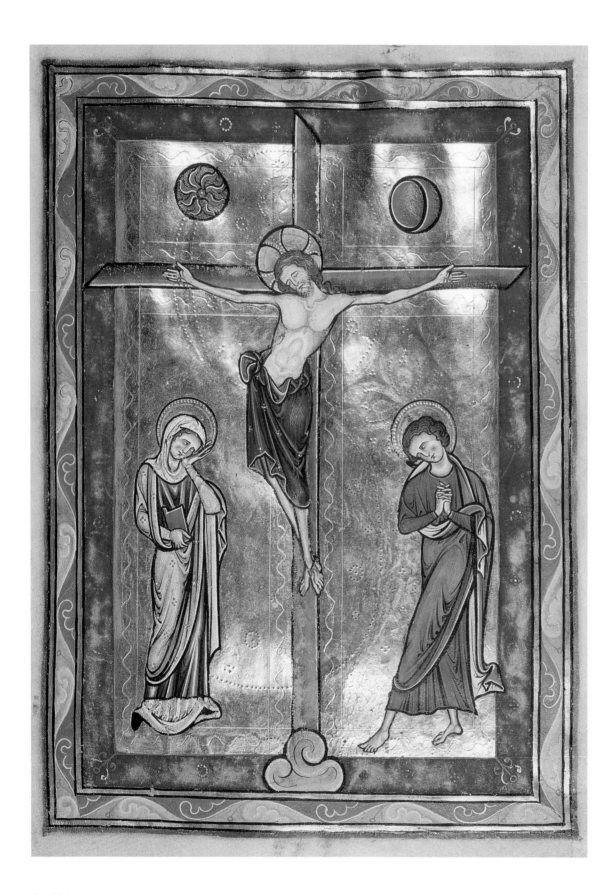

Crucifixion
The Peterborough Psalter, *c.*1220

The Psalter's liturgical texts point to the Benedictine Abbey of Peterborough and associate it with Robert de Lindesey, Abbot from 1214 to 1222. As with many of his contemporaries, the artist remains anonymous. Yet, the mannered figures in suave poses, the gold ground with delicately incised patterns and the painterly modelling of draperies and faces distinguish him as the finest English illuminator of the early thirteenth century. They also reveal Fitzwilliam's remarkable taste and independent judgement at a time when collectors neglected Gothic, and particularly English, art in favour of Italian, Flemish, and French Renaissance illumination.

Gold leaf and tempera on parchment,
31 x 19.8 cm
Founder's Bequest, 1816
MS 12, fol. 12r

Beatus initial
The Breslau Psalter, *c.*1265

This is a rare example of a fully illustrated Psalter, with large compositions, small miniatures to each Psalm, and a stunning array of marginal grotesques. The initial B to Psalm 1 is particularly engaging. David's inspired prophecy reconciles the Old with the New Testament, and a Byzantine Deësis (lower compartment) with a Western Trinity (central axis). Emulating the decorative style of manuscripts written by the Paduan scribe Giovanni da Gaibana in the 1250s, the manuscript was produced at the Ducal court of Breslau for a lady whose husband, Henry, is mentioned in a prayer. Previously associated with Helen of Saxony, wife of Henry III of Breslau, the Psalter singles out the patron saints of Prague and suggests a patron from the dynasty of the Premyslids, such as Anna (1195–1265), sister of Wenceslas of Bohemia, wife of Henry II, Duke of Breslau, and mother of Henry III. The manuscript preserves the rich flavour of thirteenth-century European culture, devout and courtly, local and international at the same time.

Gold leaf and tempera on parchment, 32.6 x 22.7 cm
Bequeathed by T. H. Riches, 1935
MS 36-1950, fol. 23v

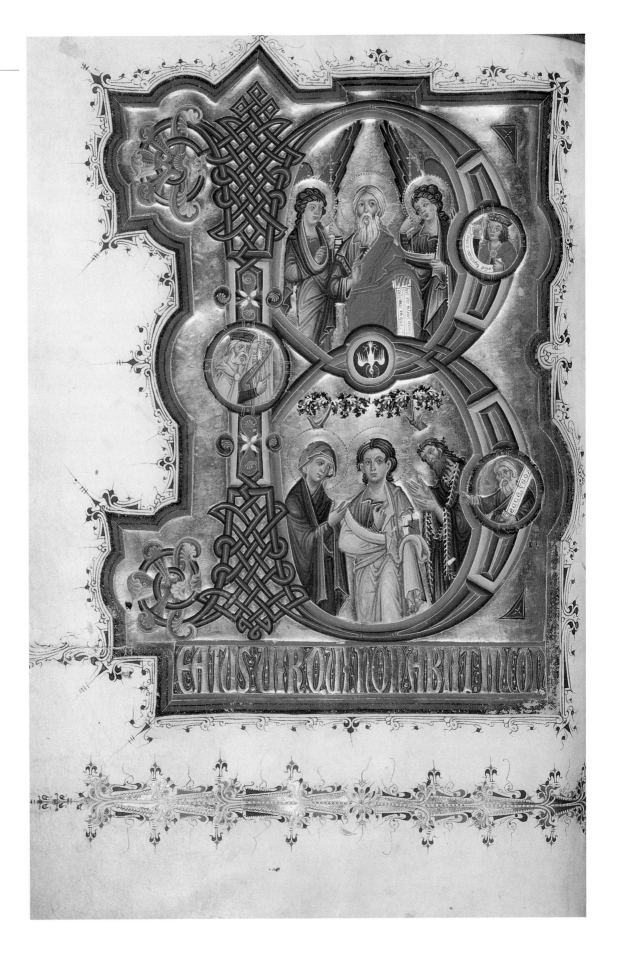

Solomon's Coronation, David's Burial
The Psalter and Hours of Isabelle of France, *c.*1260

With its rich pictorial narrative, delicate palette and exquisite technique, this book is a lasting tribute to the artists, scribes and patrons who transformed thirteenth-century Paris into a leading centre of manuscript production. The Psalms are preceded by six full-page illustrations of David's life and followed by the Hours of the Virgin, soon to become the most popular devotional text. This was the prayer book of Isabelle (1225–1270), sister of the devout Louis IX of France (r. 1226–1270), who built Ste Chapelle to house his crusading relic, the Crown of Thorns. Its later ownership is as distinguished as its original patronage. It belonged to Charles V of France

(r. 1374–1380) and to some of the most discerning collectors of the nineteenth century: on 24 February 1854 John Ruskin wrote in his dairy: 'I got the greatest treasure I have yet obtained in my life.' When Henry Yates Thompson, the manuscript's next owner, decided to sell his collection, the Museum Director, Sidney Cockerell, launched an impressive campaign and secured this masterpiece for Cambridge.

Gold leaf and tempera on parchment, 19 x 14 cm
Purchased for the Museum by University members, 1919
MS 300, fols Vv–VIr

See enlarged detail on pages 206–7

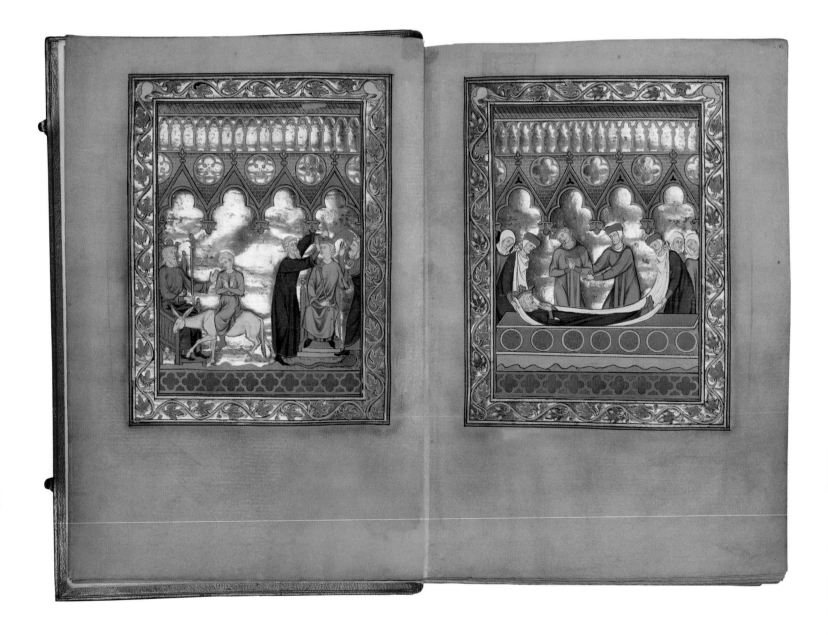

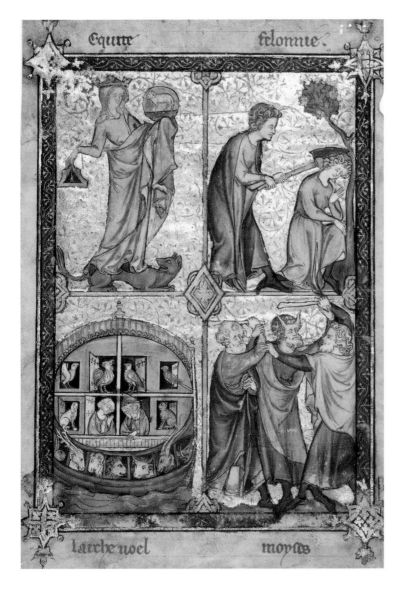

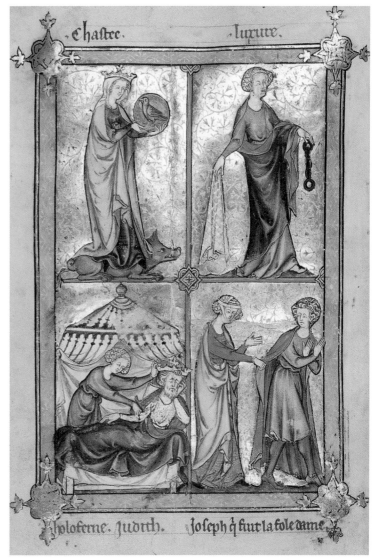

Virtues and Vices

Two leaves from a copy of Frère Laurent's *Somme le roi*, *c.*1290–95
Master Honoré d'Amiens (active 1289–1312)

The elegant outline, rich palette, delicate modelling and exquisite *rinceau* drawn in gold ink over the burnished gold background associate these images with the best-known artist of thirteenth-century Paris. Master Honoré, who worked for the crown in the 1290s, is credited with some of the finest illumination found in contemporary Parisian manuscripts, notably the copy of the *Somme le roi* (British Library, MS Add. 54180) to which these leaves once belonged. The personifications and Old Testament allegories of Equity, Chastity and Luxury illustrate the manual written by the king's confessor, Frère Laurent, to instruct princes in a Christian life and wise rule. This copy was most probably presented to Philip the Fair (1285–1314), who had the Jews expelled, the Order of the Templars brutally suppressed and Pope Boniface VIII brought to a bitter end.

Gold leaf, gold ink and tempera on parchment, 12.7 x 10.2 cm, 17 x 12 cm
Given by Samuel Sandars, 1892, and the Friends of the Fitzwilliam Museum, 1934
MSS 192, 368

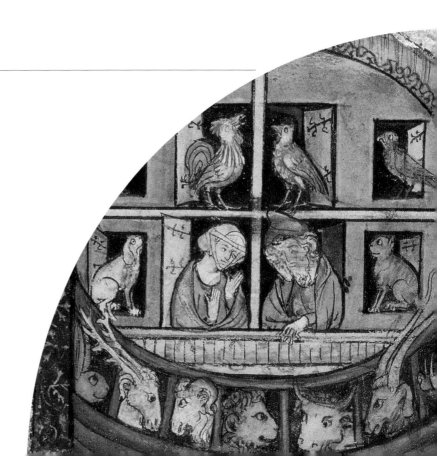

The Throne of Mercy
The Pabenham–Clifford Hours, *c.*1314–31

Based on the cycle of communal and private prayer observed by those in Holy orders, the Book of Hours structured the devotional life of the laity around the eight canonical hours, from dawn through to bedtime. If a medieval owner could afford only one illuminated manuscript, it would have been a Book of Hours. It made a perfect wedding gift, displaying the patron's wealth, status and favourite pasttimes. Formerly known as the 'Grey–Fitzpayne Hours', this manuscript is now associated with a marriage between the families of Pabenham and Clifford. The couple, clad in heraldic dress, kneel within the Throne of Mercy miniature. The woman prays to Christ at the opening of the Hours of the Trinity, while the marginal menagerie and coats of arms celebrate the couple's feudal alliances and worldly pursuits.

Gold leaf and tempera on parchment, 24.7 x 16.7 cm
Purchased from William Morris, 1895; fols 37, 55 given by Samuel Sandars, 1892
MS 242, fols 28v–29r

Right:
Dedication of a church
The Metz Pontifical, before 1316

Pontificals contained the order of services, such as the ordination of an abbess or the dedication of a church, administered only by those at the top end of the ecclesiastical hierarchy, from the bishop to the Pope himself. This copy was made for Raynaud de Bar, Bishop of Metz from 1302 and a member of a powerful aristocratic family. The miniatures would have recreated every stage of the ritual as Raynaud read the text, while the marginal combats of rabbits and snails on some folios might have entertained him in moments of leisure. Yet, the manuscript remained unfinished at Raynaud's death in 1316. The miniatures at the end of the volume, all at various stages of completion, allow us to follow the illuminator's work, step by step, and offer fascinating revelations about how manuscripts were made.

Gold leaf and tempera on parchment, 32 x 24.5 cm
Given by Henry Yates Thompson, 1918
MS 298, fol. 30r

faciat eps benedictionem aque que fit
in confecratione ecclefie. Qua facta eg
diens eps ad altare faciat cruce de aqua
bndicta cum pollice fuo. in medio alta
ris. ita dicendo.

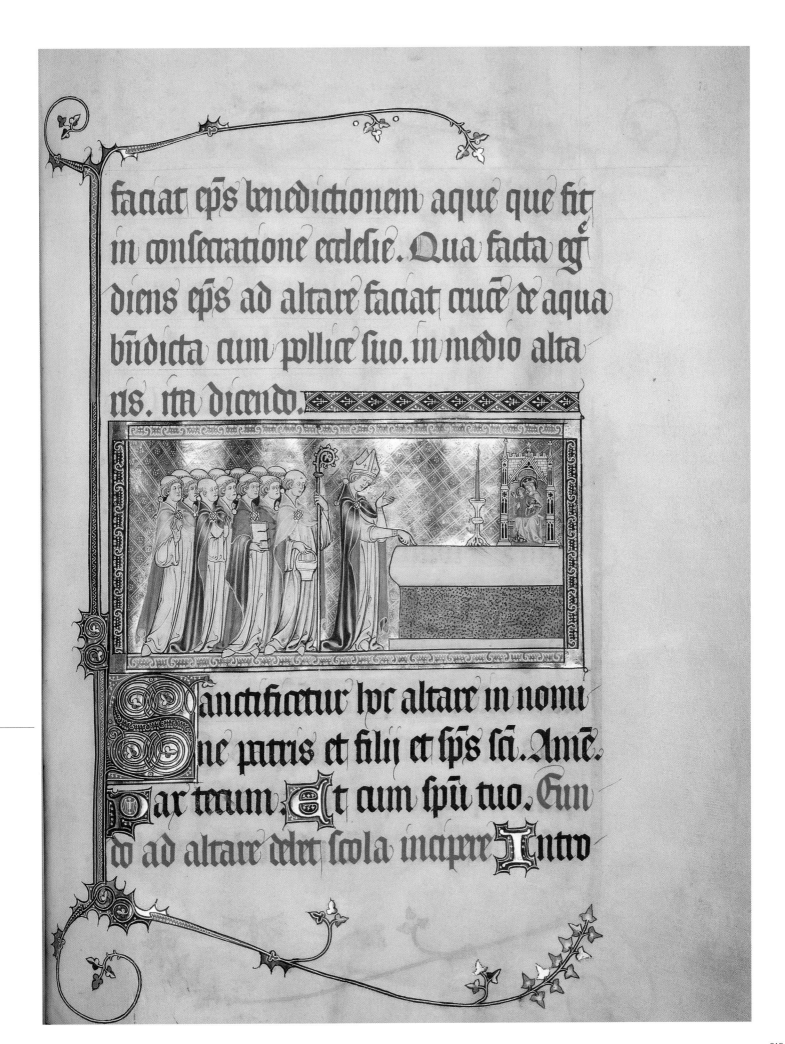

anctificetur hoc altare in nomi
ne patris et filii et fps fci. Ame.
ar tecum. Et cum fpu tuo. Eun
do ad altare debet fcola incipere Intro

Below:
Tree of Affinity
Gratian, *Decretum*, France, *c.*1300–30

Gratian's twelfth-century *Decretum* became the standard textbook on ecclesiastical law. Reflecting political and social realities, the cases dealt with individuals in their everyday life. The Tree of Affinity visualized the eligibility of marriage partners. Headed by a couple, it listed the relatives by marriage, who could not become a second spouse. As with most law books, this manuscript was originally a massive volume, but by the sixteenth century it had been reduced to the causes dealing with marriage. This and the illuminator's uninhibited emphasis on sexuality are particularly poignant, given that the manuscript belonged to John Ruskin, whose marriage was annulled on the grounds of non-consummation.

Right:
Wedding (detail)
Gregory IX, *Decretals*, southern France or England, *c.*1300
The Jonathan Alexander Master

The artist, named after the modern scholar who identified his work, Professor Jonathan Alexander, was probably trained in Toulouse, a leading centre of legal studies, but worked mainly for English patrons. He created an unusual composition for Book IV of the *Decretals*, which contained the legislation on marriage. The common exchange of a ring or joining of hands is replaced with a couple kneeling before a priest, against the rich background of a golden cloth of honour and in the company of numerous guests. One of the Church's sacraments, marriage was also a crucial instrument of wealth and power in medieval society.

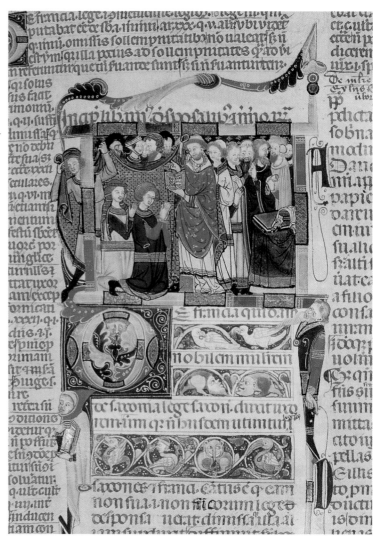

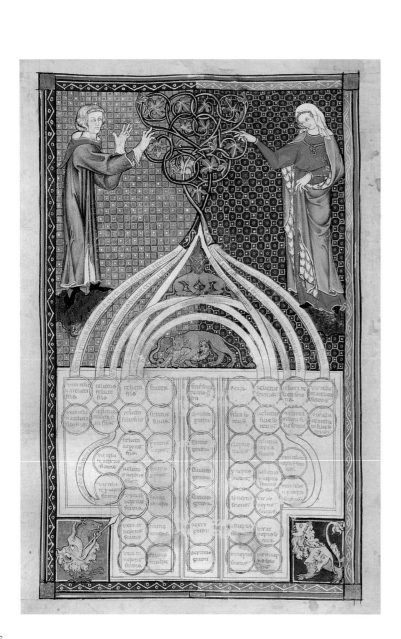

Left:
Gold leaf and tempera on parchment, 43.5 x 28.5 cm
Purchased from A. Denham & Co., 1902
MS 262, fol. 71v

Above:
Gold leaf and tempera on parchment, 42.2 x 24.5 cm
Bequeathed by Frank McClean, 1904
MS McClean 136, fol. 188r

Right:
Annunciation
Hours of Philip the Bold, Paris, 1370s and 1390s; Brussels, *c.*1440 and *c.*1451

The Annunciation miniature is set within a distinct frame, the blue, red and white mouldings characteristic of fourteenth-century Parisian manuscripts produced for royal patrons. The man praying in the initial below is Philip the Bold (1364–1404), the first Valois Duke of Burgundy. The arms of Burgundy, supported by two lions, are still visible in the lower border. As a manuscript collector, Philip matched the splendour of his bibliophile brothers, Charles V of France and Jean, duc de Berry. Yet, this was not a coffee-table book. It was heavily thumbed and frequently reshaped. Having employed two leading Parisian artists, the Master of the Bible of Jean de Sy and the Master of the Coronation of Charles VI, in the 1370s, Philip had his book rebound to take new prayers *c.*1390. His grandson, Philip the Good (1419–1467), did the same around 1440, adding illuminations by no fewer than six miniaturists, and, finally, in 1451 added works by a dozen new artists and had the book rebound in two volumes (the second is Brussels, Royal Library, MS 11035-37). He transformed the personal prayerbook of the dynasty's founder into a gallery of contemporary illumination and a testimony to his own art patronage.

Gold leaf and tempera on parchment, 25.3 x 17.8 cm
Bequeathed by Viscount Lee of Fareham, 1947, and presented by his widow, 1954
MS 3-1954, fol. 13r

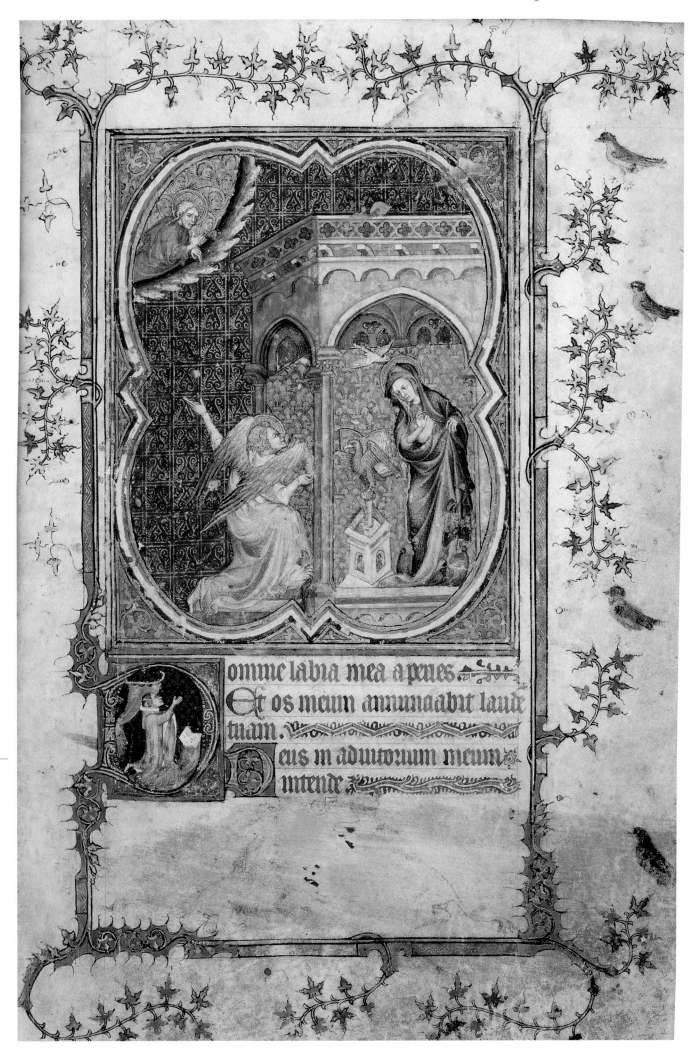

Presentation in the Temple
Historiated initial from a Gradual of
S. Maria degli Angeli, Florence, *c.*1375
Don Silvestro dei Gherarducci (1339–1399)

As the interest of eighteenth-century collectors in manuscript illumination began to awaken, choir-books fell victim to dealers and enthusiasts who were recovering 'a lost art'. Their images were cut out of the massive volumes and framed as miniature paintings. A superb example of the dialogue between manuscript illumination and panel painting, this composition echoes Lorenzetti's work (now in the Uffizi) for the Crescentius Chapel in Siena Cathedral. Enclosed within the initial *S*, it once introduced the sung parts of the Mass for the feast of the Purification of the Virgin in a magnificent Gradual. The main body of the manuscript, now preserved as Corale 2 in the Biblioteca Laurenziana, Florence, was part of an elaborate set of choir-books illuminated for the Monastery of S. Maria degli Angeli by 17 leading Italian artists between 1370 and 1506. The first was Don Silvestro, acknowledged as the most distinguished Florentine illuminator of his time by Vasari and by the impressive sum of 100 florins paid for Corale 2 in 1375.

Gold leaf and tempera on parchment,
30 x 27 cm
Bequeathed by Charles Brinsley Marlay, 1912
Marlay Cutting It.13.A

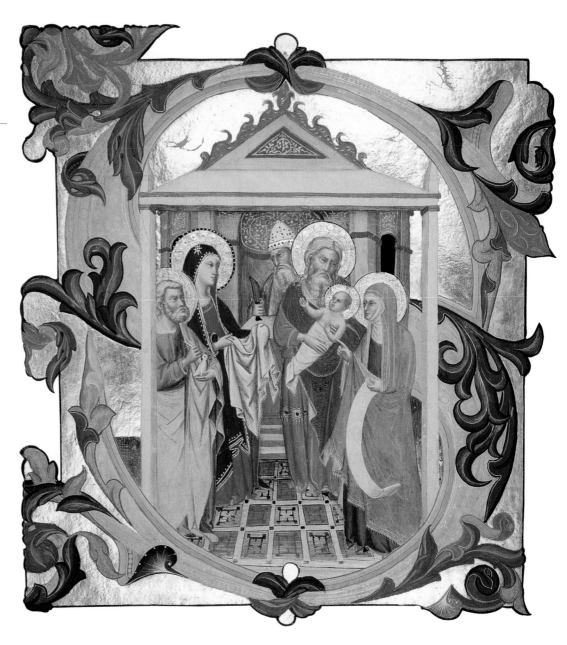

The Charity of St Nicholas
Historiated initial from an Antiphonal, Bologna, *c.*1376
Niccolò di Giacomo Nascimbene da Bologna (active 1349–1403)

The tradition of Christmas gift-giving and Santa Claus originated in the story depicted within this initial. St Nicholas throws a purse of gold coins into the house of an impoverished father who cannot provide dowries for his three daughters. The depiction of the distressed lawyer may reflect the demise of wealthy legal families in the aftermath of Bologna's revolt against papal control in 1376. Niccolò da Bologna dominated Bolognese illumination in the second half of the fourteenth century. Although he was in the habit of signing his illustrations, the inscription on the father's bench step is not in his hand. It was probably copied from a genuine signature elsewhere in the volume from which this initial was removed.

Gold leaf and tempera on parchment, 31.5 x 27.5 cm
Given by the Friends of the Fitzwilliam Museum, 1915
MS 278a

Dormition of the Virgin
Historiated initial from a Gradual of S. Mattia in Murano,
Venice, *c.*1450
The Master of the Murano Gradual

Like the choir-books of S. Maria degli Angeli (see opposite), those of the Venetian monastery of S. Mattia in Murano were a collaborative project of the highest quality. In addition to the refined images by Cristoforo Cortese, they contain contributions from Belbello da Pavia and the Master of the Murano Gradual. Like the Florentine volumes, the Murano choir-books had many of their images dispersed. Their reconstruction is greatly advanced when private collections enter public institutions. Charles Brinsley Marlay's collection

of 245 cuttings, many of which had belonged to nineteenth-century connoisseurs, is one of the richest resources for the study of modern tastes as well as medieval and Renaissance illumination.

Gold leaf and tempera on parchment, 30.5 x 32 cm
Bequeathed by Charles Brinsley Marlay, 1912
Marlay Cutting It. 18

Pentecost
Missal of Cardinal Angelo Acciaiuoli, Florence, 1404

Missals combined the texts read and chanted at Mass with directions for the performance of the ritual. Apart from images at the Canon of the Mass and the Common Preface, they rarely had elaborate illumination at other text divisions. This Missal contains no fewer than 65 scenes on highly burnished gold grounds. In addition, several major feasts received lush borders, such as the one accompanying Pentecost. It includes the arms and portrait of the patron, Cardinal Angelo Acciaiuoli. In 1404, he made payment for the illumination of his Missal to Matteo Torelli, his brother Bartolomeo, and Bartolomeo di Fruosino, three of Lorenzo Monaco's most gifted contemporaries in early Renaissance Florence.

Below:
The Tree of Jesse
Utrecht Bible, c.1425

The Tree of Jesse opens St Matthew's Gospel in one of the finest surviving products of the great era of Dutch manuscript production. It was illuminated by a group of artists known as the Masters of Zweder van Culemborg active in Utrecht c.1415–30. An encyclopaedia of imagery, this manuscript demonstrates the unprecedented flourishing of the art of illumination in the Netherlands during the fifteenth century. Yet, it is unusual in being a three-volume Bible in Latin, when most of its contemporaries were single volumes in Dutch. It belonged to a member of the wealthy Utrecht family of Lochorst, most probably Herman van Lochorst, Dean of Utrecht Cathedral, who died in 1438.

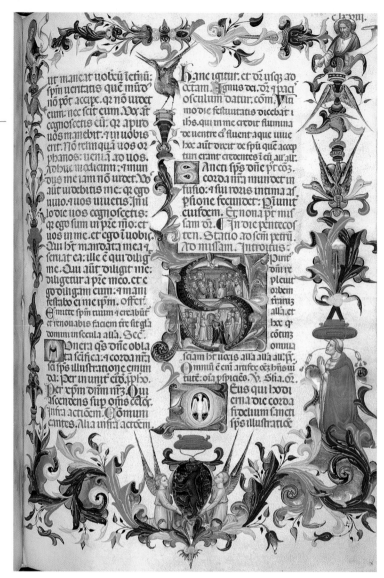

Left:
Gold leaf, gold ink, and tempera on parchment, 22 x 16.5 cm
Bequeathed by Revd E. S. Dewick, 1917
MS 289, vol. 3, fol. 67v

Above:
Gold leaf and tempera on parchment, 35.5 x 25.5 cm
Founder's Bequest, 1816
MS 30, fol. 148r

Right:
The Marriage of Adam and Eve
Des proprietes de chozes by Jean Corbechon, c.1414
The Boucicaut Master (active early 15th century)

God joins the hands of Adam and Eve in the Garden of Eden, a symbol of the harmony between him and Creation, which is the central theme of the text. Bartholomaeus Anglicus' *De proprietatibus rerum* of the mid-thirteenth century was the most popular medieval encyclopaedia. The French translation was made by Jean Corbechon in 1372 at the command of Charles V of France. This, one of the most elaborate surviving copies, was illuminated by the Boucicaut Master, a leading Parisian artist of the early fifteenth century. It was commissioned, and paid for in 1414, by Amadeus VIII, Count of Savoy. Cousin of Charles VI of France and grandson of Jean, duc de Berry, Amadeus of Savoy shared their passion for deluxe manuscripts.

Gold leaf, gold ink and tempera on parchment, 40.5 x 28.5 cm
Given by Brigadier Archibald Stirling of Keir, 1897
MS 251, fol. 16r

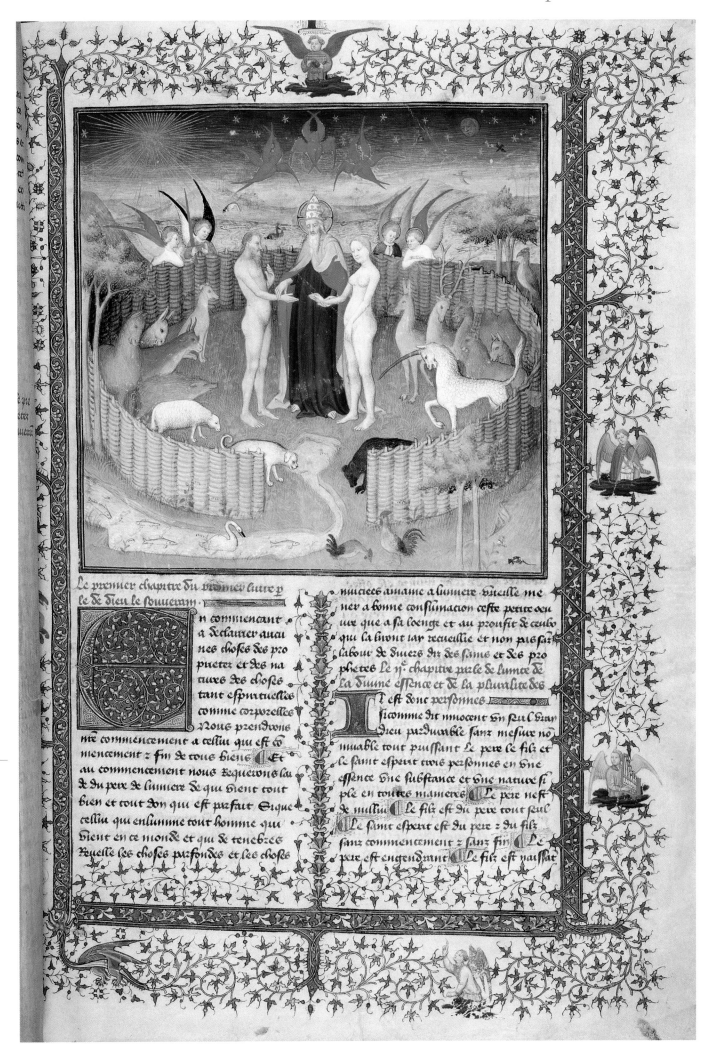

Manuscripts & Printed Books

Title-page and preface
Life of Charlemagne, 1461
Francesco di Antonio del Chierico (active 1452–d. 1484)

On 2 January 1462 the Florentine ambassadors presented the new-crowned Louis XI of France with a deluxe copy of the *Life of Charlemagne*. Few texts could have evoked the humanistic ideal of the learned monarch more successfully, while providing the French king with a most flattering gift, the biography of his glorious ancestor. The author, Donato Acciaiuoli (1428–1478), was the renowned Aristotelian scholar who served as Lorenzo de' Medici's ambassador to Paris in 1461. Louis XI's copy was produced by Vespasiano da Bistici (*c*.1422–1498), the 'prince of booksellers' who enjoyed the patronage of the Medici. Vespasiano entrusted the copying of the manuscript to Messer Piero di Benedetto Strozzi (1416–*c*.1492), whom he called the finest scribe of his time. The decoration consisting of white vine-scrolls, the hallmark of early humanistic illumination, is by Francesco di Antonio del Chierico (active 1452–d. 1484), the favourite illuminator of the Medici. Lorenzo had commissioned a royal gift of outstanding quality and diplomatic importance.

Gold leaf, gold ink and tempera on parchment, 24.5 x 17 cm
Founder's Bequest, 1816
MS 180, fols 1v–2r

Frontispiece and King David in prayer
The Medici Psalter, Florence, *c.*1480–90
Gherardo di Giovanni di Miniato (*c.*1444–1497)

Gherardo and his brother Monte, the distinguished Florentine artists who assisted
Ghirlandaio on various projects, illuminated books for the wealthiest rulers of
Europe. This manuscript was made for a member of the Medici family, whose
arms and devices (the flaming branches) feature in the borders and within the
opening words of Psalm 1. King David plays his psaltery to a vision of the Trinity.
Medallions with the Annunciation, Nativity, Last Judgment and prophets are set
within borders in the jewelled *all' antica* style, rich in vases, candelabra, plump
putti and precious stones. The exceptional nature of this commission is confirmed
by the gold lettering and the dyed parchment, both elements of ancient imperial
and Carolingian manuscripts revived in the Renaissance. The frontispiece features
another major humanistic contribution to book design, the origin of the modern
title-page.

Gold ink and tempera on parchment,
19.3 x 12.5 cm
Bequeathed by T. H. Riches, 1935
MS 37-1950, fols 1v–2r

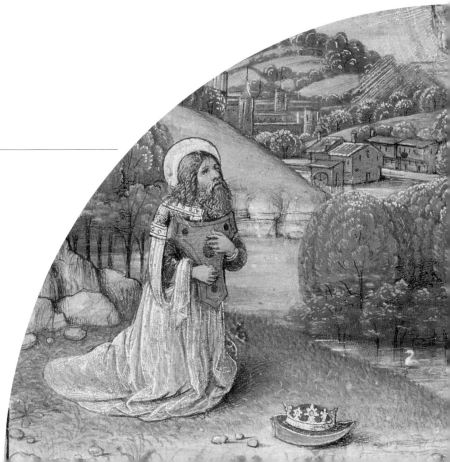

King David in prayer
Leaf from a Book of Hours, Florence, *c*.1480–90
Mariano del Buono di Jacopo (1433–?1504)

Painted by one of the Medici's favourite artists, this leaf shows King David in the initial, Old Testament prophets in the gold roundels, and Goliath's head with the pebble from David's slingshot in the vignette below. It introduces Psalm 6 and would have opened the Penitential Psalms in the Book of Hours to which it belonged. The fashionable gem-studded borders are paralleled in deluxe manuscripts from Renaissance Florence. The textual significance of the leaf matches its artistic importance. The German translation of the Psalm text in a Book of Hours is unique.

Gold ink and tempera on parchment, 11.5 x 8.5 cm
Purchased from the Wormald Fund with the aid of a grant from the Resource / Victoria & Albert Purchase Grant Fund, 2001
MS 11-2001

Annunciation and Nativity

Florentine Hours, *c.*1480–90

Vante di Gabriello di Vante Attavanti, 1452–1524

Unfolding the pictorial narrative over a double opening was
among the greatest achievements of Renaissance illuminators.
The story of the Annunciation, the common visual introduc-
tion to the Hours of the Virgin, continues across the page with
the Nativity within the facing initial. The work is attributable
to Attavante, the most distinguished Florentine illuminator of
the late fifteenth and early sixteenth centuries.

Gold ink and tempera on parchment,
14 x 10 cm
Founder's Bequest, 1816
MS 154, fols 13v–14r

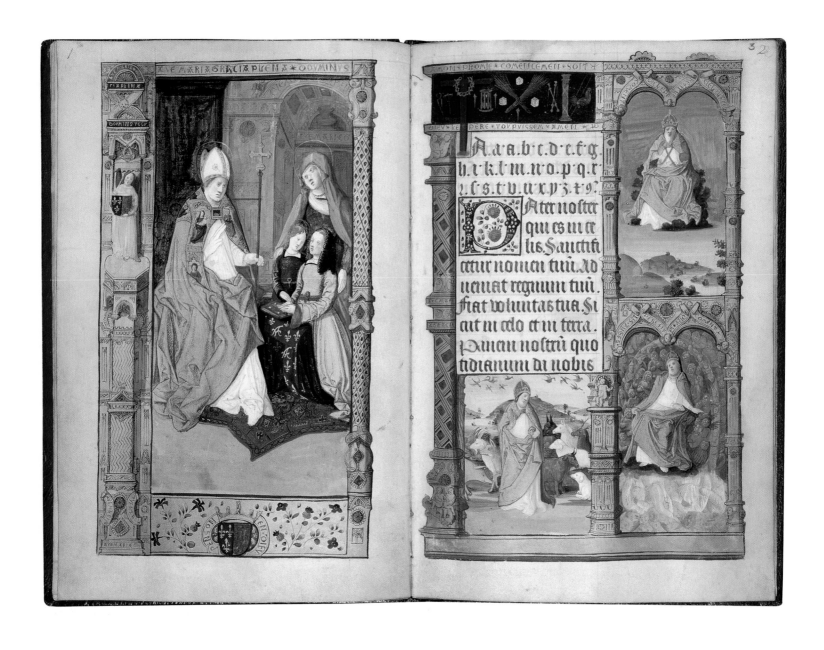

**Anne of Brittany presented to St Claude by St Anne
and the Virgin, and Creation scenes**
The Primer of Claude of France, *c.*1505
Guido Mazzoni of Modena (active 1473–1518)

Children's books are among the rarest medieval survivals. Most children learned to read from a Psalter or a Book of Hours (hence its English name, Primer), but some had specially designed Primers. This one opens with the alphabet and contains the universal prayers of the Christian Church. The stories of Creation, Fall and Redemption unfold across the pages of what is, essentially, a picture book. The arms of France and Brittany impaled on the carpets and borders, and the initials embroidered on the fabric covering the two prayer-desks, reveal the commissioner and the intended reader. The girl presented by Bishop St Claude to St Anne and the Virgin is Louis XII's and Anne of Brittany's eldest daughter, Claude (1499–1524). Her black gown and Breton headdress, the fashion introduced by Anne of Brittany in the royal court, garbs the girl in her mother's role and anticipates her future. In 1505 Claude was engaged to Francis, Duke of Angoulême. In 1515 they were crowned King and Queen of France.

Like many of his gifted contemporaries, Guido Mazzoni was appreciated by patrons on either side of the Alps. He left for France with Charles VIII in 1496. After the king's death in 1498, he remained closely associated with his widow, Anne of Brittany, and her third husband, Louis XII. It was Anne who entrusted him with the illustration of the Primer. She appears in the frontispiece, presented by St Anne to the saintly bishop after whom she named her daughter. On the prayer-desk embroidered with her initial rests the Primer, a most befitting gift from a royal mother to the future Queen of France.

Gold ink and tempera on parchment, 26 x 17.5 cm
Founder's Bequest, 1816
MS 159, pp. 1–2, p. 14

Above: pages 1 and 2
Right: page 14

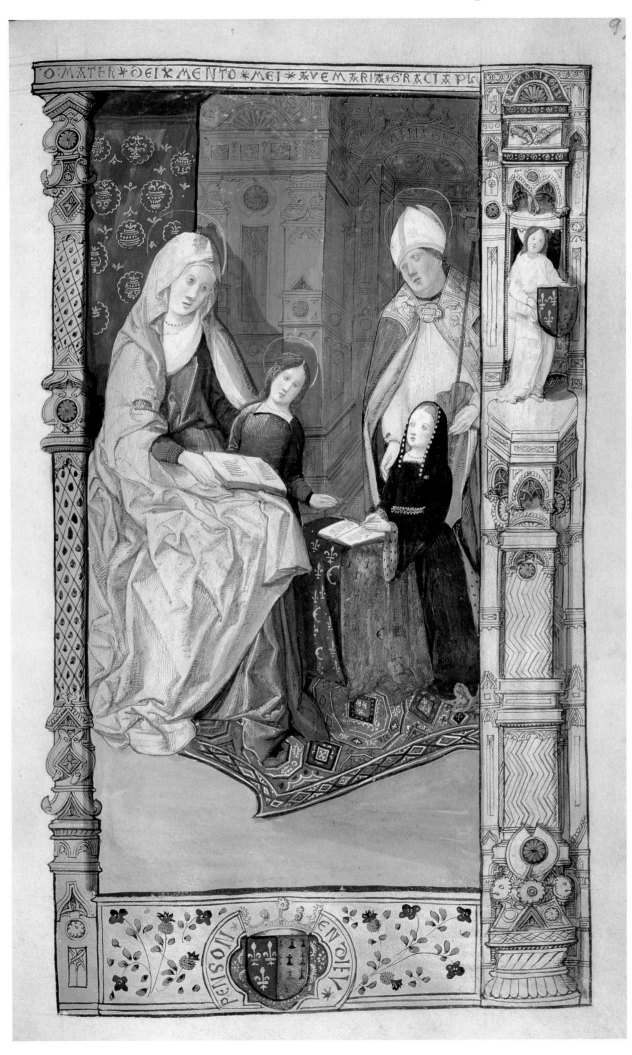

King David praying to the Virgin and Child, with a miniature of the Creation of Eve
Book of Hours, Bruges, *c.*1510

With its vast number of images, this Book of Hours called for the collaboration of four distinct artists: the Master of the Dresden Prayerbook, the Master of James IV of Scotland, the Master of the Lübeck Bible, and the painter of British Library Add. MS 15677 (an example of whose contribution is reproduced here). It shows them recycling popular patterns (such as David praying on his terrace, seen here) to satisfy the growing demand for richly illustrated manuscripts, but also unleashing their creative imagination in response to the highly competitive environment. This page exemplifies the triumph of illusionism in Renaissance illumination. The superimposed planes of initial, text and border transform the flat surface of the page into an object of tangible texture and depth. The viewer's eye is teased by the promise of a beautiful vista, if only the court lady behind David would pull the text aside.

Gold ink and tempera on parchment, 19.2 x 13.3 cm
Given by Henry Davis, 1975
MS 1058–1975, fol. 74r

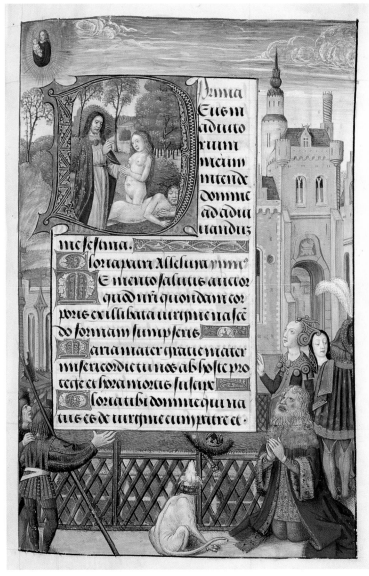

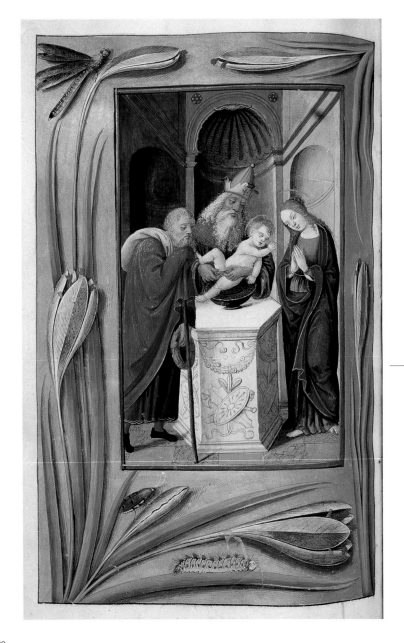

Christ's Circumcision
Book of Hours, Tours, *c.*1515
Workshop of Jean Bourdichon (1457–1521)

The most beautiful and arresting feature of this manuscript are its borders. The flowers and insects depicted as if scattered over the page, and casting shadows on the liquid gold ground, first appeared in Flemish manuscripts of the 1460s and quickly spread throughout Northern Europe. They were brought to perfection, rendered with scientific detail and precision, by Jean Bourdichon, the Tours artist and favourite court painter who designed the opulent decorations for the meeting of Henry VIII and Francis I at the Field of the Cloth of Gold near Guines in 1520. This manuscript is a witness to the expert skills available in his prolific workshop.

Gold ink and tempera on parchment, 25.8 x 16.5 cm
Founder's Bequest, 1816
MS 131, p. 156

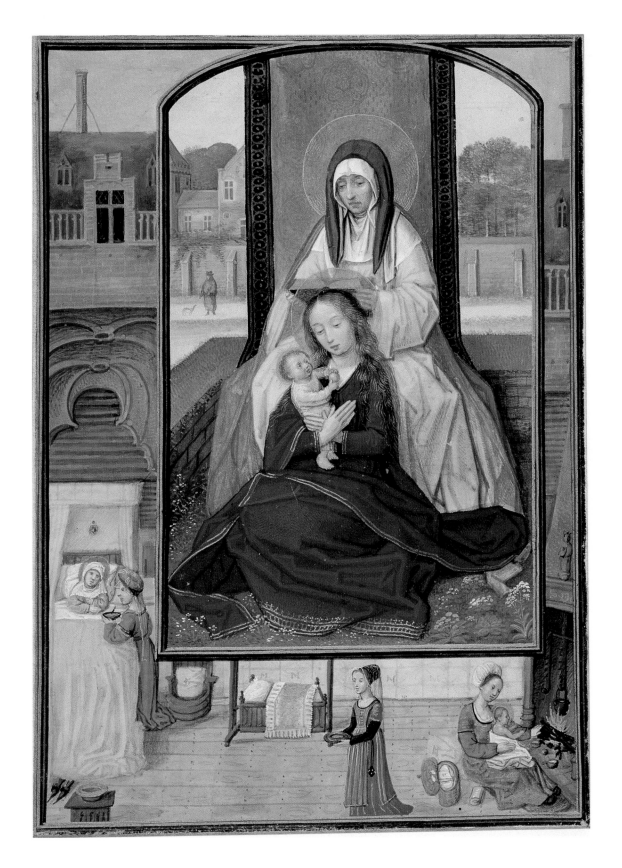

St Anne, the Virgin, and the Christ Child
Miniature from the Hours of Albrecht of Brandenburg, *c.*1522
Simon Bening (1483–1561)

This miniature once embellished the Hours of a major patron, Albrecht of Brandenburg (1490–1545), archbishop and elector of Mainz.His agent commissioned it from the Bruges artist Simon Bening, the last great illuminator of the Northern Renaissance. Famous for his subtle handling of light, colour, texture and depth, Bening was a master of painted borders, which unfolded space and narrative beyond the miniature in a sequel, or prequel, fashion. In a cross-section of St Anne's house we witness the birth of the Virgin, the interior's domestic details adding down-to-earth charm to the main devotional image and offering a glimpse into contemporary everyday life.

Gold ink and tempera on parchment, 18 x 13 cm
Given by the Friends of the Fitzwilliam Museum, 1918
MS 294c

Pope Leo the Great worships the Virgin
Miniature and borders from a Missal of Pope Clement VII, *c.*1523

When Napoleon's troops looted the Sistine Chapel in 1798, its magnificent choir-books were sold and cut down. Many images came to England with the collection of Luigi Celotti, the abbot turned dealer, and were dispersed at sales from 1825 onwards. The Fitzwilliam Museum preserves fragments from books that belonged to Cardinal Antonio Pallavicini and popes Innocent VIII, Pius V and Clement VII,

the last-named one of the greatest art patrons in High Renaissance Rome. This miniature boasts the commission of a Medici pope through the arms and devices of the powerful family, the diamond ring and feathers, the yoke and the mottos 'Suave' and 'Semper', and through Clement VII's personal emblems: the sun, the burning-glass, and the motto 'Candor illesus'. This cutting belonged to one of the

Missals (A.I.9 or A.I.14) listed under Clement VII's name in the early eighteenth-century inventory of the Sistine Chapel.

Gold ink and tempera on parchment, 31.2 x 26 cm
Bequeathed by Charles Brinsley Marlay, 1912
Marlay Cutting It. 35

Ecce homo
Book of Hours, Paris, *c.*1525–30
Master of the Doheny Hours (active 1530s)

The lush liquid gold borders strewn with naturalistic flowers and butterflies reached their zenith in a group of deluxe Parisian Hours illuminated from the 1520s through to the 1540s. The Master of this Book of Hours was one of the highly sophisticated artists who worked with Noël Bellemare, the painter, illuminator, stage and stained-glass designer trained in the style of the Antwerp Mannerists and employed by the royal court at Paris and Fontainebleau in the 1530s. By then, the flower borders were being displaced by classicizing Italianate tabernacle frames like the one surrounding this miniature. The image of Christ revealing himself to Judas and blessing the Apostles is among the most striking compositions in the Bellemare group of manuscripts, a dramatic fusion of darkness and glowing colour.

Gold ink and tempera on parchment, 14.8 x 8.2 cm
Founder's Bequest, 1816
MS 134, pp. 36–37

Jewelled initial (detail)
Pliny, *Historia naturalis*, in the Italian translation
of Cristoforo Landino, 1476
Venice: Nicholaus Jenson, 1476, fol. 226v

This printed page does not appear very different, at
first, from the pages of contemporary manuscripts.
Introduced from Germany to Italy in 1465, printing
with movable type was a risky enterprise, requiring
substantial investment. To appeal to wealthy
bibliophiles, the early printers produced elaborate
editions, illuminated by the leading artists of the
time. Nicholaus Jenson was particularly attuned to
demands at the top end of the market. Sponsored by
the Florentine banking firm of the Strozzi, his 1476
edition of Pliny's *Natural History* was among the
most sumptuous incunables in which the art of
illumination experienced its last flowering.

Gold ink and tempera on paper, 42.2 x 28 cm
Bequeathed by Frank McClean, 1904

LIBRO.XXI.DELLA.HISTORIA.NA
TVRALE.DI.C.PLINIO.SECONDO.

PROHEMIO

NATVRA.DI.FIORI.ET.LORO.MA
RAVIGLOSA.VARIETA.CAP.PRIMO

PRECEPTO.DI.CATONE.CHE. NE.GLOR-
ti seminiamo ecoronaméti cioe herbe da fare corone
con inenarrabile subtilita maxime difiori: perche a
nessuno puo essere piu facile elparlarne che alla natu
ra dipignerli : laquale in questo e molto lasciua & in
gaudio di si gran fertilita molto trastullantesi Et cer
to laltre chose produxe per halimento & cibo Et per
questo decte loro ani & secoli: Ma efiori & glodori ge
nera di di in di: Ilche da grand e & manifesta admo-
nitione aglhuomini che lechose lequali excellentemé
te fioriscono prestissimamente mariscono. Ma ne â
che la pictura e abastanza exprimere la imagine de colori & la uarieta delle mixture o
quado scambieuolmte & di uarie ragioni insieme si contexono:o quando alchune co-
rone oghyrlande facte dua sola ragione corrono per altre ghyrlande in rondo o in obli
quo o in circuito.

GHYRLANDA.DECTA.STROPHIO.ET.CHI.
COMINCIO.A.MESCOLARE,EFIORI.CAP.II.

Antiquités Etrusques, Grecques et Romaines,
tirées du cabinet de M. William Hamilton
Pierre-François Hugues, called Baron d'Hancarville
(1719–1805)
Naples: François Morelli, 1766–67, vol. 2, pl. 22

Left:
Les plaisirs de l'île enchantée
Paris, 1673, pl. 100

When Viscount Fitzwilliam left his art and music collections to the University of Cambridge, he also bequeathed his books, 'for the Increase of Learning'. This was not a students' library, however. It was an eighteenth-century gentleman's collection of literature, history, voyages, antiquities and art. Fitzwilliam's love for fine books and for things French is well represented by this volume. It bears the title of the magnificent festivities that Louis XIV (r. 1643–1715) gave in the gardens of Versailles to 600 guests between 6 and 13 May 1664. Officially organized in honour of the Queen-Mother, Anne of Austria, and to Louis' consort, Marie-Thérèse, they were really dedicated to Louise de la Vallière, the king's mistress. The parks, re-designed by the landscape gardener André Le Nôtre, became the stage for concerts, theatrical performances, ballets, fireworks, spectacles, balls and exotic banquets. Celebrated writers, poets, dramatists, musicians, sculptors, painters and, of course, cooks were brought together to celebrate the wealth and power of the Court. *Les plaisirs de l'île enchantée*, of which limited copies were printed under the auspices of the Sun King and presented as diplomatic gifts, sent the same message, pressing the arts into the service of the absolute monarchy.

Hand-coloured engraving on paper, 40.5 x 27 cm
Founder's Bequest, 1816

Sir William Hamilton (1730–1803), British Plenipotentiary to Naples and husband of Lord Nelson's mistress, Emma, was the first collector to acknowledge the Greek origin of vases that, up until then, had been considered Etruscan. The catalogue of his first collection, illustrated with magnificent hand-coloured engravings and often 'enhancing' the ancient models with illusionistic *tromp l'œil* shadows, was inspired by the current fashion for elaborate publications on Grand Tour artefacts. 'These paintings ought to have a place at the head of all collections of prints and drawings', advised the preface. Viscount Fitzwilliam promptly acquired the complete set. In addition, the catalogue had a pragmatic goal. The proportions of vases were meticulously drawn to provide contemporary craftsmen with refined classical models. Josiah Wedgwood was among the first to incorporate the wealth of material into his designs.

Engraving on paper, 46.5 x 35.5 cm
Founder's Bequest, 1816

PLATE V.

Bonaparte Fly Catcher.
MUSCICAPA BONAPARTII.

The Birds of America
John James Audubon (1785–1851)
Edinburgh and London, 1831–39, vol. 1, no. 5

In 1820 Audubon began the project of his life, a pictorial encyclopaedia of all American birds with life-size engravings. A series of disappointments, professional and personal, brought him to Liverpool in 1826. By the end of the year Audubon had reached an agreement with the Edinburgh engraver William Lizars, but Lizars resigned after the first ten prints. Moving to London, a year later Audubon secured the collaboration of Robert Havell and his son, Robert Havell Jr. Over the next 12 years they transformed his originals into prints of unprecedented accuracy and beauty. During Audubon's visit to Cambridge, the Fitzwilliam Museum subscribed for the first edition, known as the double elephantine folio, and still preserves the complete set of 435 original plates, plates so coveted by collectors that other copies have often lost many of them to the art market.

Engraving on paper, 98.5 x 66 cm
Purchased through subscription, 1828

The Works of Geoffrey Chaucer
William Morris (1834–1896)
Kelmscott Press, Hammersmith, 1896, frontispiece

William Morris conceived of this edition in the early days of the Kelmscott Press, his last passion and the first of the great private printing presses. The project was not completed until just before his death. As the best-known of the 66 Kelmscott titles and Morris's crowning achievement, the 'Kelmscott Chaucer' encapsulates its designer's credo that texts should be printed with 'a definite claim to beauty'. By July 1892 Morris had developed the Chaucer type, reducing and 'Gothicising' the earlier Troy type. He designed the binding with silver clasps, the title-page, borders, initials and frames, but entrusted the illustrations to Edward Burne-Jones, whose delicate pencil drawings are also preserved in the Museum.

Woodcuts and black type on paper, 42.4 x 29 cm
Bequeathed by Jane Alice Morris, 1935

The Fitzwilliam Virginal Book
Early 17th century

The Fitzwilliam Museum preserves the richest collection of music to be found in a museum of fine art, and the Virginal is one of its greatest treasures. The most important anthology of sixteenth- and early seventeenth-century English keyboard music, it contains nearly 300 works by 30 of the greatest composers of the time. Its creation remains the subject of debate, as the widely accepted attribution to Francis Tregian the younger, who died as a recusant in the Fleet Prison in 1619, is contested by an association with a group of professional scribes working for court circles.

Ink on paper, 33.5 x 22 cm
Founder's Bequest, 1816
MU MS 168, p. 301

The Lute Book of Lord Herbert
*c.*1620–40

This manuscript was copied in tablature for and by the notable diplomat and intellectual Edward, Lord Herbert of Cherbury and Castle-Island (1583–1648). Still in its original gilt olive morocco binding, it contains some 240 pieces for lute by English and French composers, including Lord Herbert's own compositions. To musicologists and practising lutenists, it remains one of the most important anthologies in existence.

Ink on paper, 33.2 x 21.7 cm
Given by an anonymous donor and the Friends of the Fitzwilliam Museum, 1956
MU MS 689, p. 3

Henry Purcell (1659–1695)
Anthology of English Anthems, *c.*1670–80

Purcell assembled this album in the late 1670s and early 1680s, writing from both ends. The manuscript opens, in his characteristically youthful script, with compositions by his former teachers and pre-Civil War anthems that were revived during the Restoration. Probably intended as a political statement, they celebrated the triumph of High Anglicanism during the Elizabethan and Jacobean periods. Around 1680 Purcell began writing from the end of the volume, in a mature hand, and on fol. 27v he included a composition of his own for the first time, the anthem *Save me O God*. The number of old works decreased and the manuscript was transformed into the fair-copy of a composer conscious of his professional standing, the primary source for 12 of his most famous anthems.

Ink on paper, 43.6 x 27.5 cm
Founder's Bequest, 1816
MU MS 88, fol. 27v

Georg Frideric Handel (1685–1759)
Rinaldo, 1711

Handel was the great hero of Viscount Fitzwilliam, who travelled around Europe in search of original scores and expert tuition. Handel left his compositions to his copyist, Johann Christoph Schmidt, and many of them passed, through Schmidt's son to King George III and subsequently to the British Library. The rest were acquired by Fitzwilliam and left to Cambridge. Sketches such as this one are the most fascinating Handel autographs. They reveal his methods of composing directly into full score, drafting a raw skeleton before filling in the orchestration. Handel's compositions were often performed while the ink was still wet on the pages. The premiere of *Rinaldo* was on 24 February 1711 at the King's Theatre, Haymarket, London.

Ink on paper, 35.5 x 39 cm
Founder's Bequest, 1816
MU MS 254, p. 59

Sir Isaac Newton (1642–1727)

Notebook, 1665–8

Celebrated as the 'father' of modern science, Newton is less well known as a theologian. His private life remains a mystery. His notebooks offer invaluable insight. Perhaps often carried in his pocket while at Trinity College, Cambridge, this notebook preserves his thoughts on optics together with the sums he spent on laundry and the confession of past sins he could remember in 1662. 'Making a mousetrap on the Lord's Day' or 'robbing my mother's box of plums and sugar', repented he in a cryptic shorthand. This little booklet brings together the scientist, the believer and the everyday man.

Ink on paper, 12 x 7 cm
Presented by the Friends of the Fitzwilliam Museum, with the aid of a grant from Sir Thomas Barlow, 1936
MS 1-1936

John Keats (1795–1821)

Ode to a Nightingale, 1819

One of the best-loved poems ever composed in the English language survives in its original draft, written by Keats on two sheets of scrap paper. His friend Charles Brown recalled how Keats sat in his garden in Hampstead on a beautiful May morning, and, moved by the song of a nightingale nesting nearby, wrote the lyrics within hours. Embellished as this account may be, the hastily penned lines recapture a moment of spontaneous creativity as experienced by one of the greatest Romantic poets.

Ink on paper, 30.5 x 21.5 cm
Presented by the Marquess of Crewe, 1933
MS 1-1933, fol. 1r

Thomas Hardy (1840–1928)

Jude the Obscure, c.1894

Thomas Hardy's best-known work was also his last novel. *Jude the Obscure* (1895) was a turning-point in his career. Its dark, fateful pessimism unleashed the critics' hostility and persuaded Hardy to abandon prose for poetry. He presented the original manuscript of the novel, as well as one of his eight volumes of verse, *Time's Laughingstocks*, to the Fitzwilliam, whose Director, Sydney Cockerell, he had befriended.

Ink on paper, 26.5 x 20 cm
Presented by the author, 1911
MS 1-1911, p. 1

Virginia Woolf (1882–1941)
A Room of One's Own, 1929

Widely acclaimed as one of the most innovative novelists of twentieth-century modernism, Virginia Woolf was a critic and a journalist with a powerful voice in contemporary debates. As a founder member of the Bloomsbury Group, the circle of intellectuals that met in her London home, she spoke and wrote against the Victorian prejudices of class and gender. Based on her lectures 'Women and Fiction', *A Room of One's Own* became a feminist classic, predicting a future for women writers that would be free from social,

financial or educational constraints. Woolf's learned and elegant, but accessible prose is the best advocate for her belief that high standards of education should be maintained in a world of mass-produced culture, and that the general public should share in the masterpieces of intellectual creativity.

Ink on paper, 26.5 x 20.5 cm
Presented by Leonard Woolf, 1942
MS 1-1942, p. 91

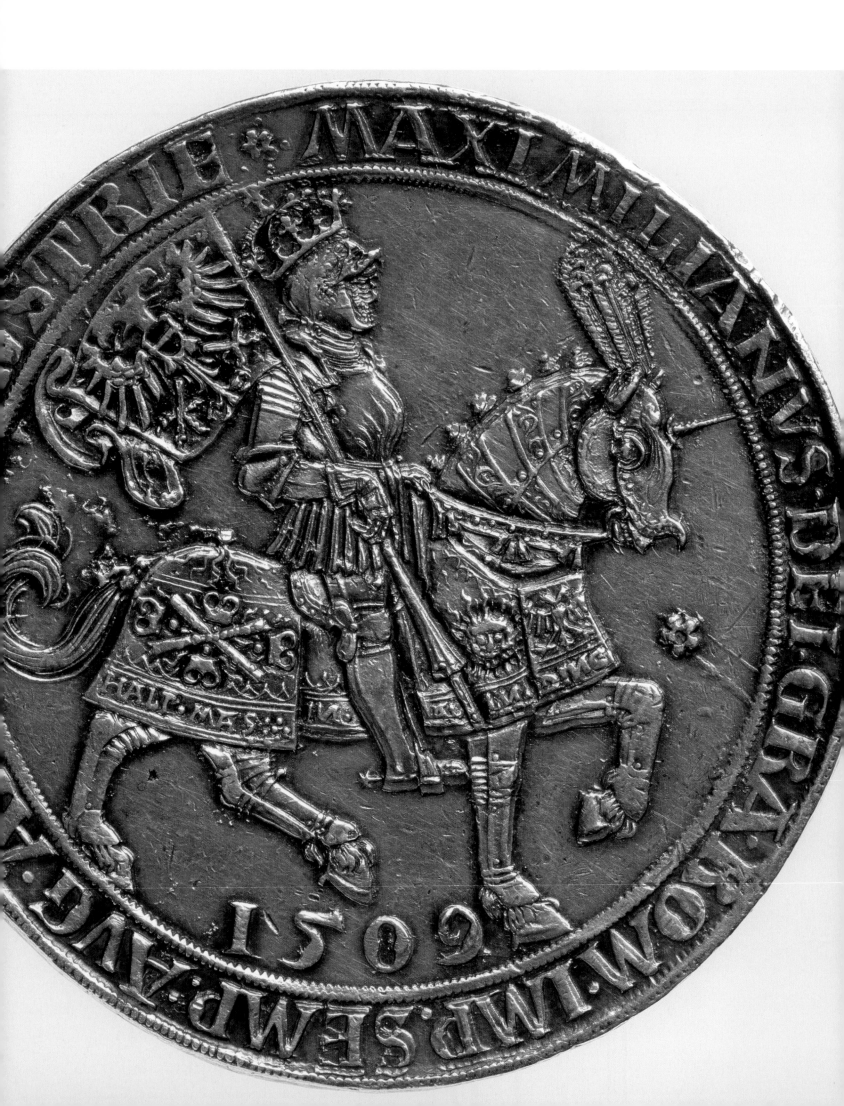

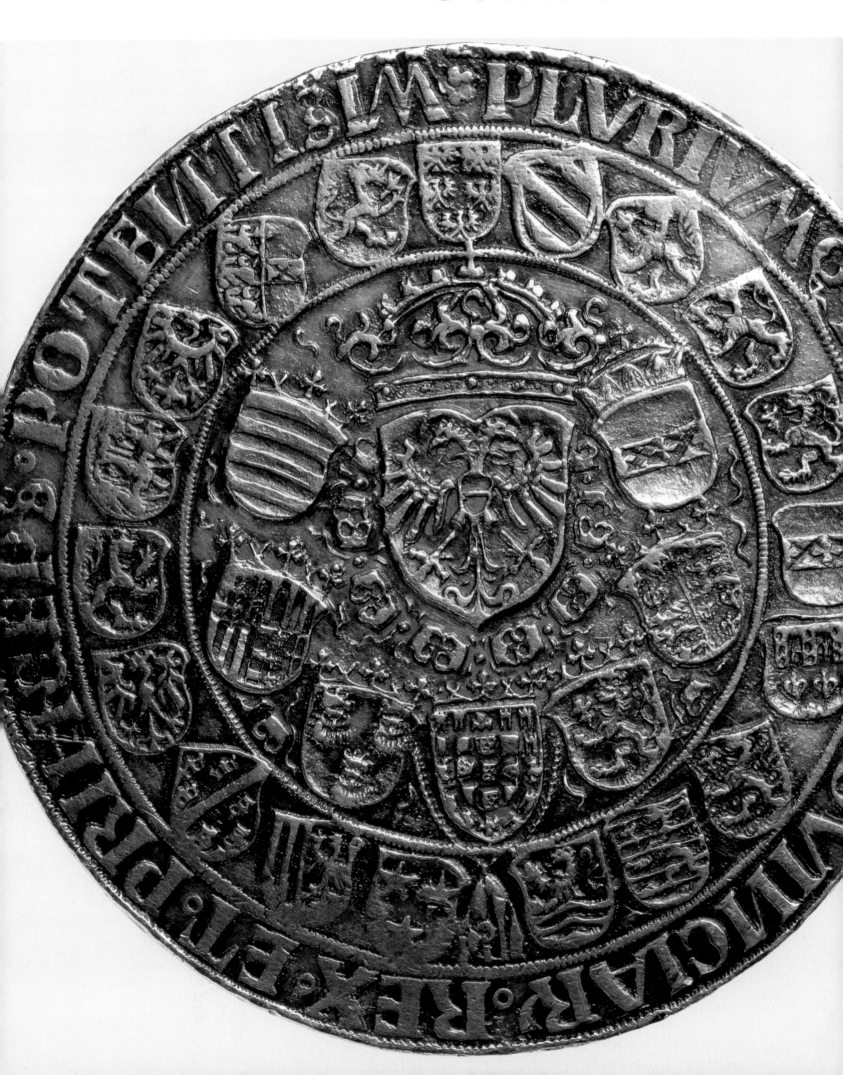

Early money of China

The Chinese were the first to develop a monetary system. The earliest 'coins' reproduced familiar objects, which had themselves probably been used as a means of exchange. Natural cowry shells had long served this function, and towards the end of the second millennium BC replicas in bone, jade, mother-of-pearl, bronze, gilt-bronze and even terracotta began to be used. These were followed, from around the eighth century BC, by replica spades and knives with inscriptions that often indicate the place or province in which they were issued and their value. They came initially from different regions, the knives from those areas where the people were pastoralists for whom a knife was an essential tool, and the spades from more fertile parts where agriculture was important. The typical circular Chinese coins first appear as smaller denominations in the fourth century BC and become dominant by the late second.

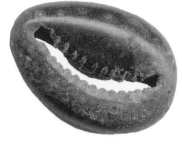

A selection of replica cowries
China, late 2nd to mid-1st millennium BC
Bone, mother-of-pearl, jade, bronze, gilt-bronze and terracotta. Varying widths, 1.4–2.3 cm

Hollow-handled spade,
reading *bau* ('value')
Zhao kingdom, 7th to 6th century BC
Cast bronze, h. 9.9 cm, w. 5.2 cm
Given by Christopher Jeeps
CM.450-1999

Right:
Five-character knife of the Kingdom of Qi,
value 30 *hua*
Jimo (modern Pingdu, Shandong province),
5th to 4th century BC
Cast bronze, h. 18.5 cm, w. 3.1 cm
Bought 2000
CM.520-2000

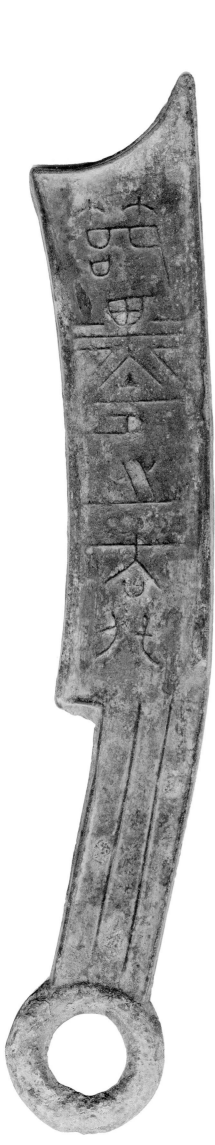

Early electrum coinage

The earliest coins in the Greek world were produced in Lydia and Ionia (western Asia Minor, now western Turkey) towards the end of the seventh century BC. The metal used was a plentiful natural mixture of gold and silver, known as electrum (white gold), found in river-beds. These primitive coins are small pre-weighed ingots stamped with a punch to confirm their value. One side of this third-*stater* from Ionia shows irregular striations resulting from the flan having been struck on a rough surface. The other side displays double rectangular incuse punch marks that expose the interior. This was probably intentional, the issuer seeking to show that the metal was of the intended quality.

This early phase of crude anonymous coinage was soon superseded by coins bearing distinctive images to distinguish the various city-states responsible for their issue. The second coin here belongs to a small issue of electrum *staters* of the fifth century BC from Lampsakos, in north-west Turkey. All known specimens are struck from the same pair of dies, indicating a very limited issue. By this time much of the Greek world had gone over to producing separate gold and silver issues, and the use of electrum was concentrated in the Hellespont, where Europe meets Asia Minor, the economic area to which Lampsakos belonged. The obverse shows the forepart of a winged horse surrounded by a grapevine. The reverse still has the appearance of punch marks, but it is in fact a distinctive mill-sail pattern that is also found on coins of neighbouring Cyzicus.

Third of a *stater* from Ionia,
late 7th century BC
Electrum, 2.35 grams, max. diam. 1.0 cm
Given by Prof. A.J.B. Wace, bought in
Athens a few years before 1914; said to
have been found at Lindos, on Rhodes
CM.G.1-R

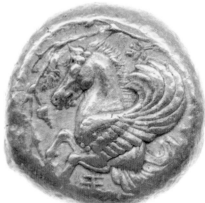

Stater of Lampsakos, second half of
5th century BC
Electrum, 15.22 grams, , max. diam. 2.0 cm
Lent by Corpus Christi College: S. S. Lewis
Collection, ex-Whittal (1884)
CM.LS.823-R

Money and art

Akragas, the largest and wealthiest city on the south coast of Sicily, was founded in 582 BC. Its geographical position, on higher ground near sea and at the confluence of rivers Akragas and Hypsas, was one of the reasons for its prosperity. Its trade was mainly with North African cities, and it was second only to Syracuse. After the victory of Syracuse and Akragas over Carthage in 480 BC, there followed a period of peace and prosperity to which this coin belongs.

On this beautiful coin an eagle is seen with spread wings and lowered head holding down its prey, a hare, on a rock. On the other side is a crab, the city's device, together with a fish identified as the giant sea-perch, while on the left is a scallop shell. These are among the finest animal studies depicted on ancient coins, illustrating the ability of the die engraver to observe and record nature accurately.

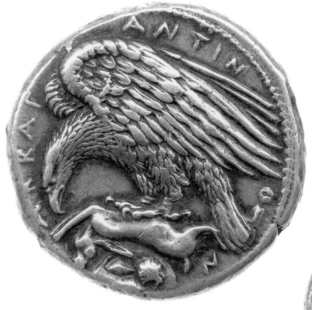

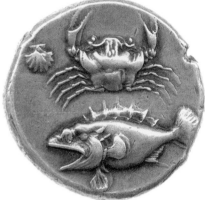

Tetradrachm of Akragas, *c.*420 BC
Silver, 17.46 grams, diam. *c.*2.7 cm
Given by J. R. McClean, 1906
McClean 2044

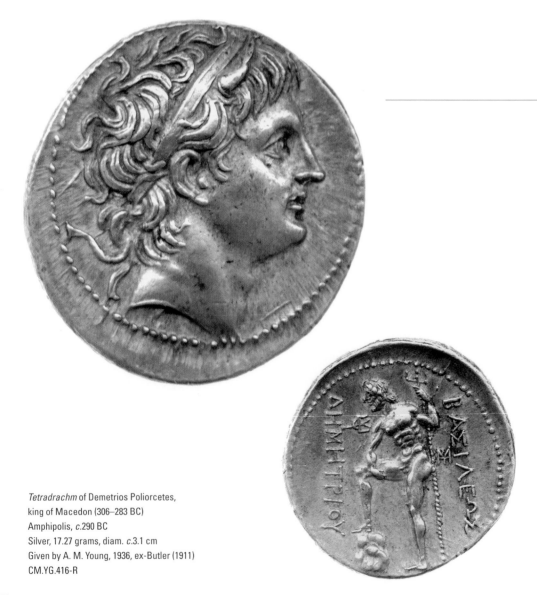

Tetradrachm of Demetrios Poliorcetes,
king of Macedon (306–283 BC)
Amphipolis, *c.*290 BC
Silver, 17.27 grams, diam. *c.*3.1 cm
Given by A. M. Young, 1936, ex-Butler (1911)
CM.YG.416-R

Two Macedonian kings

The period following the death of Alexander the Great in 323 BC saw interesting developments in coinage, the portrayal of living rulers, coupled with the exceptional ability of Hellenistic artists to render lifelike portraits. The first coin (left) depicts the head of one of the most colourful and forceful Hellenistic monarchs, Demetrios I of Macedon (306–282 BC), adorned with attributes of divinity (the bull's horn) and royalty (the diadem). As Demetrios styled himself the son of Poseidon, that god appears on the reverse holding a trident and with his right foot on a rock that might well represent an island. After his brilliant victory at sea over Ptolemy I off Salamis in Cyprus (306 BC), in celebration Demetrios took the title of king. In 305 BC he laid one of the most famous sieges of antiquity, trying to capture Rhodes. The siege lasted one year and was unsuccessful, but it earned him the nickname *Poliorcetes* (the 'Besieger'). His rule over Macedonia established the Antigonid dynasty.

The second coin (opposite above) shows a more youthful portrait, that of Perseus (179–168 BC), the last king of Macedonia. The strong image on the reverse, depicting an eagle holding a thunderbolt in its claws, all within an oak wreath – symbols alluding to the powerful Zeus – was in stark contrast to the situation that the kingdom and its ruler were in fact in. Rome was increasingly in control, and after Macedonian resistance was crushed at Pydna in 168 BC, the Antigonid dynasty was brought down, and with it the kingdom itself, which was divided into four regions.

Tetradrachm of Perseus, king of Macedonia
(179–168 BC)
Silver, 16.65 grams, diam. *c*.3.2 cm
Given by J. R. McClean, 1906
McClean 3675

Mithradates VI Eupator, liberator of the Greeks

The long reign of Mithradates VI
(126–63 BC), known as the liberator of
the Greeks, was marked by wars with
Rome over Greece and Asia Minor.
The fine late-Hellenistic portrait on this
coin shows an idealized, deified image of
Mithradates with floating hair, wearing a
diadem. The reverse depicts a grazing stag,
alluding to the popular goddess Artemis, and a star
within a crescent, the dynastic device of the kings of
Pontus. The ivy wreath with leaves and berries
represents the king's aspiration to be thought of as
Dionysus, the god of vegetation and fruits. The coin
is dated very precisely to the sixth month of year 222
of the Pontic era, which began in October 297 BC,
thus March 75 BC.

Tetradrachm of Mithradates VI Eupator Dionysus,
king of Pontus (126–63 BC)
March 75 BC
Silver, 16.43 grams, diam. *c*.3.3 cm
Given by A. W. Young; ex-Bunbury (1896)
CM.YG.417-R

'Ides of March' *denarius* of Brutus

The 'Ides of March' *denarius* is one of the most famous coins of antiquity. This coin, struck at the order of Brutus himself in 42 BC, was referred to by the Roman historian Dio Cassius: 'On the coins which he struck, he impressed his own image, and a cap of Liberty and two daggers, demonstrating from this and through the inscription that he, with Cassius, had freed their country.' The coin indeed shows a fine portrait of the conspirator with his name. The reverse bears the inscription EID MAR (*Eidibus Martiis*, 'on the Ides of March', i.e., 15 March 44), and shows the daggers used to murder Caesar in the name of liberty, represented by the cap (*pileus*) worn by freed slaves. It is ironic that Brutus should depict himself on this coin, continuing a practice of self-promotion established by Caesar for which he was much criticized. To escape unpopularity following the assassination of Caesar, Brutus and his fellow conspirators fled to Greece and Asia Minor, where this coin is likely to have been struck. Losing the battle against Marc Antony and Octavian at Philippi in northern Greece, Brutus committed suicide in October 42 BC.

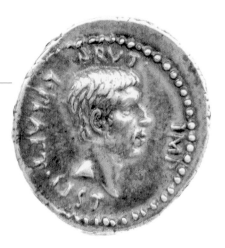

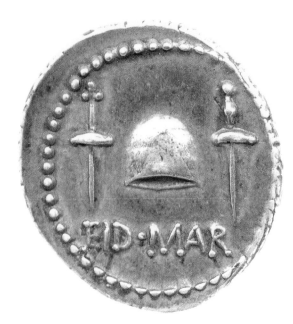

Denarius of Quintus Caepio Brutus
Moneyer: Lucius Plaetorius Caestianus
Struck at a mint moving with Brutus, 42 BC
Silver, 3.83 grams, diam. 2.0 cm
Given by Revd Dr H. St J. Hart
CM.1474-1963

Revival of realism

This massive and spectacular coin represents a short-lived attempt in the mid-third century to extend the range of denominations at a time when the depreciating silver coinage was in crisis. The large size of this new denomination gave the die engraver the opportunity to create a magnificent portrait of the ageing emperor with close-cropped hair, capturing very clearly his mental state: determined, tough. This represents the peak of the third-century revival of late Republic realism.

Decius held high offices under Philip I, before treacherously leading legions in battle against him in AD 249. Once emperor, Decius took the name of Trajan, after the second-century emperor on whom he wished to model himself. In the summer of AD 251, while campaigning against the Goths, the Roman troops under the personal command of Decius and his son Etruscus were ambushed in the marshes at Abrittus in Moesia Inferior. Decius and his teenage son were the first Roman emperors to die on the battlefield fighting against foreign invaders.

Double *sestertius* of the
Roman emperor Decius (AD 249–251)
Rome, *c.*AD 250
Copper-alloy, 39.92 grams, diam. 3.6 cm
Given by A. W. Young
CM.YG.367-R

Bactrian stater

Despite its remoteness, Bactria, the region of Afghanistan and neighbouring states north of the Hindu Kush, lay at the hub of Asia, by means of important routes that crossed the continent. It was culturally very rich, and major powers vied to control it. This *stater* marks one such transition. Although struck in the name of one of the later Kushan kings, Vasudeva I (*c.*AD 163–200), its style and fabric indicate that it was produced *c.*230, when the region had come under the control of the Sasanian rulers of Persia. The obverse shows the king wearing a helmet and armour and holding a trident in his left hand while making an offering at a small Zoroastrian altar. The reverse apparently shows a typical image of the Indian god Shiva standing in front of a bull, but certain additional attributes, such as the crescent on his head, and inscriptions on some Kushan coins identify this as a local deity Washo.

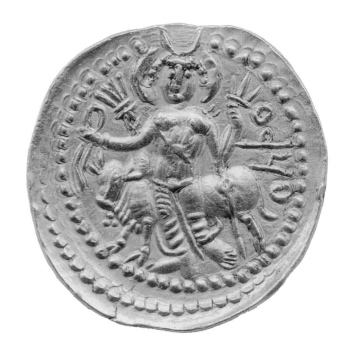

Kushano-Sasanian *stater* in the
name of Vasudeva I (*c.*AD 163–200)
Bactria, *c.*AD 230
Gold, 7.86 grams, diam. 2.5 cm
Bought 1968
CM.425-1968

After the fall of the Roman Empire

This coin represents that very earliest phase of state formation after the collapse of the Roman empire in the fifth century, when Germanic tribes such as the Burgundians moved into western Europe and established often short-lived but influential kingdoms. The Burgundian kingdom was initially based on the region around Geneva, but it expanded westwards to include the important cities of Lyon and Vienne. Its small but distinctive coinage was imperial in nature and paid homage to the authority of the emperor reigning in Constantinople – in this case Justin I (518–527), the inscription reading DN IVSTINVS PP AVG. Yet the coin is recognizably Burgundian,

because of its characteristic style of portrait but more obviously from the monogram, reading MAR for Gundomar II, on the reverse beside the standing figure of Victory. It was probably struck at Lyon. Gundomar was the last Burgundian ruler, for the kingdom was conquered by the Franks in 534, a little more than a century after it was formed.

Tremissis of Gundomar II, king of the Burgundians (524–534)
Lyon, AD 524–7
Gold, 1.43 grams, diam. 1.4 cm
Philip Grierson Collection; ex-Lord Grantley (1944)
PG 228

Anglo-Saxon penny of King Offa

King Offa's coinage stands at a turning-point in English currency. It marks a transition from the small thick coins of Classical fabric to the broader, thinner pennies of a type that would endure throughout the Middle Ages. Offa's coins were also artistically the most accomplished in the English series. One die-cutter in London, in particular, had an amazing talent for portraiture and letter design. This coin is among his most interesting products. It portrays Offa with a very unusual hairstyle, and since there are no contemporary portraits of eighth-century rulers other than those on coins, we cannot tell whether this represented the height of court fashion. Alternatively, it has been argued recently that this coin portrays Offa in the image of King David – the virtuous king – with wavy locks of flowing hair similar to David's depiction on the St Andrew's Sarcophagus or in eighth-century manuscripts.

Portrait penny of King Offa of Mercia (757–796)
Moneyer: Eadhun, London, *c.*780–92
Silver, 1.19 grams, diam. 1.7 cm
Given by A. W. Young, 1936; found at Deddington Castle, Oxfordshire, *c.*1866
CM.YG.418-R

Islamic Granada

In the fourteenth century, the court of Muhammad V in Granada was a centre of culture and scholarship. Muslim writers, historians and artists would gather at his exquisite palace–citadel Alhambra – 'the Red (fortress)' – which included royal residential quarters, court complexes with official chambers, a bath and a mosque. Occupying the mountainous region of south-east Spain, the Nasrids had been the only surviving Islamic state in the Iberian Peninsula since the mid-thirteenth century. Their coins were influenced by those of the Hafsids and Merinids of North Africa, and the largest denomination, the gold *dinar* (or *dobla*) shown here, displays a love of geometric design woven from the Arabic script. The dynasty came to an end in 1492 when Muhammad XII handed Granada over to Ferdinand and Isabella, as the culmination of their unification of the petty kingdoms that made up Spain.

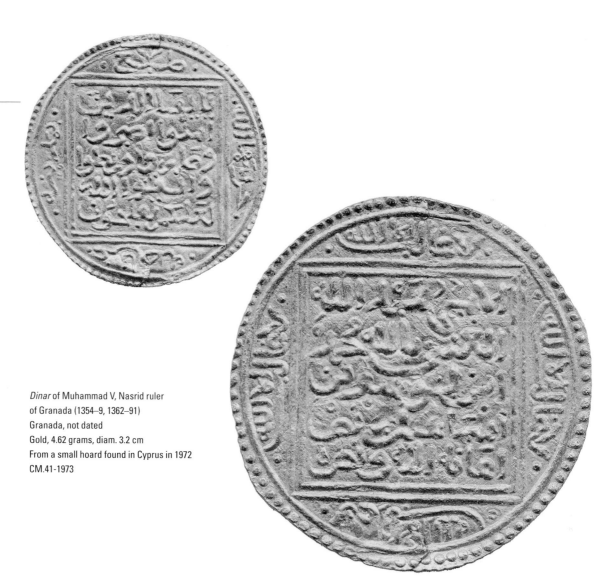

Dinar of Muhammad V, Nasrid ruler
of Granada (1354–9, 1362–91)
Granada, not dated
Gold, 4.62 grams, diam. 3.2 cm
From a small hoard found in Cyprus in 1972
CM.41-1973

Mughal gold

Akbar the Great (1556–1605) was not only a highly effective military leader who established the Mughals as the dominant and stable authority in India, but also a remarkable innovator. He introduced new systems of taxation and other administrative reforms, his own religion (a blend of the Islamic and Hundu faiths) and a new system of dating, as well as commissioning the construction of many fine buildings. This drive for reform coupled with aesthetic taste is also evident in Akbar's coinage.

This gold *muhr* from the last year of his reign has exquisite calligraphy, with fine flower tendrils intertwined within the inscription. Rather than the usual *Kalima*, Muslim profession of faith, it carries a poem in the form of a Persian couplet: 'The impression of the die of Shah Akbar is the glory of this gold, / Whilst earth and sky are illuminated by the shining sun.' The coin bears the date '49 *Azar*', which was the ninth month (*Azar*) of the 49th year in his new Ilahi calendar. This counts up from Akbar's accession, using solar rather than the customary lunar years of the Hijri calendar.

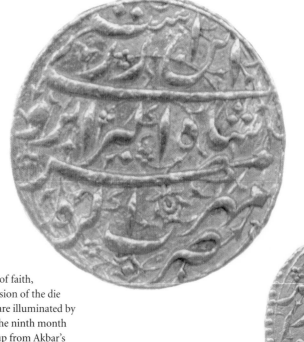

Muhr of the Mughal emperor, Akbar (1556–1605)
Agra, Ilahi era 49 *Azar* (November–December 1604)
Gold, 10.90g, diam. 2.5 cm
Bequeathed by J. D. Tremlett, 1918
CM.TM.1116-1918

End of the Hundred Years War

The *fort d'or* of Charles of France is one of the rarest and most celebrated coins in the French feudal series. In 1469 the French monarch Charles VII made his younger brother, Charles of France, the Duke of Aquitaine, a province that had been captured from the English in 1453 as the last act in the Hundred Years War. The new duke ordered a splendid series of gold and silver coins to be struck at his ducal capital, Bordeaux. The *fort d'or* was the largest denomination, rivalling in its originality of design and quality of workmanship the finest royal coins of France. The obverse is dramatic, showing Charles in full armour trampling on an English lion. The central shield on the reverse shows the French royal arms now quartered with those of Aquitaine. Only two specimens of the *fort d'or* are known to have survived, of which this is the finer.

Fort d'or of Charles of France,
Duke of Aquitaine (1469–1472)
Bordeaux, 1469–72
Gold, 7.86 grams, diam. 3.5 cm
Given by the Friends of the Fitzwilliam Museum with assistance from the Heritage Memorial Fund and the National Arts Collection Fund; ex-E. Gariel (1885); ex-M. Dassy (1869)
CM.552-1995

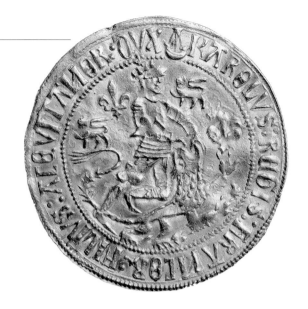

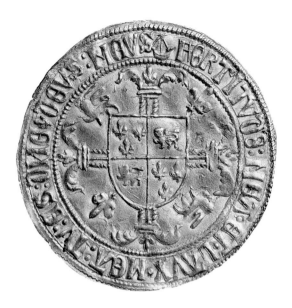

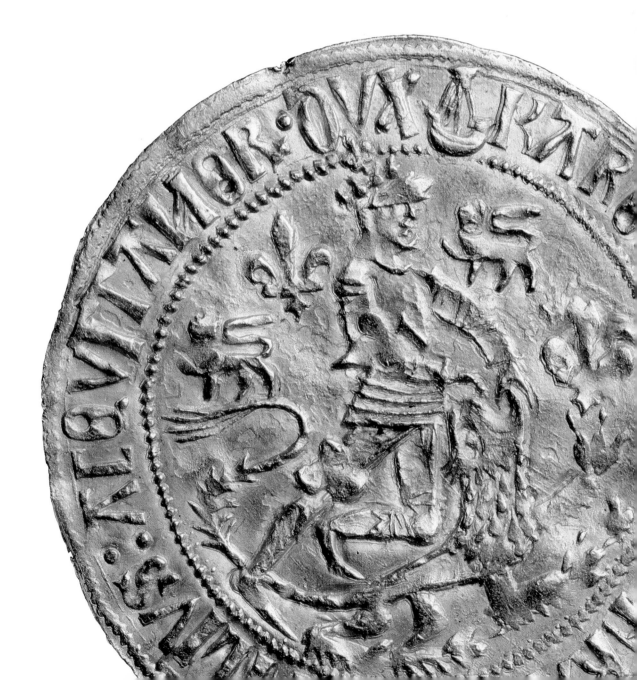

Equestrian statue by Leonardo

A new silver coin called the *testone*, with a portrait in the latest Renaissance style, was introduced in Milan by Galeazzo Maria Sforza in 1474; other rulers in northern Italy soon followed his example. The coins of Ercole d'Este, Duke of Ferrara (1471–1505), are particularly distinguished for their artistic excellence. The obverse has a striking profile portrait and a simple inscription in the manner of a Roman coin of the first century AD. The equestrian figure on the reverse, completely free from the distraction of any inscription, is believed to represent Leonardo da Vinci's famous lost statue of Francesco Sforza. The statue was never completed, but Leonardo produced a full-size clay model of the horse for casting in bronze. Having languished in Milan and been damaged by Louis XII's French troops, Ercole d'Este asked that it be transferred to Ferrara in 1501. Its subsequent fate is unknown.

Testone o quarto of Ercole I d'Este, Duke of Ferrara (1471–1505)
Ferrara, c.1503

Silver, 9.59 grams, diam. 2.9 cm
Philip Grierson Collection
PG 8099

Coronation coin of Maximilian I

The *Krönungsdoppelguldiner* was first produced in 1508–9 as a presentation piece to mark the coronation of Maximilian I as Emperor. The dies, by the court engraver Ulrich Ursentaler, were taken from Austria to the mint of Antwerp in 1517 where they were used, with an added rosette, to strike this specimen. Its massive size and exquisite equestrian portrait would certainly have impressed.

Maximilian is shown in full ceremonial armour, with an imperial crown on his helmet and carrying the imperial banner. The horse is draped with an ornate mantle richly decorated with symbols of the Empire and the House of Burgundy. The composition compares with Hans Burgkmair's well-known engraving of 1508, also marking the imperial coronation. On the coin, however, the horse is shown wearing the famous bards or horse armour made for Maximilian by Lorenz Helmschmied (1445–1516) of Augsburg, and which covered all parts of the horse, including the legs, articulated at the knees and above the hooves. This armour has not survived, and is otherwise only depicted in a painting of 1480 in the Kunsthistorisches Museum, Vienna.

Krönungsdoppelguldiner (double-*Shauguldiner*)
of Emperor Maximilian I (1493–1519)
Ulrich Ursentaler (1482–1562)
Antwerp, 1517, from dies of 1509
Silver coin, 60.4 grams, diam. 5.3 cm
Purchased from the Grierson Fund, with assistance from the National Art Collections Fund
CM.82-1999

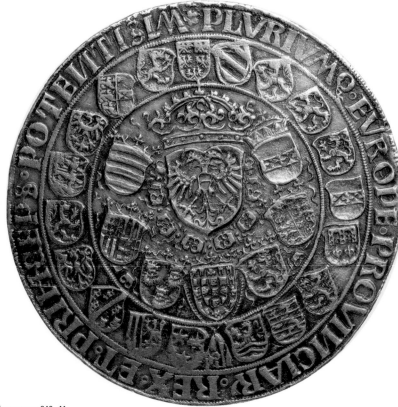

See enlarged detail on pages 240–41

Erasmus medal

This is one of the earliest masterpieces of Flemish
medallic art. Erasmus, the celebrated classical
scholar, philosopher and satirist, was Lady Margaret
Professor of Theology in Cambridge from 1511 to
1515. In 1519 he commissioned this medal from
Quentin Metsys, a portrait painter and medallist
who was a master of the painters' Guild of St Luke in
Antwerp. In a letter to the humanist Willibald
Pirkheimer, Erasmus related that he paid the artist
over 30 florins for this 'Terminus medal', as much, he
adds, as for his painted portrait. The Greek
inscription around the portrait tells the viewer that
the philosopher's true likeness is to be found in his
works. Erasmus explained the appearance of the
Roman god Terminus on the reverse of his medal
thus: 'Out of a profane god I have made for myself a
symbol exhorting to decency in life. For death is the
real terminus that yields to no one.'

Portrait medal of Desiderius Erasmus (c.1469–1536)
Quentin Metsys (c.1462–1530)
Antwerp, 1519.
Cast bronze, c.300 grams, diam. 10.6 cm
Bought from the University Purchase Fund with
a contribution from the Victoria & Albert Museum
Regional Fund
CM.28-1979

Lucy Harington, a Jacobean celebrity

Lucy Harington, who is also depicted in a miniature by Isaac Oliver (see page 56), was one of the most vivacious and cultured women in court circles. She is known to have been interested in ancient coins, as well as fine art and literature, and it is appropriate that this medal should be one of the first in England to have been commissioned for a private citizen. It is only known from this one piece, which may well have been the sole specimen produced for Lucy herself. The medal is the work of Nicholas Briot, a celebrated French coin engraver, medallist and inventor of minting machinery. He held the post of engraver-general at the Paris mint (1606–25), but in the summer of 1625 he moved to England, becoming principal die engraver at the Royal Mint.

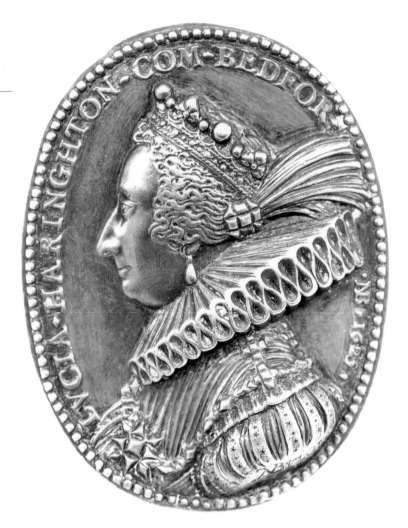

Portrait medal of Lucy Harington,
Countess of Bedford (1581–1627)
Nicholas Briot (c.1579–1646)
London, 1625
Silver, cast and chased, h. 5.3 cm, w. 4.2 cm
Purchased from the Cunliffe Fund with
a contribution from the National Art
Collections Fund
CM.2111-2004

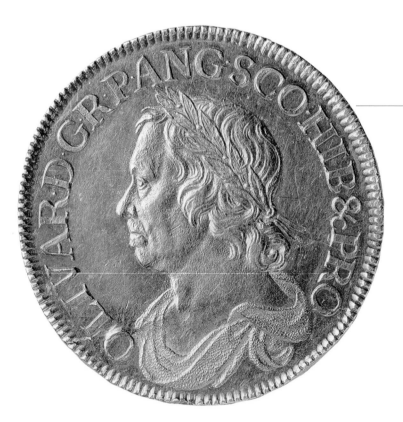

Oliver Cromwell. Lord Protector

This is one of only two known specimens in gold of the portrait crown of Oliver Cromwell. Cromwell had been created Lord Protector in 1653, and in 1656–8 he commissioned a coinage in his own name to be made by Pierre Blondeau, an inventor of new minting machinery. The dies were made by Thomas Simon, who is justly regarded as one of the greatest English engravers of coin and medal dies. On the obverse is a superb profile portrait of the Lord Protector, wearing a laurel wreath in the manner of a Roman emperor; on the reverse is the crowned arms of the Protectorate. The inscription PAX QVÆRITVR BELLO ('Peace is sought by war') refers to Cromwell's belief that it was necessary to fight the Civil Wars against Charles I to secure a just peace.

Proof crown of Oliver Cromwell
(Protector of England, 1653–1658)
Thomas Simon (1618–1665)
London, 1658
Gold, 49.14 grams, diam. 4.0 cm
Given by A. W. Young, 1936;
ex-T. Wakely (1909)
CM.33.3.514-1936

School prizes

Prizes for good work have been awarded by some public schools since the sixteenth century, although they only became more widespread from the 1780s. Among the earliest prizes recorded are silver or silver-gilt pens awarded by Christ's Hospital, London, and Tonbridge School. None of these very early pens survive, but the practice was revived at Christ's Hospital. This example is inscribed along the quill 'From the Governors of Christs Hospital to William Ormes for Eminence in Penmanship, 25 Sepr 1801', and the pen is quite functional.

The prize medal (below) is the earliest recorded from a girl's school. It was awarded in 1760 by the boarding school of Mrs Castelfranc at the Manor House, Clapham in London to 'H-M L'. It is exceptional in having the design cast in relief and then chased and engraved. For the small number of prizes that private schools required it was uneconomic to strike them from dies, but casting did not catch on and most prize medals down to the mid-nineteenth century are simply engraved on sheet silver.

Writing prize, Christ's Hospital
London, 1801
Silver gilt, 11.53 grams, l. 21.0 cm, w. 3.7 cm
Given by Miss M. E. Grimshaw
CM.767-1989

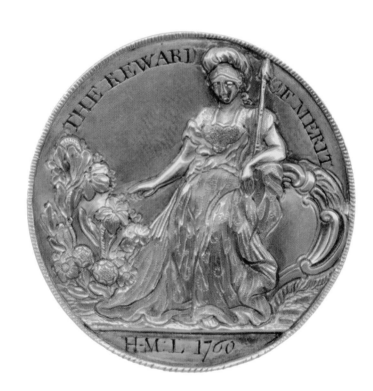

Prize medal from Mrs Castelfranc's
boarding school
Clapham, London, 1760
Silver, cast and chased, 21.58 grams, diam. 3.5 cm
Given by Miss M. E. Grimshaw
CM.759-1989

Index

Index